Light Science

Thomas D. Rossing •
Christopher J. Chiaverina

Light Science

Physics and the Visual Arts

Second Edition

 Springer

Thomas D. Rossing
Department of Music, Center for Computer
Research in Music and Acoustics (CCRMA)
Stanford University
Stanford, CA, USA

Christopher J. Chiaverina
New Trier Township High School
Winnetka, IL, USA

ISBN 978-3-030-27105-3 ISBN 978-3-030-27103-9 (eBook)
https://doi.org/10.1007/978-3-030-27103-9

This Springer imprint is published by the registered company Springer Nature Switzerland AG
The registered company address is: Gewerbestrasse 11, 6330 Cham, Switzerland

Preface

The title of this book, *Light Science,* can take on several meanings. First, it is intended to be an introduction to the science of light, especially intended for students in the visual arts and for readers with an interest in art. Second, it means that the book emphasizes the phenomena of light rather than the mathematical theories of light. Third, it suggests an approach that makes science accessible to a wide audience.

The close relationship between science and the arts has always been a special interest of both authors. Visual art depends on light to communicate with its intended audience, and an understanding of light and color by both the artist and the viewer will (hopefully) enhance this communication. We would like to hope that this is a book that Monet and Renoir would have enjoyed, just as we enjoy their exquisite paintings.

The material in this book was originally designed for an introductory course in physics for students having an interest in the visual arts. We have used it in both high school and university classes. It demands no previous training or experience in physics or mathematics beyond that of high school algebra. When used in its entirety, it is appropriate for a one-semester college course. Many chapters are "stand-alone" chapters and can be used as supplemental material for courses in physics, art, or psychology.

We are great believers in hands-on learning. In each chapter, we suggest simple experiments for the reader to do with common materials at home or that can be demonstrated in class. Laboratory experiments are in Appendix J.

Each chapter includes the following: summary, references, glossary, review questions, questions for thought and discussion, exercises, and experiments for home, laboratory, and classroom demonstration.

The authors wish to thank graphic artist Jennifer Geanakos for her indispensable contribution to *Light Science*. A thank you also goes out to Pam Aycock for her meticulous proofreading of the manuscript. Any mistakes that remain are our responsibility.

There are so many others who generously shared their art, knowledge, and wisdom with us and, ultimately, the readers of *Light Science*. Thank you to Alan Brix, Austine Wood Comarow, Hans Bjelkhagen, Linda Burkhart (Sanford Museum), Caltech/MIT/LIGO Lab, Mike Chiaverina, Paul Christie (Liti Holographics), Andrew Davidhazy, Brittany Illana Fader, Antoine Ferguson, Stephanie

Fitzpatrick, Benjamin Freeberg, Gordon Gore, Thomas B. Greenslade, Jr., Jim Hamel Photography, James Hicks, Susan Illingworth, Lauri Kangas, Akiyoshi Kitaoka, Kodansha, Ltd., Sanjay Kothari, Yayoi Kusama, Darius Kuzmickas, Robert Mark, Rebecca Newman, John Pugh, Bernard Richardson, Roscoe Laboratories, Jonathan Ross Hologram Collection, Veronica Savu (Morphotonix), Stephanie Schueppert, David Seagraves, Raymond Simonson, Smithsonian Institution, Carly Sobecki, stpmj Architecture P.C., Surrey Nanosystems Ltd., Joan Truckenbrod, Mark Welter, Sandra Whipple, C.J. Wilson, and Loren Winters.

Stanford, USA Thomas D. Rossing
Winnetka, USA Christopher J. Chiaverina

The original version of the book was revised: Belated corrections have been incorporated throughout the book. The correction to the book is available at https://doi.org/10.1007/978-3-030-27103-9_15

Contents

Our World of Light and Color

1

Throughout history, the knowledge and culture of each civilization have been expressed through its science, its literature, and its arts. To fully appreciate the beauty of our natural world, we should appreciate and understand both the scientific and the artistic interpretations. The physicist's sunset, the poet's sunset, and the artist's sunset are complementary to each other. The main purpose of this book is to expand our view of the world around us by helping to develop an understanding of the science of light.

We know the world through our senses: sight, hearing, touch, taste, and smell. Each sense responds to particular stimuli, and the sensations we experience tell us about the world around us. All of our senses are important, and each of them provides us with a unique set of information, but perhaps sight is the most important of all. Through sight we perceive the size, shape, and color of objects, both natural and man-made. We recognize human beings by their visual features. We communicate. We form impressions of the world around us.

Sight is a wonderful gift. In addition to allowing us to observe the world around us, it fills our lives with richness and beauty. The miracle of vision results from a combination of two things: the first is light, a physical entity that carries the information to us, and the second is our eye–brain system, which receives and interprets this information. (For simplicity, we will often refer to our eye–brain system simply as our "eye.") Since one of the main tasks of this book is to develop an understanding of vision, we will need to understand both the physical nature of light and the nature of visual perception.

© Springer Nature Switzerland AG 2019
T. D. Rossing and C. J. Chiaverina, *Light Science*,
https://doi.org/10.1007/978-3-030-27103-9_1

1.1 What Is Light?

For the rest of my life I will reflect on what light is.

—Albert Einstein

A successful model of light must address questions about light's properties, how it travels from one point to another, and its interactions with matter. For example, how is light able to travel through solid substances, such as glass, as well as the emptiness of space? How can the color of objects be explained? And perhaps the overarching question: is light a particle or a wave? That is, does light exist as tiny packets or is it a disturbance that travels like a ripple on a pond?

The Greeks were perhaps the first to theorize about the nature of light. Led by the scientists Euclid and Hero, they came to realize that light travels in straight lines. The Greeks learned that when light bounces off a surface, the angles of incidence and reflection are equal and saw that a beam of light bends as it enters a denser medium, such as water or glass. The Greeks also created mirrors from polished metals and experimented with lenses.

While the Romans extended the understanding of light somewhat, it was not until around 1000 CE that Arab scholars, most notably the Egyptian Ibn al-Haytham, Latinized as Alhazen, conducted detailed experiments regarding the behavior of light. Alhazen's experiments on light and vision as recorded in his *Book of Optics* (Kitab al-Manazir) and its Latin translation (De Aspectibus), earned him the title father of modern optics. Many examples of the optical phenomena that Alhazen explored, including perspective effects, the rainbow, mirrors, and refraction, are shown in the illustration in Fig. 1.1.

Six centuries would pass before Sir Isaac Newton, considered by many to be the greatest scientist of all time, would propose a comprehensive theory of light. Newton envisioned light to be made up of small discrete particles called corpuscles, which travel in straight lines with a finite velocity. Perhaps his most compelling argument in support of his model was that particles are capable of traveling through the vacuum of space. Furthermore, the particle theory of light handily explains the reflection of light since light reflects off shiny surfaces like billiard balls bounce off the cushion of a pool table.

In 1690, Christiaan Huygens, a contemporary of Newton, published an opposing theory of light. His wave theory suggested that light propagates as a disturbance or wave. While able to explain many optical phenomena, Huygens' theory failed to take traction. Since Newton was considered to be the grandmaster of science, it's no surprise that his particle theory of light won the battle against Huygens' wave theory. Newton's corpuscular theory of light remained the accepted model of light for over a century. It was then time for the wave theory's day in the sun.

During the nineteenth century, experiments by Thomas Young, Augustin Fresnel, and others established the validity of the wave model of light beyond any doubt, and the particle model was all but forgotten until the beginning of the twentieth century when Albert Einstein employed it to explain the photoelectric

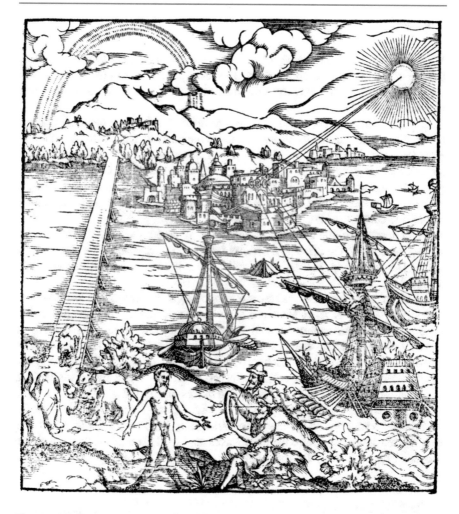

Fig. 1.1 Front page of the *Opticae Thesaurus*, which included the first printed Latin translation of Alhazen's *Book of Optics* (Public Domain via Wikimedia Commons)

effect. According to his theory, massless bundles of light energy (like Newton's corpuscles) are absorbed by atoms, resulting in the emission of electrons. These bundles of energy became known as *photons*.

So what is light: a wave or a particle? As strange as it may seem, the nature of light is determined by the way we observe it. At times light behaves as a particle; at other times, it behaves as a wave. The dual nature of light is an example of the complementarity of two models seemingly in conflict. Both models will be explored in more detail in subsequent chapters.

1.2 What Is Color?

Most people become fascinated with color at an early age. Shortly after receiving their first box of crayons, children begin to learn the names of colors, realize that they have favorites, and may even discover that colors can be combined to create new hues.

Color continues to play an important role in our lives far beyond childhood. It seems like we are constantly faced with color quandaries. What color car should I buy? Does this tie go with my shirt? Do I look better as a blonde or a brunette? We see color on the printed page, the television screen, and on electronic billboards. We go out of our way to see the perfect sunset or are willing to get wet to enjoy a rainbow. However, rarely do we think about sources of color and why things exhibit the colors they do.

What does determine the color of an object? What are the rules that govern the mixing of colors? Do an object's surroundings have any effect on its apparent color? Do objects appear the same color when illuminated with different light sources?

To begin to answer these and other questions regarding color, it is convenient to consider light as a wave. A wave is a disturbance that travels from one location to another, transferring energy without transporting matter. When people think of waves they often picture swells such as those shown in Fig. 1.2. Looking at these waves, one is perhaps most conscious of the amplitude, or height of the waves, and the wavelength, the distance between successive crests. These two quantities are important, for they are used to characterize waves of all kinds.

As you will learn in more detail later, light is an electromagnetic wave, a disturbance composed of undulating electrical and magnetic fields to which our eyes are sensitive. All electromagnetic waves are fundamentally the same; they are produced by oscillating electrical charges or electronic transitions in atoms, are

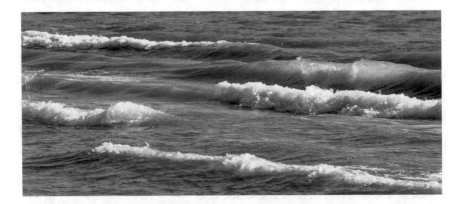

Fig. 1.2 Waves, such as these photographed on Lake Michigan, transmit energy without transferring matter (rossograph (https://commons.wikimedia.org/wiki/File:Lake_Michigan_Waves.jpg), https://creativecommons.org/licenses/by-sa/4.0/legalcode)

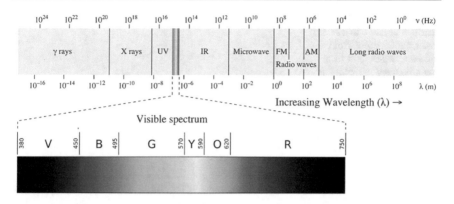

Fig. 1.3 Visible light represents only a small portion of a continuum of radiation known as the electromagnetic spectrum (Philip Ronan, Gringer (https://commons.wikimedia.org/wiki/File:EM_ spectrumrevised.png), "EM spectrum revised", https://creativecommons.org/licenses/by-sa/3.0/ legalcode)

capable of traveling through empty space as well as through air and other substances, and share a common speed in a vacuum, viz. approximately 3×10^8 m/s.

The entire range of all possible wavelengths of electromagnetic radiation is called the electromagnetic spectrum, as shown in Fig. 1.3. At one end of the spectrum are radio waves having wavelengths of thousands of meters. At the other end are electromagnetic waves with extremely short wavelengths. Sometimes referred to as gamma rays, these waves have wavelengths that are smaller than a billionth of a meter.

Color is a psycho-physiological response to electromagnetic waves ranging in length from roughly 4×10^{-7} to 7×10^{-7} m or 400–700 nm. (One nanometer [nm] equals one billionth of a meter [m], or 1 nm = 10^{-9}m.) When light in this range of wavelengths impinges on the color-sensitive receptors in the human eye, and is subsequently processed by the brain, we perceive color. However, to say that color is "all in our heads" would be incorrect. The intrinsic properties of objects and the nature of the light illuminating them both play important roles in how we see our world.

Most colors are due to a distribution of wavelengths. Thus, one way to describe a certain color might be to show an intensity distribution curve (a graph of intensity versus wavelength), as shown in Fig. 1.4. The curve shows a single prominent peak in the green portion of the visible spectrum, and so the observer would most likely perceive this light as having a green color. When the intensity distribution curve has several peaks, however, it is not so easy to predict the color that will be perceived.

In practice, the eye cannot extract all the information in an intensity distribution curve by looking at the light. Indeed, many lights with different curves appear to have the same color. Rather than specifying the intensity distribution then, it is more profitable to specify three qualities of colored light that determine how the light appears: hue, saturation, and brightness.

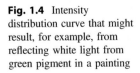

Fig. 1.4 Intensity distribution curve that might result, for example, from reflecting white light from green pigment in a painting

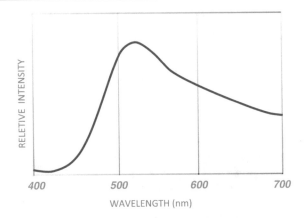

Hue refers to the color name or what distinguishes one color from another; all reds differ in hue from all blues regardless of other qualities. Hue is specified as a dominant wavelength in the visible spectrum that best matches the perceived color, even though light of that particular wavelength may not be present.

Saturation corresponds to the "purity" of the color; a saturated color has its intensity concentrated near the dominant wavelength, while an unsaturated color includes contributions from other wavelengths as well. Spectral colors have the greatest saturation; white light, which consists of all colors, is unsaturated. Artists sometimes use the terms *chroma* or *color intensity* to mean something similar to saturation.

Brightness (or *lightness*) refers to the sensation of overall intensity, ranging from dark, through dim, to bright. Other terms used to describe brightness are *value*, *brilliance*, and *luminosity*. To change the brightness of a light, we can adjust the intensity of the source; to change the lightness of a surface, we can make it less reflecting. Reducing the overall illumination on a sheet of white paper doesn't necessarily make it appear gray; however, it may continue to look white.

1.3 Origins of Color in Nature

Because a rose appears red, we tend to think of red as the essence of a rose. Similarly, we associate rose petals with the color green. Ironically, the colors perceived in both instances are associated with wavelengths rejected by these objects. A rose is red because it reflects red light and absorbs other wavelengths of light. A rose petal does not require green light for photosynthesis and therefore reflects light of this color while absorbing light of both shorter and longer wavelengths.

Like a rose and its petals, the color of many organic and inorganic objects is determined to a great extent by the wavelengths of light reflected or absorbed. This selective reflection and absorption is due to the presence of chemicals called pigments. However, not all color is due to selective absorption and reflection.

In 1801, British scientist Thomas Young demonstrated the wave nature of light. In the process, a second source of color in nature was revealed. According to wave theory of light, the colors seen on the surface of a soap bubble are not due to pigments within the soap film, but rather result from the combination, or interference, of light waves. Light incident on the bubble is reflected from both its outside and inside surfaces. The reflected light from the two surfaces overlaps and interferes. Depending on the bubble's thickness, certain wavelengths of light are reinforced while other wavelengths are extinguished.

Since the time of Young's discovery, a wide variety of living as well as inanimate objects have been shown to derive their color from physical processes. Microstructures on the outer surfaces of some animals are responsible for the most beautiful colors found in nature. In some instances, these structures consist of thin layers of material of alternating indices of refraction. As is the case with a soap film, light reflected from the top and bottom of these layers recombines and interferes. Recent research has revealed that the bright colors of a peacock feather are produced by tiny, intricate two-dimensional (2D) crystal-like structures. Slight alterations in the spacing of these microscopic structures cause different wavelengths of light to be reinforced, creating the feathers' many iridescent hues.

Other examples of such structure-generated colors can be seen in moth scales, beetle wing cases, the feathers of hummingbirds, and the shimmering metallic morpho butterfly wings seen in Fig. 1.5. Similar reflective structures made from silica are also responsible for the shimmering color found in opals.

The wave nature of light also explains another process called scattering. When light interacts with an object whose size is comparable to the wavelength of light, it shakes electrons in the object. Electrons then radiate, or scatter, light in all directions.

Fig. 1.5 Top view of the blue morpho butterfly wing (Photograph by Raymond Simonson)

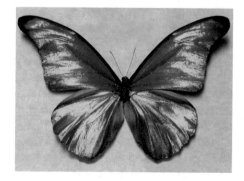

Scattering occurs when light passes through dust or smoke. The path of sunlight streaming into a room is seen because dust particles scatter light into our eyes. Without these particles, the light beam would not be seen from the side.

Still another source of color in nature is due to a process known as refraction, the bending of light as it passes from one material into another. As we shall see, refraction is responsible for splitting sunlight into its component colors as the light passes through a raindrop or a prism.

1.4 Rainbows

My heart leaps up when I behold
A rainbow in the sky:
So was it when my life began;
So is it when I am a man;
So be it when I grow old,
Or let me die!

—William Wordsworth

This poem by Wordsworth expresses the wonder and delight that most of us experience when we see a rainbow in the sky. Rainbows, such as those seen in Fig. 1.6, are certainly one of the most beautiful and remarkable natural displays of color, and they appear in many landscape paintings.

To some people, they signify good luck (or a pot of gold); to others they have a religious significance. Before you read any further, take out a pencil and make a list of all the things you can remember about the rainbows you have seen (e.g., Where do they appear in the sky? In what direction? What color appears on top?).

Most people realize that white light (including sunlight) is made up of light of many colors and that passing white light through a glass prism (or a drop of water) "breaks up" white light into a spectrum of colors. This is because light is slowed down when it enters the prism, as we will discuss in more detail in Chap. 4.

An artificial rainbow can be created by shining light on a spherical flask filled with water or a glass sphere as shown in Fig. 1.7, but a natural rainbow generally arises from light that is reflected from raindrops (Fig. 1.8). The rainbow that we normally see in the sky is really a portion of a circular rainbow. When you fly in an airplane, it is sometimes possible to see a fully circular rainbow, often surrounding the moving shadow of the plane on a cloud below (a "cloudbow"). Some remarkable photographs of rainbows appear in a book called *Rainbows, Halos, and Glories* by Robert Greenler.

The physics of rainbow formation was first explained by René Descartes in 1637. He concluded that the light that enters a spherical drop of water is reflected inside the drop, and emerges at an angle of 42°. Thus, the rainbow appears to be a circle with an angular radius of 42°, centered on the antisolar point, as shown in Fig. 1.9. Facing away from the sun, the antisolar point is also the direction in which the observer's shadow appears.

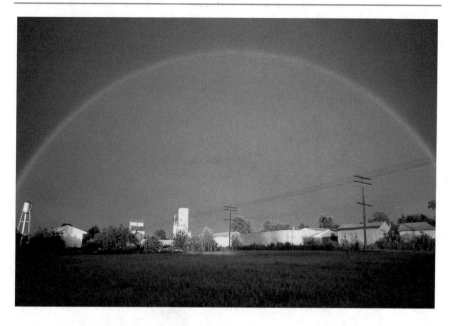

Fig. 1.6 Rainbow framing a midwestern town (Photograph by Mike Chiaverina)

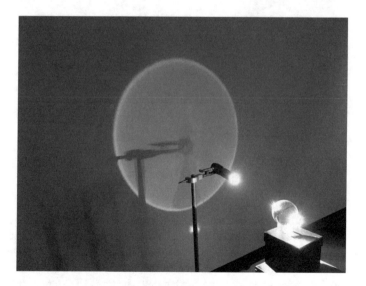

Fig. 1.7 White light shining on a glass sphere produces a circular artificial rainbow (Photograph by Mark Welter)

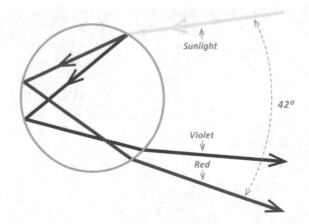

Fig. 1.8 Natural rainbow from light reflected in a raindrop

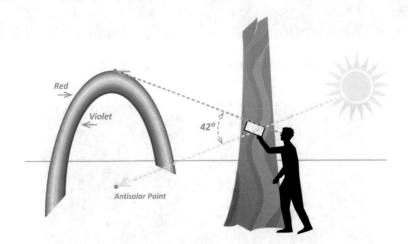

Fig. 1.9 The rainbow we see in the sky is a portion of a circular rainbow

Since only raindrops on the surface of a cone (whose tip is centered on the observer's eye) can contribute to the observed rainbow, it is clear that two people standing side by side admiring a rainbow are actually seeing light reflected by different sets of raindrops. Thus, each person has his or her own personal rainbow.

Although Descartes explained the fundamental features of the rainbow, he was unable to explain the colors. These were explained by Isaac Newton some 30 years later. Newton understood that white light is a mixture of light of many colors, and that they will be reflected at different angles by the raindrops (we will discuss why in Chap. 3). The angle varies from about 42° for red light to 40° for violet light. Thus, the bow circle of violet light lies inside the circle of red light. (You may have

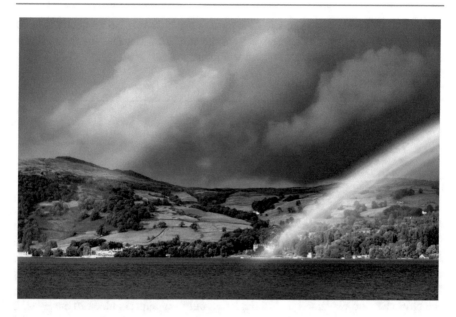

Fig. 1.10 The colors in a secondary rainbow are reversed from those of a primary rainbow (Shutterstock/Another John Winter)

noticed that pictures of rainbows on t-shirts and even in paintings sometimes have the colors in the wrong order.)

In addition to the regular (primary) rainbow, we sometimes can see a fainter secondary rainbow of a larger diameter. As is seen in Fig. 1.10, this rainbow has the order of the colors reversed from those of the primary rainbow.

The reversal of colors in the secondary rainbow results from two reflections inside each drop (see Fig. 1.11). The angular diameter of this rainbow is about 51°, and it was also explained by Descartes. Edmund Halley (who also discovered the

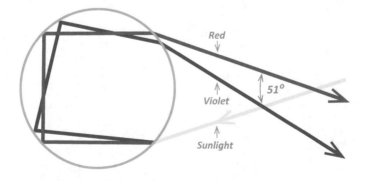

Fig. 1.11 A secondary rainbow is formed by two reflections inside a raindrop. Colors are reversed from those of a primary rainbow

comet that bears his name) predicted a tertiary rainbow with an angular radius of about 40 1/3° appearing as a circle around the sun itself. Because it appears in the direction of the sun, however, it is very difficult to see.

1.5 Blue Skies and Red Sunsets

Oh suns and skies and clouds of June
And flowers of June together,
You cannot rival for one hour
October's bright blue weather.

—Helen Hunt Jackson

The largest expanse of color in nature is the bright blue sky on a cloudless day. The blue color of the sky is due to scattering of sunlight by molecules of air. Blue light is scattered much more efficiently than light with longer wavelengths, so it appears brighter. This process is often called *Rayleigh scattering* in honor of Lord Rayleigh, the physicist who explained it. Although the night sky appears black to our eyes, it appears blue on photographs with very long exposure due to Rayleigh scattering of moonlight.

The orange-red color of a sunset is another product of Rayleigh scattering of sunlight by air molecules (Fig. 1.12). Even when the sun is overhead, it appears slightly orange, since some of the blue light has been removed by scattering. As it

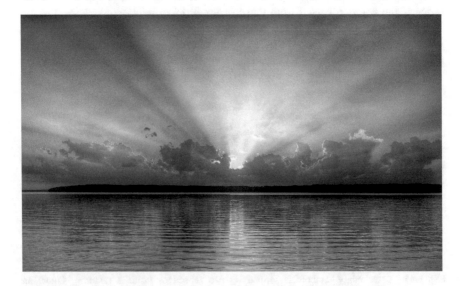

Fig. 1.12 The sun's orange-red appearance at sunset is a result of Rayleigh scattering. The apparent spreading of the sun's rays is an optical illusion due to perspective (Photograph by Raymond Simonson)

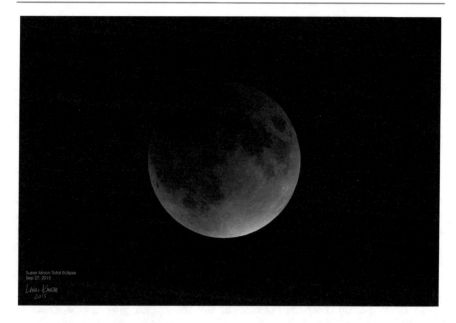

Fig. 1.13 The moon's unusual color is produced by orange-red light refracted by the Earth's atmosphere (Photograph by Lauri Kangas)

approaches the horizon, its light has a longer path through the atmosphere, and thus more of the blue light is scattered before it reaches our eyes.

The redness of a sunset can be increased by the addition of small scattering particles to the atmosphere. Large forest fires, for example, can add enough smoke particles to the atmosphere to intensify sunsets, as can volcanic eruptions. Smoke from a wood fire may appear blue due to scattered sunlight, while its shadow on the snow may appear quite reddish.

A sunset can be simulated by passing a beam of light through a flask of water to which a few drops of milk or a few grains of powdered milk have been added to serve as scatterers. The projected light appears red, while the light scattered to the side has a bluish cast to it.

During a solar eclipse the Earth's shadow blocks direct sunlight, but the moon is illuminated by light refracted by the Earth's atmosphere, which is predominantly red since the blue has been scattered (see Fig. 1.13).

1.6 Why Clouds Are White

Small particles, such as air molecules, scatter light preferentially, as we learned in Sect. 1.5. In contrast, particles that are significantly larger than the wavelengths of visible light scatter all colors more or less equally. This nonselective scattering is

responsible for the white appearance of clouds. Clouds consist of water droplets or ice crystals that typically range in size from 1 to 100 μm (0.001–0.1 mm), while light has wavelengths of approximately 0.4–0.7 μm (400–700 nm). For droplets of this size, Rayleigh scattering gives way to broadband scattering. Looking at a cloud, an observer will, in most cases, receive all wavelengths of light and perceive it as white.

A cloud's appearance is governed by a number of factors. These include cloud thickness, shadows, the age of the cloud, and the brightness of the surrounding sky and clouds. Figure 1.14 illustrates how these factors working in concert can produce dramatic differences in cloud brightness.

When a variety of paper samples, each of which seems to be white in isolation, are placed side by side, usually only one sample will be perceived as white; the remaining samples will appear gray by comparison. So it is with clouds: What we identify as white is simply the brightest gray in sight. While most clouds appear white, some appear whiter and brighter than others, and some clouds seem to be quite dark.

In the case of thick clouds that transmit little light, the brightness depends on direct illumination. If one cloud falls in the shadow of another, the obscured cloud will receive a diminished amount of light and will appear gray in comparison to neighboring clouds that are fully exposed to the sun. An isolated cloud may also

Fig. 1.14 Cloud thickness, shadows, the age of the cloud, and the brightness of the surrounding sky and clouds can all contribute to a cloud's appearance (Photograph by Lauri Kangas)

appear darker in some regions and brighter in others due to self-shadowing and a variation in particle size at different locations in the cloud.

As a cloud ages, its constituent water droplets coalesce. This decreases the number, but increases the size, of the droplets. The combined effects of a reduced number of scattering particles and the increased absorption by the larger droplets diminish the amount of scattered light. Thus, older clouds appear darker.

Closer to the Earth's surface, fog and mist serve as examples of scattering by large particles. The water droplets that comprise these examples of condensed water vapor are sufficiently large to scatter all wavelengths of light. The mist that appears above a tea kettle illustrates both Rayleigh and large-particle scattering. The fine mist, newly issued from the kettle, consists of small droplets of water. This mist is seen to have the bluish tint associated with Rayleigh scattering. The larger, more mature droplets that form as the water rises and further condenses appear white.

The nonpreferential scattering that gives rise to the appearance of clouds, fog, and mist is also responsible for the whiteness of a wide range of common materials. Salt, sugar, sand, and crushed glass all appear white when illuminated with white light. Like their water-based counterparts, they consist of particles capable of scattering all wavelengths of light equally.

1.7 The Color of Water in Its Various Forms

When viewed from space, one of the Earth's most commanding features is the blueness of its vast oceans and lakes. Small amounts of water do not portend the color of these large bodies of water; when pure drinking water is examined in a glass, it appears clear and colorless. Apparently a relatively large volume of water is required to reveal the azure color. Why is this so?

When light penetrates water, it experiences both absorption and scattering. Water molecules strongly absorb infrared and, to a lesser degree, red light. At the same time, water molecules are small enough to scatter shorter wavelengths, giving water its blue-green color.

The amount of long-wavelength absorption is a function of depth; the deeper the water, the more red light is absorbed. At a depth of 15 m, the intensity of red light drops to 25% of its incident value and falls to zero beyond a depth of 30 m. Any object viewed at this depth is seen in a blue-green ambient light. For this reason, red denizens of the sea, such as lobsters and crabs, appear black to divers not carrying a lamp.

A striking example of water's signature characteristic is illustrated by the Great Blue Hole located off the coast of Belize. The deep blue color of this natural wonder is caused by the high transparency of water and bright white carbonate sand within the hole. Long wavelengths of light are absorbed as light passes through water in the hole. The scattered blue light is reflected by the sand, giving water in the hole its intense color (Fig. 1.15a).

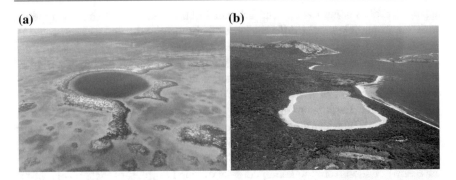

Fig. 1.15 The color of a body of water depends, in part, on its purity. **a** Scattered blue light gives the pristine water in Belize's Great Blue Hole its intense color (Shutterstock/Tami Freed). **b** Australia's famous Pink Lake's color is due to a single-celled algae producing pigments called carotenoids (Shutterstock/matteo_it)

The color of water may also be affected by minerals, bacteria, or algae. The Colorado River provides an example of water's chameleon-like nature, for it can appear green or red depending on its contents. One form of algae that sometimes accompanies spring snowmelt can give the river a greenish appearance; however, the river can sometimes take on a reddish quality due to the scattering of light from suspended silt. The bubble gum pink color of Australia's aptly titled Pink Lake has been traced to the presence of carotenoid-producing algae (Fig. 1.15b).

With a change of state, water's appearance changes dramatically. As everyone knows, snow is white and icebergs and glaciers tend to be blue. What is responsible for the distinctive color of these solid forms of water?

Snow is composed of tiny ice crystals interspersed with pockets of air. When sunlight enters a layer of snow, it bounces from one tiny ice crystal to another. Due to the relatively large size of the crystals, all wavelengths of light are reflected nearly equally, giving snow its white appearance. The low-density ice crystals in snow limit the absorption, allowing most of the incident light to escape.

However, the situation is different when it comes to densely packed ice crystals such as those found in glaciers and icebergs. As with liquid water, ice absorbs more red light than green and blue. The cumulative effects of many encounters with closely spaced ice particles lead to the reduction of light at the red end of the spectrum. What remains is a predominance of blue-green light. Figure 1.16 shows what happens when long-wavelength light is absorbed, leaving blue to be the predominant scattered color.

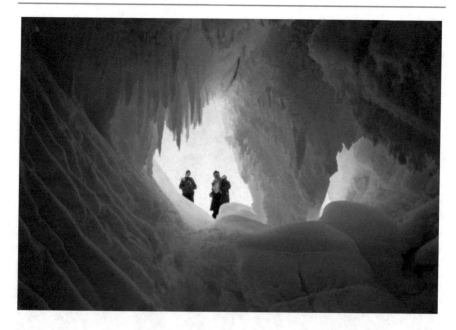

Fig. 1.16 An ice cave's blue color is due to the absorption of red light (By Fishdecoy [Public domain], via Wikimedia Commons)

1.8 Green Leaves of Summer, Crimson Leaves of Autumn

What is more spectacular than the vivid colors of autumn foliage? They have inspired poets, painters, and scientists; tourists travel great distances to view particularly good displays of autumn leaves. The dazzling colors of autumn are a direct consequence of chemical changes that occur within each leaf.

Photosynthesis, the process that combines water and carbon dioxide to form sugar, requires the presence of the energy-converting chemical chlorophyll. *Chlorophyll* absorbs blue and red light for the photosynthetic process and reflects green light. Pigments known as carotenoids are also present in leaves in lesser amounts. Carotenoids reflect longer wavelengths of light: yellows, oranges, and reds.

As autumn approaches, chlorophyll production ceases. With the loss of the dominant green pigment, the brilliant colors associated with the less-prominent carotenoids become visible, giving us one of nature's most stunning spectacles. The brilliant colors of autumn were in the leaves all summer, hidden by the green chlorophyll, just waiting to be seen and enjoyed (Fig. 1.17).

Fig. 1.17 The brilliant colors of autumn appear when chlorophyll production ceases

1.9 Color In Art

Drawing gives shape to all creatures, color gives them life.

—Denis Diderot

Our world is awash with color. From time immemorial, visual artists have been in search of colorants capable of permanently capturing the hues they witness in nature. Using paints, dyes, and inks, artists have used color to bring their work to life. The impact of color on the senses of the viewer can be profound. Even a dab of color in an otherwise monochromatic picture can transform the work. Numerous types and colors of pigments are available to artists today. This, however, has not always been the case.

The works of the earliest artists, found on the walls of caves, reveal the limited palette available during prehistoric times. The first cave paintings were discovered in Altimira, Spain. This early art is believed to be created during the Magdalenian period sometime between 16,000 and 9000 BCE. Here, cave-dwelling artists used berries, soot, charcoal, and red ochre (iron oxide) to create images of animals. The Lascaux caves, which were later discovered in southwestern France, reveal some of the best-known examples of Paleolithic art. The caves, consisting of seven inter-connected chambers, contain over 2000 images of humans and animals, also created with a limited number of pigments (Fig. 1.18).

Fig. 1.18 A painting from the decorated Lascaux caves of the Vézère Valley in France Francesco Bandarin [CC BY-SA 3.0-igo (https://creativecommons.org/licenses/by-sa/3.0-igo)]

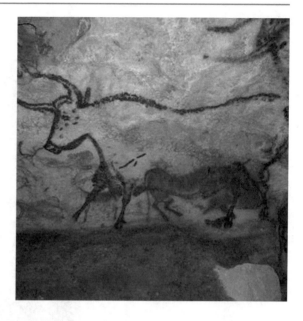

As time progressed, so did the availability of pigments. By the time of the pharaohs, the artist's palette had grown to include six basic colors: red, green, blue, yellow, white, and black, most of which were natural in origin. Later, Greek and Roman artists added colors based on lead compounds.

Through the following centuries, painters continued to experiment with color, not only as artists but also as, according to art conservator Dusan Stulik, "formulator[s] of paints." This is perhaps best illustrated by Tuscan painter Cennino Cennini's treatise entitled *Il Libro dell'Arte*, written around 1390, in which he gives detailed instructions on the preparation of materials for painting in fresco and on panel. Cennini describes systems of color for painting flesh, draperies, buildings, and landscapes in fresco and egg tempera. To paint faces, for example, Cennini explains how the flesh must first be underpainted with the pale green earth, *terre verte*. The pink flesh tones are then hatched or painted thinly on top, working in progressively paler shades from shadow to light. He recommends the pale yolk of a town hen's egg for painting the faces of young people with cool flesh colors, but the darker yolk of a country hen's egg for aged or swarthy persons.

Cennini describes the preparation of pigments from a variety of materials, both natural and artificial. Some pigments were very rare and expensive, such as ultramarine blue (literally, from "over the sea," since it was then found only in Afghanistan), extracted from the semiprecious stone lapis lazuli.

The development of oil painting in northern Europe paved the way for the brilliant use of color by the Renaissance and Baroque painters, such as Titian, Rubens, Velázquez, and Rembrandt. Each of them developed new pigment mixtures to achieve the desired effects. Titian's *Assumption of the Virgin*, shown in Fig. 1.19, uses vivid colors to produce high visual impact.

Fig. 1.19 Titian's
Assumption of the Virgin,
located on the high altar in
the Basilica di Santa Maria
Gloriosa dei Frari in Venice
(Titian creator QS:P170,
Q47551 (https://commons.
wikimedia.org/wiki/File:
Tizian_041.jpg), "Tizian
041", marked as public
domain, more details on
Wikimedia Commons: https://
commons.wikimedia.org/
wiki/Template:PD-1923)

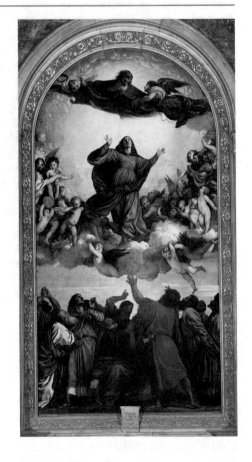

The use of synthetic pigments began early in the eighteenth century with the invention of Prussian blue. The synthesis of artificial ultramarine and the discovery of cobalt, chromium, and cadmium in the nineteenth century gave painters a wide variety of brilliant, stable colors. These advances, along with the introduction of collapsible paint tubes, made it possible for artists to work out of doors. The impressionist painters of the nineteenth century took advantage of this newly acquired freedom and made brilliant use of color, especially complementary pairs such as blue with orange, red with green, and yellow with violet.

One of the most significant things to happen to painting in the twentieth century was the invention of acrylic paint. Available in numerous colors, acrylic paints are water-based and fast drying. Once dry, acrylics become water-resistant even though they are initially water-soluble. Acrylic paint is popular among artists because a finished painting can resemble a watercolor or an oil painting, or have its own unique characteristics. Artists who have worked with acrylic paint include Andy Warhol, David Hockey, and Robert Motherwell, just to name few.

1.10 Summary

The nature of light is determined by how it is observed. At times light behaves as a particle; at other times, it behaves as a wave.

There are many interesting examples of color in nature, including rainbows, blue skies, red sunsets, and leaves that change from green to crimson. In each of these examples, the origin of the color involves a different principle of physics (refraction of light in the case of rainbows; Rayleigh scattering in the case of the blue sky and red sunset; interference in the case of butterfly wings; selective absorption and reflection in the case of green and crimson leaves).

Visual artists have long been in search of colorants capable of permanently capturing the hues they witness in nature. As a result of experimentation over the ages, numerous types and colors of pigments are available to artists today.

◆ Review Questions

1. Why must you look in the direction of your shadow in order to observe a rainbow?
2. Explain why the colors are "reversed" in a secondary rainbow.
3. Why is the sky blue and the setting sun red?
4. Photographs taken on the moon's surface show a colorless sky. Explain why.
5. Why are clouds white on a sunny day?
6. What is the range of wavelengths in the visible spectrum expressed in nanometers and expressed in meters?
7. How could you determine whether a certain green light has a single wavelength or a broad distribution of wavelengths?
8. List the factors that affect the color of water.

▼ Questions for Thought and Discussion

1. What is a nanometer?
2. How many nanometers are there in a millimeter (1 mm equals 10^{-3} m)?
3. Why is it said that each person has his or her own personal rainbow?
4. Suppose we lived in a world in which the atmosphere consisted of particles that scattered orange and red light more effectively than blue light. What color would the setting sun be in such a world?

● Experiments for Home, Laboratory, and Classroom Demonstration

Home and Classroom Demonstration

1. **Making your own rainbow.** Direct a fine spray from a garden hose in a direction away from the sun. Notice that a rainbow is formed. Do you see your

shadow? Where is it located in relation to the rainbow? How far away do you estimate the rainbow to be? If you look very carefully, you may see two rainbows. If so, how do you account for the existence of two bows? If you want to explore further, stand on a ladder while producing your rainbow. Describe the rainbow you see now. Can you explain what you observe?

2. **Making your own rainbow II**. Produce a circular rainbow by shining light from an LED flashlight on a spherical flask filled with water or on a glass sphere, such as those used by photographers to produce special effects (see Fig. 1.7).

3. **Sunset simulation I**. A sunset can be simulated by passing a beam of light through a glass of water to which a few drops of milk or a few grains of powdered milk have been added to serve as scatterers. Hold the glass to the side of a lightbulb (for classroom demonstration, use a slide projector and a fish tank). Scattered blue light may be seen throughout the liquid. Now observe the color of the transmitted light when the solution is placed in front of a lightbulb. With much of the blue light removed from the incident white light, only the orange-red portion of the spectrum remains. Try adding more droplets of milk to the solution. What effect does this have on the transmitted and scattered light?

4. **Sunset simulation II**. A clear glue stick designed for use in hot glue guns will also scatter light preferentially. When a relatively intense light beam (a Mini-Maglite™ flashlight works well) is directed into the end of a clear glue stick, blue light is scattered more effectively than red light. Consequently, the glue stick takes on a bluish tint along its length. With much of the blue light scattered out of the beam, the end opposite the light source appears orange-red. You may wish to experiment further by taping additional glue sticks end to end.

5. **Photographing a rainbow**. Try photographing rainbows using different exposure settings.

Glossary of Terms

brightness Sensation of overall light intensity, ranging from dark, through dim, to bright.

chlorophyll The material in leaves that strongly reflects green light.

hue Color name (e.g., red, yellow, green) that distinguishes one color from another.

photosynthesis Chemical process by which plants produce sugar from water and carbon dioxide by using sunlight.

rainbow Display of colors due to refraction in raindrops or other droplets of water.

Rayleigh scattering Selective scattering of light by small particles; it makes the sky appear blue and the setting sun red.

saturation Purity of a color (similar to "chroma" or "color intensity") .

wavelength Distance between two successive wave crests or troughs.

Further Reading

Eckstut, J., & Eckstut, A. (2013). *The Secret Language of Color*. New York: Black Dog and Leventhal Publishers, Inc.

Falk, D. S., Brill, D. R., & Stork, D. G. (1986). *Seeing the Light*. New York: John Wiley & Sons.

Finlay, V. (2014). *The Brilliant History of Color in Art*. Los Angeles: Getty Publications.

Greenler, R. (1980). *Rainbows, Halos, and Glories*. Cambridge: Cambridge University Press.

Heidorn, K., & Whitelaw, I. (2010). *The Field Guide to Natural Phenomena - The Secret World of Optical, Atmospheric and Celestial Wonders*. Buffalo, New York: Firefly Books, Inc.

Lamb, T., & Bourriau, J. (1995). *Colour: Art and Science*. Cambridge: Cambridge University Press.

Lynch, D. K., & Livingston, W. (2001). *Color and Light in Nature* (2nd ed.). Cambridge: Cambridge University Press.

Minnaert, M. (1993). *Light and Color in the Outdoors*. New York: Springer-Verlag.

Overheim, R. D., & Wagner, D. L. (1982). *Light and Color*. New York: John Wiley & Sons.

Smith, A. M. (2001). *Alhacen's Theory of Visual Perception (First Three Books of Alhacen's de Aspectibus)*. Philadelphia: American Philosophical Society.

Watson, B. (2016). *Light: A Radiant History from Creation to the Quantum Age*. New York: Bloomsbury USA.

The Wave Nature of Light

<div style="text-align:right">**2**</div>

*It seems we have strong reason to conclude that light itself
(including radiant heat, and other radiations if any) is an
electromagnetic disturbance in the form of waves propagated
through the electromagnetic field according to electromagnetic
laws.*

—James Clerk Maxwell

As was noted in Chap. 1, light exhibits a dual nature: At times, light behaves as a
particle, and at other times, as a wave. In this chapter, we will examine the properties of waves and introduce the wave nature of light.

2.1 What Is a Wave?

The world is full of waves. The room in which you are sitting is being crisscrossed
by radio waves and sound waves of many different wavelengths (or frequencies).
Almost all communication depends on waves of some type. All waves possess
certain common properties. In this and the following sections, we will discuss some
of these properties.

As was noted in Chap. 1, waves transport energy and information from one
place to another through a medium, but the medium itself is not transported.
A disturbance, or change in some physical quantity, is passed along from point to
point as the wave propagates. In the case of sound waves, the air pressure changes
slightly as the wave passes; in the case of light waves, the disturbance is a changing
electric and magnetic (electromagnetic) field. In either case, the environment reverts
to its undisturbed state after the wave has passed.

All waves have certain properties in common. For example, they can be
reflected, refracted, or diffracted, as we shall see in Chaps. 3–5. Waves of different
types propagate with widely varying speeds, however. Light waves and radio waves
travel 3×10^8 m (186,000 miles) in one second, for example, while sound waves
travel only 343 meters per second. Water waves are still slower, traveling only a
few meters in a second. Light waves and radio waves can travel millions of miles
through empty space, whereas sound waves require some medium (gas, liquid, or
solid) for propagation.

© Springer Nature Switzerland AG 2019
T. D. Rossing and C. J. Chiaverina, *Light Science*,
https://doi.org/10.1007/978-3-030-27103-9_2

2.2 Periodic Waves

Suppose that one end of a rope is tied to a wall and the other end is held, as shown in Fig. 2.1. If the end being held is moved up and down, a repeating or *periodic* wave will propagate down the rope, as shown. (When it reaches the tied end, a reflected wave will return, but we ignore this for the moment.) The wave travels at a speed v that is determined by the mass of the rope and the tension applied to it.

If we were to observe the wave carefully, we would note that the "crests" (and also the "troughs") of the wave are spaced equally; we call this spacing the *wavelength* λ (the Greek letter lambda) (see Fig. 2.2). The wavelength is measured in meters (m). The frequency of a periodic wave is the number of waves passing a given point per second and is measured in hertz (Hz). One hertz is equal to one wave or cycle per second or 1/s or s^{-1}.

The time between the arrival of one crest and the next is called the period T. The period, which is measured in seconds, and the frequency are reciprocals of each other. That is, $f = 1/T$. For example, if 100 waves are produced per second, the time between waves is 1/100 s.

Fig. 2.1 Waves can be created on a rope by moving one end up and down f times per second

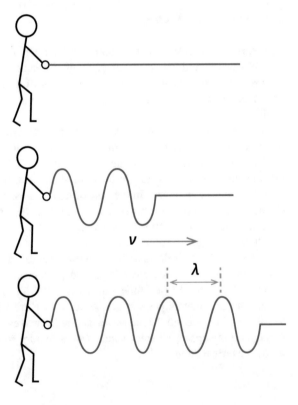

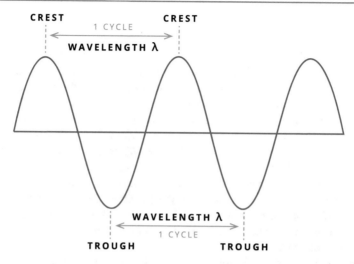

Fig. 2.2 The wavelength λ of a simple wave is the distance between adjacent crests or adjacent troughs

When is a wave is produced on a rope, the wave travels one wavelength along the rope in the time required for one complete vibration of the source. That is, it travels a distance λ in a time T. Speed is defined as distance divided by the time. Therefore, a wave's speed is equal to λ/T. Since the frequency f equals $1/T$, it follows that $v = \lambda/T = f\lambda$. This relationship is known as the *wave equation*.

▲ Example

A bobber floating on the surface of a lake is set into up-and-down motion by waves produced by a passing powerboat. The bobber vibrates up and down three times each second and adjacent wave crests are 2 m apart. What is the frequency, wavelength, and speed of the wave?

Solution Since the bobber vibrates at a rate of three times per second, the frequency is 3 Hz. A distance of 2 m between adjacent crests indicates a wavelength of 2 m. The speed of the wave is therefore

$$v = f\lambda = (3\,\text{Hz})(2\,\text{m}) = (3\,\text{s}^{-1})(2\,\text{m}) = 6\,\text{m/s}.$$

An amazing characteristic of waves is that their speed depends only on the medium through which they are moving and is not governed by the maximum height, or amplitude, of the wave. This means that no matter how hard a rope is shaken, the wave will travel away from the source at the same speed. In the case of sound waves, wave speed is completely independent of loudness. A shout travels at the same speed as a whisper. Similarly, bright light and dim light will cover the same distance in the same amount of time.

2.3 Types of Waves

The waves described above, produced by moving the end of a rope up and down, are examples of what are called transverse waves. In such a wave, the particles making up the medium, in this case a rope, move perpendicular to the direction in which the wave is traveling. Transverse waves most often require a solid medium such as a rope, a wire, or a spring, as shown in Fig. 2.3a. However, as we shall see, electromagnetic waves are transverse but require no material medium.

A second type of wave, a longitudinal wave, is produced by displacing a medium back and forth, parallel to the direction in which the wave is traveling. When the medium is pushed in the direction the wave is traveling, a compression is formed. In a compression, particles in the medium are bunched together (see Fig. 2.3b). When the medium is displaced in a direction opposite the motion of the wave, a rarefaction is created. In the case of a spring, a rarefaction is a portion of the spring where the coils are spread out.

Sound waves are a prime example of longitudinal waves. When sound is produced by a tuning fork, the tines of the fork alternately move forward and backward, forming a succession of regions of compressed and rarefied air. These compressions and rarefactions move outward from the tuning fork in the form of a longitudinal wave.

As we shall see later, one of the most familiar types of waves, water waves, exist as a combination of transverse and longitudinal waves. As a result, the particles composing the wave move in circles.

(a) **(b)**

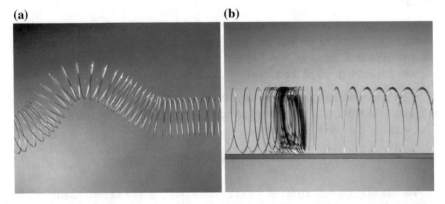

Fig. 2.3 Disturbances on a coiled spring. **a** Crest in a transverse wave. **b** Region of compression in a longitudinal wave (© Richard Megna, FUNDAMENTAL PHOTOGRAPHS, NEW YORK)

2.4 Impulsive Waves: Reflection

Suppose that the rope in Fig. 2.1 is given a single impulse by quickly moving the end up and down. As shown in Fig. 2.4, the impulse will travel at the wave speed v and will retain its shape fairly well as it moves down the rope.

What happens when the pulse reaches the end of the rope? Careful observation shows that the pulse reflects back toward the sender. In Fig. 2.5a, it is seen that this reflected pulse is very much like the original pulse, except that it is upside down. If the end of the rope is left free to "flop" like the end of a whip, the reflected pulse would be right side up, as illustrated in Fig. 2.5b. Photographs of impulsive waves on a long spring with a fixed end are shown in Fig. 2.6. Note that the reflected pulse is upside down. This is called a *reversal of phase*.

It is instructive to imagine the rope tied to the base of a mirror, as in Fig. 2.7. Then the mirror image of the pulse (generated by your image shaking the rope) travels at the same speed and arrives at the end of the rope at the same time as the actual pulse and appears to continue as the reflected pulse. (To make the phase [direction] of the pulse correct, two mirrors could be used to form a corner reflector, but this is not necessary to achieve the sense of the reflected pulse coming from a virtual source and meeting the original pulse at the point of reflection.)

Fig. 2.4 An impulsive wave generated by moving the end of a rope

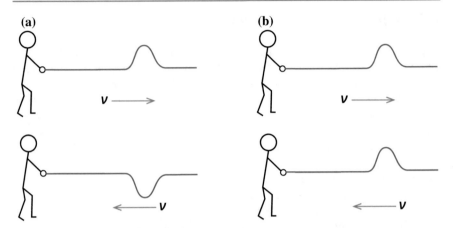

Fig. 2.5 Reflection of an impulsive wave: **a** at a fixed end, **b** at a free end

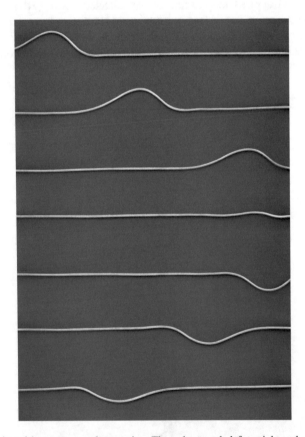

Fig. 2.6 An impulsive wave on a long spring. The pulse travels left to right and reflects back to the left, as in Fig. 2.5. The returning pulse is inverted, indicating reflection from a fixed end (© Richard Megna, FUNDAMENTAL PHOTOGRAPHS, NEW YORK)

Fig. 2.7 The mirror image of an impulsive wave approaching a point of reflection *P*. In a plane mirror, as shown in **a**, the two pulses have the same phase, but in a corner mirror, as shown in **b**, the two pulses have opposite phase (just like the incident and reflected pulses on the rope with a fixed end)

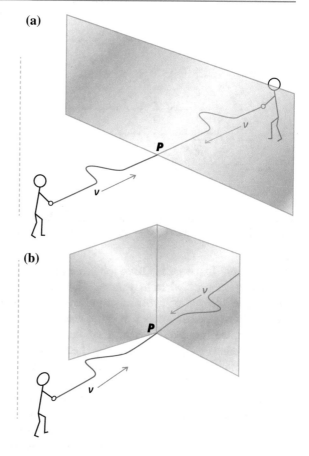

One can think of the reflected wave on the rope as coming from an imaginary source, whether or not a mirror is there to show a reflected image. If the rope is tied to a solid object at its far end, the deflection must always be zero, even when the pulse arrives; this requires that the pulse be met by a pulse of opposite phase, as shown in Fig. 2.7b. If the end is free, it snaps like a whip, momentarily doubling its displacement when the pulse arrives. This is equivalent to the arrival of a pulse with the same phase, which then continues as the reflected pulse shown in Fig. 2.7a.

2.5 Superposition and Interference

An interesting feature of waves is that two of them, traveling in opposite directions, can pass right through each other and emerge with their original identities. The *principle of linear superposition* describes this behavior. For wave pulses on a rope, for example, the displacement at any point is the sum of the displacements due to each pulse by itself. The wave pulses shown in Fig. 2.8 illustrate the principle of

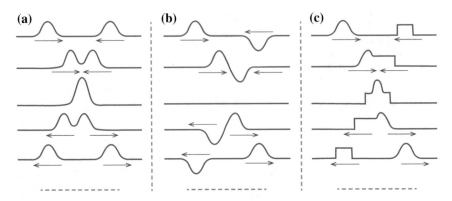

Fig. 2.8 The superposition of wave pulses that travel in opposite directions: **a** pulses of the same phase; **b** pulses of opposite phase; **c** pulses with different shapes

superposition. If the pulses have the same sense, they add; if they have opposite sense, they subtract when they meet. These are examples of the *interference* of pulses. The addition of two similar pulses is called *constructive interference*; the subtraction of opposing pulses is called *destructive interference*.

Interference has many practical applications. Among them, the reduction of ambient sound using noise-canceling headphones. Microphones located in the headphones pick up noise from a listener's surroundings. A digital signal processor then produces sound waves that are 180° out of phase with the noise. Fed through speakers in the headphones, this "anti-noise" cancels out much of the unwanted sound through destructive interference. The principle is applied on a larger scale in the cabins of many of today's automobiles and airplanes.

Interference also has many optical applications. As you will learn later, interference governs the operation of measuring devices called interferometers and is the basis of holography, the production of three-dimensional images on two-dimensional photographic plates.

2.6 Standing Waves

Suppose that both ends of a rope are shaken up and down at the same frequency, so that continuous waves travel in both directions. Continuous waves interfere in much the same manner as the impulsive waves we have just considered. If two waves arrive at a point when they have opposite sense, they will interfere destructively; if they arrive with the same sense, they will interfere constructively. Under these conditions, the waves do not appear to move in either direction, and we have what is called a *standing wave*.

 In the case of two identical waves (same frequency and amplitude) traveling in opposite directions on a rope or spring, there will be alternating regions of constructive and destructive interference. The points of destructive interference that always have zero displacement are called *nodes*; they are denoted by *N* in Fig. 2.9. Between the nodes are points of constructive interference, where displacement is a maximum; these are called *antinodes*. At the antinodes, the displacement oscillates at the same frequency as in the individual waves; the amplitude is the sum of the individual wave amplitudes.

 Note that the nodes in Fig. 2.9, formed by the interference of two identical waves, are a half-wavelength apart. Because these points of maximum displacement do not move through the medium, the configuration is called a standing wave.

Fig. 2.9 Interference of two identical waves in a one-dimensional medium. At times t_1 and t_5, there is constructive interference, and at t_3 there is destructive interference. The blue wave added to the green wave gives the red wave in all cases. Note that at points marked *N*, the displacement is always zero

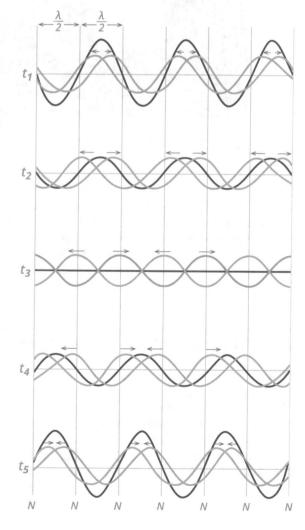

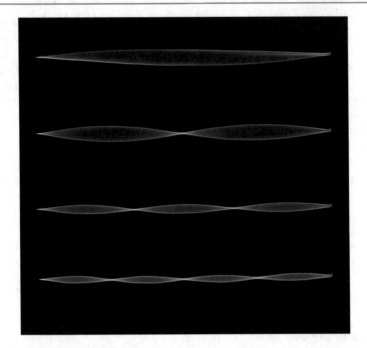

Fig. 2.10 A photograph showing four modes of a standing wave on a cord (Ted Kinsman/Science Source)

Standing waves can result whenever waves are reflected back to meet the oncoming waves. The case illustrated in Fig. 2.10, in which the forward and backward waves have the same amplitude, is a special case that leads to total interference. If the two incident waves do not have the same amplitude, the nodes will still be points of minimum, but not zero, displacement. The four modes, or patterns of vibration, of the cord shown in Fig. 2.10 result from shaking the cord at different frequencies; the higher the frequency, the greater the number of nodes and antinodes.

2.7 Wave Propagation in Two and Three Dimensions

Thus far we have considered only waves that travel in a single plane. One-dimensional waves of this type are a rather special case of wave motion. More often, waves travel outward from a source in two or three dimensions.

Water waves are a familiar example of two-dimensional waves. Many wave phenomena, in fact, can be studied conveniently by means of a ripple tank in the laboratory. A ripple tank uses a glass-bottom tray filled with water; light projected through the tray forms an image of the waves on a large sheet of paper, as shown in Fig. 2.11.

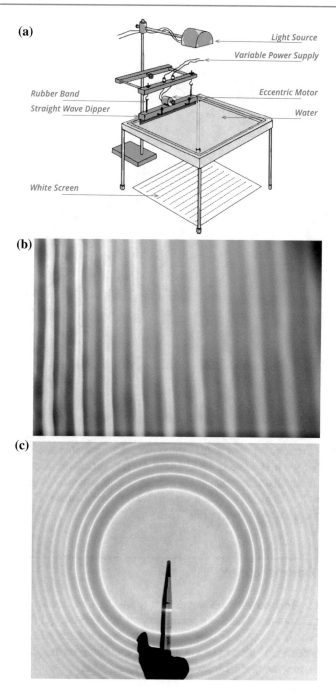

Fig. 2.11 **a** A ripple tank for projecting an image of water waves; **b** straight waves on a ripple tank (© Richard Megna, FUNDAMENTAL PHOTOGRAPHS, NEW YORK); **c** circular waves on a ripple tank. (Berenice Abbot/Science Source)

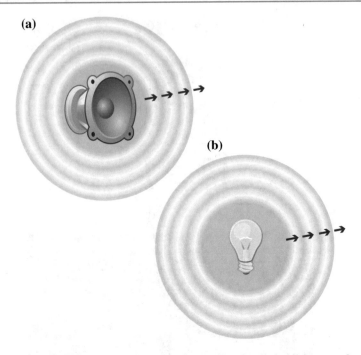

Fig. 2.12 a Spherical sound waves from a small loudspeaker; **b** spherical light waves from a bulb with a small filament

Different sources radiate different patterns: A point source radiates spherical waves; a line source radiates cylindrical waves; and a large flat source radiates plane waves. Real sources are never true point sources, line sources, or flat sources, however; what we may have in real life are sources that approximate one of these geometries. A small loudspeaker will radiate nearly spherical waves at low frequency, as will a light bulb with a small concentrated filament (as used in automobile headlamps), as shown in Fig. 2.12.

2.8 The Doppler Effect

Ordinarily, the frequency of the waves that reach the observer is the same as the frequency at the source. There is a notable exception, however, if either the source or the observer is moving. If they are moving toward each other, the observed frequency increases; if they are moving apart, the observed frequency decreases. This apparent frequency shift is called the *Doppler effect*.

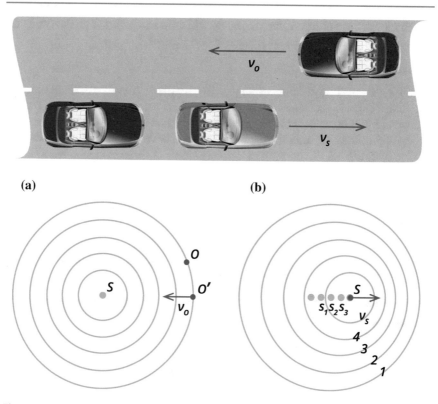

Fig. 2.13 The Doppler effect: **a** observer moving toward the sound source; **b** source moving toward the observer

The Doppler effect is explained quite simply with the aid of Fig. 2.13. Suppose that a source S emits 100 waves per second. An observer at rest O will count 100 waves per second passing. However, an observer O' moving toward the source will count more waves since he or she "meets" them as he or she moves, just as the driver of an automobile meets oncoming traffic. The apparent frequency (the rate at which the observer meets the waves) will be $f = f_s \frac{v + v_o}{v}$, where f_s is the frequency of the source, v_o is the speed of the observer, and v is the speed of sound. Note that after the observer passes the sound source, v_o must be subtracted from v. Thus, the frequency drops abruptly (not gradually) when the observer passes the source.

There is also a Doppler effect if the source is in motion. You have probably observed a drop in pitch of the noise as a truck or car passes by while you are standing at the side of the road. The case of the moving source is shown in Fig. 2.13b. The source emitted wave number 1 when it was at position S_1, number 2 when at S_2, and so on. The wavefronts resemble spheres with centers constantly shifting to the right as the source moves. Thus, the observer O receives waves at a greater rate than he or she would from a stationary source. If the speed of the source is v_s, the apparent frequency will be $f = f_s \frac{v}{v - v_s}$. Note that if the source moves

directly toward the observer, the frequency will drop abruptly, not gradually, as the source passes by. The apparent frequency will now be $f = f_s \frac{v}{v + v_s}$.

▲ Example

A police car traveling at 30 m/s (roughly 67 miles/hour [mph]) passes an observer standing alongside the highway. If the car's siren produces a sound with a frequency of 900 Hz, what is the frequency of the waves reaching the observer (a) as the car approaches, (b) after the car has passed the observer? The speed of sound at 0 °C is 332 m/s.

Solution

(a) Since the source of sound is approaching the observer, the apparent frequency of the siren is given by $f = f_s \frac{v}{v - v_s}$.

$$f = f_s \frac{v}{v - v_s} = \left(900\,s^{-1}\right) \left(\frac{332\,m/s}{332\,m/s \;-\; 30\,m/s}\right) = \left(900\,s^{-1}\right)(1.099) = 989\,Hz.$$

(b) With the source now receding from the observer, the apparent frequency of the siren is now given by $f = f_s \left(\frac{v}{v + v_s}\right)$.

$$f = f_s \left(\frac{v}{v + v_s}\right) = \left(900\,s^{-1}\right) \left(\frac{332\,m/s}{332\,m/s \;+\; 30\,m/s}\right) = \left(900\,s^{-1}\right)(0.917) = 825\,Hz.$$

2.9 Water Waves

Surface waves on water are among the most interesting types of waves in nature. We know that they travel rather slowly (at least compared to sound waves or light waves), that they appear to be transverse waves, and that they can carry a lot of energy.

We have learned that a wave disturbs the medium of propagation in some way, and that in order to propagate there must be a restoring force. In the case of waves on the surface of water, that restoring force has two different origins: gravity and surface tension. Both produce a downward force on wave crests. For waves of short wavelength, surface tension dominates, while gravity is more important in the case of waves of long wavelength, such as those found in the middle of the ocean. In both cases, the speed of propagation depends upon the wavelength; in other words, water waves are *dispersive*.

Figure 2.14 illustrates the way in which the speed of water waves varies as a function of wavelength and depth. For deep water, the wave speed c is independent

Fig. 2.14 Speed of water waves as a function of wavelength λ and depth h

of the depth and proportional to the square root of wavelength: $c = \sqrt{\lambda g/2\pi}$, where λ is wavelength and g is the acceleration due to gravity. This corresponds to the line $h = \infty$ in Fig. 2.14, where h is the depth of the water. In shallow water, where h is less than the wavelength λ, the wave speed c is independent of wavelength λ but proportional to the square root of the depth h: $c = \sqrt{gh}$. This is shown by the horizontal lines for different values of h on the right-hand side of Fig. 2.14.

The photograph in Fig. 2.15 shows water waves slowing down as they encounter a shallow region in a ripple tank produced by a submerged glass plate. This reduction in wave speed results in both a decrease in wavelength and a change in direction of motion of the wavefront.

In deep water, each particle of water moves in a circle, as shown in Fig. 2.16a. The radius of the circle decreases rapidly with depth, however, so that deep-water waves do not disturb the water more than a few wavelengths below the surface. You may have noticed this by observing fish swimming underwater in an aquarium quite undisturbed by waves on the surface. In shallow water, each particle travels in an elliptical orbit, as shown in Fig. 2.16b. The lengths of all the ellipses are the same, but the heights decrease in proportion to the depth, being zero on the bottom.

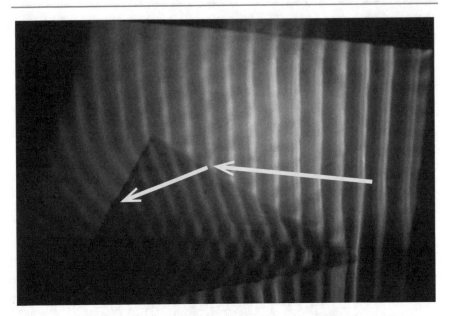

Fig. 2.15 Water waves slow down, get closer together, and bend as they encounter a shallow region produced by a submerged glass plate (Dicklyon (Richard F. Lyon) (https://commons. wikimedia.org/wiki/File:Wave_refraction.gif), "Wave refraction", https://creativecommons.org/ licenses/by-sa/3.0/legalcode)

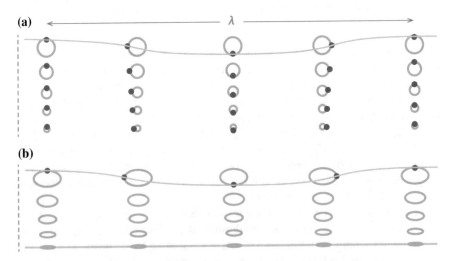

Fig. 2.16 **a** Particle orbits in deep water are circular, and their diameters decrease rapidly with depth; **b** particle orbits in shallow water are elliptical, and their heights decrease with depth, but their lengths stay the same

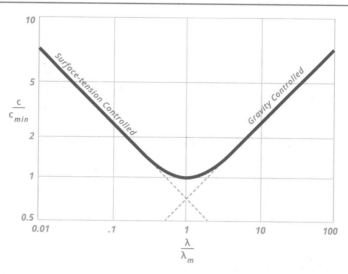

Fig. 2.17 Speed of surface water waves decreases with wavelength for small λ (when surface tension dominates) but increases with wavelength for large λ (when the force of gravity dominates)

Figure 2.14 shows that in deep water, where the water depth is greater than the wavelength, the wave speed increases with wavelength. When the wavelength is very short, however, the opposite is true: The speed decreases with wavelength, as shown in Fig. 2.17. (In fact, it is proportional to the square root of $1/\lambda$: $c = \sqrt{2\pi\tau/\rho\lambda}$, where τ is and ρ is density). Thus, water surface waves can show either positive or negative dispersion, depending on their wavelength.

2.10 Speed of Light

Throughout history, many attempts have been made to measure the speed of light with ever greater precision. The earliest estimates were based on astronomical measurements. In 1676, the Danish astronomer Olaf Roemer noted that the time interval between successive disappearances of one of Jupiter's moons seemed to be longer while Earth was moving away from Jupiter than when it was approaching. Roemer reasoned that this small difference (about 14 s compared to a total time of 42½ h) could be accounted for by assuming that the speed of light is finite. Each new light message that an eclipse has taken place has to travel farther when Earth is moving away from Jupiter than a previous message does while Earth is approaching Jupiter.

In 1929, Albert Michelson measured the speed of light over a measured distance of $L = 22$ miles between two mountains in California using an ingenious method of timing, as shown in Fig. 2.18. An octagonal mirror M is mounted on the shaft of a

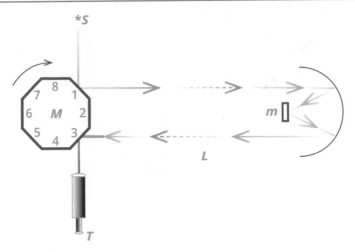

Fig. 2.18 Michelson's method for measuring the speed of light

variable-speed motor. Light from source S falls on the mirror M at an angle of 45 degrees and is reflected to a distant mirror m, which returns it. With M stationary, the selected ray strikes face 3 of the octagonal mirror at an angle of 45 degrees so that it is reflected into telescope T. When mirror M is rotating, however, light returning from mirror m will not generally be reflected at the proper angle to enter the telescope. When the speed of M is sufficient so that face 2 of the mirror is brought into the position formerly occupied by face 3 in the time required for light to go from face 1 to m and back to face 2, light will again enter the telescope. The time for the light to travel a distance $2L$ is then one-eighth of the time required for one revolution of M. Michelson obtained a speed close to the correct value $c = 3 \times 10^8$ m/s.

Michelson measured the speed of light in air, of course, but it is only 0.03% less than in free space. The speed of light in other materials, such as glass and water, is substantially slower than in free space, however. In glass, it is only 60–66% of the free space value, while in water it is 75%.

2.11 Light as an Electromagnetic Wave

The existence of electromagnetic waves was predicted by James Clerk Maxwell in 1864. Maxwell formulated what are known as Maxwell's equations by concisely summarizing all the known laws of electromagnetism. Using these equations, Maxwell showed that the speed of an electromagnetic wave was equal to the speed of light. Not only did Maxwell's equations provide an elegant way of describing electromagnetic phenomena, but, perhaps more importantly, they seemed to lead to the inescapable conclusion that light is an electromagnetic wave.

At the time physicists were hesitant to accept Maxwell's theory since there seemed to be insufficient physical evidence to support it. The fact that he showed the speed of electromagnetic waves was the same as the speed of light was felt by many to be a coincidence. This all changed in 1887 when Heinrich Hertz observed that a spark jumping across a gap between two electrodes produced a weak spark across a similar pair of electrodes several meters away (Fig. 2.19). Since there was no physical connection between the two pairs of electrodes, Hertz concluded that he had produced and detected electromagnetic waves. He went on to demonstrate that electromagnetic waves exhibit all the properties of light, namely, reflection, refraction, interference, and polarization, phenomena that will be examined in subsequent chapters.

Electromagnetic waves, sometimes referred to as radio waves, are generated whenever electric charges or tiny magnets accelerate. When electrons oscillate back and forth rapidly in a television transmitting antenna, for example, electromagnetic waves are transmitted, and these waves can be received by another antenna connected to your television. Rapid motion of molecules in a hot gas can result in the transmission of infrared (heat) waves. Light waves generally result from the motion of electrons inside atoms.

A careful analysis of light waves indicates that their energy is closely associated with electric and magnetic fields, customarily represented by the vectors **E** (electric field) and **B** (magnetic field), which are at right angles to each other, as shown in Fig. 2.20. Fortunately, it is not necessary to completely understand the nature of electromagnetic fields to understand light. These same **E**- and **B**-fields, incidentally, are used to describe the forces on an electric charge in the vicinity of other charges or on a magnet in the vicinity of electric currents or other magnets.

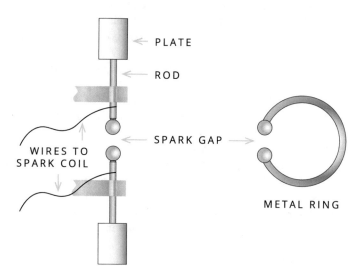

Fig. 2.19 Sketch of apparatus similar to that used by Heinrich Hertz to demonstrate the existence of electromagnetic waves

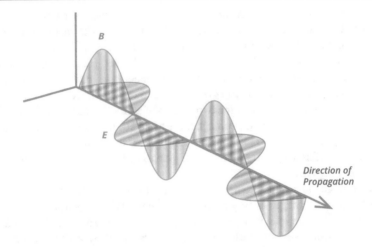

Fig. 2.20 As an electromagnetic wave propagates, the E (electric) and B (magnetic) fields oscillate at right angles to each other and to the direction of propagation

2.12 Summary

Our understanding of the nature of light combines two different models: the particle model, which views light as a stream of particles called photons, and the wave model, which views light as electromagnetic waves that can be reflected, refracted, or diffracted like sound waves or water waves. The speed of a wave is equal to the product of its wavelength and its frequency. Light waves travel at a speed of 3×10^8 m/s in free space, slightly slower than this in glass, water, or other transparent media. Waves that reflect from a "fixed" boundary reverse their phase; waves that reflect from a "free" boundary do not.

According to the principle of linear superposition, waves can interfere constructively or destructively to set up standing waves having positions of minimum and maximum amplitude called nodes and antinodes. The Doppler effect is the apparent shift in frequency of waves when the source, the observer, or both are in motion.

The restoring force in water waves is partly due to gravity and partly due to surface tension; in waves of short wavelength surface tension dominates, while in waves of long wavelength the force of gravity dominates. In deep water, the wave speed is independent of the depth but proportional to the square root of wavelength; in shallow water, the wave speed is independent of wavelength but proportional to the square root of the depth. Particle orbits are circular in deep water but elliptical in shallow water.

Many attempts had been made to accurately measure the speed of light before Albert Michelson obtained a speed close to the correct value $c = 3 \times 10^8$ m/s. Michelson measured the speed of light in air. The speed of light in other materials, such as glass and water, is substantially slower.

The existence of electromagnetic waves was predicted by James Clerk Maxwell. He developed equations unifying all known laws of electricity and magnetism, and posited that light was an electromagnetic wave. Maxwell's electromagnetic theory was later experimentally verified by Heinrich Hertz.

◆ Review Questions

1. **a.** What is a wave?
 b. Give four examples of waves observed in everyday life.
2. Which of the following determines the speed of a wave? (a) wavelength, (b) amplitude, (c) frequency, (d) medium through which it travels.
3. **a.** Distinguish between a transverse wave and a longitudinal wave.
 b. How would you produce a transverse wave on a long spring? A longitudinal wave?
4. **a.** How did Roemer measure the speed of light (1676)?
 b. How did Michelson measure the speed of light (1929)?
5. What is meant when a medium is described as "dispersive"? Cite an example of a dispersive medium.
6. Compare the frequencies of waves of red light and blue light.
7. What happens to the wavelength of waves on a rope if you move your hand up and down less often?
8. Describe the pitch of a train whistle as it approaches, passes by, and continues on its way.
9. How do police officers use the Doppler effect to determine the speed of an automobile?
10. Describe the motion of water in a wave in (a) deep water and (b) shallow water.
11. How does the wave speed depend on wavelength and depth in (a) deep water and (b) shallow water?

▼ Questions for Thought and Discussion

1. **a.** Will a larger pulse (with more energy) overtake a smaller pulse as they travel down a rope?
 b. Will a baseball thrown with more energy overtake a baseball thrown with less energy?
 c. Will a brighter light wave (with more energy) travel faster than a dimmer light wave?

2. How could astronomers determine the speed of a distant star using the Doppler effect?

■ Exercises

1. The pulse shown below propagates down a rope and is reflected at a fixed end. Sketch the shape of the reflected pulse.

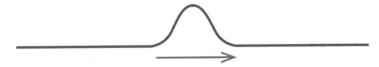

2. Two pulses meet on a rope. Sketch the shape of the pulse that occurs just as they meet, a moment later, and after they have passed through each other.

3. Lightning strikes the ground one kilometer away. (a) How long does it take the light to reach us? (b) How long does it take the sound (thunder) to reach us?
4. Water waves are observed approaching the shore at a speed of 6.0 m/s. The distance between adjacent crests is 7.0 m. (a) What is the frequency of the waves? (b) What is their period?
5. An automobile horn has a frequency of 440 Hz. What frequency is heard when the automobile is approaching at a speed of 50 mph (23.85 m/s)?
6. A fire engine has a siren whose frequency is 600 Hz. What frequency is heard by a stationary observer when the engine moves toward him at 25 m/s? When it moves away from him at 25 m/s?

● Experiments for Home, Laboratory, and Classroom Demonstration

Home and Classroom Demonstration

1. **Waves on a rope**. Demonstrating wave phenomena with a rope is so instructive and easy to do that you are strongly urged to do it yourself. Just tie a length (3–5 m) of clothesline rope to a wall and hold the other end in your hand. Move it up and down at different frequencies and observe what happens to the wavelength. Determine the number of times per second you must move your hand up and down (the frequency, in other words) to get the rope to vibrate in

one loop (half a wavelength), two loops (one full wavelength), three loops, and so on. If you multiply the frequency times the wavelength in each case, what do you notice about the product?

Now try to keep the frequency the same while increasing the tension on the rope (by moving back from the wall). What happens to the wavelength? What happens to the wave speed (frequency times wavelength)?

2. **Reflection of impulsive waves.** With the other end tied to the wall, give your rope a single impulse by striking it with your other hand or by quickly moving the end up and down. The impulse will travel at the wave speed v and should retain its shape fairly well as it travels down the rope. What happens when the pulse reaches the end of the rope? Is the reflected pulse the same as the incident pulse or is it upside down? Do the incident and reflected waves travel at the same speed? Observe the speed of the incident and reflected waves as you change the tension (by moving toward or away from the wall).

3. **Superposition and interference of wave.** About the time that the first impulse on your rope reaches the wall, generate a second, similar impulse and carefully observe what happens when they meet. Try giving the second impulse the opposite phase and see what happens. In which case do the two pulses interfere *constructively* and in which case do they interfere *destructively*?

4. **Standing waves.** Move the end of the rope up and down at the right frequency to create a full wave; note that the center of the rope appears to stand still. This stationary point is called a *node*. Have a friend grab the rope between two fingers at the node. Does this prevent the waves from propagating to the wall and back? Ask your friend to grasp the rope tightly with both hands as near the node as possible. What happens? Note that although the rope may be prevented from moving up and down, in order for waves to propagate it must be allowed to pivot at the node. Can you explain why?

5. **Wave demonstrator (with soda straws).** Construct a "wave machine" by attaching a series of equally spaced soda straws to a long strip of sticky tape. Attach a second strip of sticky tape on top of the straws to hold them in place. Fasten your wave machine to the ceiling or to a high overhanging shelf. Measure the speed of wave pulses of various types. Note how the pulses reflect at the fixed (ceiling) end and at the free (dangling) end. Attach paper clips to the ends of the soda straws and again measure the wave speed. You may wish to construct a second wave machine with short straws so that you can compare the wave speeds in the two "media."

6. **Principle of superposition (two dimensions).** Add water to a cookie sheet or baking pan until it is about one-third full. With the container on a flat surface, disturb the water by pushing on a corner of the container in a direction parallel to the diagonal extending from that corner. Two plane waves will be produced, each moving parallel to a side of the sheet. Note that the waves pass right through each other. Close attention to the area of overlap of the two waves will reveal an amplitude greater than that of either component wave.

7. **Two-dimensional standing waves**. Fill a Styrofoam cup to the top with water. Drag the base of the cup along a smooth surface such as a tabletop of Formica, slate, or polished wood. By adjusting the pressure, you should be able to cause it to vibrate. The vibrating cup will produce a sound and set the surface of the water into vibration. Carefully examine the surface of the water while it is vibrating and note that regions of moving water alternate with regions of relative calm. This is a two-dimensional standing wave pattern.

8. **Standing waves on a soap film**. A soap film may serve as a medium for standing waves. A simple soap solution consists of one part dishwashing detergent (such as Dawn or Joy) mixed with 15 parts of water. A frame for producing the soap film can be made by bending a coat hanger into a circular shape. The hanger's hook conveniently serves as the frame's handle. After transferring the soap solution to a pan large enough to accept the frame (e.g., a frying pan), dip the frame into the solution. Slowly removing the frame from the pan will reveal a circular soap film. Standing waves may be produced by moving the frame up and down at the proper frequencies. To begin, try exciting the fundamental mode of vibration in which the entire film heaves up and down in phase. Increasing the frequency will produce other modes in which the film vibrates in two or three segments.

Laboratory (See Appendix J)

2.1 Waves on a Coiled Spring (Using a Slinky)
2.2 Transverse and Longitudinal Waves in One Dimension
2.3 Waves in Two Dimensions (Using a Ripple Tank).

Glossary of Terms

amplitude Maximum displacement from equilibrium in a wave.

antinode Point of maximum amplitude due to constructive interference.

dispersion Variation in the speed of a wave with frequency (or wavelength). The spreading of light into a spectrum of different colors.

Doppler effect Change in the frequency of waves due to motion of the source, the observer, or both.

frequency Number of waves per second.

hertz Unit of frequency; equals one wave per second.

interference Superposition of two or more waves. Constructive interference occurs when the waves are in phase and therefore combine to form a larger wave; destructive interference occurs when the waves are out of phase and partially (or fully) cancel each other.

linear superposition The resultant displacement of two waves at a point is the sum of the displacements that the two waves would separately produce at that point.

node Point of minimum amplitude due to destructive interference of two waves.

standing wave An interference pattern formed by two waves of the same frequency moving in opposite directions; the pattern has alternative minima (nodes) and maxima (antinodes).

wave equation The relationship between wave speed, frequency, and wavelength: $v = f\lambda$.

wave model of light Light consists of electromagnetic waves.

wavelength Distance between adjacent crests or adjacent troughs.

Further Reading

Hewitt, P. G. (2014) *Conceptual Physics*, 12th ed. Boston: Pearson.

Kirkpatrick, L. D., & Wheeler, G. F. (1995). *Physics: A World View*, 2nd ed. Philadelphia: Saunders College Publishing.

Raichlen, F. (2012). *Waves*. Cambridge, MA: The MIT Press.

Rossing, T. D., Moore, F. R., & Wheeler, P. A. (2001). *The Science of Sound*, 3rd ed. Reading, MA: Addison-Wesley.

Ray Optics: Reflection, Mirrors, and Kaleidoscopes

<div style="text-align:right">**3**</div>

3.1 Shadows

By observing shadows and the positions of the light sources and objects that cause the shadows, it is easy to deduce that light normally travels in straight lines. (We will discuss a few cases in which it does not in the chapters that follow.) In drawings illustrating the paths of light, it is convenient to use the idea of *light rays*. In Fig. 3.1, a point source of light sends out light rays in all directions. Such a point source casts a shadow whose position and size can be easily determined by drawing light rays. The shadow has the same shape as the object but is larger. A very small light bulb, such as a halogen-filled automobile headlamp bulb or a light-emitting diode, approximates a point source.

Most sources of light are not points but extend over some space, as does the light bulb in Fig. 3.2a. We can think of each point on the surface of the bulb as a point source sending out rays in all directions. Each point on the surface, acting as a point source, casts its own shadow. When all of these point source shadows are superimposed, as in Fig. 3.2b, there will be a dark region in the center (*umbra*) where all the shadows overlap surrounded by a lighter region (*penumbra*) where only some of the individual shadows overlap.

Now suppose you stand in the shadow and look back at the source. If your eye is in the umbra, you will not see any of the source; if it is located in the penumbra, you will see part of the light source. This is what happens during eclipses of the Sun when the Moon intervenes and casts a shadow on Earth. Observers in the umbra see a spectacular total eclipse, while observers in the penumbra see only a partial eclipse, as shown in Fig. 3.3.

Eclipses of the Moon occur when Earth blocks the direct rays of the Sun from reaching the Moon. The Moon is still visible, however, because some sunlight, refracted by Earth's atmosphere, reaches the Moon. No two lunar eclipses are exactly the same. Generally, the color at the center of Earth's shadow is a faded copper-red, surrounded by a grayish edge (see Fig. 1.13). Earth's atmosphere transmits mainly red light because blue light has been scattered.

© Springer Nature Switzerland AG 2019
T. D. Rossing and C. J. Chiaverina, *Light Science*,
https://doi.org/10.1007/978-3-030-27103-9_3

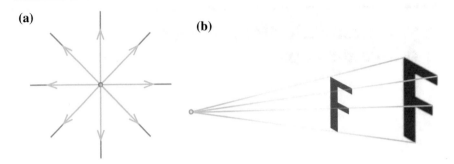

Fig. 3.1 **a** Light rays from a point light source; **b** well-defined shadow cast by a point source of light

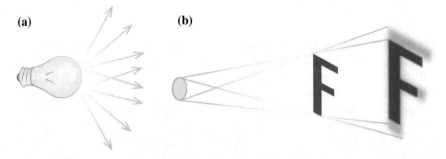

Fig. 3.2 **a** Light rays travel in all directions from each point on the surface of an extended source, such as a light bulb; **b** combining shadows cast by each point leads to a diffuse (fuzzy) shadow

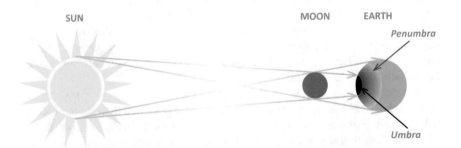

Fig. 3.3 Shadow of the Moon during an eclipse

3.2 Pinhole Camera

Another simple illustration of light rays is the *pinhole camera* in Fig. 3.4. If a pinhole is placed between an object and a piece of photographic film, a dim inverted image of the object appears on the film. A pinhole camera is capable of making very

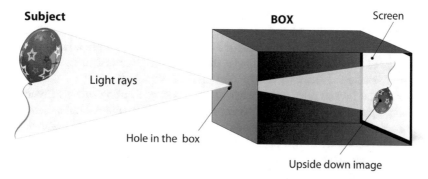

Fig. 3.4 A pinhole camera produces an inverted image. (Designua/Shutterstock.com)

Fig. 3.5 Light passing through a small hole in a sheet of plastic covering a window forms an inverted image of an outside scene (Photograph by Darius Kuzmickas: http://cameraobscuraproject.com)

sharp photographs, but exposure times are very long because of the dim image. A larger pinhole will admit more light, but the resulting image is less sharp. Therefore, most cameras use a lens to collect more of the light rays and focus them onto the film. Notice that the image created by the pinhole camera in Fig. 3.4 is inverted, while the shadows in Figs. 3.1 and 3.2 are upright.

Prior to the invention of photography, a method of forming images involved admitting light into a darkened enclosure or room through a small hole. Called a *camera obscura* (from the Latin meaning "dark chamber"), the device is essentially a large pinhole camera. The camera obscura shown in Fig. 3.5 was created by covering a window with a sheet of opaque plastic containing a small hole. As is the case with all pinhole cameras, the projected image is inverted.

3.3 Light Behavior at a Boundary

When a ray of light encounters a boundary between two media, as shown in Fig. 3.6, it is partially reflected and partially transmitted in a new direction. The portion of the light that is transmitted and reflected depends upon the electrical properties of the two materials. For simplicity, let us suppose that the first medium is air. If the second medium is a good electrical conductor, such as silver or aluminum, nearly all the light is reflected. (This is also true for a thin metal surface deposited on glass, as in a bathroom mirror.) On the other hand, if the second material is an insulator, such as glass, a substantial share of the light is transmitted. We now study these two cases in some detail.

When a ray of light is reflected at an interface dividing two materials, as shown in Fig. 3.6, the reflected ray remains in the *plane of incidence*, the plane that includes the incident ray and the normal to the surface (the yellow line in Fig. 3.6). The angle of reflection θ_r equals the angle of incidence θ_i.

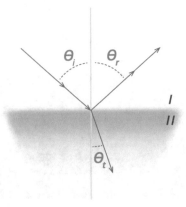

Fig. 3.6 A ray passing from medium I to medium II is partially reflected and partially transmitted. All three rays remain in the plane of incidence, and the angle of reflection θ_r equals the angle of incidence θ_i

The reflection of one-dimensional wave pulses on a rope was discussed in Sect. 2.3. Waves of two or three dimensions undergo similar reflections when they reach a barrier. Figure 3.7a shows the reflection of water waves from a straight barrier. Note that the circular wavefronts of the reflected waves appear to come from a point behind the barrier. This point, the *image* of the source, is denoted by S' in Fig. 3.7b. It is the same distance from the reflector as the source S is.

Reflection of waves from a curved surface can lead to the *focusing* of energy at a point, as shown in Fig. 3.8. Plane waves focus at the point F, which is called the focal point of the curved mirror. On the other hand, if a light source is placed at the point F, light from the source will form a beam of plane waves, as shown in Fig. 3.8b; this is the principle used in a spotlight or an automobile headlight.

(a)

(b)

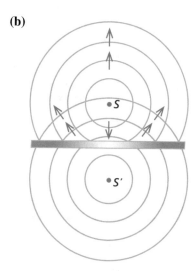

Fig. 3.7 Reflection of waves at a barrier: **a** waves on a ripple tank from a point source; **b** reflected waves appear to originate from image S' (Photograph by Mark Welter)

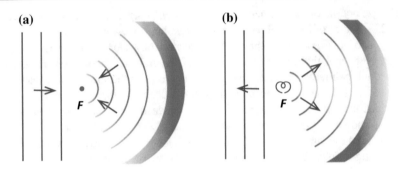

Fig. 3.8 **a** Reflection of plane waves from a curved surface directs energy to the focal point F; **b** waves originating at the focal point F are reflected as plane waves

3.4 Images Formed by Plane and Curved Mirrors

Reflections occur all around us. We rely on reflected light to see most objects in our environment. When reflected from a smooth surface, light behaves like a ball bouncing off a pool table cushion. More specifically, the *law of reflection* tells us that the angle of incidence equals the angle of reflection. The angles of incidence and reflection are measured with respect to a line perpendicular (normal) to the reflecting surface, as shown in Fig. 3.9. The law of reflection holds, on a point by point basis, for all types of reflecting surfaces, smooth and rough, straight and curved.

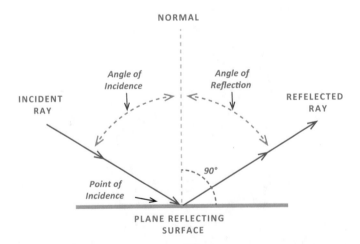

Fig. 3.9 The angle of reflection equals the angle of incidence, according to the law of reflection (Both angles are generally measured from the normal or perpendicular.)

Fig. 3.10 A tree and its image formed by specular reflection from the surface of a calm pond (Brittany Illana Fader—American Association of Physics Teachers High School Photo Contest)

Light is reflected from both shiny and dull surfaces. Reflection from a smooth, mirror-like surface, such as a highly polished table or a calm lake, results in the production of a clear, well-defined image (Fig. 3.10). This is called regular or *specular reflection*.

The reflection of light from an optically rough surface, on the other hand, is referred to as *diffuse reflection* (see Fig. 3.11). When light falls on a painting, it is reflected in all directions. You, and everyone around you, can see the painting, but you can't see *your* reflection in the canvas. Ask yourself: Is this specular reflection or diffuse reflection?

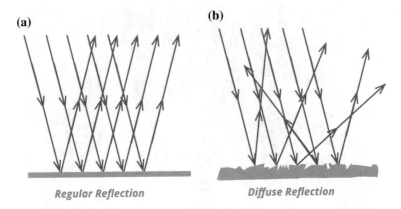

Fig. 3.11 **a** Regular or specular reflection from a mirror; **b** diffuse reflection from a sheet of paper

Regular and diffuse reflection have distinctly different applications. Shaving or putting on makeup would be difficult without specular reflection. On the other hand, using a mirror as a movie screen would not be prudent, for most members of the audience wouldn't receive any light while others would be blinded. Consequently, movie screens are diffuse reflectors.

Mirrors form likenesses of objects, called *images*. The nature of the image depends, in part, on the shape of the mirror. Mirrors may be plane, concave, or convex. Concave mirrors are capable of converging light rays, while convex mirrors diverge them. Plane mirrors are neither convergent nor divergent. All three shapes are found in carnival mirrors, where they produce some interesting effects, as in Fig. 3.12.

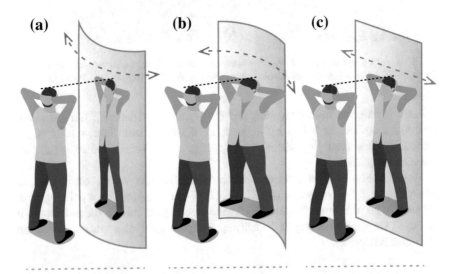

Fig. 3.12 **a** A convex mirror makes you look slender; **b** a concave mirror makes you look heavy; **c** a plane mirror shows you in natural proportion

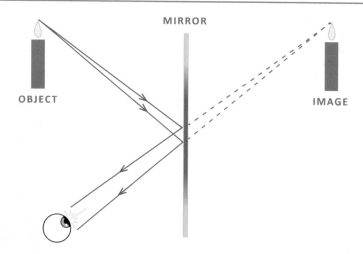

Fig. 3.13 How an image is formed by a plane mirror. To the eye-brain, light rays seem to come from a candle located behind the mirror

Figure 3.13 illustrates how an image is formed by a plane mirror. Light rays from a point on an object are reflected from the mirror's surface in accordance with the law of reflection. When the reflected rays are extended behind the mirror, they intersect at a point that defines the position of the image. From previous experience with locating objects, our eye–brain system interprets the origin of the reflected rays to be this point of apparent intersection.

Actually, rays from all points on an object are reflected in a manner similar to that shown in Fig. 3.13 for a single point on the source. When we draw rays from all the points on the object, as in Fig. 3.14, they diverge as if they had originated at a material object located behind the mirror. Anyone who has been startled by their own reflection in a mirror knows how real the illusion is!

Our inability to distinguish between an object and its image is often put to use by magicians. To say that "it's all done with mirrors" may be an overstatement, but many magic tricks rely on reflection from a plane mirror. In nineteenth century theater, images of apparitions were made to appear on stage through reflections from sheets of clear glass. Today, such images work their "magic" in amusement parks and museums.

The image produced by a plane mirror is right-side up, the same size as the object, and located behind the mirror. Because no light actually exists behind the mirror, the image is referred to as a *virtual image*. The virtual image one sees in a plane mirror appears to be the same distance behind the mirror as the object is in front of it, as shown in Fig. 3.14. For this reason, plane mirrors are often employed by interior decorators to make rooms appear twice their actual size.

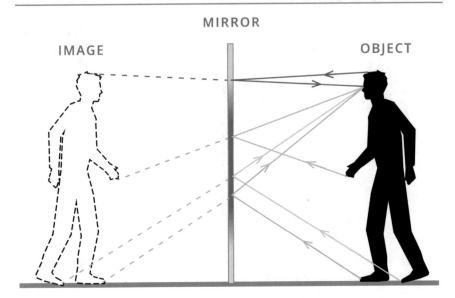

Fig. 3.14 The virtual image seen in a plane mirror appears to be the same distance behind the mirror as the object is in front of it

● **A Challenge**

With a pencil, highlight the part of the mirror in the figure above that is actually necessary to produce the image. Compare its length with the length of the object. How long must a "full-length" mirror be? Does your answer depend upon your distance from the mirror? Try this experiment in your own bedroom or bathroom.

3.5 Concave Mirrors

A single plane mirror does not converge light; however, a circular arrangement of small plane mirrors may be used to concentrate light, as shown in Fig. 3.15. Reflection from each mirror follows the law of reflection. The concave side of a spoon, or any concave reflector, can be thought of as a very large collection of plane mirrors.

Concave mirrors are often spherical. Spherical mirrors have a well-defined radius of curvature R that extends from the center of the sphere C to the surface of the mirror, as shown in Fig. 3.16a. As shown in Fig. 3.16b, vertex V marks the center of the mirror surface, and the line drawn through C and V is called the *principal axis*.

Most rays that approach a concave mirror parallel to the principal axis are reflected through a point called the *principal focus*. For spherical mirrors, the distance from the vertex to the principal focus is equal to half the radius of curvature, as shown in Fig. 3.17. This distance FV is known as the focal length f.

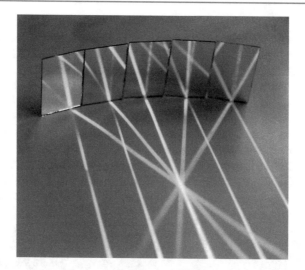

Fig. 3.15 Circular arrangement of small plane mirrors concentrates the light (Photograph by Mike Chiaverina)

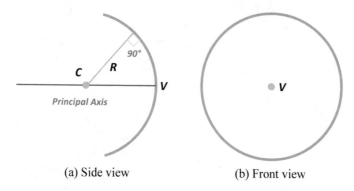

(a) Side view (b) Front view

Fig. 3.16 a Side view and **b** front view of concave mirror

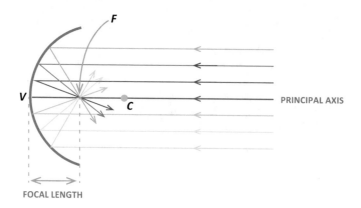

Fig. 3.17 Parallel rays are reflected through the principal focus *F* by a concave mirror

The location of images produced by curved mirrors can be found experimentally, graphically, or by formula. In the experimental method, an object is generally placed in front of the mirror and the position of the image is observed directly. Such is the case with a candle and its image produced by a concave mirror, as is shown in Fig. 3.18. Can you determine which is the real candle flame and which is its image?

The graphical or *ray-tracing method* is illustrated in Fig. 3.19. Three incident rays are drawn from one point on the object (the tip of the arrow in Fig. 3.19) to the mirror's surface, where each one is reflected. The reflected rays are then extended until they intersect. As with plane mirrors, the point of intersection of the reflected rays determines the image position. The rays that are shown in Fig. 3.19, the easiest ones to draw, are sometimes called *principal rays* because they can be drawn without measuring angles. From the figure, we see that an incident ray:

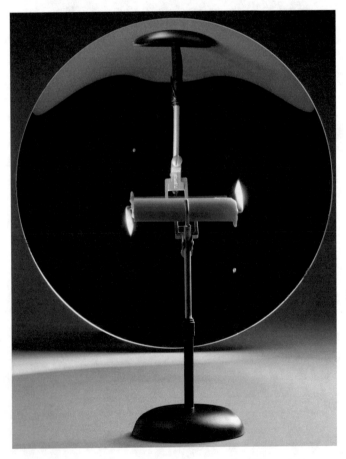

Fig. 3.18 A candle and its image in a concave mirror (Richard Megna—Fundamental Photographs)

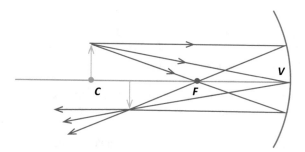

Fig. 3.19 Locating the image graphically by ray tracing

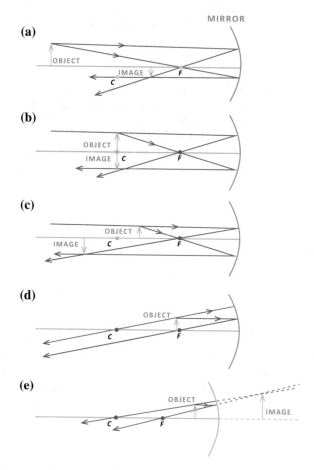

Fig. 3.20 Five cases of image formation by a concave lens: **a** object lies outside C, image lies between C and F; **b** object and image both lie at C; **c** object lies between C and F, so image lies outside C; **d** object is at F, so image is at infinity (parallel rays); **e** object lies inside F, so no real image is formed; a virtual image lies behind the mirror

1. parallel to the principal axis is reflected through the principal focus;
2. passing through the principal focus is reflected parallel to the principal axis;
3. striking the vertex is reflected back such that the principal axis is midway between the incident and reflected rays.

To locate an image, only two rays are actually needed; the third ray may be used for confirmation. Figure 3.20 shows images produced by some representative object positions.

Note that in Fig. 3.20a, the image is smaller than the object, whereas in (c) and (e) it is larger; in (b) they are of the same size. Concave mirrors can produce either real or virtual images, depending on where the object is located. Arrangement (e) is the one used in a shaving mirror, for it creates an enlarged virtual image behind the mirror. Real images are formed by reflected rays that intersect in front of the mirror; virtual images are formed by reflected rays that appear to intersect behind the mirror.

The Mirror Equation

As was mentioned previously, the location of images produced by curved mirrors can be found by formula as well as experimentally and graphically. The formula, known as the *mirror equation*, relates the object's distance from the mirror, the image's distance from the mirror, and the mirror's focal length. If the object distance and the focal length of the mirror are known, the image distance can be calculated from the mirror equation. This relationship can be written as:

$$1/d_o + 1/d_i = 1/f. \tag{3.1}$$

In the equation d_o is the object distance, d_i is the image distance, and f is the mirror's focal length. For concave mirrors, the focal length is positive. It should be noted that a positive image distance indicates that the image is real, inverted, and is in front of a mirror. A negative image distance means that the image is virtual and erect.

The ratio of the image height h_i to the object height h_o is called the *magnification* m and can be shown to be equal to the ratio of the image distance to the object distance. Image height is considered positive when the image is above the principal axis and negative when below the axis. Therefore, a negative sign must be added to the magnification equation in order to convey that real images with positive image distances are inverted and, conversely, that virtual images are erect.

That is,

$$m = h_i/h_o = -d_i/d_o. \tag{3.2}$$

▲ **Example**

1. An object is placed 30 cm from a concave mirror whose focal length is 10 cm. (a) Determine the location of the image and (b) the magnification.

Solution Substituting the given data into Eq. (3.1),

$$1/30\,\text{cm} + 1/d_i = 1/10$$
$$1/d_i = 1/10 - 1/30\,\text{cm}$$
$$d_i = 15\,\text{cm}.$$

Applying Eq. (3.2), the magnification is

$$m = -d_i/d_o = -15\,\text{cm}/30\,\text{cm} = -0.5.$$

Therefore, the distance from the mirror to the image is 15 cm. A magnification of -0.5 indicates that the image is inverted and half the size of the object.

The mirror and magnification equations may be used in all cases involving curved mirrors. However, for convex mirrors, which will be discussed in the next section, both f and d_i are negative.

3.6 Convex Mirrors

Convex mirrors diverge light, which is the opposite from concave mirrors. Rays reflected from a convex mirror appear to originate at a source behind the mirror. Incident rays parallel to the mirror's principal axis diverge as if coming from a common point referred to as the virtual focal point.

Figure 3.21 shows how a convex mirror forms a virtual image. An incoming ray parallel to the principal axis is reflected as though it originated at the virtual focal point F. A second ray that approaches the mirror on a path, which if extended behind the mirror, would pass through F. The resulting reflected ray leaves the mirror parallel to the principal axis. The two reflected rays, when traced to their point of apparent intersection behind the mirror, determine the location of the virtual image. The image is virtual, upright, and smaller than the object, as is always the case for images formed by convex mirrors. It should be noted that only two rays are used in this instance; a third ray, not shown, may be used for confirmation.

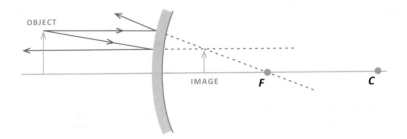

Fig. 3.21 Image formation by a convex mirror

Fig. 3.22 Reflection in a
convex mirror produces a
reduced, right-side up image

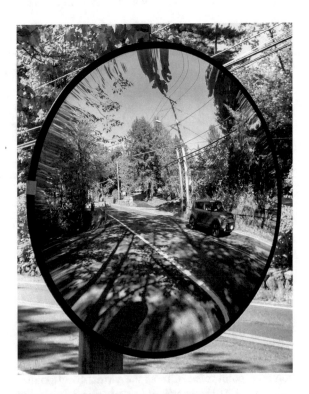

Convex mirrors have a variety of applications. Spherical Christmas tree orna-
ments, lawn ornaments, and security mirrors produce wide-angle images of
reflected objects, diminished in size, as shown in Fig. 3.22.

Convex mirrors also have applications in art, both as subject matter and as
vehicles for drawing art. M. C. Escher (Dutch 1898–1972) often featured spherical
reflectors in his drawings. Artist/scientist Bob Miller used a rectangular array of
silver Christmas ornaments as the basis for his *spherical reflectors*, on exhibit at the
Exploratorium in San Francisco. During the Victorian period, reflective cylinders
were used to transform intentionally distorted works of art into recognizable images
(anamorphic art).

3.7 Anamorphic Art

Most people are familiar with fun house mirrors that employ a combination of concave and convex reflecting surfaces to create distorted images of recognizable objects. Less familiar are distorted objects that require mirrors to make them intelligible. This rather curious application of reflection in the arts is called *anamorphosis*.

The Greek root of this word—*anamorphoo*, to transform—suggests the process common to all forms of anamorphic art. Anamorphic artists purposely distort their images to render them virtually unrecognizable. Only when transformed by reflection in cylindrical or conical mirrors, or, in some instances, viewed from a particular vantage point, do anamorphic paintings regain their normal proportions.

Figure 3.23 provides an example of the reflective anamorphic process. A drawing is first made on a rectangular grid. The drawing is then mapped, point by point, onto a cylindrical coordinate system. The anamorphic image appears normal when reflected in a cylindrical mirror. This approach to anamorphosis is believed to have first appeared in China during the seventeen century.

Beyond illusion, the purpose of anamorphosis was usually concealment. Anamorphic artists sometimes presented controversial subject matter via their hidden images. Commentary on political figures and erotica were disguised through distorted perspective. Anamorphic religious paintings were often created to provide a sense of revelation.

Fig. 3.23 Creating anamorphic art: A drawing on a rectangular grid is mapped onto a cylindrical coordinate system; the distorted image appears normal when reflected from a cylindrical mirror (Anamorphic drawings by Stephanie Schueppert)

Fig. 3.24 Painter Hans Holbein used anamorphic techniques to conceal a skull (near the bottom) in his painting *The Ambassadors*. To reveal the skull, the white object is viewed from the upper right (see Fig. 3.25) (Hans Holbein [Public domain], via Wikimedia Commons)

Leonardo da Vinci is believed to be one of the earliest practitioners of anamorphosis. His form of anamorphic art (perspective anamorphosis) did not require the use of mirrors, only the correct point of view. Using this approach, distorted images become intelligible when viewed from a particular angle. This technique was later employed by Hans Holbein to conceal a skull in his anamorphic painting entitled *The Ambassadors*, shown in Figs. 3.24 and 3.25.

A collection of two dozen delightful anamorphically distorted lithographs are currently available in an inexpensive reproduction of the nineteenth-century book *The Magic Mirror*. In Hollywood, anamorphosis is certainly alive and well! During

Fig. 3.25 From an oblique point of view, the white object in the foreground, at the bottom, in Fig. 3.24 is revealed to be a human skull (Hans Holbein [Public domain], via Wikimedia Commons)

the filming of a motion picture, an anamorphic camera lens is used to compress a scene so that it can be recorded on standard film. During projection, the process is reversed: An anamorphic lens is used to expand the image to its original proportions.

3.8 Kaleidoscopes

A plane mirror will produce a virtual image of an object placed before it. When two plane mirrors are arranged edge to edge to form an angle, multiple images may be formed, as in one of the most popular optical toys of all time: the kaleidoscope.

The kaleidoscope, invented by Sir David Brewster in 1817, uses two mirrors to create beautiful symmetrical patterns with reflected light. The public reaction to the device was phenomenal: Initial kaleidoscope sales exceeded 200,000 in London and Paris alone.

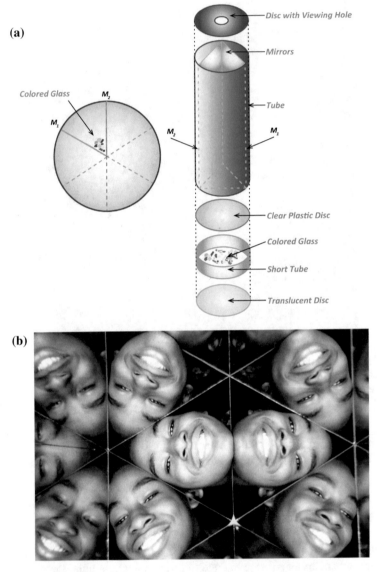

Fig. 3.26 a Kaleidoscope with mirrors at 60° angle; **b** multiple images in a student-size kaleidoscope (Photograph by Rebecca Newman)

Brewster's kaleidoscope consisted of two mirrors placed in a tube. An object chamber at one end of the tube held trinkets or bits of colored broken glass. It remains the custom to use as objects small-colored glass fragments, placed at one end of the tube and between the mirrors, as shown in Fig. 3.26a. Kaleidoscopic images produced by a large-scale kaleidoscope are seen in Fig. 3.26b.

The number of images produced by a kaleidoscope depends on the angle of separation between the mirrors. The angular wedge formed by the mirrors may be thought of as a piece of pie. The total number of pieces in the imaginary pie may be found by dividing 360° by the angle. Since one piece of the pie contains the object, there will be 360/angle—1 images formed. In Fig. 3.26a there are five images; in Fig. 3.27 there are seven images.

When the angle between two mirrors is made very small, the number of images becomes very large, as in Fig. 3.28. This is evident in a hairdresser's parlor where nearly parallel mirrors mounted on opposing walls generate almost limitless images.

Brewster believed that works of art, as well as objects in nature, derive their beauty from their symmetry. Not surprisingly, he was convinced that the kaleidoscope was the ideal instrument for inspiring the design of everything from architectural ornamentation to carpet patterns. Whether or not members of the fine and applied arts communities shared Brewster's enthusiasm for the kaleidoscope is not known. Nevertheless, the kaleidoscope has managed to retain its popularity almost 200 years after its invention. Beautifully crafted kaleidoscopes are commonplace in gift shops. As in the past, artisans strive to produce kaleidoscopes that are attractive on the outside as well as on the inside.

"Duck into" kaleidoscopes have become popular interactive exhibits in science centers. Typically, three large mirrors supported on stilts are used to form this popular incarnation of Brewster's invention. People take the place of the colored pieces of glass. Couples escaping into the kaleidoscope for privacy are often amazed to find themselves in a crowd.

Fig. 3.27 Kaleidoscope with mirrors at 45° angle

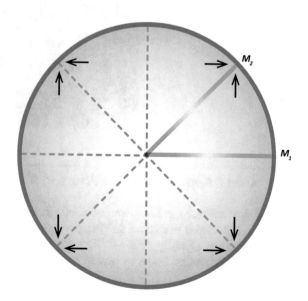

Fig. 3.28 Multiple images
formed by two nearly parallel
mirrors

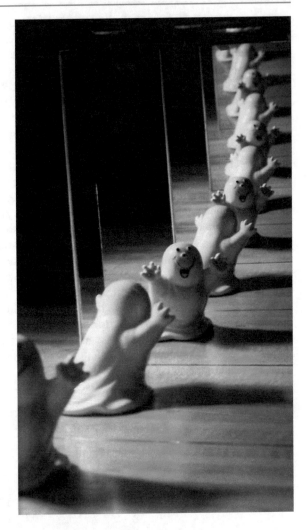

3.9 Other Applications of Mirrors in the Visual Arts

Mirrors first appeared in Egypt around 4500 B.C. when the Egyptians observed that
wet slate reflected a usable image. Bronze and copper mirrors appeared in Egypt
during the First Dynasty (2920–2770 B.C.). Glass, discovered sometime around
2500 B.C. in Phoenicia, found its way to Egyptian mirror makers about the fifteenth

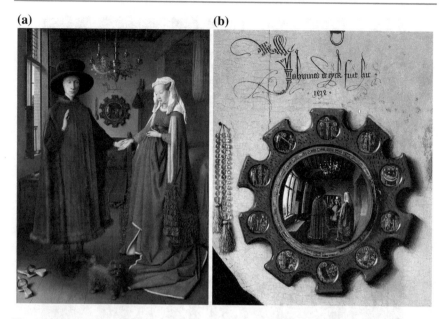

Fig. 3.29 **a** A portrait of Giovanni di Nicolao Arnolfini and his wife by Jan van Eyck. **b** The convex mirror on the back wall reveals Arnolfini and his wife and two other persons who look into the room through the door (Jan van Eyck [Public domain], via Wikimedia Commons)

century B.C., although the images produced by the early Egyptian glass mirrors (glass backed with plaster or resin) were faint and diffused. Mirrors were also used in China, Japan, and the Americas by the fifth century B.C.

The modern mirror appeared during the Renaissance, when Venetian glass-makers learned how to produce clear, flat, colorless glass and how to apply a reflective backing to it. By "foiling" the glass with a mixture of tin and mercury, the Venetians created mirrors capable of producing images of amazing clarity and intensity. In the mid-nineteenth century, methods for coating glass with silver were developed, and the modern mirror was born. It comes as no surprise that throughout their evolution, mirrors in all their incarnations have intrigued artists both as subject matter and as a tool. The following examples illustrate artists' fascination with mirrors and use in their art.

In Jan van Eyck's (Flemish, 1385–1441) *The Arnolfini Portrait* (Fig. 3.29a), a virtual wedding party is precisely depicted as a reflection in a convex mirror seen on the far wall in the painting. Close inspection of the mirror and its images reveals amazing attention to detail (see Fig. 3.29b).

Fig. 3.30 Petrus Christus, *Saint Eligius* (ca. 1444) (Petrus Christus [Public domain], via Wikimedia Commons)

A convex mirror appears again in *Saint Eligius* by Flemish artist Petrus Christus (ca. 1420–1470). As seen in Fig. 3.30, a mirror, sitting on a goldsmith's table, provides an expanded view of an exterior scene.

Sometimes artists get the physics of reflection right, sometimes they don't. *The Bar at the Follies-Bergere*, seen in Fig. 3.31, reveals Édouard Manet's (French, 1832–1883) rather interesting notions about plane mirrors and their images. Here, in one of his most famous works, the artist has taken some rather obvious liberties with the rules of image formation. The barmaid's reflection, shifted too far to the right, continues to fuel debate amongst art critics and historians as to the artist's intent.

Fig. 3.31 Édouard Manet's *The Bar at the Follies-Bergere* (Yelkrokoyade [Public domain or CC BY-SA 4.0 (https://creativecommons.org/licenses/by-sa/4.0)], from Wikimedia Commons)

Graphic artist M. C. Escher demonstrated an enchantment with mirrors throughout his career. According to artist and Escher biographer Bruno Ernst: "To Escher … the mirror image was no ordinary matter. He was particularly fascinated by the mixture of the one reality (the mirror itself and everything surrounding it) with the other reality (the reflection in the mirror)." In *Hand with Reflecting Sphere* (Fig. 3.32) Escher explores the image produced by a spherical reflector.

Escher examined plane mirror reflections in *Magic Mirror* and *Three Worlds*. In *Magic Mirror*, mystical creatures emerge from both sides of a vertical mirror, circle around, and become pieces of a two-dimensional jigsaw tiling in the foreground of the lithograph. In *Three Worlds*, reflections of trees are seen in a pool of calm water.

Fig. 3.32 *Hand with Reflecting Sphere* by M. C. Escher (1935) (© 2018 The M.C. Escher Company-The Netherlands. All rights reserved. www.mcescher.com)

3.10 Mirrors in Artistic Installations

Mirrors not only appear as subject matter in art, but often serve as the medium. Mirrors, and other reflective surfaces, have the power to transform objects, expand space, and, in the process, provide the viewer with unusual perceptual experiences. Perhaps more than ever, mirrors, both plane and curved, are finding their way into artistic installations.

Japanese artist Yayoi Kusama may be best known for her infinity mirror room installations, chambers with mirrored walls, ceilings, and floors. These unique spaces can be filled with colored lights, polka dots, or sculptures, all of which seem to go on forever.

An example of her fascination with infinite nature of space is *Infinity Mirror Room-Filled with the Brilliance of Life*, seen in Fig. 3.33. Stepping inside, the viewer is met with an immersive experience in which countless images of shimmering LEDs provide the feeling of being adrift in a cosmic void. Visitors to this and other Kusama infinity mirror rooms often use adjectives such as calming, ethereal, and meditative to describe their experience.

Designed and constructed by the New York-based architectural firm stpmj, the *Invisible Barn* shown in Fig. 3.34 is a wooden structure covered with reflective foil. The mirror image of the surrounding landscape makes the building appear transparent. Observers are often amazed to learn that the barn isn't a real building with four walls, but essentially only a thin façade.

The transformative power of reflection could not be more dramatically demonstrated than by the images produced by Anish Kapoor's *Cloud Gate*, seen in Fig. 3.35. Located in Chicago's Millennium Park, the "Bean," as it is affectionately called, combines both concave and convex surfaces to form fun house-like images of the Chicago skyline. The convex upper surface of the sculpture creates inward-pointing distorted images of the surrounding buildings; the concave lower surface forms kaleidoscopic images of those occupying the arched space. Consisting of 168 highly polished, seamlessly connected stainless steel plates, the sculpture's design is said to have been inspired by a drop of mercury.

Fig. 3.33 Yayoi Kusama's *Infinity Mirror Room-Filled with the Brilliance of Life* presents the viewer with what appears to be an infinite number of twinkling lights (YAYOI KUSAMA Infinity Mirror Room-Filled with the Brilliance of Life 2011 Installation, Mixed Media Copyright: YAYOI KUSAMA)

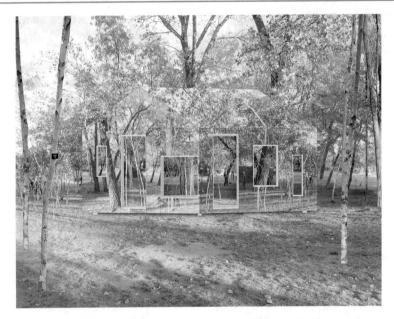

Fig. 3.34 A barn-shaped wooden structure covered with reflective foil. Mirror images of the surrounding trees and ground make the structure appear transparent (Courtesy of stpmj Architecture P.C.)

Fig. 3.35 Anish Kapoor's highly reflective *Cloud Gate* sculpture, located in Chicago's Millennium Park, is one of the city's most popular attractions (Epremkishan (https://commons. wikimedia.org/wiki/File:Sunrise_behind_the_Bean.jpg), https://creativecommons.org/licenses/by-sa/4.0/legalcode)

3.11 Mirrors in the Performing Arts: One-Way Mirrors

Unsilvered glass can reflect 10% or more of the light incident on it; partial silvering results in even higher reflectivity. Anyone who has stood before a window at night in a well-lighted room is aware of the mirror-like quality of window glass. The operation of "one-way" mirrors for surreptitious observation in stores and police line-ups, for example, takes advantage of this phenomenon. The subject, located on one side of partially silvered glass, is brightly illuminated, while the observer is kept in darkness. To the observed, the glass appears to be a mirror; to the observer, it's a window.

The one-way mirror has played a role in the performing arts. It was exploited for theatrical purposes in the mid-nineteenth century when J. H. Pepper produced what appeared to be a hovering apparition on a London stage. By angling a large glass plate between the stage and the audience, Pepper produced an image of an actor who seemed to float above the stage (see Fig. 3.36). To create the illusion, a well-illuminated actor was located in front of and below the stage, out of the audience's view. A light source of variable intensity was employed to make "Pepper's Ghost" come and go at will. A darkened theater insured that unwanted reflections would not reveal the presence of the glass. Similar techniques are currently used in amusement parks and museums to startle and amaze unsuspecting visitors and with smartphones using what is known as a pyramid projector (see "Home and Classroom Demonstration").

With the advent of improved video projection systems and advanced thin-film technology, Pepper's Ghost has once again taken the center stage. The glass plate once used to produce the illusion of an apparition hovering in mid-air has been replaced with a lightweight, essentially invisible reflective film. In addition to the thin-film upgrade, the updated version of the nineteenth-century illusion employs a high-definition projector to produce images so life-like that it is almost impossible to distinguish projected images from actual objects on the stage.

Fig. 3.36 A large mirror angled between the stage and audience produces an image of an actor who seems to be hovering about the stage (Courtesy of Thomas B. Greenslade, Jr.)

(a) **(b)**

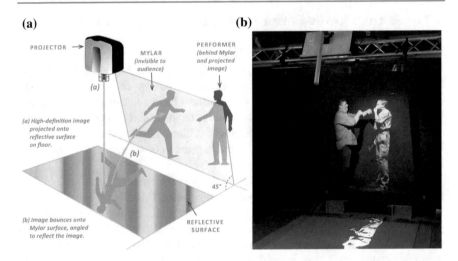

Fig. 3.37 a Projection system utilizing thin-screen and high-definition projection technology. **b** The system allows live performers to appear on a stage alongside virtual images, human or animated (By Riksutställningar/Swedish Exhibition Agency (https://www.youtube.com/watch?v= zM9c-zidvkk) [CC BY-SA 3.0 (https://creativecommons.org/licenses/by-sa/3.0)], via Wikimedia Commons)

Figure 3.37a shows the projection system. Images are first projected onto a horizontal reflective surface. The film, which is suspended at a 45° angle, then reflects light from the reflective surface, allowing the audience to see a life-like image. As the figures show, the projection system allows live speakers and performers to appear on a stage alongside and interact with virtual images, human or animated, as is shown in Fig. 3.37b.

Perhaps the most remarkable use of the projection system has been the reanimation of deceased performers. This amazing technology not only allows living entertainers in different locations to share the same stage, it has allowed Tupac Shakur, Maria Callas, and Michael Jackson, and others, to do an encore performance, sometimes alongside living musical artists.

While the modern Pepper's Ghost illusion is often referred to as "holographic," it should be noted that the modern Pepper's Ghost system does not produce a real hologram, but simply an amazing life-like mirror image.

3.12 Summary

That light normally travels in straight lines can be deduced from observing shadows and the positions of the light sources and objects that cause the shadows. In drawings illustrating the paths of light, it is convenient to use the idea of light rays. When a ray of light encounters a boundary between two media, it is partially

reflected and partially transmitted in a new direction. A mirror reflects most of the incident light, and the angle of reflection (measured from the normal to the surface) equals the angle of incidence. Reflection of light from a curved surface can lead to focusing of the rays, thereby concentrating the energy and making it possible to form images. The image can be located by tracing rays. In the case of a plane mirror, the image will generally be located the same distance behind the mirror as the object is in front of it; the image is right-side up but inverted left to right (for a single reflection).

Mirrors have intrigued artists both as subject matter and as a tool. Convex mirrors have numerous uses in art, one of them being the creation of anamorphic images that are intended to be viewed with curved mirrors. The kaleidoscope, still popular some 200 years after its invention, uses plane mirrors attached to each other at an angle to create symmetrical images. Mirrors, both plane and curved, can be found in artists' installations and sculptures. The one-way mirror continues to play a role in the performing arts. Using modern technology, it is possible to produce reflected images so life-like that it is almost impossible to distinguish projected images from actual people and objects on the stage.

◆ **Review Questions**

1. State the law of reflection and draw a sketch that illustrates this law.
2. Distinguish between specular and diffuse reflection. Give an example of each.
3. Why wouldn't you want to use a specular reflector as a movie screen?
4. Why wouldn't you want to use a diffuse reflector when shaving or applying makeup?
5. Can you "shake hands" with a plane mirror image of either hand? Explain.
6. Why is the lettering seen on the front of many emergency vehicles backwards?
7. Why can you see a spot of light on the wall where a flashlight beam strikes it when you cannot see the flashlight beam itself?
8. Can the image formed by a concave mirror be either larger or smaller than the object? Explain.
9. Can the image formed by a convex mirror be either larger or smaller than the object? Explain.
10. Is it possible for a convex mirror to form a real image? Explain.
11. Where should a light source be placed with respect to a concave mirror to form a searchlight?
12. If the image formed by a convex mirror is closer to the mirror than the object, why do convex mirrors on cars and truck carry the warning: "Caution: Objects are closer than they appear"?
13. What type of mirror would you use to produce a magnified image of your face?
14. What type(s) of mirror may be used:
 a. to converge light rays?
 b. to diverge light rays?
 c. to neither converge nor diverge light rays?
 d. to form a real image?

e. to form a virtual image?
f. to produce an inverted image?
g. to produce an erect image?
h. to produce an enlarged image?
i. to produce a reduced image?
j. to construct a searchlight?
k. as a shoplifting mirror?
l. as a solar collector?
m. to increase the perceived size of a room?

▼ Questions for Thought and Discussion

1. What happens to the image in a pinhole camera if the film or screen is moved farther from the pinhole?
2. What effect does enlarging the hole in a pinhole camera have on the image?
3. How can we see objects in the shade even though a barrier cuts off the rays of the Sun?
4. Why does a plane mirror reverse left to right but not up to down?
5. If you stand inside a triangular space formed by three rectangular mirrors, how many images of yourself will you see?

■ Exercises

Note: It is recommended that you draw on photocopies of the figures in exercises 1 through 6 rather than on the figures in the book.

1. Two rays of light from a point source are shown striking a plane mirror. Carefully draw the reflected light rays and locate the image of the point source.

2. The figure below shows a plane mirror and two reflected rays of light.

a. Indicate the location of the point source of light that was the origin of these rays.

b. Draw the incident rays of light associated with the two reflected rays.

3. Construct the image of the triangle *ABC* produced by mirror *M*. Note that the mirror only extends to a point just below vertex *C*. (Hint: A complete image of the triangle exists but only for some observers. To find the image, extend the mirror to the right and treat the extension as part of the actual mirror.)

4. Draw the images of the arrow produced by the kaleidoscope.

5. Objects (red arrows) are placed in front of a concave mirror (Fig. a) and a convex mirror (Fig. b). Use ray tracing to locate the images produced by the mirrors.

(a)

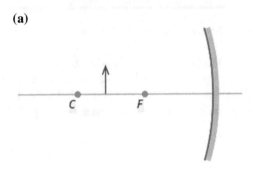

(b)

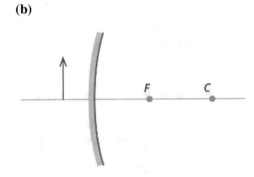

6. An object and its image formed by a concave mirror are shown in the figure below.
 Use ray tracing to locate the focal point and center of curvature of the mirror.

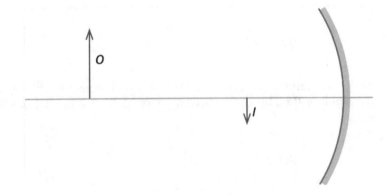

7. How many images of a penny will be produced by a two-mirror kaleidoscope if the angle between the mirrors is (a) 90°, (b) 60°, (c) 45°, (d) 30°?

8. An object is placed 16 cm away from a concave mirror having a focal length of 8 cm.

 Using a ruler and compass, make a scale drawing and trace rays to locate the image.

9. If the radius of curvature of a concave mirror is 7 cm, what is its focal length?

10. Using the mirror equation, determine the location of the image formed when an object is placed 25 cm from a concave mirror whose focal length is 5 cm.

11. Apply the mirror equation to find the location of the image produced by a convex mirror having a focal length of -12 cm when the object is placed 12 cm from the mirror.

12. Use Fig. 3.19 to verify that the ratio of image height to object height equals the ratio of image distance to object distance. That is, show that $h_i/h_o = d_i/d_o$. (Hint: Use a ruler to carefully measure the distances in centimeters.)

● **Experiments for Home, Laboratory, and Classroom Demonstration**

Home and Classroom Demonstration

1. **Seeing ghosts**. Careful observation of images produced by a common plane mirror reveals a rather spooky phenomenon: the existence of a faint secondary image adjacent to each principal image. To observe this secondary image, hold an object in front of a mirror. Can you see both images? Compare the appearance of the fainter image to the principal image. How are the two images similar? How do they differ? Do the images change as you view them from various positions? Can you explain the presence of the second image?

2. **Curved reflectors**. A spoon is actually a double mirror: One side is concave, the other convex. Hold the concave side of a shiny spoon in front of your face. Do you see an image? Is it right-side up or upside down? Is the image enlarged or reduced? Slowly move the spoon away from your face. What do you observe? Now move the spoon toward your face until it is very close to your eye. Does the image ever become blurry? When this occurs, your eye is at the mirror's focal point. Repeat the preceding steps with the convex side of the spoon. How do the images formed by concave and convex mirrors compare?

3. **Examining your car's mirrors**. Examine the mirror on the passenger side of your car. If your car is relatively new, the mirror will more than likely have the following message inscribed on it: "Objects in mirror are closer than they appear." What does this mean? Examine the type(s) of image(s) produced by this mirror. Is the mirror plane, concave, or convex?

4. **Constructing a simple kaleidoscope**. Tape the edges of two plane mirrors together to produce a hinge (the reflective surfaces should face each other). Any pair of plane mirrors will work; pairs of small pocket mirrors or larger decorative mirror tiles are good choices. Place an object such as a coin, a small toy,

or a drawing or lettering on paper between the mirrors. Observe the images formed by the mirrors. What happens when you make the angle between the mirrors smaller? Larger? Line up a narrow object such as a pencil parallel to one of the mirrors and slowly rotate the second mirror toward the pencil. What happens when the two mirrors become nearly parallel to one another? Have you ever been between parallel mirrors in a hallway or hairdresser's shop? If so, describe the number of images produced. Using a protractor, adjust the mirrors so that they form a 90° angle. After placing an object between the mirrors, count the images produced. Now count the images produced at 72, 60, and 45°. There is a simple "kaleidoscope equation" that gives the number of images produced for a particular mirror angle. Can you determine this equation from the data you've gathered?

5. **A view of infinity**. A mirror may form an image of another mirror image. When two plane mirrors face each other, a very large number of images may be formed. This phenomenon is familiar to anyone who has been to a hairdresser's shop. To experience a view into infinity, hold a small pocket mirror between your face and a second larger mirror. The reflecting surfaces of the two mirrors should face each other. Adjust the mirrors so that they are as close as possible to parallel. When you look around the smaller mirror into the larger mirror, you should see reflections that appear to stretch into the distance. The number of images produced is limited by the absorption of light by the mirrors.

6. **Anamorphic art**. Make an enlarged photocopy of the figure shown below. Draw or paint a picture on the rectangular grid, and then map it onto the circular grid by transferring each point on the rectangular grid to the corresponding point on the curved grid. To view your art, place a cylindrical mirror (a section of shiny pipe or can or a sheet of reflecting plastic rolled up into a cylinder) at the spot marked +.

7. **Smartphone projection pyramid**. Draw a trapezoid, according to the pattern shown below, on a sheet of plastic or discarded CD case.

Using scissors, or a utility knife if a CD case is used, carefully cut out the traced trapezoid. Using this piece as a template, produce three additional plastic pieces. Form a pyramid by connecting the sides of the four pieces together with either clear tape or glue. After downloading one of many "pyramid hologram videos" from the internet, place the pyramid on the phone's screen so that the top of the pyramid rests in the middle of the video's four images. When a face of the pyramid is viewed from the side, a projected image will be seen that appears to be suspended in air. It should be noted that although the images are often referred to as holographic, they are not. They are simply reflections.

8. **Discovering examples of reflection in painting**. Examine paintings at art museums and in art books in the library. Note all the cases you find where a painter has used reflections (in mirrors, water surfaces, or otherwise).

Laboratory (See Appendix J)

3.1 Shadows and Light Rays
3.2 Law of Reflection and Plane Mirrors
3.3 Construct a Kaleidoscope
3.4 Image Formation by Concave Mirrors

Glossary of Terms

anamorphosis (anamorphic art) Artistic use of distorted images that require special mirrors to make them intelligible.

camera obscura A darkened enclosure having an aperture through which light from external objects enters to form an image of the objects on the opposite surface.

concave surface A surface curved like the inside of a ball.

convex surface A surface curved like the outside of a ball.

diffuse reflection Reflection of rays from a rough surface. The reflected rays scatter and no image is formed.

focus (focal point) A point at which incident rays parallel to the axis of a mirror will cross after reflection.

image Replica of an object formed by a mirror (or lens).

kaleidoscope A device that uses two or more mirrors to form symmetrical, colorful images.

law of reflection The angle of incidence equals the angle of reflection. Ordinarily, both angles are measured from the normal (perpendicular) to the surface.

magnification The ratio of the size of image to size of object.

plane of incidence Plane that includes the incident ray and the normal (perpendicular) to the surface.

reflection Change of direction (with reversal of the normal component) at a surface.

specular reflection Reflection from a polished surface in which parallel rays remain parallel.

virtual image An image created by the apparent intersection of reflected light rays when they are extended behind the reflecting surface. A virtual image cannot be projected onto a screen.

Further Reading

Ernst, Bruno. (1994). *The Magic Mirror of M. C. Escher*. New York: Taschen America.

Goldberg, B. (1985). *The Mirror and Man*. Charlottesville: University Press of Virginia.

Hewitt, P. G. (2014). *Conceptual Physics*, 12th ed. Boston: Pearson.

Kirkpatrick, L. D., & Wheeler, G. F. (1995). *Physics: A World View*, 2nd ed. Philadelphia: Saunders College Publishing.

McLaughlin Brothers. (ca. 1900). *Magic Mirror*. Reprinted by Dover, Mineola, NY, 1979.

Miller, Jonathon. (1998). *On Reflection*. London: National Gallery of London.

Pendergrast, Mark. (2003). *Mirror, Mirror: A History of the Human Love Affair with Reflection*. New York: Basic Books.

Rossing, T. D. (1990). *The Science of Sound*, 2nd ed. Reading, MA: Addison-Wesley.

Schuyt, M., & Joost, E. (1976). *Anamorphoses: Games of Perception and Illusion in Art*. New York: Abrams.

Refraction of Light

<div style="text-align:right">

4

</div>

In general, when light encounters the boundary between two media, a part of the light is reflected and part is transmitted into the second medium. The ray that enters the second medium usually experiences a change in direction. This bending of light is called *refraction*. In this chapter we will introduce a law that governs the path of the refracted light in the second medium.

An understanding of how light behaves when passing from one medium to another is of importance for it is central to the operation of optical devices such as eyeglasses, cameras, microscopes, and telescopes, and is the basis for understanding the functioning of the human eye and the formation of rainbows and mirages.

4.1 Bending of Light at a Boundary

The most obvious result of the phenomenon of refraction is the bending of light when it passes from one medium to another (Fig. 4.1a). When a light ray goes from air to glass, for example, it is slowed down and bent *toward* the normal. When it leaves the glass, it is bent away from the normal. If the two boundaries of the glass are parallel (as in a thick pane of window glass), the angle of deviation (bending) in both cases is the same, so the ray emerges traveling parallel to its original path, as shown in Fig. 4.1a, b. This is a good thing, of course, or else the world would appear to be pretty distorted when viewed through a window!

Note that if the ray had traveled the shortest *distance* between A and D, it would have taken the straight-line path AD, shown as a dashed line. However, to get from A to D in the shortest *time*, it is advantageous to follow path ABCD, which reduces the time spent in the slow medium. (This is like driving a few miles out of your way in order to travel part of the distance on an expressway, which may reduce your total travel time.) The *principle of least time*, in fact, predicts that light will always choose the path of least time. This powerful principle, formulated by French physicist Pierre de Fermat in 1657, can also be used to arrive at the law of reflection $\theta_i = \theta_r$ (see Chap. 3).

© Springer Nature Switzerland AG 2019
T. D. Rossing and C. J. Chiaverina, *Light Science*,
https://doi.org/10.1007/978-3-030-27103-9_4

Fig. 4.1 **a** Refraction at the two boundaries of a pane of glass. **b** The emerging light ray travels parallel to its original path; however, it is displaced with respect to the incident ray (GIPhotoStock/Science Source)

Fig. 4.2 **a** A ray of light saves time by traveling path *ABCD*. **b** Laser light passing through a prism

Now consider a ray traveling through the triangular prism in Fig. 4.2a. Again, it is bent toward the normal at the first boundary and away from the normal at the second boundary, but this results in a net deviation through an angle ϕ as shown. Again the ray saves time by traveling path *ABCD* as compared to the straight-line path *AD*, and so it takes this path. Figure 4.2b shows the path of a ray of laser light as it passes through a glass prism.

4.2 Index of Reflection

The *index of refraction* of a medium n expresses the ratio of the speed of light in air c (3.00×10^8 m/s), to its speed in the medium:

$$n = \frac{\text{speed of light in vacuum (or air)}}{\text{speed of light in medium}} = \frac{c}{v} \qquad (4.1)$$

Table 4.1 Indices of refraction for some common materials

Vacuum	1.00
Air	1.0003
Water	1.33
Lucite	1.49
Lens (human)	1.40
Glycerol	1.47
Crown glass	1.52
Flint glass	1.66

▲ Example

Given that the speed of light in water is 2.25×10^8 m/s, what is the index of refraction of water?

Solution

$$n = \frac{c}{v} = \frac{3.00 \times 10^8 \, \text{m/s}}{2.25 \times 10^8 \, \text{m/s}} = 1.33$$

The speed of light in diamond is considerably slower, specifically, 1.24×10^8. As a consequence, diamond's index of refraction is quite large, namely,

$$n = \frac{c}{v} = \frac{3.00 \times 10^8 \, \text{m/s}}{1.24 \times 10^8 \, \text{m/s}} = 2.42$$

The greater the index of refraction of the medium, the greater the bending at each boundary. In this sense, we could view the index of refraction as representing the "bendability" of the medium. If the angle of incidence is quite small (less than 60°), the bending angle is roughly two-thirds of the angle of incidence. This is only a rough approximation; however, we need a mathematical relationship called Snell's law if we wish to predict the angles with greater precision. Table 4.1 gives the indices of refraction of a number of common materials.

4.3 Snell's Law

A mathematical relationship called *Snell's law* relates the angle of incidence θ_i, the angle of refraction or transmission θ_t, and the ratio of the indices of refraction n_1/n_2:

$$n_1 \sin \theta_i = n_2 \sin \theta_t. \tag{4.2}$$

Fig. 4.3 The angle of
incidence θ_i and angle of
refraction θ_t are measured
with respect to the normal

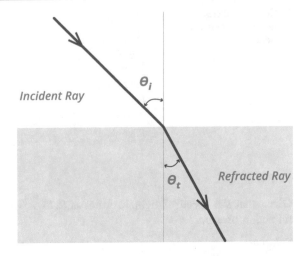

If the first medium is air, as in Fig. 4.1, $n_1 = 1$, so the formula becomes simply:

$$\sin \theta_i = n_2 \sin \theta_t.$$

Figure 4.3 shows the angles used when describing refraction. The *angle of
incidence* θ_i is the angle between the incident ray and the normal at the point of
incidence. The *angle of refraction* θ_t is the angle between the transmitted or re-
fracted ray and the normal.

▲ Example

A ray of light passes from air into crown glass ($n = 1.52$) at an angle of incidence of
60°. What is the angle of refraction? Note: Use a calculator to find sine values. θ_t
may be found on a calculator by selecting [\sin^{-1}] (on some calculators, press [INV]
or [2nd] followed by [SIN]). Google and digital assistants such as Alexa and Siri
may also be used to find sine values.

Solution Substituting the given data into Eq. (4.2),

$$(1)\,(\sin 60) = (1.52)\,(\sin \theta_t)$$
$$(1)\,(0.866) = (1.52)\,(\sin \theta_t)$$
$$\sin \theta_t = (0.866)/1.52 = 0.5697$$
$$\theta_t = \sin^{-1}(0.5697)$$
$$\theta_t = 34.7°.$$

The graph in Fig. 4.4 provides another representation of Snell's law. It shows
the angle of refraction θ_t for different angles of incidence when the first medium is
air and the second medium is water ($n = 1.33$) or crown (window) glass ($n = 1.52$).

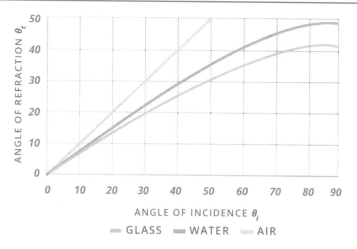

Fig. 4.4 Angle of refraction θ_t for different angles of incidence θ_i

The greater the index of refraction of medium 2, the more the ray of light will be bent in going from medium 1 to medium 2.

Figure 4.5 provides experimental verification of Snell's law. Both the mathematical and graphical representation of Snell's law predict that light entering glass at an angle of 60° will result in an angle of refraction of approximately 35°. Examination of the photograph reveals that this is the case.

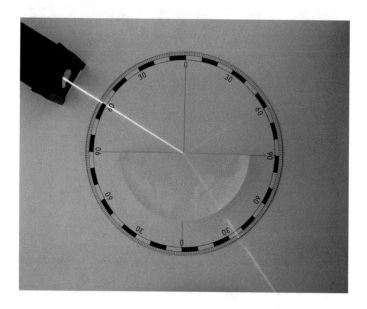

Fig. 4.5 Light being refracted as it passes from air to glass (Zátonyi Sándor (ifj.) Fizped (https://commons.wikimedia.org/wiki/File:Fénytörés.jpg), Fénytörés, https://creativecommons.org/licenses/by-sa/3.0/legalcode)

(a) **(b)**

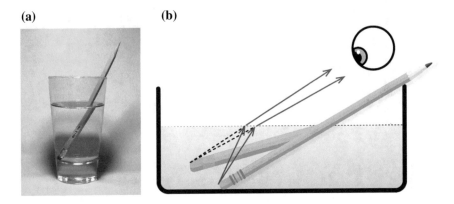

Fig. 4.6 a Refraction causes a pencil in a glass of water to appear bent. **b** Apparent bending is due to light bending away from the normal

The refraction of light produces many interesting effects. A pencil partially in water appears to be bent (Fig. 4.6a). The bending effect is due to light bending away from the normal as it passes from water into air (Fig. 4.6b).

On a larger scale, the head and body of a man in a swimming pool appear to be separated as a result of refraction, as shown in Fig. 4.7.

Fig. 4.7 Losing one's head over physics! (Photograph by Susan Illingworth)

(a) **(b)**

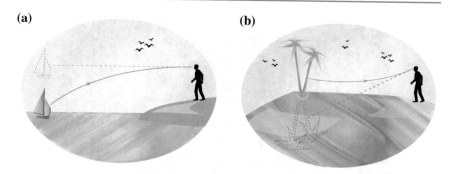

Fig. 4.8 Examples of atmospheric refraction: **a** cold air near the water causes light rays to bend downward; **b** hot air near the ground causes light rays to bend upward

The rainbow we discussed in Chap. 1 is one familiar example of refraction in nature. Another is the formation of a mirage when the surface of Earth is very warm or very cold. When the surface is cold, as over a large lake, the density of the atmosphere decreases more rapidly than usual. This bends light rays traveling near the surface so that a boat in the water appears to be in mid-air, as shown in Fig. 4.8a. A layer of very warm air near the ground can cause the opposite effect. If the air near the ground is warmed, the index of refraction is low near the ground, and light from an object is bent upward, as shown in Fig. 4.8b. For this reason, motorists often see "wet" spots on the road in hot weather (Fig. 4.9).

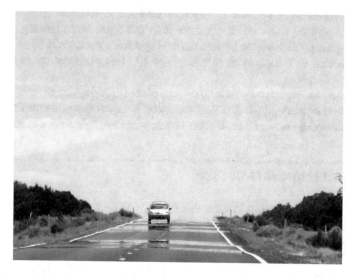

Fig. 4.9 The mirage of the blue sky looks like water on a highway (Artesia Wells/Shutterstock.com)

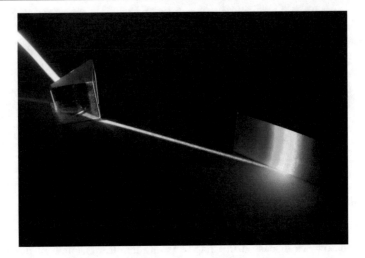

Fig. 4.10 Dispersion of white light by a prism. Note that violet light is bent more than red light. The name ROY G. BIV (red, orange, yellow, green, blue, indigo, violet) is a handy mnemonic for remembering the order of the colors produced by a prism (or in a rainbow) (Photograph by Andrew Davidhazy)

4.4 Dispersion

In most transparent materials, such as glass and water, the speed of light depends upon its wavelength (color). In one type of glass, for example, the index of refraction varies from 1.51 for red light to 1.54 for violet light. This means that violet light will be refracted (bent) more than red light. Light passing through a triangular prism will therefore separate into its spectral colors; white light will yield a full spectrum of colors, as shown in Fig. 4.10. This phenomenon is known as *dispersion* of light.

Of course, we have already seen how drops of rain produce the colors of a rainbow by dispersion of sunlight (Sect. 1.4). Dispersion is also responsible for the brilliant colors produced by diamonds and other jewels when sunlight shines on them.

4.5 Total Internal Reflection

It is probably not surprising to learn that the rays of light are reversible. If a ray of light were to pass from the slower medium 2 into the faster medium 1, it would bend *away* from the normal, so θ_i and θ_t are interchanged and θ_t is the larger angle, as shown in Fig. 4.11a. As θ_i becomes larger, sin θ_t reaches the value 1 (θ_t reaches 90°). The value of θ_i at which this happens is called the *critical angle* of incidence. For light traveling from glass to air, the critical angle is about 42°. When θ_i exceeds this angle, the light is unable to pass from the glass to the air; it is totally reflected.

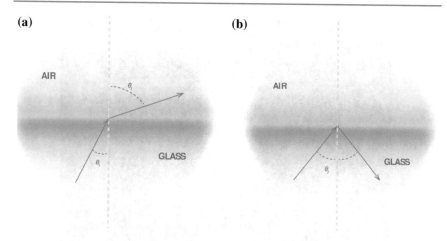

(a)

AIR

θ_i

GLASS

θ_i

(b)

AIR

GLASS

θ_i

Fig. 4.11 A light ray can pass from glass to air when the angle of incidence is less than the critical angle (**a**), but undergoes total internal reflection when the angle of incidence is greater than the critical angle (**b**)

This is called *total internal reflection*, and it is illustrated in Fig. 4.11b. The large index of refraction of diamond (2.42) gives rise to a small critical angle (only 24° for diamond-to-air), and this leads to many internal reflections and much "sparkle."

Total internal reflection may occur when light passes from a slower to a faster medium. Figure 4.12 shows light incident on a water–air boundary for three angles of incidence. The angle of incidence of the ray on the right exceeds the critical angle, resulting in total internal reflection.

▲ **Example**

What is the critical angle for light passing from water into air?

Solution The critical angle, θ_c, for any pair of substances may be calculated using Snell's law. Since $\theta_i = \theta_c$, Snell's law becomes

$$n_1 \sin \theta_c = n_2 \sin \theta_t$$
$$(1.33)(\sin \theta_c) = (1)(\sin \theta_t)$$

At the critical angle the refracted ray just skims the boundary between the water and air. Therefore, the angle of refraction $\theta_t = 90°$. Rearranging terms yields

$$\sin \theta_c = \frac{(1)(\sin 90°)}{(1.33)} = \frac{1}{(1.33)}$$

Since the sin 90° equals 1, $\sin \theta_c = \dfrac{1}{(1.33)} = 0.752$

$$\theta_c = 48.8°$$

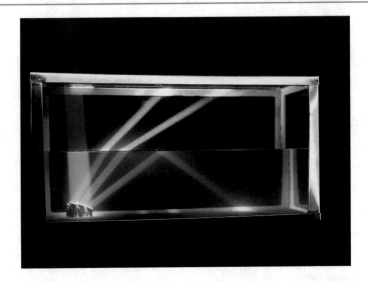

Fig. 4.12 A light beam enters the top left of the tank and hits three mirrors placed at the bottom of the tank. The angle of incidence of the ray on the right exceeds the critical angle. As a result, the ray is reflected back into the water (© Ken Kay, Fundamental Photographs, New York)

Figure 4.13 (an extended version of Fig. 4.4) shows how the angles of incidence and refraction are related, both for light passing from air to water or glass and vice versa; these angles were obtained from Snell's law. Total internal reflection has many applications. A 45°, right-angle prism can be used as an efficient mirror, as shown in Fig. 4.14, and such reflecting prisms are frequently employed in cameras, binoculars, and other optical instruments. Since the incident angle of 45° at which light hits the back surface is greater than the critical angle, the beam is totally reflected.

Another important application of total internal reflection is "piping" light through a glass rod or thin optical fiber. Light enters the fiber from one end, as shown in Fig. 4.15, and once inside it doesn't escape because the angle of incidence is greater than the critical angle. As will be discussed in detail in Chap. 13, fiber-optic cables are used to transmit telephone messages and TV signals with great efficiency.

Total internal reflection can easily be demonstrated by shining light from a laser into a stream of water. The water acts as a liquid light pipe, as shown in Fig. 4.16.

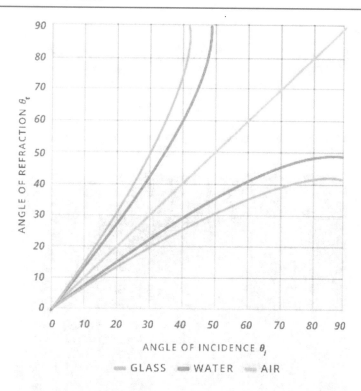

Fig. 4.13 Relationship of incidence angle θ_i to refraction (transmission) angle θ_t for light going from air to water or glass and vice versa, as calculated from Snell's law

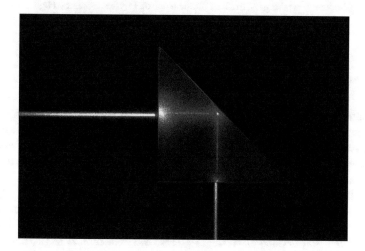

Fig. 4.14 A right-angle prism is used as a high-quality mirror in binoculars, cameras, and other optical instruments. The angle of incidence is greater than the critical angle for a glass-to-air boundary, and so total internal reflection occurs (GIPhotoStock/Science Source)

LIGHT PIPE

Fig. 4.15 Light can be "piped" through solid plastic or glass rods using total internal reflection

Fig. 4.16 Laser light enters a stream of water and travels through it by means of total internal reflection (Benjamin Freeberg—American Association of Physics Teachers High School Photo Contest)

4.6 Diamonds

Diamonds have a number of interesting physical properties: They are very hard, they conduct heat very well, they have a very high index of refraction, and they have a very high optical dispersion. It is these latter two properties that explain their "brilliance," "fire," and "flash," and that have, for the most part, made diamond jewelry so cherished throughout history.

The large index of refraction ($n \approx 2.4$) gives diamond a critical angle of reflection of only about 24.5°, much smaller than that of glass, and accounts for the brilliance of diamonds. A diamond is cut so that almost every ray of light from the front hits the rear surface at an angle greater than the critical angle, and thus is internally reflected to another surface (and eventually out the front). Viewed from the front, therefore, the diamond is extremely brilliant.

The fire or beautiful colors of a diamond are a result of its large dispersion. The index of refraction varies from 2.41 for red light to 2.45 for blue light, a difference of about 1.7%, nearly twice that of ordinary crown glass. No matter how you look at a diamond, chances are that you will see light spread out into its spectral colors. As you move your eye slightly or rock the diamond, you will see another ray; this causes the diamond to flash or sparkle. Diamonds are at their best in a room with lots of candles and mirrors, and one can imagine how popular they were in the famous mirrored ballroom at Versailles.

It is possible to imitate the brilliance of diamond with glass that has been silvered on the back like a mirror. However, it is much more difficult to imitate the fire of a diamond. Nevertheless, very clever imitations have appeared throughout history. One traditional way to distinguish glass from diamond is by using one of its sharp edges to scratch glass. This is dangerous, however, and perhaps a better way is to observe its high thermal conductivity by touching it to one's cheek or tongue. Diamond appears cool to the touch, since it conducts away heat, much like a metal. In fact, this unusual physical property was recognized by old-time gangsters who often referred to diamonds as "ice."

4.7 Lenses

We have observed that a ray of light is bent toward the thicker part of a glass prism. Suppose that we combine two prisms, as shown in Fig. 4.17a. Sets of parallel rays are shown entering each prism. Each set remains parallel, and the first set will cross the second set, as shown. However, the rays do not reach any common point. Such a pair of prisms does not focus a set of rays.

By curving the surfaces, however, so that each of the parallel rays is bent by a different amount, it is possible to get all the rays to intersect at a common point, as shown in Fig. 4.17b. We now have a *lens*, and the common point of intersection is called its *focus* or *focal point*. The distance from the lens to the focal point is called the *focal length* of the lens.

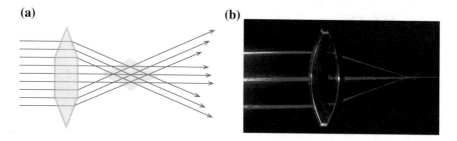

Fig. 4.17 a Two prisms combined to cause parallel light rays to cross; **b** if the surfaces are curved, rays intersect at a common point (called the *focus*)

Fig. 4.18 a Forms of converging lenses; **b** forms of diverging lenses

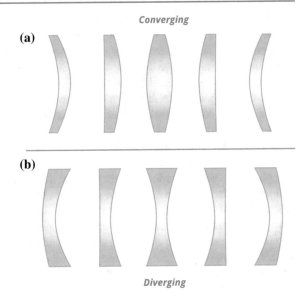

The most common forms of lenses are those in which the surfaces are portions of spheres or one of the surfaces is spherical and one is plane, as shown in Fig. 4.18. If the lens is thicker in the center, it is a *converging* lens (Fig. 4.18a); if it is thinner at the middle, it is a *diverging* lens (Fig. 4.18b).

4.8 Image Formation by Lenses

We can locate the images formed by lenses by tracing rays in much the same way as we did for curved mirrors in Sect. 3.5. Three rays are easily drawn without measuring angles, and the intersection of any two of these rays determines the location of the image.

Converging Lens

For a converging lens, shown in Fig. 4.19, the rules governing these three rays may be stated as follows:

1. A ray through the center of the lens continues in the same direction (it is bent equally in opposite directions at the two surfaces).
2. A ray traveling parallel to the optic axis (the imaginary horizontal line that passes through the geometrical center of a lens) is bent so that it passes through the principal focal point.
3. A ray that passes through a focal point is bent so that it travels parallel to the optic axis.

Fig. 4.19 Three rays are easily traced through a converging lens

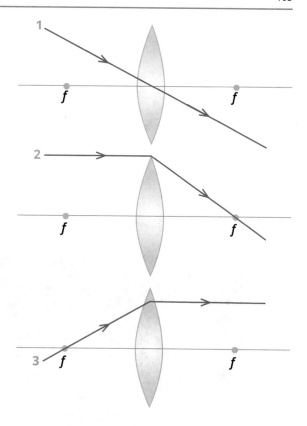

In Fig. 4.20 these rules are applied to locate the image of a candle located on the optic axis outside the focal point of a converging lens. For purposes of ray tracing, the lens is treated as a plane through the center of the lens. Note also that the image formed is inverted. Since all the rays actually meet at a point, we call it a *real image*. A real image can be projected on a screen or a sheet of paper placed at the point where the rays cross.

The water droplets shown in Fig. 4.21 act as converging lenses. The large upside down M in the background serves as an object. Inverted images indicate the object lies outside the focal point of the tiny lenses.

If the object were moved inside the focal point, as illustrated in Fig. 4.22, no real image is formed. Ray 3 doesn't actually pass through the focal point, but it is drawn as if it came from one. To a viewer on the side of the lens opposite the candle, the rays appear as if they came from a virtual candle behind the real one. This is called a *virtual image*. Note that it is erect rather than inverted, as the real image in Fig. 4.20 was. Note also that it is larger than the real candle. This is the arrangement that is used in a simple magnifying glass.

You can demonstrate real and virtual images for yourself by viewing a printed page with a converging lens. When the lens is close to the page, an erect, enlarged

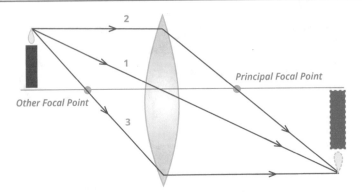

Fig. 4.20 Ray-tracing rules applied to an object outside the focus

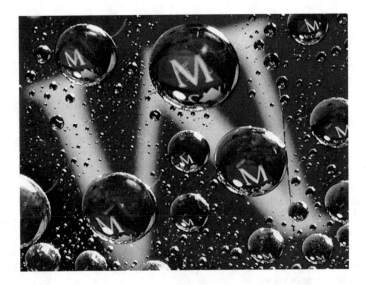

Fig. 4.21 Water droplets produce real, inverted images (Antoine Ferguson—American Association of Physics Teachers High School Photo Contest)

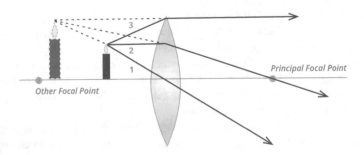

Fig. 4.22 Ray tracing applied to an object inside the focus; the image is virtual

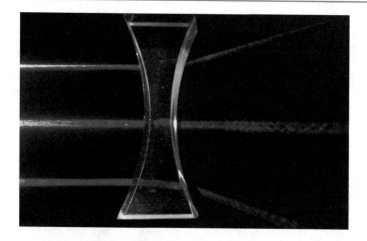

Fig. 4.23 A concave lens diverges incoming parallel light rays

virtual image is seen. As the spacing approaches the focal length of the lens, the image fades out; and when the spacing exceeds the focal length, an inverted real image appears. Compare the image size to the object size (the actual print size) for various lens spacings. What is the focal length of your lens?

Diverging Lens

Diverging lenses spread out incoming parallel rays, as shown in Fig. 4.23. They cause parallel rays to appear as if they came from a focal point (on the opposite side of the lens). This simple principle can be used to predict how images will be formed by lenses.

For a diverging lens, such as shown in Fig. 4.24, the rules for ray tracing are modified slightly, as follows:

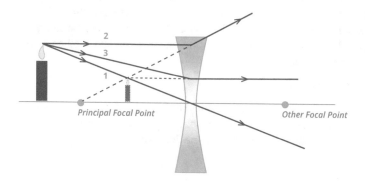

Fig. 4.24 Ray tracing to find the image from a diverging lens

Fig. 4.25 Lens
configurations for practicing
ray tracing

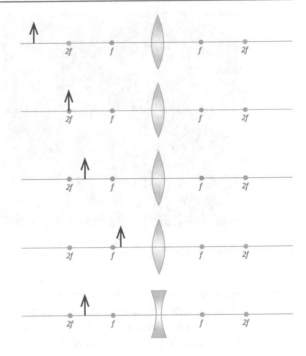

1. Any ray through the center of the lens continues in the same direction.
2. A ray traveling parallel to the optic axis is bent so that it appears to come from
 the focal point f.
3. A ray that is traveling directly toward the focal point on the other side of the lens
 is bent so that it travels parallel to the optic axis.

Figure 4.24 shows how these rules can be applied to image formation by a
diverging lens. Once again, we notice that the image is virtual and erect. A di-
verging lens, by itself, will always produce a virtual image (although it can produce
a real image when used in combination with one or more converging lenses).

Figure 4.25 has several lens configurations that you can copy and use to practice
ray-tracing procedures.

The Lens Equation

Convex lenses form images in a manner similar to concave mirrors. Concave lenses
are similar to convex mirrors in this respect. Therefore, the same equation used with
curved mirrors can be used to find the location of images produced by lenses,
namely,

$$1/d_o + 1/d_i = 1/f, \tag{4.3}$$

where, once again, d_o represents the object distance, d_i the image distance, and f the focal length. The magnification m is found by determining the absolute value of the ratio of image distance to object distance.

$$m = h_i/h_o = |d_i/d_o| \qquad (4.4)$$

As with curved mirrors, d_i is positive when the image is real; d_i is negative when the image is virtual. For concave lenses, f is always negative. Negative image distances correspond to an image appearing on the same side of the lens as the object.

▲ Example

1. Determine the location of the image produced by an object that is located 10 cm from a convex lens whose focal length is 30 cm.

Solution Substitute the given data into Eq. (4.3),

$$1/10 \text{ cm} + 1/d_i = 1/30$$
$$1/d_i = 1/30 \text{ cm} - 1/10 \text{ cm}$$
$$1/d_i = -0.066$$
$$d_i = -15 \text{ cm}.$$

The magnification m is equal to $d_i/d_o = |-15 \text{ cm}/10 \text{ cm}| = 1.5$.

A negative image distance indicates that the image is virtual. A magnification of 1.5 means that the image is half again as large as the object.

Stopped Lens

In cameras and other optical instruments, the lens opening is sometimes reduced by means of a diaphragm or "stop" placed in front of the lens to reduce the amount of light reaching the film. Does this cut out part of the image? No, it doesn't if it is placed right at the lens. An important principle to remember is that every part of the lens is capable of making an image of the entire object.

Note, for example, that rays 1, 2, and 3 in Fig. 4.20 all come from the same point on the object, pass through different parts of the lens, and converge to the same point on the image. If the top half of the lens were covered, rays 1 and 3 (and many more rays that pass through the bottom half of the lens) would create an image that is *half* as bright as the image from the full lens but otherwise identical to it. The lens stop on a camera usually covers up the outer portion of the lens so that just the desired inner portion is used. This has an additional advantage: The image will be sharper if only the inner portion of the lens is used. We will discuss this further in Chap. 10.

Fig. 4.26 Simple "point-and-shoot" film camera uses a converging lens with a fixed focal length to concentrate the light on the film

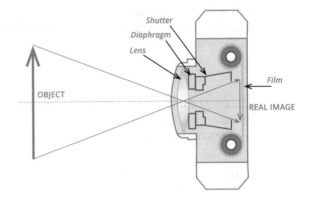

4.9 Simple Cameras

The pinhole camera, described in Chap. 3, is capable of producing sharp images if the pinhole is sufficiently small. With a traditional pinhole camera that uses photographic film, the amount of light striking the film is very small; however, long exposure times are required. The amount of light reaching the film can be greatly increased by replacing the pinhole with a converging lens. For a fair approximation, the amount of light that reaches the film is proportional to the area of the lens, and thus lenses of large diameter are referred to as "fast" lenses because shorter exposure times are required. (There are disadvantages in using lenses of large diameter; however, so many cameras have an iris or variable stop that controls the portion of the lens that is used.)

Simple "point-and-shoot" cameras, such as the one-time-use models often given as wedding favors, have a single lens at a fixed distance from the film, as shown in Fig. 4.26. The distance from the lens to the film will be nearly the same as the focal length of the lens, so a sharp image of distant objects can be recorded on the film. Objects close to the camera will be slightly out of focus, however, and that is why in more sophisticated film and digital cameras, the lens-to-film distance can be changed in order to "focus" the camera. This will be discussed in Chap. 10.

4.10 The Human Eye

The eye contains a lens that forms a real, inverted image of objects within the field of view (Fig. 4.27a). The eye is a nearly spherical structure held in a bony cavity of the skull in which it can be rotated, to a certain extent, in different directions. The delicate eye is protected, to some degree, by the transparent cornea, and the iris automatically controls the amount of light that is admitted (Fig. 4.27b).

(a)

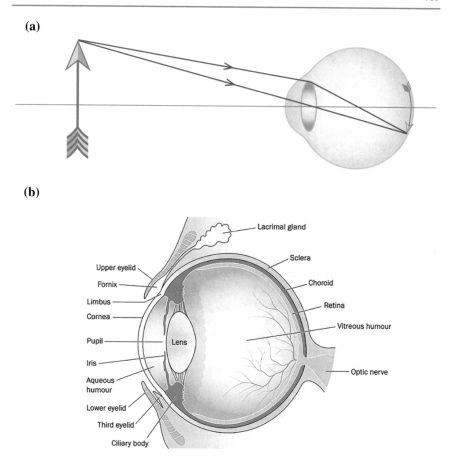

(b)

Fig. 4.27 The eye: **a** image formation at the retina; **b** structure (Blamb/Shutterstock.com)

Lining the wall is the sensitive *retina*, whose stimulation produces visual sensation. The space between the cornea and the lens is filled with a salt solution called the *aqueous humour*, and the region between the lens and retina is filled by the jelly-like *vitreous humour*. Both humours have about the same index of refraction as water.

Millions of light receptors, the *rods* and the *cones*, form one layer of the retina. These are connected to the *optic nerve*, which, in turn, connects to the brain. There are no rods or cones at the point of attachment of the optic nerve, and so this forms a small "blind spot" on the retina. The existence of the blind spot can be verified by closing the left eye and looking intently at the x in Fig. 4.28. As the book is moved toward the eye, the square should disappear when the page is about 25 cm from the eye. On moving the page closer, the black dot may also be made to disappear. Still closer, the square and dot will reappear in turn.

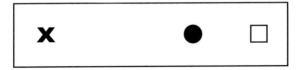

Fig. 4.28 The blind spot in the eye can be verified by closing the left eye and looking intently at the x

More centrally located than the blind spot is the *fovea*, a small area of the retina that contains only cones. Here, vision is most acute, and this area of the retina is used when we look directly at an object.

In order to focus the eye on both near and distant objects, the shape of the lens is changed by means of the *ciliary muscle*. When this muscle is totally relaxed, a normal eye will form an image of a distant object on the retina, as illustrated in Fig. 4.27a. A nearsighted (myopic) eye has a "fat" lens that focuses a distant object in front of the retina, when totally relaxed, and thus produces a blurred image, as shown in Fig. 4.29a. Such a condition can be corrected by placing a diverging lens in front of the eye, as shown. A farsighted (hyperopic) eye, on the other hand, focuses behind the retina, as shown in Fig. 4.29b, and a converging lens is needed for correction. Thus, nearsighted persons wear eyeglasses with diverging lenses, and farsighted persons wear eyeglasses with converging lenses.

Eyeglass prescriptions specify the type and strength of the lens in "diopters," units that are equal to one divided by the focal length in meters; negative numbers denote diverging lenses and positive numbers converging lenses. Thus, a correction of—1.5 means a diverging lens with a focal length of 0.67 m.

Another common defect in human eyes is *astigmatism*, the failure to focus all portions of an image at the same time. Astigmatism is generally due to nonuniform curvature of the cornea (Fig. 4.29c). A cylindrical lens is needed to correct for

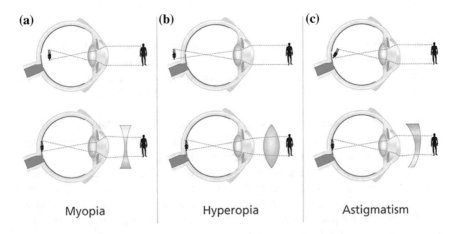

(a) **(b)** **(c)**

Myopia Hyperopia Astigmatism

Fig. 4.29 Correction of eye lens defects with eyeglasses (Peter Hermes Furian/Shutterstock.com)

astigmatism, and this is generally combined with the necessary correction for near- or farsightedness in a single lens.

A natural decrease in accommodation, or the ability to focus on near objects, occurs with advancing age. This requires the use of special eyeglasses for reading and other close work. Bifocal lenses have different focal lengths for the upper and lower portions, so that the upper portion is used for viewing distant objects and the lower portion is used for reading.

In Chap. 5, we will discuss the resolving power of the eye (our ability to resolve two objects that are very close together). In Chap. 9, we will discuss the perception of color.

4.11 Telescopes and Microscopes

Lenses are used in many different types of optical instruments. We will briefly discuss two of them: telescopes and microscopes. Both are widely used to extend the limits of human vision. The telescope allows us to see objects that are too distant to be seen with our eyes alone, while the microscope enhances our ability to see very small objects. Both instruments use combinations of two or more lenses (or mirrors) to accomplish this.

The simple refracting telescope in Fig. 4.30 consists of two converging lenses. Rays from a distant object are focused by the objective lens to form a real image near its focal point F_o. This real image serves as an object for the eyepiece, and since it lies just inside the focal point F_e of this lens, a large virtual image is formed. What really matters to the observer is the angular magnification, the ratio of angle β to angle α, and this turns out to equal the ratio of the focal lengths f_o/f_e, so the objective lens generally has a long focal length and the eyepiece a short one.

In practice, there are many different telescope designs. Some use a diverging lens as an eyepiece; others use more than two lenses. Most astronomical telescopes are reflecting telescopes; they substitute a converging (concave) mirror for the objective lens.

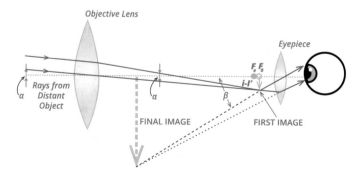

Fig. 4.30 Simple refracting telescope

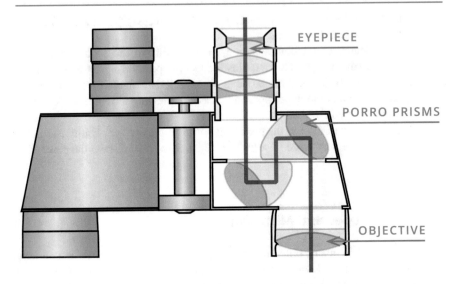

Fig. 4.31 The prism binocular consists of two telescopes with totally reflecting prisms to shorten the length and make the image erect rather than inverted

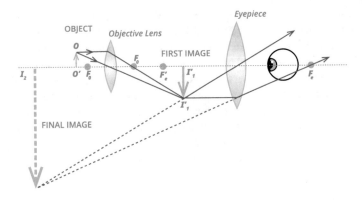

Fig. 4.32 A basic microscope has an objective lens with a short focal length

The prism binocular, shown in Fig. 4.31, consists of two telescopes, each one including two totally reflecting right-angle prisms that shorten the length and also cause the image to be erect rather than inverted. Since the objective lenses have a greater separation than the user's eyes, depth perception is enhanced.

The basic microscope in Fig. 4.32 is similar to the simple telescope in Fig. 4.30 in that the real image formed by the objective lens is viewed through the eyepiece. In a microscope, however, the objective lens has a very short focal length, since the object to be viewed is very small. The magnification produced by a microscope is the product of the magnifications produced by the eyepiece and the objective lens.

4.12 Summary

When a ray of light encounters a boundary between two media, it is partially reflected and partially transmitted in a new direction. The index of refraction of a medium expresses the ratio of the speed of light in air to the speed in the medium. Total internal reflection occurs when light passes from a slow to a fast medium at a large angle of incidence. It is employed in prism binoculars, optical fibers, and other optical devices.

Convex lenses converge light rays to form either real or virtual images. Concave lenses diverge light rays and form virtual images. Images formed by lenses can be determined by tracing rays as well as by mathematical calculation.

Combinations of lenses are used in many optical instruments, such as telescopes, microscopes, and cameras. The human eye is a most useful and remarkable optical instrument.

◆ **Review Questions**

1. Does light travel faster in water or in glass? How do you know this?
2. Is the critical angle greater at a water–air surface or a glass–air surface?
3. What is dispersion? Does water exhibit dispersion? How do you know?
4. Why does increasing the diameter of a converging lens increase the brightness of the image?
5. To magnify print, would you use a convex or a concave lens?
6. When an object is brought closer to a converging lens, does the image move closer to or farther from the lens? Does the image increase or decrease in size?
7. What kind of lens would you place in front of a simple camera to photograph very close objects?
8. Where must an object be placed with respect to a converging lens to produce an image one focal length from the lens?
9. What kind of lens is used to correct for myopia (nearsightedness)?
10. What kind of lens is used to correct for hyperopia (farsightedness)?

▼ **Questions for Thought and Discussion**

1. Can total internal reflection occur when light is entering a material with a higher index of refraction? Explain your answer.
2. A converging lens forms a real, inverted image of an object on a screen. What happens to the image if the top half of the lens is covered up?
3. People who are in need of corrective eyeglasses often squint to improve their vision. Why squinting may produce temporarily improved vision?
4. Nonprescription sunglasses are often curved, as are automobile windshields. Why don't these converge or diverge light rays?
5. How can you quickly determine whether a lens is converging or diverging?
6. How can you quickly determine the focal length of a convex lens?
7. Explain why the telescope in Fig. 4.30, consisting of two convex lenses, inverts the image.

■ Exercises

1. Using a calculator, find the sines (sin) of the following angles: 20°, 30°, 45°, 60°, 70°, 80°, and 90°. Make a graph of sin θ versus θ.
2. Light travels from air into water. What is the angle of refraction if the angle of incidence is 30°?
3. Light travels from crown glass into water. The angle of incidence in the crown glass is 40°. What is the angle of refraction?
4. The critical angle for light traveling from a particular type of glass into air is 39.1°. What is the index of refraction of the glass?
5. What is the critical angle for light passing from flint glass into air?
6. To a person (or fish) lying on the bottom of a pool, all external objects appear to be within a cone. What is the size (angle) of this cone? Does the observer see anything outside this cone?
7. Photocopy Fig. 4.25 (you may wish to enlarge it) and find the image in each case by tracing two rays and determining where they cross. To check your ray diagram, trace a third ray and see that it intersects the other two at the crossing (image) point.
8. What is the strength (in diopters) of a converging lens with a focal length of 20 cm? A diverging lens with a focal length of 30 cm?
9. An object 5.0 cm high is 20 cm from a convex lens that has a focal length of 15 cm.
 a. Find the image distance.
 b. Is the image real or virtual?
 c. Calculate the magnification and height of the image.
10. An object is 4.0 cm from a convex lens whose focal length is 6.0 cm.
 a. Where is the image located?
 b. Is the image real or virtual?
 c. Calculate the magnification of height of the image.
11. An image is 12 cm from a convex lens whose focal length is 4.0 cm. Where is the object located?
12. If an object is four focal lengths away from a converging lens, where is the image located?

● Experiments for Home, Laboratory, and Classroom Demonstration
Home and Classroom Demonstration

1. **Bent pencil**. Fill a clear glass or beaker about three-quarters full of water. Insert a pencil vertically into the water so that half the pencil is submerged. How does the pencil appear when viewed from the side? Why does the pencil look this way? Tilt the submerged pencil. How does the pencil appear? What do you suppose causes this effect?
2. **Floating coin**. Place a coin at the bottom of a drinking glass and slowly fill the glass with water. What happens to the image of the coin? Locate the image by holding a similar coin to the side of the glass; move it up and down until it

appears to be at exactly the same height as the image of the coin under water. (The ratio of the actual depth of the coin to the apparent depth is approximately equal to the index of refraction of water.)

3. **Hidden coin**. Place a coin at the bottom of an opaque cup (a coffee cup works well). After placing the cup on a table, move away until you can no longer see the coin. Have a friend slowly pour water into the cup. What do you see as the water reaches the top of the cup? Draw a ray diagram to explain what you observed.

4. **Disappearing drinking glass**. If glass is immersed in a clear liquid whose index of refraction matches that of the glass, the glass will disappear! Encountering no optical discontinuity at the interface of the two materials, the light is neither reflected nor refracted. Place a small drinking glass inside a larger one (the smaller glass should be plain with no decorative features). Pour baby oil or clear vegetable oil into the larger glass until the smaller glass is completely submersed. Voilá. The small glass disappears!

5. **Disappearing crystals**. Soil Moist Crystals™ become virtually invisible in distilled water. The crystals, which may be purchased at hardware and garden stores, have nearly the same index of refraction as water. Similar material is available as a toy and comes in the shape of animals.

6. **Silver egg**. Total internal reflection may be demonstrated rather dramatically by dropping a soot-covered egg into a glass of water. A considerable amount of the light traveling through the water is totally internally reflected when it encounters an air layer that adheres to the soot. To produce the "silver egg," hold an egg in a candle flame (with forceps) until it is completely covered with soot.

7. **Liquid light pipe**. Total internal reflection may be observed when a beam of light travels through a stream of water. This phenomenon may be demonstrated using a flashlight and the plastic basket from an automatic drip coffee maker. Hold your finger over the small hole on the bottom of the basket as you fill it with water. With the basket over a sink, remove your finger from the hole. If a flashlight is directed downward onto the water in the basket, light will be totally internally reflected inside the stream. To see that the light will follow a curved stream of water, gently move the basket from side to side over the sink. The light will remain inside the water even though the stream becomes curved.

8. **Edible optics**. Converging and diverging lenses, prisms, and even light pipes can be fabricated from unflavored gelatin. After preparing a pan of clear gelatin, use a utility knife or razor blade to cut out optical elements of your choice. A source of parallel rays will be useful when you are ready to examine the optical properties of these components; use a commercial light box or pass a flashlight beam through the teeth of a comb. Observe what happens when you send parallel rays through the lenses and prisms you've made. Squeeze the ends of the converging (convex) lens to change its focal length. Send a single ray through the light pipe and note the total internal reflection. Does the light remain in the pipe when it is bent?

9. **Determining the focal length of a simple magnifier**. Use a converging lens to observe a magnified (virtual) image of the print in this book. Move the lens away from the page and note that the image gets larger, blurs, and disappears. As you move it still farther away, an inverted (real) image appears. The distance from the book to the lens when the image disappears is the focal length of the lens.

10. **Observing your pupil**. To witness the response of your pupil to light intensity, punch a small hole in a card or piece of aluminum foil with a pin or paper-clip. Keeping both eyes open, use one eye to view a source of light through the opening. The light passing through the hole casts a shadow of your pupil on the retina; the circle you see is not the hole in the paper, but your pupil! Covering the other eye with your hand will cause both pupils to get larger. Now uncover the eye and watch the pupil shrink. You may wish to use a flashlight to vary the intensity of the incoming light.

11. **Pinhole magnifier**. The size of an image on the retina depends on the proximity of the object to the eye. Closer objects form larger images, and we perceive them to be bigger. At first blush, it would appear that we should be able to magnify objects without limit simply by bringing them closer to the eye. The problem is that the eye lens cannot form clear images of objects closer than about 25 cm if you are young, a greater distance as you age. If we wish to bring an object closer than 25 cm to magnify it, we must limit the number of rays entering the lens; this may be accomplished with a pinhole viewer. Punch a pinhole in a smooth square of aluminum foil and view some well-illuminated fine print or an object with minute detail through the pinhole. It should appear magnified but rather dim. Thus, limiting the amount of light entering the eye allows objects to be optically magnified without the use of a lens.

12. **Retinal inversion**. The eye lens produces an inverted image on the retina. Early in life, the brain learns that it must "flip" the retinal image to make our perception consistent with reality, and we perceive our world to be right-side up. To experience the inversion introduced by the brain, close one eye and place a piece of aluminum foil with a small hole before the open eye. With the other hand, hold the head of a straight pin between your open eye and the hole in the aluminum foil. When the pin is sufficiently close to the eye, the lens will be unable to form an image on the retina. However, the pin will cast a sharp, erect shadow on the retina. You should perceive an inverted pin, even though it is actually right-side up!

13. **Discovering examples of refraction in paintings**. Find all the examples you can of refraction in paintings in books and art galleries.

Laboratory (See Appendix J)

Glossary of Terms

astigmatism An aberration in a lens or mirror that causes the image of a point to spread out into a line.

converging lens Lens that is thicker in the center; it causes parallel rays to converge and cross at the focus.

critical angle The maximum angle of incidence for which a ray will pass from a slow medium (such as glass) to a faster medium (such as air); the minimum angle of incidence for which total internal reflection will occur.

diverging lens Lens that is thinner at the center; it causes parallel rays to diverge and appear as if they came from the focus.

focal length Distance from a lens (mirror) to the focus.

focus (focal point) A point at which rays parallel to the axis of a lens will cross.

hyperopic Farsighted, The eye forms images of near objects beyond the retina.

image Replica of an object formed by a concentration of rays from the object.

index of refraction Ratio of the speed of light in air to the speed in the medium.

lens An optical device that can form images by refracting light rays.

magnification The ratio of the size of image to size of object.

microscope An optical instrument that enlarges tiny objects to make them visible.

mirage An optical effect that produces an image in an unusual place due to refraction. Typically, the image appears as if it had been reflected from a water surface.

myopic Nearsighted. The eye forms images of distant objects in front of the retina.

optic axis The imaginary horizontal line that passes through the geometrical center of a lens.

optical fiber A tiny glass pipe from which total internal reflection prevents the escape of light.

plane of incidence Plane that contains the incident ray and the normal to the surface.

real image An image created by a concentration of rays that can be projected onto a screen.

refraction Bending that occurs when rays pass between two media with different speeds of light.

retina The light-sensitive screen in the eye on which images are formed.

rods and cones Light-sensing elements on the retina.

Snell's law A mathematical relationship between the angle of incidence, the angle of refraction (transmission), and the index (indices) of refraction.

telescope Optical device for viewing and enlarging distant objects.

total internal reflection Total reflection of light when it is incident at a large angle on an interface between a slow material (such as glass) and a faster material (such as air).

virtual image An image formed by light rays that do not converge at the location of the image. A virtual image cannot be projected onto a screen.

Further Reading

Bloomfield, L.A. (2008). *How Everything Things Works*. Hoboken, NJ: John Wiley & Sons.
Hewett, P. G. (2014). *Conceptual Physics*, 12th ed. Boston: Pearson.
Kirkpatrick, L. D., & Wheeler, G. F. (1995). *Physics: A World View*, 2nd ed. Philadelphia: Saunders College Publishing.

Interference and Diffraction

<div align="right">**5**</div>

In Chap. 2 we learned about several interesting properties of waves, including constructive and destructive interference. Figure 2.8 illustrates the constructive and destructive interference that occurs when two wave pulses travel in opposite directions on a one-dimensional medium such as a rope. In the case of continuous waves, constructive and destructive interference can lead to standing waves, as shown in Fig. 2.9. We now discuss what happens when waves travel in a two-dimensional medium (such as water waves on the surface of a pond) or a three-dimensional medium (such as light waves in a room).

In Fig. 2.11 we showed how propagation of water waves in a ripple tank can be studied by projecting light through them so that they project shadows on a screen or on the table below the ripple tank. In this chapter we begin our study of interference with water waves in a ripple tank and then proceed to light waves (where we can see the end result but not the propagating wavefronts themselves).

5.1 Interference of Waves from Two Identical Sources

Two examples of interference between waves from two identical sources are shown in Fig. 5.1. In Fig. 5.1a, water waves in a ripple tank from two identical sources add up in certain directions (where they have the same phase) and cancel each other in certain directions (where their phases are opposite to each other). The lighter areas in the photo are regions of cancellation. The alternating light and dark bars correspond to regions where waves add together. In Fig. 5.1b, sound waves from two loudspeakers supplied with a single frequency by the same amplifier outdoors produce loud and soft sounds in different directions due to constructive and destructive interference. (In the case of two loudspeakers inside a room, however, the interference patterns are much more complicated due to many "images" of the loudspeakers formed by reflections from the walls and other surfaces.)

© Springer Nature Switzerland AG 2019
T. D. Rossing and C. J. Chiaverina, *Light Science*,
https://doi.org/10.1007/978-3-030-27103-9_5

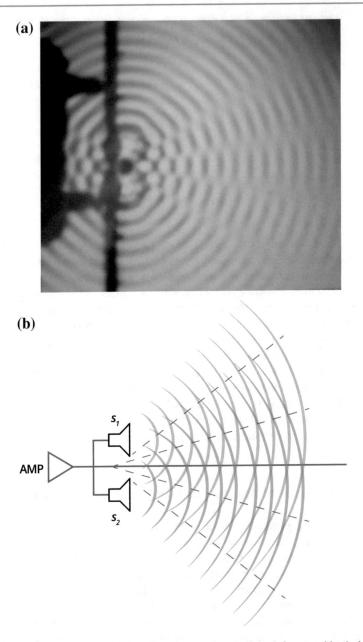

Fig. 5.1 Two examples of interference: **a** water waves in a ripple tank from two identical sources (Photograph by Mark Welter). **b** Sound waves from two loudspeakers driven by the same amplifier

In Fig. 5.1, the two identical sources are assumed to be in phase with each other, so constructive interference occurs wherever the distance to both sources is the same (such as along the center line). What happens if the two sources vibrate in opposite phase (if, for example, the wires to one loudspeaker are reversed)? Then the positions of constructive and destructive interference are interchanged. That is, destructive interference occurs along the center line where the distance to both sources is the same, and constructive interference occurs when the distance to one source is a half-wavelength greater. (Some people inadvertently connect their loudspeakers this way, which moves the stereo sound image but also distorts it because it moves by a different amount for each different frequency represented in the music.)

5.2 Light Passing Through Two Slits: Young's Experiment

The interference of light from two identical sources was first demonstrated by Thomas Young in 1801; it provided one of the strongest pieces of evidence for the wave nature of light.

A convenient arrangement for demonstrating Young's experiment is shown in Fig. 5.2. Light from a point source located at A illuminates two identical slits S_1 and S_2, which then act as two identical sources to produce an interference pattern on a screen, as shown. The spacing of the bright lines D depends upon the ratio of the wavelength λ to the slit spacing d and the distance L to the screen:

$$D/L = \lambda/d. \tag{5.1}$$

The interference pattern formed by red light is therefore wider than that produced by blue light as is shown in Fig. 5.3.

▲ **Example**

Two slits spaced 0.5 mm apart are located 40 cm from a screen. Describe the resulting pattern when the slits are illuminated with red light (λ = 633 nm) and with blue light (λ = 450 nm).

<u>Solution</u> Substituting the given data for red light into Eq. (5.1),

$$D = L\lambda/d = (0.4\,\text{m})(633 \times 10^{-9}\,\text{m})/(0.5 \times 10^{-3}\,\text{m}) = 5.06 \times 10^{-4}\,\text{m}$$
$$= 0.51\,\text{mm}.$$

A bright fringe will occur at the center, and at distances of 0.51, 1.1, 1.52 mm, and so on. There will be dark fringes at 0.25, 0.76 mm, and so on.

For blue light, $D = L\lambda/d = (0.4\ \text{m})(450 \times 10^{-9}\ \text{m})/(0.5 \times 10^{-3}\ \text{m}) = 3.60 \times 10^{-4}\ \text{m} = 0.36\ \text{mm}$.

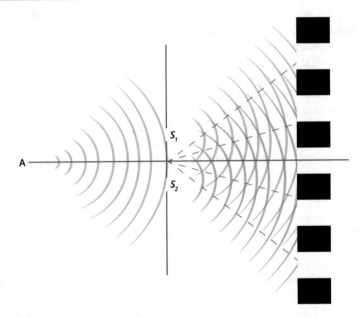

Fig. 5.2 Interference between light waves from two narrow slits illuminated by the same light source (Young's experiment). The spacing of the bright lines depends on the ratio of wavelength to slit spacing

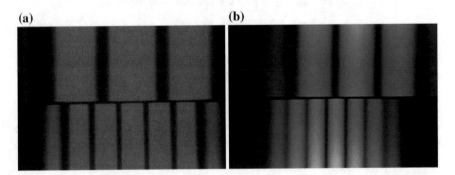

Fig. 5.3 Interference patterns produced by **a** red and **b** blue light (Courtesy of Kodansha, Ltd.)

Bright fringes will occur at 0, 0.36, 0.72 mm, and so on, with dark fringes at 0.18, 0.54 mm, and so on.

What happens if the slits are illuminated with white light? The center bright fringe will be white (because the interference patterns for all the component colors have a maximum there), but the next maximum on each side will be a "rainbow" of colors, with violet having the smallest spacing and red the largest.

5.3 Interference in Thin Films

Thin transparent films, such as soap bubbles or oil on water, show patterns of color due to interference. In this case, the interference is between light reflected at the upper and lower surfaces of the thin film, as shown in Fig. 5.4. An observer will see different parts of an oil slick (*A* and *B*, for instance) as having different colors, because light of a different wavelength will interfere at *A* as compared to *B*. This phenomenon is known as *iridescence*. Iridescence occurs because the optical path length depends on the location of the observer or light source.

Soap bubbles and films produce colors in the same way as oil films. The only difference is that the thin film has air on both sides. Just before a bubble breaks, it usually becomes dark because the film is so thin that only destructive interference takes place, as shown in Fig. 5.5. Museums often have interactive soap film exhibits in which wire frames are withdrawn from a tank of a special soap film solution so that interference effects may be admired and studied.

Phase of the Reflected Wave

To explain the dark area in a soap bubble, we have to consider the phase of the reflected wave, as we did in Sect. 2.3. Light reflected at the first surface of the soap bubble undergoes a phase reversal, much like the pulse on a rope does at a fixed end (see Fig. 2.5a). At the second or soap-to-air surface, the reflected light has the same phase as the incident light, much like the pulse on a rope at a free end (Fig. 2.5b). Thus, if the soap film is very thin, the two reflections will come back with opposite phase and will interfere destructively, thus the black appearance.

Where the film has a thickness of λ/4 (a quarter-wavelength), the wave that reflects at the second surface will have its phase retarded by half a cycle, since it has traveled a half-wavelength in the soap, and thus it will be in phase with the light reflected at the first surface. Constructive interference occurs, and we see a bright

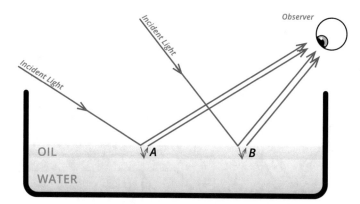

Fig. 5.4 Interference between light reflected at the upper and lower surfaces of a thin film of oil floating on water. Light reflected at *A* will have a different color than light reflected at *B*

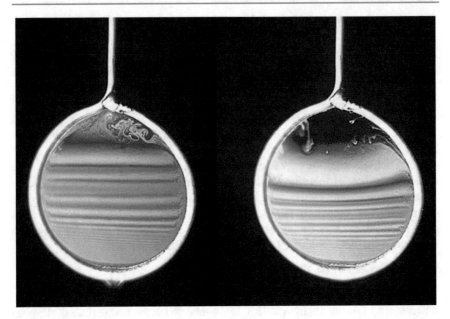

Fig. 5.5 Soap films show patterns of color due to interference. The top of the film shown on the right appears dark because the film is so thin that only destructive interference takes place (Courtesy of Kodansha, Ltd.)

fringe of light. Where the film has a thickness $\lambda/2$, we have destructive interference again, and so forth. Both situations are shown in Fig. 5.6.

Figure 5.7 illustrates how interference patterns can be formed by light reflected at the top and bottom of an air wedge between two glass plates. In this case, the thickness t of the air wedge at the mth fringe is given by $t = m\lambda/2$, where λ represents the wavelength of light used to illuminate the wedge. Interference

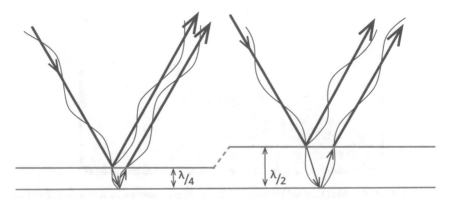

Fig. 5.6 Interference occurs when light is reflected from the top and bottom of a thin film

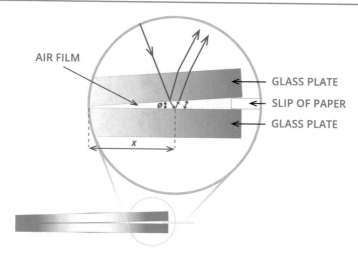

Fig. 5.7 Two glass plates separated by a wedge of air

patterns of this type can be used to measure the thickness of very thin objects or to determine the flatness of a surface.

Figure 5.8 shows two plane glass plates illuminated with light from a sodium source placed one on top of the other. The uniformly spaced light and dark fringes indicate that the two plates forming the air film are flat. If the plates had uneven surfaces, the fringes would appear curved.

Fig. 5.8 Two plane glass plates illuminated with light from a sodium source are placed one on top of the other. A very thin sheet of paper inserted at one end forms a wedge-like air film. The resulting interference pattern consists of uniformly spaced parallel lines (Courtesy of Kodansha, Ltd.)

Fig. 5.9 Newton's rings rings produced using sodium light (left) and white light (right) (Courtesy of Kodansha, Ltd.)

An interference pattern between a flat and a spherical glass surface is shown in Fig. 5.9. Each fringe is created by an air film of a certain thickness. The circular fringes are called *Newton's rings*.

5.4 Michelson Interferometer

Another example of interference is created by the Michelson interferometer in Fig. 5.10. Light from source S is split into two beams by the half-silvered mirror A; one beam is reflected by the movable mirror M and one beam by the stationary mirror M'. When they recombine, they interfere to form bright or dark fringes, depending upon the relative path lengths they have traveled. Alternate bright and dark fringes can be counted as they pass a reference mark. If n fringes are counted as mirror M moves through a distance d, then the wavelength λ of the light is given by: $\lambda = 2d/n$. The Michelson interferometer can be used to determine the wavelength of light λ or the distance d with great accuracy.

The Michelson-Morley experiment (1887) showed that the speed of light (and thus the wavelength) is the same when measured parallel and perpendicular to Earth's motion through space. This experiment was of great significance in establishing Einstein's special theory of relativity.

Later, with his formulation of the general theory of relativity, Einstein predicted the existence of gravitational waves, ripples in the fabric of space–time created by accelerating masses. Einstein was doubtful that an instrument with sufficient sensitivity to detect changes in space–time could ever be devised. However, a century after Einstein's prediction of the existence of gravitational waves, work was completed on the Laser Interferometer Gravitational-Wave Observatory (LIGO), the first gravitational wave observatory.

At the heart of LIGO are two enormous laser interferometers, one in Louisiana, the other in Washington state (Fig. 5.11). With 4-km long arms, the two LIGO detectors are the world's largest and most sensitive interferometers, capable of measuring a change in arm length over 1000 times smaller than a proton.

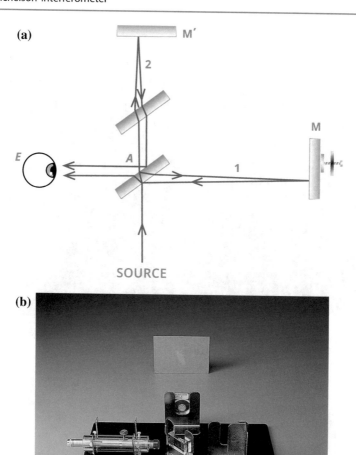

Fig. 5.10 a Michelson interferometer. Light from the source is split into beams 1 and 2 by a half-silvered mirror. They recombine at the observer to create an interference pattern. **b** A Michelson interferometer for use in introductory physics laboratories (© Cenco Physics/Fundamental Photographs, NYC)

As with the Michelson interferometer, the central components of each L-shaped detector are a laser light source, beam splitter, and mirrors at the ends of the arms (Fig. 5.12). After being divided into two by the beam splitter, light travels down the two steel vacuum tubes that form the arms of the L. Reflected light from mirrors at the ends of the tubes combine to form an interference pattern. A change in the

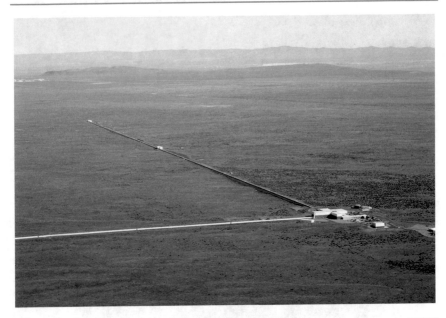

Fig. 5.11 An aerial view of the laser interferometer gravitational-wave observatory (LIGO) detector near Hanford, WA (Courtesy of Caltech/MIT/LIGO Lab)

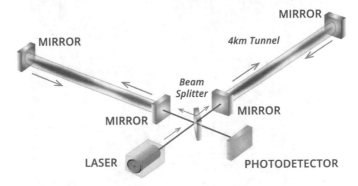

Fig. 5.12 The key components of each of LIGO's L-shaped detectors are a laser, beam splitter, and mirrors at the ends of the two arms

interference pattern formed by the recombined light beams signals the arrival of a gravitational wave.

In 2015, LIGO detected gravitational waves produced by the merging of two black holes over 1.3 billion light-years away from the Earth. Heralded as a breakthrough of monumental scientific importance, these observations validated Einstein's prediction of the existence of gravity waves and ushered in the era of gravitational wave astronomy, a powerful new way of probing the far reaches of the universe.

5.5 Applications of Interference

Antireflection Coatings

Lenses of sophisticated cameras and other optical instruments may combine many lens elements. As light passes through such a lens combination, a considerable amount of light would be lost by reflection at the many lens surfaces. This loss of light can be minimized by coating the lens with a thin layer of a transparent material having an index of refraction between air and glass. If the layer is a quarter-wavelength thick, light reflected at the upper surface of this layer will interfere with the light reflected at the lower surface in such a way as to cancel the reflection. This cancellation will be complete only for a single wavelength, of course, which is usually near the center of the visible spectrum (yellow light). If the coating has the right thickness to cancel out reflection of yellow light, blue light (short wavelength) and red light (long wavelength) will still be reflected, and this is why coated lenses appear to have a purple color. (Examine a high-quality camera to verify this.)

Glass with an antireflection coating is often used to protect paintings. Although it is strictly antireflecting for only one wavelength (color), it is fairly effective in eliminating reflections over the entire visible range.

Multilayer Mirrors

An ordinary mirror, consisting of glass with a coating of aluminum or silver, typically reflects about 90% of the light incident on it. This is certainly enough for most ordinary purposes, but for some applications (such as laser cavities) a higher reflectivity is needed. This is accomplished by using several layers of transparent material with alternating high and low indexes of refraction ($n_H = 2.3$ and $n_L = 1.2$, for example), as shown in Fig. 5.13. Partial reflection occurs at each interface. If the thicknesses are chosen so that all the reflected beams are in phase, it is possible to achieve nearly 100% reflection. For this reason, multilayer mirrors are used in a wide range of applications which require especially high reflectance at a given wavelength.

Many examples of multilayer mirrors can be found in nature. For example, the silvery scales of some fish are made reflective by multiple layers. These mirrors reflect a range of colors by having a variety of layer thicknesses. Another interesting example from the animal world is the tortoise beetle, which has multiple layers in its wing cases, making them iridescent. The beetle can vary the moisture content of these thin films, which changes the thickness and hence the color of the reflected light from gold to reddish copper. Pearls and abalone shells also derive their luster from layers of semi-transparent nacre.

Fig. 5.13 A multilayer mirror with close to 100% reflection uses transparent layers with alternating high and low refractive indexes. The thicknesses of the films are chosen so that all the reflected beams will be in phase

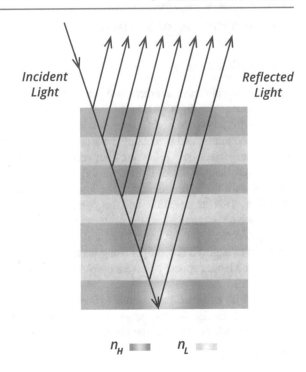

Artists have tried to incorporate interference colors in their work. The great glassmaker Louis Tiffany, for example, incorporated thin films within the glass to produce his iridescent favrile glass. Many contemporary sculptors incorporate multilayer mirrors into their work.

Multilayer Interference Filters

Closely related to multilayer mirrors are multilayer interference filters that pass a narrow range of wavelengths and reflect the rest. Generally, thin coatings of silver or other metal alternate with thin transparent layers. Because they absorb very little light (nearly all the light that is not transmitted is reflected), they are very efficient and are used in color TV cameras, for example, to separate the image into its three primary color components.

Iridescent Inks and Pigments

Iridescence inks, also known as optically variable inks, display two distinct colors depending on the viewing angle. These inks are often used to prevent counterfeiting. Many countries, including the United States, employ these inks to produce markings on currency, such as numerals or designs, which change color as the bill is viewed from different angles. Identifying counterfeit bills and other forged documents is possible because a color copier or scanner can only copy a document at one fixed angle and is unable to capture the color shifting properties of the iridescent inks.

Interference pigments are tiny, transparent mica flakes coated on all sides with a thin layer of either titanium dioxide (TiO_2) or iron oxide (FeO_2). Both oxides are

Fig. 5.14 Pearlescent paints produce stunning effects not possible with conventional pigments (Courtesy of C. J. Wilson)

highly reflective and refractive. Light is refracted and reflected at the boundaries between the metal oxide and mica. The metal oxide layer reflects light twice, from the outer surface and from the boundary with the mica flake. The delay between the first and second reflection phase shifts the light waves. The shift cancels out some wavelengths of light and reinforces others. The reinforced wavelengths appear as the dominant iridescent color.

There are numerous commercial and artistic applications of interference pigments. These include a variety of pearlescent or "metallic" paint formulations used in cosmetics and hard coatings on automobiles, as shown in Fig. 5.14. Artists find that these paints produce effects not possible with conventional pigments. The colors produced by iridescent pigments result in a color shift when the viewing angle changes.

5.6 Diffraction

When waves encounter an obstacle, they tend to bend around it. This is an example of a phenomenon known as *diffraction*. Waves passing through a slit tend to spread out due to diffraction at each boundary, as shown in the ripple tank in Fig. 5.15. The amount of diffraction depends upon the ratio of the wavelength to the slit width. In Fig. 5.15a, the wavelength is substantially smaller than the slit width and

(a) (b)

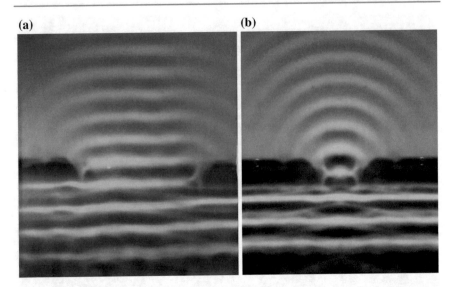

Fig. 5.15 Diffraction of water waves in a ripple tank as they pass through a slit (Photographs by Mark Welter)

little diffraction occurs; in Fig. 5.15b, the wavelength is comparable to the slit width and considerable diffraction occurs.

Like waves in a ripple tank, ocean waves may diffract when they encounter an obstacle, for example, an offshore rock formation, or pass through an opening such as the gap in the breakwater shown in Fig. 5.16. As with all types of waves, the amount of diffraction depends on the ratio of the wavelength to the size of the obstacle or the opening.

If you stand beside an open doorway, you can hear sounds from inside the room but you cannot see into the room. Sound waves have wavelengths comparable to the width of the doorway, and thus they are highly diffracted as they pass through; light waves, however, have wavelengths that are much smaller than the doorway and thus the effects of diffraction are negligible.

In addition to spreading out, waves passing through a slit exhibit another interesting type of behavior, also due to diffraction: dark and bright fringes form on either side of the central bright area. If you look through a narrow slit between your fingers at a light source, especially a bulb with a straight-line filament or a fluorescent tube, you should see alternating bright and dark lines due to diffraction. The narrower you make the slit, the greater will be the spacing between these bright and dark lines.

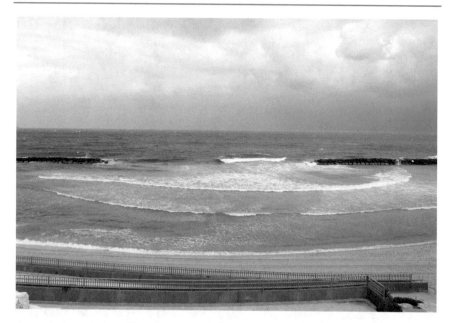

Fig. 5.16 Ocean waves diffract as they pass through an opening in a breakwater (Dmitris1 (https://commons.wikimedia.org/wiki/File:BreakWaterDiffraction_Ashkelon1.jpg), https:// creativecommons.org/licenses/by-sa/4.0/legalcode)

Fringes from Single-Slit Diffraction

One way to try to understand these alternating bright and dark fringes is to envision the slit being divided into eight or ten smaller slits, as shown in Fig. 5.17.

At the position of the first dark fringe, the path traveled by light from imaginary slit 1 is a half-wavelength greater than that traveled by light from slit 5; similarly, the path traveled by light from slit 2 is a half-wavelength greater than light from slit 6, and so on. Thus, light from the imaginary slits cancels in pairs and darkness results. At the first bright fringe, the path differences are a full wavelength, and so light from slit 1 reinforces light from slit 5 and so on. When light having a wavelength λ passes through a slit of width a to a screen a distance L away, the spacing $D(0)$ of the first dark fringe can be calculated from the formula (provided $L \gg a$):

$$D(0)/L = \lambda/a \qquad (5.2)$$

Note the similarity of this formula to formula (5.1), which gave the position of the first bright fringe in an interference pattern, but remember that now we are describing the first dark fringe in a diffraction pattern. From formula (5.2), the total width of the beam (between the dark fringes on either side of the center) is given by $2D(0) = 2\lambda L/a$. Note that the beam gets wider as the slit width a gets narrower.

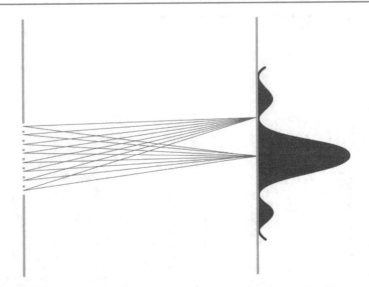

Fig. 5.17 Diffraction of light as it passes through a single slit can be understood by imagining that the slit is divided into eight smaller slits. At a point where the distance from slit 1 is $\lambda/2$ greater than from slit 5, the contributions of these two slits cancel, as do other pairs

▲ Example

Green light falls on a slit 1.00×10^{-4} m wide and produces the first dark fringe 5.5×10^{-3} m from the center of the diffraction pattern on a screen 1.00 m away. Find the wavelength of the green light.

Solution Solving Eq. (5.2) for λ and inserting the given data,

$$D(0)/L = \lambda/a \text{ or } \lambda = aD(0)/L$$
$$\lambda = aD(0)/L = (1 \times 10^{-4}\,\text{m})\,(5.5 \times 10^{-3}\,\text{m})/1\,\text{m} = 5.5 \times 10^{-7}\,\text{m}.$$

The spacing $D(1)$ of the first bright fringe right next to the dark fringe is given by the formula:

$$D(1)/L = 3\lambda/2a. \tag{5.3}$$

To see a two-dimensional diffraction pattern, look at a light source through a piece of woven cloth or a fine mesh screen. The finer the mesh, the greater will be the spread in the diffraction pattern you observe.

Diffraction effects are not only noticed when waves pass through a slit, but when they encounter a barrier, as when an opaque object casts a shadow. Figure 5.18 shows how a bright spot appears at the center of the shadow of a penny due to diffraction of light at the edge. Diffracted light from every point on the edge travels the same distance to the center of the shadow, and thus the waves add up to produce the bright spot.

Fig. 5.18 Diffraction of light by a penny results in a bright spot at the center of the shadow

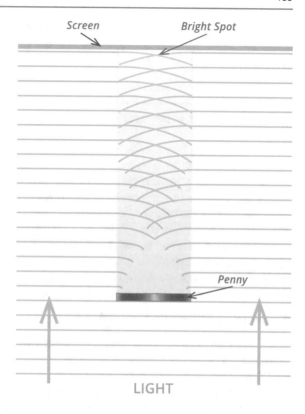

Fig. 5.19 Diffraction effects at the edges of the shadows of **a** a screw and **b** a safety pin (Photographs by Gordon Gore)

The photographs in Fig. 5.19 show the diffraction of light around a screw and a safety pin. Note the different effects around the edges of the objects and at the openings within the safety pin.

5.7 Combined Interference and Diffraction

When light passes through two or more narrow slits, both interference and diffraction effects can be observed. Figure 5.20 illustrates a typical pattern produced by the overlapping phenomena. Diffraction and interference are two different phenomena; try not to confuse them. When water waves pass through two slits, diffraction causes the waves to spread out so that they interfere over a large area. The same thing happens when light passes through a double slit.

Diffraction determines the width of the central bright area. In particular, the width depends on the ratio λ/a, where λ is the wavelength and a is the slit width. When the slits are made narrower, the central bright area expands. The central bright area is pretty much the same whether there is one slit or two slits.

● **Spacing of Fringes from a Double Slit**

When there are two or more slits, interference fringes are observed within the central bright area. The spacing of these bright and dark fringes depends upon the ratio λ/d, where d is the spacing between the slits. When the two slits are made narrower, but remain the same distance apart, the spacing of the interference fringes remains unchanged, but more of them can be seen in the central bright area, of course (see Fig. 5.21).

Fig. 5.20 When light passes through a double slit, both interference and diffraction are observed

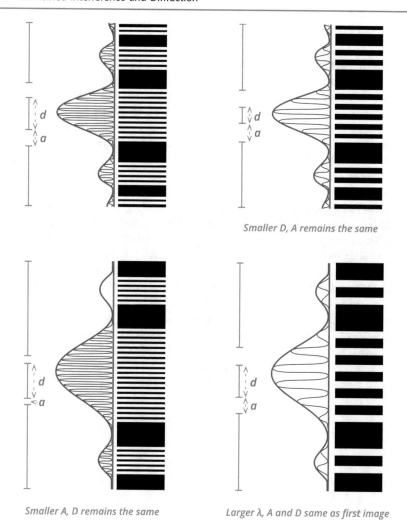

Smaller D, A remains the same

Smaller A, D remains the same *Larger λ, A and D same as first image*

Fig. 5.21 Diffraction determines the width of the central bright region; interference determines how many light and dark lines will appear in this region

Observe that:

1. Changing *a* changes the size of the central bright area.
2. Changing *d* changes the spacing of the interference fringes.
3. Changing λ changes both the size of the central bright area and the spacing of the interference fringe.

5.8 How Diffraction Limits Resolution

If a circular opening is illuminated by light from a point source, the diffraction pattern will be a set of circular fringes. When a lens is used to form an image, the image of each point is actually a small circular diffraction disk; the size of the disk depends upon the diameter of the lens and the wavelength of the light. A larger diameter decreases the size of the disk, while a longer wavelength increases it. In the image formed by a lens, two points will appear to be separate if their diffraction disks do not overlap by more than the radius of the disks, as shown in Fig. 5.22a. In Fig. 5.22b the central maximum of one pattern lies on the first minimum of the other. In Fig. 5.22c the patterns are at the limit of resolution.

You can test the resolution of your eye lens by viewing a piece of paper with two brightly lighted pinholes. As you back away from the paper, at some distance you will no longer see points of light but a single one. Generally, the light coming from two point sources can be resolved if the angle between the objects is greater than 1.22 times the ratio of the wavelength of the light to the diameter of the eye aperture. Using a pupil diameter of 5 mm and a wavelength of 500 nm gives an angular resolution of 1.22×10^{-4} rad or 0.007°. The limit of resolution can be obtained by multiplying the angular resolution (in rad) times the viewing distance. At a distance of 10 km, this suggests that we can resolve two objects that are about 1.22 m apart, so we should just be able to distinguish the two headlights of an oncoming car. At a typical reading distance of 25 cm, the limit of resolution is about 0.03 mm or about the diameter of a human hair.

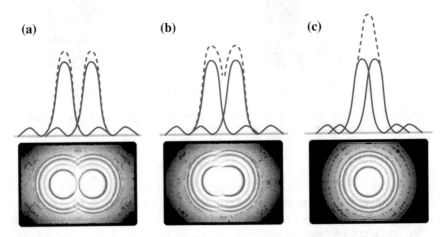

Fig. 5.22 Diffraction patterns due to two pinholes with varying spacing. In **b** and **c**, the holes are so close together that the central peaks in their diffraction patterns overlap

Fig. 5.23 In *A Sunday Afternoon on the Island of La Grande Jatte*, Seurat applied small strokes or dots of color so that, due to limits of resolution, from a distance they blend together (Georges Seurat [Public domain], via Wikimedia Commons)

Georges Seurat and other Pointillist painters depend upon the limits of resolution of the viewers' eyes to blend dots of different colors together into a single color (see Fig. 5.23). The viewer can easily see the individual dots up close, but these blend into a single color as he or she moves away. How close should the dots be in order to blend together at a viewing distance of one meter? Of two meters? (Do you think Seurat calculated this or did he learn it by experiment?).

The face of a television tube is covered with small dots or rectangles of red, blue, and green phosphors. How close must these dots be spaced in order for the colors to blend at a viewing distance of one meter?

The Great Wall of China was the greatest engineering feat of the pre-industrial age. It remains the longest and most massive structure ever built. There are a number of legends about the wall. One is that it is the only man-made structure that can be seen from the Moon. It is easy to show, however, that from the Moon the human eye cannot resolve the ramparts of the wall, even at their widest separation. Since the distance from Earth to the Moon is about 3×10^8 m, the minimum angle needed to resolve the 7-m wide wall is about 1.8×10^{-8} rad. The resolving power of the human eye is about 3×10^{-4} rad, or about 10,000 times too large. In fact, NASA scientists have confirmed that the astronauts on the Moon did *not* see the Great Wall. The only man-made feature on Earth that is visible from the Moon is air pollution.

5.9 Multiple Slits and Gratings

What happens to patterns such as that shown in Fig. 5.20 when more slits are added? Provided that a, d, and λ remain the same, the number and spacing of the bright lines stays the same; the only thing that happens is that they get narrower and considerably brighter as light from more slits constructively interferes. *Diffraction gratings*, having many equally spaced slits, are very useful devices. They can break up light into its spectrum of colors in much the same manner as a prism, only better.

The relationship connecting d, λ, and L for a diffraction grating is the same as for a double slit, namely $D/L = \lambda/d$. For a diffraction grating, d is equal to the reciprocal of the number of slits per centimeter, n: $d = 1/n$.

▲ **Example**

A diffraction grating has 1.0×10^4 slits per centimeter. What is the distance between two slits?

Solution Since d is equal to the reciprocal of the number of slits per centimeter,

$$d = (1\,\text{cm})/(1/10^4) = 1.0 \times 10^{-4}\,\text{cm} = 1.0 \times 10^{-6}\,\text{m}.$$

▲ **Example**

Determine the distance from the center of the interference pattern to the first bright line on a screen 2.5 m from the diffraction grating when red light ($\lambda = 633$ nm) is used to illuminate the grating. Use the distance between two slits found in the previous example.

Solution Substituting the given data into Eq. (5.1) and solving for D,

$$D = (2.5\,\text{m})(6.33 \times 10^{-7}\,\text{m})/(1.0 \times 10^{-6}\,\text{m}) = 1.58\,\text{m}.$$

An observant student viewing a spectrum through a diffraction grating will notice that the colors are *reversed* from the way they appear in the spectrum produced by a prism. Blue light is refracted more than red light, so it is bent through a greater angle by the prism. On the other hand, the angle of deviation by a diffraction grating depends upon λ/d, so red light (which has the greater wavelength λ) is bent through a greater angle.

In addition to transmission gratings, there are also reflection gratings, which are essentially mirrors with tiny parallel lines or grooves. A very nice example of a reflection grating is a compact disc (CD), whose playing surface has concentric circles of pits spaced 1.6 μm (1.6×10^{-6} m) apart (see Chap. 13). White light reflected from the surface of a CD shows a brilliant spectrum of colors, as shown in Fig. 5.24.

Fig. 5.24 Light from a candle flame is broken into a dazzling array of spectral colors by the circles of pits on a CD (Stephanie Fitzpatrick—American Association of Physics Teachers High School Photo Contest)

5.10 Using Diffraction Gratings to Produce 3D Effects

Chromostereoscopy is the name given to the process that produces a stereoscopic effect using high-tech holographic diffraction gratings. The gratings, which may be found in commercially available "ChromaDepth® glasses," purposely exaggerate dispersion. They give the illusion of colors taking up different positions in space, with red being in front and blue being behind. The gratings are specially designed so that 75% or more of the light is diffracted into the first order on one side only. Thus, the grating behaves like a prism with very high dispersion, except that red is dispersed far more than blue. The grating over the left eye diffracts to the right, and that over the right eye to the left, so that a red dot appears to be raised above the page because of the effects of stereoscopic vision. A blue dot is raised much less.

A rather detailed analysis of these gratings is given by Sicking et al. The grating is made up of small steps spaced 30 μm apart that are etched onto the grating. The result is a grating with about ten times the dispersion of a glass prism.

5.11 Photonic Crystals

Photonic crystals are sub-wavelength structures that can be periodic in one, two, or three dimensions. Constructed from semi-transparent materials, the index of refraction of photonic crystals varies periodically. Two types of photonic arrangements are shown in Fig. 5.25. A photonic crystal's periodicity results in what are known as band gaps that prevent the propagation of light within a certain range of wavelengths. Light that is not allowed to pass through a photonic crystal is reflected. In many ways, photonic crystals are the optical counterpart to electrical semiconductors. With semiconductors, the flow of electric charge is controlled; in the case of photonic crystals, it's the propagation of light that's manipulated.

There are numerous examples of naturally occurring photonic crystals. Fashioned from organic materials, they are often responsible for the iridescence and opalescence observed in minerals, flora, and fauna. Prime examples include the photonic structures that produce the brilliance of some gemstones, a notable one being opal.

In opal, an ordered arrangement of silica (SiO_2) spheres results in a periodic variation in refractive index (Fig. 5.26). At each change in refractive index, light is partially reflected and partially transmitted. The light reflected at these discontinuities may result in either constructive or destructive interference depending on wavelength as well as the spacing between spheres. If the reflected light waves combine constructively, the light will be completely reflected and no light will be transmitted.

In the animal kingdom perhaps no creature is more beautiful that the morpho butterfly. The morpho's brilliant coloration, as seen in Fig. 1.5, is due to small photonic structures residing on the scales that cover the insect's wings. On the

(a) **(b)**

Fig. 5.25 Two examples of photonic crystal structure: **a** an array of sub-microscopic holes in a semi-transparent substrate. **b** "Woodpile" stacks of dielectric material (Public domain via Wikimedia Commons)

Fig. 5.26 An opal's brilliance is due to light interacting with an ordered arrangement of silica spheres (TinaImages/Shutterstock.com)

surface of each scale is a Christmas tree-shaped structure whose "branches" are perpendicular to the scale. These sub-microscopic photonic structures are spaced at 220-nm intervals, a spacing conducive to reinforcing 440-nm blue light. When viewed from above, the color of the morpho's wing lies in the blue–green region of the spectrum. As the viewing angle increases, the iridescence shifts toward the

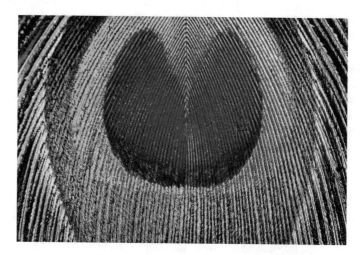

Fig. 5.27 The bright colors exhibited by the "eye" of a peacock feather are produced by tiny, intricate two-dimensional crystal-like structures (iPhoto-Thailand/Shutterstock.com)

violet, ultimately reaching the ultraviolet at a grazing viewing angle. Since the eye is not sensitive to ultraviolet light, all that is seen is the drab brown of the pigment melanin.

Photonic crystals are also the source of the spectacular colors found in the "eye" of the feathers of the male peacock, as shown in Fig. 5.27. The coloration is due to repetitive, two-dimensional structures consisting of air holes in an array of melanin cylinders that cover the feathers.

Potential applications of photonic crystals seem to be unlimited. Indications are that they may one day be key components in solar cells, sensing devices, high-speed communication systems, fiber lasers, optical computer chips, and flat displays.

5.12 Summary

Waves from two identical sources produce maxima and minima due to constructive and destructive interference. Light waves from two narrow slits illuminated by the same source produce alternating bright and dark bands on a screen whose spacing depends on the ratio of the wavelength to the spacing of the two slits. Thin transparent films, such as soap bubbles or oil on water, show patterns of color due to interference between light reflected at the upper and lower surfaces of the film. Newton's rings are an interference pattern formed by a spherical and flat glass surface. Michelson's interferometer splits a light beam with a half-silvered mirror; the two beams travel different paths and interfere when they recombine. Lenses in optical instruments are often coated with a $\lambda/4$ layer to cancel surface reflections by means of interference.

Diffraction, which leads to a spreading out of waves, occurs when light encounters an obstacle or passes through a slit. When light passes through two or more narrow slits, both interference and diffraction effects can often be observed. Diffraction limits the resolution of circular apertures (including our eyes), a phenomenon applied to art by the Pointillist painters.

Photonic crystals are sub-wavelength structures that have the ability to control light in much the same way that semiconductors control electricity. Many examples of photonic crystals can be found in nature. Potential applications of photonic crystals include use in sensing devices, solar cells, high-speed communication systems, fiber lasers, and optical computer chips.

◆ **Review Questions**

1. What is the difference between interference and diffraction?
2. What role does diffraction play in the formation of a two-slit interference pattern?
3. Describe what happens to a two-slit interference pattern as the slits are brought closer together.

4. Describe what happens to a two-slit interference pattern as the slits are made narrower.

5. Describe a two-slit interference pattern made with white light. What color is the central bright fringe? Explain.

6. Why don't we see interference patterns in a room when we turn on two lights of the same color?

7. Radio waves and light waves are both electromagnetic. Why do radio and television signals bend around buildings but light does not?

8. A thin film strongly reflects blue light. Should it be made thicker or thinner to reflect red light?

9. What are Newton's rings and how are they produced? Draw a diagram to explain.

10. Why does a pinhole image get fuzzier when the pinhole gets smaller?

11. Why is a telescope of large diameter said to have a greater resolving power?

12. Explain why a very thin soap film can appear black even when it is illuminated.

13. What causes the spectrum of colors seen in gasoline spilled on a wet street?

▼ Questions for Thought and Discussion

1. If increasing the size of a lens increases its resolving power, why do photographers "stop down" a camera lens to get a sharper picture?

2. How does the limit of resolution of the human eye depend on the brightness of lighting in a room?

3. How does the diffraction pattern from a diffraction grating having many evenly spaced slits differ from that of a double slit?

4. CDs are read with red laser light. By using blue light to read DVDs, the storage capacity is increased. Can you explain why?

5. How does the wavelength of light compare with the size of a human hair? Of an atom?

6. Light of a single wavelength light falls on a diffraction grating. What happens to the interference pattern if the same light falls on a grating that has more lines per centimeter? What happens to the interference pattern if a longer-wavelength light falls on the same grating? Explain how these two effects are consistent in terms of the relationship of wavelength to the distance between slits.

■ Exercises

1. What is the thinnest film that will strongly reflect light having a wavelength of 500 nm in the film?

2. Make a sketch of Newton's rings resulting from white light showing the arrangement of the colors.

3. If the speed of sound is 343 m/s, what is the wavelength of a sound having a frequency of 262 Hz (middle C)? Will it be diffracted appreciably in passing through a doorway?

4. Draw a sketch of a Michelson interferometer. Discuss its operation.
5. White light illuminates two slits spaced 0.2 mm apart. How far from the center will the first red diffraction line occur on a screen 50 cm from the slit? How far from the center will the first blue line occur?
6. Blue light of wavelength 4.8×10^{-7} m passes through a single slit and falls on a screen 1.2 m away. What is the width of the slit if the center of the first dark band is 5.0×10^{-3} m away from the center of the bright central band?
7. A diffraction grating has 1000 lines/cm. How far from the center will the first red line appear on a screen that is 70 cm away?

● **Experiments for Home, Laboratory, and Classroom Demonstration**

Home and Classroom Demonstration

1. **Thin film interference with soap bubbles**. White light reflecting off the front and back surfaces of a soap film can produce beautiful bands of color by interference. A suitable soap solution can be made by mixing one part dish-washing detergent with 15 parts water. Mix in a pan large enough to accept a frame approximately eight inches wide, which can be made from a coat hanger. Bend the hanger into either a circular or square shape. After dipping the frame into the solution, view the soap film with white light shining on the film from behind. Do you see bands of color? What colors do you see in each band? Do the bands repeat? How does the thickness of each band of color compare as you observe them from the top to the bottom of the frame? After the soap solution has moved downward, note that the top of the soap film has become black. Why does this occur?

2. **"Floaters" in the eye**. The fluid inside the eye contains blood cells and cellular debris shed from the lining of the eye. These cells, often referred to as floaters, manifest themselves as little visible spheres and chains that seem to move around randomly inside the eye. What we see are actually diffraction patterns that are projected on the receptor-rich fovea. Floaters may be observed by looking at a bright light through squinting eyes. Looking at a light through a pinhole in a card also works well. Perhaps the best way to see floaters is just to relax and wait for them to appear. The number of floaters seems to increase with age.

3. **Two-slit interference**. Place two razor blades or blades from a utility knife side by side with their cutting edges aligned. Using the blades, cut parallel slits in an overexposed 35-mm slide or a soot-covered microscope slide. The slits should be 1–1.5 cm long. With one eye, look at a light source through the slits (a showcase bulb with a vertical filament works best). Do you see colored fringes? Slowly rotate the slits around an axis between the slits to change the effective distance between the slits and note the effect on the interference pattern. Place a colored filter over the bulb and observe the resulting interference pattern. How is this pattern different from the white light pattern?

4. **Finger slit diffraction**. View a vertical filament (showcase) light bulb through the opening between your index and middle fingers. As you bring your fingers together, you should note that the light spreads out and bright and dark fringes appear. Look closely as you squeeze your fingers together, reducing the width of the slit.

5. **Gift wrap interference filters**. Colorful transparent gift wrap often consists of a sheet of plastic coated with a thin transparent film. Examine a sample of this material. You should observe faint interference colors running along the length of the plastic. Hold the sheet in front of a white light source and note the color of the light transmitted through a certain region. Observe this same region by reflected light. How are the colors of the reflected light and transmitted light related? Why? Repeat this procedure for another region on the sheet.

6. **Resolution of the eye**. Make two small holes about 5 mm apart in a sheet of paper (10–20 mm apart for classroom demonstration) and place a light source behind the card. View the holes up close and gradually move away until the images of the two holes merge into one. This is the limit of resolution of your eye. The angle (in rad) is approximately equal to the distance between the holes divided by the viewing distance; to convert this to degrees, multiply by 57.3 ($180/\pi$). The angular resolution of the eye depends upon pupil size (hence, upon light level in the room), but it should be in the neighborhood of $0.01°$.

7. **Photography through diffraction gratings**. Photograph different scenes through a diffraction grating. Mercury vapor lamps and gas-filled advertising signs are particularly interesting.

8. **Diffraction from a compact disc**. Place a CD on a flat surface with the shiny side facing up. Hold a penlight or white LED directly over the center hole of the CD (2–3 cm above it) so that the reflected image of the light is at the center hole. Note that a circular spectrum similar to the one in Fig. 5.24 is produced. Adjust the distance between the light source and the disc until the red ring is at the edge of the disc. What colors, in addition to red, do you see? Are these colors the same as the ones seen in Fig. 5.24? Explain your observations.

9. **ChromaDepth® glasses**. Draw and color a picture using colored markers. View your picture through the diffraction spectacles and note the 3D effect (see Sect. 5.10).

Laboratory (See Appendix J)

5.1 Diffraction and Interference of Water Waves (Ripple Tank)
5.2 Diffraction Grating
5.3 Diffraction from Tracks of a Compact Disc
5.4 Michelson Interferometer

Glossary of Terms

diffraction The spreading of waves when they pass through an opening or around a barrier.

interference The superposition of two identical waves to create maxima and minima.

Michelson interferometer An instrument that splits a light beam with a half-silvered mirror and creates an interference pattern between the two beams when they recombine after traveling two different paths.

Newton's rings An interference pattern of concentric circles formed by multiple reflections between a flat glass surface and a convex surface.

photonic crystal Three-dimensional, periodic, sub-wavelength structure fashioned from semi-transparent material.

Pointillism A technique used by painters to create colors by partitive (additive) mixing of small dots of paint.

resolution, limit of The ability to separate the images of two objects that are very close to each other. The images can no longer be resolved when their diffraction patterns overlap.

Further Reading

Falk, D. S., Brill, D. R., & Stork, D. G. (1986). *Seeing the Light*. New York: John Wiley & Sons.

Hewitt, P. G. (2014). *Conceptual Physics*, 12th ed. Boston: Pearson.

Kirkpatrick L. D., & Wheeler, G. F. (1995). *Physics: A World View*, 2nd ed. Philadelphia: Saunders College Publishing.

Riley, B. (1995). Colour for the Painter. In T. Lamb and J. Bourriau, eds., *Colour Art and Science*, Cambridge: Cambridge University Press.

Rossing, T. D. (1990). *The Science of Sound*, 2nd ed. Reading, MA: Addison-Wesleys.

Polarized Light

<div style="text-align: right">**6**</div>

If the end of a stretched rope is shaken up and down, as shown in Fig. 2.1, a train of transverse waves will travel down the rope. As the wave progresses, all segments of the rope will be set into vibration in a vertical plane. Similarly, moving the end of the rope side to side, or, for that matter, in any single direction, will produce transverse waves that are *plane polarized.*

Polarization is not restricted to mechanical waves, such as those we excite on a rope. In the late seventeenth century, Christiaan Huygens discovered that light may also be polarized. A physical explanation of the phenomenon was somewhat long in coming, however. A theory based on the transverse nature of light waves, proposed by Robert Hooke in 1757, was verified by Thomas Young in 1817. Longitudinal waves, such as sound, cannot be polarized.

In Sect. 2.11, we learned that light waves are electromagnetic waves. As was noted there, Scottish physicist James Clerk Maxwell theorized that light occupied just a small portion of a much broader electromagnetic spectrum. According to Maxwell, all electromagnetic waves consist of mutually perpendicular electric and magnetic fields, as shown in Fig. 2.20. Heinrich Hertz verified Maxwell's theory with a series of experiments, one of which demonstrated the polarization of electromagnetic waves.

In the light waves that are emitted by common sources, such as light bulbs, candle flames, and even the Sun, the electric and magnetic fields are randomly oriented in the plane perpendicular to the direction of propagation, as shown in Fig. 6.1. Such light is unpolarized. However, it can become polarized through a variety of processes involving the interaction of light with matter. These include selective absorption, reflection, birefringence, and scattering, which we will now discuss.

© Springer Nature Switzerland AG 2019
T. D. Rossing and C. J. Chiaverina, *Light Science*,
https://doi.org/10.1007/978-3-030-27103-9_6

Fig. 6.1 Two
representations of unpolarized
light

6.1 Polarization by Selective Absorption

A *dichroic* material selectively absorbs light with **E**-field (electric field) vibrations
in a certain direction but passes light with **E**-field vibrations perpendicular to this
direction. The mineral tourmaline is an example of a natural dichroic material, but
manufactured Polaroid H-sheets are also dichroic.

To understand selective absorption, consider a rope passing through two sets of
slots or picket fences, as shown in Fig. 6.2. A vertically polarized wave on the rope
easily passes through the vertical slots but is unable to traverse the horizontal slots. If
the polarization plane of the rope is neither horizontal nor vertical, only the horizontal
or vertical component of its vibration will be transmitted, as shown. Similarly, when
unpolarized light passes through a dichroic material, only light with **E**-field vibra-
tions in a certain direction is transmitted, so polarized light emerges.

An ideal polarizer should transmit exactly half of the unpolarized light that is
incident on it and absorb the other half. We can understand this if we think of
unpolarized light as having its **E**-field randomly distributed in all directions per-
pendicular to the direction of propagation. Each vibrating **E**-field can be thought of
as being made up of a component along the axis of polarization of the dichroic
crystal (like the direction of the slots in Fig. 6.2) and a component perpendicular to
them. The components parallel to this axis add up to produce a polarized beam of
light, while the components perpendicular to the axis are absorbed. The intensity of
the polarized beam that emerges will be half as great as that of the unpolarized
beam that entered the polarizer. In real materials, the intensity of the polarized beam
will be a little less than 50% of the unpolarized beam because there is always some

Fig. 6.2 Model of polarization. Vertical vibrations in a rope (**a**) can readily pass through a set of vertical slots, but are blocked by a horizontal set (**b**). Vibrations in an oblique plane (**c**) are partially transmitted, partially blocked

loss in the material (just as window glass transmits slightly less than 100% of the incident light).

We have arbitrarily selected the direction of the **E**-field (electric field) vibrations to designate the polarization direction of the light. We could have just selected as well the **B**-field (magnetic field) vibrations, but it would needlessly complicate things to keep track of both fields. In most physics books, the **E**-field vibration direction is designated as the polarization direction, and the plane of polarization is the plane that includes the **E**-field vibration and the direction of propagation.

The light transmitted by tourmaline has a blue–green color and is therefore unsatisfactory for many applications. In 1852, W. B. Herapath discovered a synthetic polarizing material that transmits all colors about equally. Unfortunately, this material, called *herapathite* (a sulfate of iodoquinine), is a brittle crystalline substance that disintegrates easily.

The search for a durable, high-quality polarizing material continued until 1928 when Edwin Land found that he could embed herapathite crystals in sheets of plastic. In 1938, Land developed a more efficient polarizer called Polaroid H-film, nowadays simply referred to as Polaroid. Polaroid consists of long chains of polyvinyl alcohol molecules aligned on a plastic substrate. When the material is heated and stretched, the molecular chains become conducting.

Electrons may move freely along, but not between, the hydrocarbon chains found in Polaroid. Light with components of the **E**-field vibrations parallel to these molecular chains sets up electric currents in the chains. These currents dissipate energy. Components of the **E**-field perpendicular to the chains produce no electron motion and consequently pass through the material. Thus, only light with its **E**-field vibration at right angles to the molecular chains emerges from the polarizing material, and the axis of polarization of Polaroid is perpendicular to the direction of the molecular chains. An ideal polarizing filter should absorb 50% of the incident light. Actual Polaroid material absorbs slightly more than this.

Fig. 6.3 Crossed and uncrossed Polaroid filters

In Fig. 6.2b, we note that a set of vertical slots followed by a horizontal set would allow no vibrations to pass. Similarly, two Polaroid filters with their polarizing axes "crossed" (i.e., at right angles) will pass no light, as shown in Fig. 6.3. When light passes through two consecutive Polaroid filters, we call the first one the *polarizer* and the second one the *analyzer*. We can control the intensity of transmitted light by rotating either the polarizer or the analyzer.

Law of Malus

The intensity of light transmitted by two consecutive Polaroid filters can be calculated from the law of Malus:

$$I = \frac{1}{2} I_0 \cos^2 \theta, \tag{6.1}$$

where I_0 is the intensity of the light incident on the polarizer and θ is the angle between the polarizing axes of the polarizer and analyzer. Maximum transmission occurs when $\theta = 0$ or $180°$, that is, when the polarizing axes are parallel (since the cosine of 0 is 1 and the cosine of $180°$ is -1); $I = 0$ when the axes are crossed (the cosine of $90°$ or $270°$ is zero).

▲ Example

Unpolarized light passes through two Polaroids whose axes are oriented at $60°$. What percentage of the light transmitted through the first Polaroid (polarizer) will also pass through the analyzer?

Solution Substituting the given data into Eq. (6.1),

$$I = 1/2\, I_0 \cos^2(60°)$$
$$I = 1/2\, I_0 (0.25)$$
$$I/I_0 = 0.125 = 12.5\%$$

Three Polaroid Filters

If a third Polaroid filter is inserted between two crossed Polaroid filters, we note the following interesting effects:

1. If the axis of the third filter lines up with either the polarizer or the analyzer, no change in the transmitted light is noted (other than a slight absorption due to the color of the film). (Just as inserting a third picket fence whose pickets are either vertical or horizontal would have no net effect on the rope in Fig. 6.2b.)
2. If the axis of the third filter is at 45° to those of the crossed polarizer and analyzer, light will now pass through. That is because the light passing through the 45-degree filter is now polarized at 45° (and according to the law of Malus, its intensity is reduced to one-fourth) of I_0. Its intensity is therefore reduced again by one-half as it passes through the analyzer. Thus, the emerging light has one-eighth the intensity of the light originally incident on the polarizer. Careful study of Fig. 6.2c will help to explain this effect.
3. If the third filter is rotated (while the polarizer and analyzer remain crossed), the light intensity will alternate from maximum to minimum each 45° rather than each 90°, as we observed when one of the filters is rotated in the two-filter experiment.

Later, we will see that placing other materials between crossed Polaroid filters leads to some very surprising effects.

6.2 Polarization by Reflection

Light reflected from a nonmetallic surface, such as water, snow, or glass, is generally partially polarized, which means that there are more **E**-field vibrations in a certain direction than perpendicular to that direction. The degree of polarization depends upon the angle of incidence and the nature of the reflector, as we shall see. French physicist Etienne Malus (who also discovered the law that carries his name) serendipitously discovered this while observing reflected sunlight from windows in the Luxembourg Palace (Paris) through a calcite crystal, which acted as an analyzer.

When light is incident on a surface such as glass or water, it is partly reflected and partly refracted, as we learned in Chap. 3. The plane of incidence includes the incident, reflected, and refracted light rays. If the incident light is unpolarized, 50% of its **E**-field vibrations will lie in the plane of incidence and 50% will be perpendicular to this plane. On the surface, atoms are set into vibration by the **E**-field vibrations of the incident light; these vibrating atoms reradiate light, which forms the reflected and refracted rays.

Ordinarily, the reflected light will have slightly more **E**-field vibrations perpendicular to the plane of incidence than in the plane, and the refracted ray will have slightly more **E**-field in the plane of incidence, so both rays will be partially polarized. At a particular angle of incidence, however, such that the reflected and

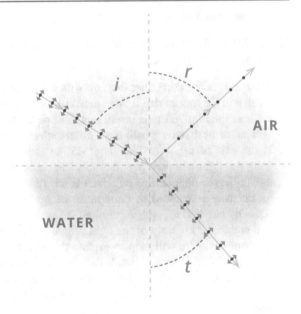

Fig. 6.4 When light is reflected at the Brewster (polarizing) angle, the reflected ray is completely polarized. The component of the E-field perpendicular to the page is represented by dots, the component parallel to the page by arrows

refracted light rays form a 90-degree angle with each other, the reflected light will be fully polarized with its E-field vibrations perpendicular to the plane of incidence, as shown in Fig. 6.4. This angle of incidence is called *Brewster's angle* in honor of David Brewster, who discovered the phenomenon in 1811.

Brewster's angle θ can be found from the relationship

$$\tan \theta = n_2/n_1, \tag{6.2}$$

where n_1 and n_2 are the indices of refraction of the media transmitting the incident and refracted rays, respectively ($n_1 = 1$ if the incident ray is in air).

▲ Example

Determine Brewster's angle for an air/diamond interface ($n_d = 2.42$).

Solution Substituting the given data into Eq. (6.2),

$$\tan \theta = 2.42/1 = 2.42$$
$$\theta = \tan^{-1}(2.42)$$
$$\theta = 67.5°.$$

Applying this relationship to other materials, the Brewster angle is found to be 53° for an air/water interface and 56° for air/glass.

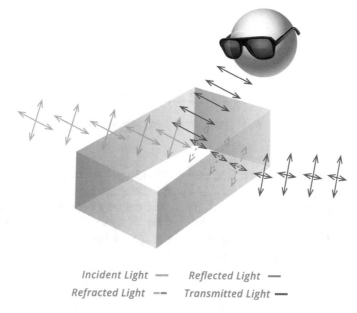

Incident Light — Reflected Light —
Refracted Light -- Transmitted Light —

Fig. 6.5 Reduction of glare with Polaroid sunglasses. Reflected light from a surface is partially polarized in a horizontal plane and is thus attenuated by Polaroid glasses with vertical polarization axes

Note that the index of refraction can be determined by measuring Brewster's angle. This is particularly useful in the case of opaque materials where the transmitted light is strongly absorbed, making the usual Snell's law techniques (Sect. 4.3) quite useless. Polarization by reflection also makes it easy to determine the axis of a Polaroid filter or sheet of polarizing material that is not marked.

Understanding the polarization of light by reflection allows drivers, fishermen, and skiers to reduce the glare from road, water, and snow surfaces by wearing Polaroid sunglasses having their axes of polarization in the vertical direction. The reflected glare, which is at least partially polarized in the horizontal direction, is reduced by the Polaroid sunglasses (see Fig. 6.5).

Polaroid filters are very useful in photography. They can be used to reduce glare or increase the contrast between clouds and sky, for example.

6.3 Polarization by Double Refraction: Birefringence

In isotropic media, such as glass and water, the speed of light is the same in all directions, and each medium has a single index of refraction. Anisotropic crystals, such as calcite and quartz, on the other hand, have two indices of refraction. They are said to be *doubly refracting* or *birefringent*. The Danish scientist Bartholinus is credited with discovering the phenomenon of double refraction in 1670.

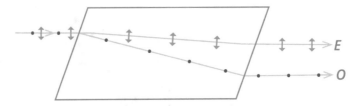

Fig. 6.6 Double refraction in a calcite crystal separates the unpolarized light into two plane-polarized components

When a ray of unpolarized light enters a birefringent crystal, it divides into two rays: an ordinary ray and an extraordinary ray. These rays have different speeds and are polarized at right angles to each other. The ordinary ray refracts according to Snell's law (Sect. 4.3), but the extraordinary ray follows a different path, as shown in Fig. 6.6. Only when light travels along a special path, the *optic axis* of the crystal, do the rays remain together.

Fig. 6.7 Double refraction in calcite (Courtesy of Kodansha, Ltd.)

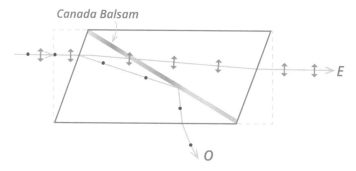

Fig. 6.8 Nicol prism

Two rays generally emerge from a birefringent crystal, giving rise to a double image, as shown in Fig. 6.7. Using a Polaroid analyzer, either ray can be extinguished while the other remains visible, verifying the unique polarization of each ray.

Prior to the invention of Polaroid sheets, calcite crystals were the principal means for obtaining polarized light in the laboratory. A *Nicol prism* is formed by joining two halves of a calcite crystal with Canada balsam adhesive, as shown in Fig. 6.8.

Light entering the prism is split into ordinary and extraordinary rays, as indicated in Fig. 6.8. The index of refraction of Canada balsam ($n = 1.530$) is between the two indices of calcite (1.658 for the ordinary ray and 1.486 for the extraordinary ray). The ordinary ray arrives at the interface with an angle greater than the critical angle (see Sect. 4.5) and is totally internally reflected; the extraordinary ray is transmitted. Both emerging rays are polarized. Polarizing prisms in optical instruments work on this same general principle.

6.4 Polarization by Scattering

Gas molecules in Earth's atmosphere scatter sunlight in all directions. This scattering is responsible for blue skies, red sunsets, and atmospheric polarization.

In 1871, Lord Rayleigh showed that the amount of light scattered depends on the size of the scattering molecules and the wavelength of light. In fact, the intensity of the scattered light is proportional to $1/\lambda^4$, where λ is the wavelength of the light. Shorter wavelengths, such as blue and violet, are scattered more effectively than longer wavelengths, such as red and orange; this is why the sky appears blue. At sunrise and sunset, the Sun's light travels near the surface of Earth, and therefore through a longer atmospheric path, and encounters more scatterers. This increases the amount of blue light that gets scattered from the initially white sunlight, leaving the familiar reddish light of sunrises and sunsets.

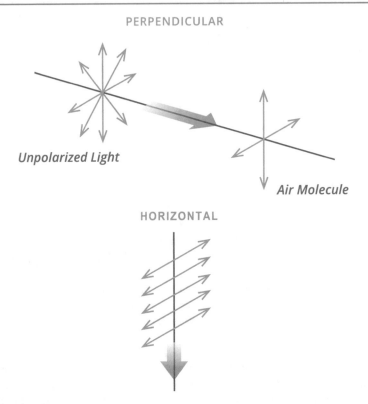

Fig. 6.9 Scattered sunlight will be polarized perpendicular to its direction of propagation. Downward scattered light will be polarized horizontally

Rayleigh scattering is also responsible for atmospheric polarization. When sunlight interacts with gas molecules, its **E**-field causes the molecules to vibrate and reradiate light that travels at right angles to the direction of propagation of the sunlight. Since the sunlight has no **E**-field in its direction of propagation, neither will the scattered light. The light that scatters to the side will be polarized vertically, while the light that scatters downward will be polarized horizontally, as shown in Fig. 6.9. An observer on the ground will see horizontally polarized light, as can be verified by viewing the sky through a Polaroid filter.

Some animals are capable of detecting polarized light. Nobel laureate Karl von Frisch demonstrated that bees use polarized light in navigation. Ants, fruit flies, and some fish also are known to be sensitive to polarized light.

In 1844, Wilhelm Karl von Haidinger suggested that at least some humans are sensitive to polarized light. A phenomenon called *Haidinger's brush* can be seen by some individuals as they stare at a blue sky in a direction perpendicular to the Sun. Observers sensitive to polarized light report a yellowish horizontal line superimposed on a field of blue.

Naturally occurring dichroic crystals called *macula lutea* are credited with a person's ability to detect polarized light. The yellow associated with Haidinger's brush results from the preferential absorption of blue light by the yellow pigment in the macula lutea.

6.5 Wave Plates

Wave plates or *retarders* are an interesting application of birefringence. Suppose that a calcite or other birefringent crystal is cut into a thin plate in such a way that the optic axis is parallel to the surface. If the E-field vibration of an incident light wave has components both parallel and perpendicular to the optic axis, then two separate waves will follow the same path through the plate but at different speeds. Thus they will get out of phase with each other (one of them is retarded compared to the other).

If the plate is the right thickness, it is possible for the slow wave to get 180° out of phase with the fast wave, which results in a rotation of the plane of polarization. Such a plate is called a *half-wave plate*, because 180° of phase shift is equivalent to a half-wavelength. Without going into detail, we will simply state that if the plane of polarization initially makes an angle θ with the fast axis, upon emerging it will have rotated through an angle 2θ.

A plate that is only thick enough for the slow wave to lag 90° behind the fast wave in phase is called a *quarter-wave plate.* Plane polarized light entering a quarter-wave plate emerges as elliptically polarized light and vice versa. Elliptically polarized light can be described by saying that the E-field vibration rotates as the light travels through space.

A special case of elliptically polarized light is circularly polarized light. Circularly polarized light is produced when plane polarized light is incident on a quarter-wave plate at an angle of 45° with respect to the fast and slow axes, as shown in Fig. 6.10. Composed of two waves of equal amplitude, differing in phase by 90°, the resulting E-field rotates in a circle around the direction of propagation, tracing a corkscrew path through space. If the E-field vibration of the light coming toward the observer is rotating counterclockwise, the light is said to be right-handed circular polarized. If the rotation is clockwise, the light is left-handed circularly polarized.

It is clear that if a half-wave plate or a quarter-wave plate is inserted between two crossed polarizers, cancellation of the light will no longer occur. Since a plate of a given thickness can act as a half-wave plate for only one wavelength (color) of light, inserting such a plate between crossed polarizers will produce light of that color. A plate whose thickness varies from place to place will show different colors. Many plastics are birefringent, and thus plastic objects act as retarders, displaying color when viewed between crossed polarizing filters.

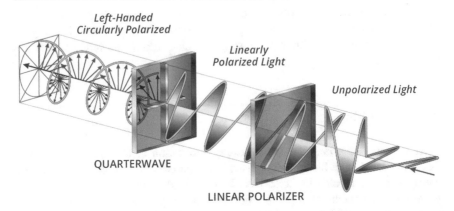

Fig. 6.10 Circularly polarized light is produced when plane polarized light, produced by a linear polarizer, is incident on a quarter-wave plate at an angle of 45° with respect to the fast and slow axes (Fouad A. Saad/Shutterstock.com)

Cellophane tape is also birefringent, so it is possible to create rather dramatic effects by applying multiple layers of cellophane tape to a glass plate so that the tape thickness varies, and then placing the plate between two crossed polarizers. Furthermore, the colors can be changed dramatically by rotating one of the polarizers. Several museums display large panels with vivid colors created in this manner (see Sect. 6.8).

A crumpled sheet of cellophane between two Polaroids will show a profusion of multicolored regions that vary in hue as one of the Polaroids is rotated. These *interference colors*, as they are generally called, arise from the wavelength dependence of the retardation. Interference colors can also be observed by placing such materials as mica insulators, ice, or a stretched plastic bag between the Polaroids.

6.6 Photoelasticity

In 1816 Sir David Brewster discovered that some materials become birefringent under stress. This phenomenon is called *photoelasticity* or *stress birefringence*. The effective optic axis is in the direction of the stress, and the induced birefringence is proportional to the stress. As shown in Fig. 6.11, you can observe photoelasticity by placing objects such as plastic forks, knives, and spoons between two crossed Polaroids.

Engineers make extensive use of photoelasticity to determine stress in bridges, buildings, and other structures. A scale model is constructed of some transparent photoelastic material such as plexiglass. This scale model is stressed as it is viewed between crossed Polaroids, so that lines of stress become apparent. Stress lines in molded glass for automobile windshields can likewise be made visible.

Fig. 6.11 Plastic spoons, knives, and forks exhibit stress birefringence when placed between crossed Polaroids (Carly Sobecki—American Association of Physics Teachers High School Photo Contest)

For many years, architects, art historians, and scientists debated whether the upper flying buttresses and pinnacles of Europe's Gothic cathedrals were decorative or functional. Princeton professor Robert Mark used photoelasticity to clarify the

Fig. 6.12 Photoelastic model cross section of flying buttresses showing stress (Courtesy of Robert Mark)

problem by building models of sections of the Amiens, Chartres, and Bourges cathedrals from epoxy plastic. The plastic was heated under load to permit deformation, and cooled back to room temperature. When observed between crossed polarizers, the "frozen" stress patterns in the models provided the desired evidence: the flying buttresses and pinnacles were indeed crucial in guaranteeing the integrity of the Gothic structures in high winds, as shown in Fig. 6.12.

6.7 Optical Activity

Certain materials are capable of rotating the plane of polarization. Such materials, said to be *optically active*, include sugar solutions, corn syrup, turpentine, aniline, amino acids, and some crystals. The rotation per unit length of travel is generally measured by placing a sample between a polarizer and an analyzer in a polariscope.

Optical activity was first observed by Dominique Arago in 1811 when he observed that polarized light underwent a continuous rotation as it propagated along the optic axis in quartz. Another French physicist, Jean Baptiste Biot, observed the same effect in liquids such as turpentine, and he observed that some substances rotated the plane of polarization clockwise while others rotated it counterclockwise. Materials that rotate the plane of polarization clockwise are called *dextrorotatory* (or *d*-rotatory) while materials that rotate it counterclockwise are called *levorotatory* (or *l*-rotatory). (*Dextro* and *levo* are the Latin designations for right and left, respectively.) In 1822, Sir John Herschel recognized that *d*-rotatory and *l*-rotatory behavior in quartz resulted from two different crystallographic structures or arrangements of the SiO_2 molecules.

Optical activity can be described phenomenologically by thinking of linearly polarized light as being composed of two circularly polarized beams rotating in opposite directions. These two beams propagate at different speeds, and thus they recombine to give linearly polarized light with a different plane of polarization than it had when it entered. This simple description was first proposed by Fresnel in 1825.

Two or more compounds with the same molecular formula but different properties are called *isomers*. Molecules that are mirror images of each other are called *optical isomers*. (Your right hand could be considered an optical isomer of your left.) Optical isomers rotate polarized light in opposite directions.

When organic molecules are synthesized in the laboratory, an equal number of *d*- and *l*-isomers are generally produced with the result that the compound is optically inactive. However, this is not the case in natural organic substances. The natural sugar sucrose is always *d*-rotatory, as is the simple sugar dextrose or *d*-glucose, which is the most important carbohydrate in human metabolism. Evidently living things can somehow distinguish between optical isomers.

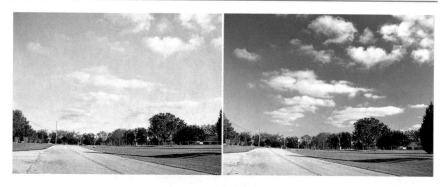

Fig. 6.13 A composite of two photographs, one with a polarizing filter (on the right) and the other without. Note how the filter accentuates the clouds and produces more saturated colors (PiccoloNamek (https://commons.wikimedia.org/wiki/File:CircularPolarizer.jpg), "CircularPolarizer", https://creativecommons.org/licenses/by-sa/3.0/legalcode)

6.8 Applications of Polarized Light in Art

▲ Photography

Photographers frequently make use of polarized light. Air molecules polarize light more effectively than do the larger water molecules and dust particles found in clouds. A photographer may take advantage of this differential polarization by placing a polarizing filter over the camera lens to accentuate clouds in a photograph, as seen in Fig. 6.13. Similarly, glare may be reduced through the use of polarizing filters.

▲ Tape Art

The birefringent nature of cellophane tape makes it possible to produce beautiful art from an otherwise colorless transparent material. In 1967, realizing the artistic potential of birefringence, artist Austine Wood Comarow invented Polage® Art, a name she derived from "polarize" and "collage."

Austine creates her stunning art by placing a drawing under a sheet of glass beneath which she positions polarizing material. She then cuts cellophane shapes that follow the lines of her drawing. To produce a desired color, she may use multiple layers, some at varying angles to each other. Since cellophane contains no pigments, the collage appears colorless to the unaided eye (see Fig. 6.14). This necessitates the wearing of polarizing sunglasses during the creation process. When ready for display, Austine places a second polarizing sheet, the analyzer, on top of the finished design, which, as almost by magic, reveals previously invisible shapes and colors.

Austine often animates her art with the use of a motorized analyzer. The effect of a rotating polarizer is seen in Fig. 6.15, which reveals three stages of the transformation of her appropriately titled *Hidden Treasure*.

Fig. 6.14 A collage consisting of pieces of cellophane appears colorless to the unaided eye (Courtesy of Austine Wood Comarow)

Fig. 6.15 A rotating analyzer produces a continuous flow of imagery in Austine Wood Comarow's Polage *Hidden Treasure*. Comarow's creations are on display in museums, science centers, offices, and homes all over the world (Courtesy of Austine Wood Comarow)

Austine's work has been displayed in numerous museum installations and is found in corporate collections worldwide. A sample of her extensive portfolio may be viewed at https://www.austine.com/polage-art-grid. After seeing her amazing creations, you may wish to try your hand at producing your own tape art. To learn how, see "Transparent tape art" in "Home and Classroom Demonstration."

▲ 3D Movies

The use of polarization in the production of three-dimensional (3D) effects in movies has evolved over the years. Early on, two cameras were used to record the action from slightly different perspectives. When the movie was shown, two projectors, each equipped with polarizing filters, were used. As is shown in Fig. 6.16,

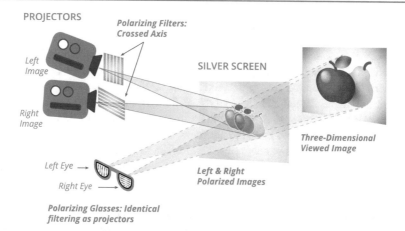

Fig. 6.16 At one time, three-dimensional (3D) movies employed linearly polarized light to produce a sense of depth

the filters' axes of polarization were at right angles to each other. A metallic screen was used so as not to alter the polarization of the projected images (as the glass beads of an ordinary projection screen would do).

The movie was viewed through polarizing filters whose axes of polarization were aligned to match those of the filters on the projectors. This insured that only one image was seen by each eye. A sense of depth was created in the brain as it combined these distinct images.

A disadvantage of using linear polarization is the requirement that the viewer's head remain level. Tilting the head sideways results in "ghost images," a bleeding together of left and right channel images. Furthermore, the alignment and synchronization of two projectors must be addressed.

Using circularly polarized light, modern technology offers a solution to both of these problems. Instead of using two projectors, the current system uses a single digital video projector that alternately projects right-eye and left-eye frames 144 times per second. Acting as a quarter-wave plate, a liquid crystal modulating device located in front of the projector circularly polarizes each frame in step with the projector. Frames intended for the right eye are circularly polarized in a clockwise direction, and vice versa.

Viewing is done with glasses whose lenses consist of a quarter-wave plate and a linear polarizer. The lenses are oppositely polarized so that each eye sees a different image. As with a projection and viewing system based on linear polarization, a metallic screen is used to maintain light polarization.

6.9 Summary

Transverse waves that vibrate in a single plane are said to be plane polarized. Light is polarized if the electric field (**E**-field) vibrations lie in a single plane. Light may be polarized by selective absorption, reflection, birefringence, and scattering.

Dichroic materials transmit light whose **E**-field vibrations are in one plane, but they absorb light whose **E**-field vibrations are perpendicular to this plane. Light reflected from smooth nonmetallic surfaces will be partially polarized, but at Brewster's angle it is completely polarized. Reflected glare from water and snow is greatly reduced when viewed through Polaroid sunglasses whose axes of transmission are oriented vertically. Doubly refracting or birefringent crystals, such as calcite and quartz, split an incident light ray into an ordinary and an extraordinary ray. These rays have different speeds and are polarized at right angles to each other. Light becomes polarized when it is scattered by molecules in our atmosphere, which can be observed by viewing the sky through a Polaroid filter.

Half-wave plates of birefringent material rotate the plane of polarization by delaying light with one plane of polarization more than the other. Quarter-wave plates convert plane polarized light to elliptically polarized light or vice versa. Inserting a half-wave plate between two crossed Polaroids produces interference colors.

Photoelastic materials become birefringent under applied stress. Scale models of structures, constructed from photoelastic materials, can be used to make stress lines visible. Optically active materials rotate the plane of polarization, either clockwise (dextrarotatary) or counterclockwise (levorotatory) as light passes through. Naturally occurring organic molecules, such as sugars, are generally dextrorotatory.

Applications of polarized light to art include photographic filters, 3D movies, and birefringent art.

◆ **Review Questions**

1. What is the difference between polarized light and unpolarized light?
2. Can sound waves be polarized? Explain your answer.
3. Describe four processes that may be used to polarize light.
4. Explain how a Polaroid filter works.
5. What is Brewster's angle?
6. How large is Brewster's angle for an air/water interface?
7. How does the transmitted light intensity compare to the incident light intensity when two ideal Polaroid filters have their axes (a) parallel and (b) perpendicular to each other?
8. When the Sun is in the east, would you expect to find the sky overhead polarized in the east–west direction or the north–south direction? Why?
9. Describe an experimental procedure that could be used to find the index of refraction of a nonmetallic material using a light source and a Polaroid filter.
10. Explain how a Polaroid filter placed over a camera lens increases the contrast between the clouds and sky.

11. What is photoelasticity? How is it used to study stress in structures?
12. Will Polaroid sunglasses reduce glare when worn upside down?
13. What is elliptically polarized light?
14. What are the disadvantages of using linearly polarized light in the production and projection of 3D movies?

▼ **Questions for Thought and Discussion**

1. When Polaroid sunglasses were first made commercially available, a small card with a transparent window in the center was attached. Prospective customers were told to rotate the card in front of either lens while wearing the glasses to ensure that they were buying Polaroid lenses, not just tinted glass. What do you suppose was observed? How did this procedure insure authenticity?
2. Explain how bees make use of polarization to navigate.
3. A piece of Polaroid material is inserted between two crossed polarizers so that its axis makes a 45° angle with theirs. What will be seen? Explain your answer.
4. Explain how a food chemist uses polarized light to determine the concentration of a sugar solution.
5. Describe how the direction of polarization of an unmarked Polaroid filter can be determined experimentally.

■ **Exercises**

1. Determine Brewster's angle for glycerin ($n = 1.47$).
2. Light reflected from the surface of a certain material is found to be completely polarized when the angle of incidence is 59°. What is the index of refraction of this material?
3. Unpolarized light passes through two Polaroids whose axes are oriented at 30°. What percentage of the light transmitted through the first Polaroid (polarizer) will also pass through the analyzer?
4. Determine the angle between transmission axes of two Polaroid filters that will produce an I/I_0 ratio equal to 0.25.

● **Experiments for Home, Laboratory, and Classroom Demonstration**

Home and Classroom Demonstration

1. **Polarization by reflection**. View light reflected from a highly polished floor, tabletop, blackboard, or puddle of water (sometimes referred to as *glare*) through a polarizing filter. Rotate the filter until the maximum amount of light is transmitted. Now rotate the filter through 90°. What happens to the intensity of the light as you rotate the filter? Why does this occur? Vary the angle of incidence by looking at light reflected at various distances away from you. At what angle of incidence does the greatest effect occur?

Use the filter to look at reflections from a variety of objects in your environment. What happens when you use the filter to view light reflected from a metallic surface such as a mirror? Does rotating the filter have any effect on the light intensity? What does this say about the light reflected from metallic surfaces? What happens when you try to use your filter to reduce the glare from the painted body of an automobile? Is this consistent with what you have learned about reflections from metals?

2. **Birefringence**. Birefringent materials such as calcite and quartz separate light into two components that possess mutually perpendicular polarizations. When stressed, plastic and glass may become birefringent. Viewed between Polaroid filters, the birefringence reveals itself as colored contours. Place a plastic object such as a tape cassette box, cellophane tape dispenser, protractor, or clear plastic fork between two Polaroid filters to make the stress lines visible. Colored patterns, revealing stresses introduced during the molding process, should be clearly visible. The stress lines in a clear plastic fork can be altered by squeezing the tines of the fork together.

3. **Polarized rainbow light**. Examine a rainbow with a Polaroid filter. For one orientation of the filter, the rainbow will be quite bright; rotating the filter will substantially reduce its intensity. This polarization is due to the reflection of light at the back of each raindrop.

4. **Polarization and liquid crystal displays**. Liquid crystal displays (LCDs) are commonplace. They are used in calculators, watches, instrument panels, and laptop computer screens. Do these devices produce their own light? To find out, observe a functioning display in a dark room. Based on your observation, what do you believe is an LCD's source of light? Now view an LCD through a Polaroid filter. What do you observe as you slowly rotate the filter? What does this tell you about the light from the display? In broad terms, how do you think an LCD works?

5. **Laptop computer display as a source of polarized light**. Dim the LCD display on a laptop computer until the screen becomes uniformly illuminated. At this point, graphics should no longer be visible. Slowly rotate a Polaroid filter between your eye and the screen. What do you observe? Now place a sample of birefringent material, such as clear plastic, quartz, or mica, between the screen and the filter. What do you see? Rotate the filter and observe the appearance of the sample. Wearing a pair of Polaroid glasses will facilitate the handling of samples.

6. **Transparent tape art**. By using pieces of transparent tape, such as clear packing tape or cellophane tape, and a pair of polarizing filters, you can create beautiful colored designs similar to Austine Wood Comarow's Polage. An acetate sheet, petri dish, or a glass plate can serve as your "canvas." Like any artistic creation, the designs you produce are limited only by your imagination. Detailed instructions for creating tape art may be found in Activity 8, Experiment 6.1.

7. **Viewing skylight**. View a portion of a clear blue sky through a polarizing filter, and note what happens as you rotate it. **Do not look directly at the Sun!** Look at other portions of the sky and note the change in brightness you can accomplish in different directions. In which direction is the sky most strongly polarized?

8. **Wax paper**. Slide a sheet of wax paper between two crossed polarizers and record what you observe. Check for evidence that the direction of polarization has changed.

9. **Corn syrup**. Put some colorless corn syrup in a beaker and place the beaker between crossed polarizers with a light source in line with them. Rotate one polarizer and carefully note what happens. If possible, try it with different depths of corn syrup.

10. **Photography with Polaroid filters**. Photograph scenes with and without a Polaroid filter in front of the camera lens and compare them. Some suggested scenes: glare of sunlight on water and pavement; reflection of an overhead light from a polished floor (at different angles of incidence) ; clouds against a blue sky, looking north, south, east, and west.

11. **Edible birefringents**. Home and Classroom Demonstration Experiment 8 in Chap. 4 showed how to make edible lenses, prisms, and light pipes from unflavored gelatin. If you examine gelatin between two polarizers, you will notice that it is birefringent—not surprising, given the long chain molecular structure of gelatin. Furthermore, it is photoelastic. Try bending and squeezing a gelatin strip to see color patterns resulting from stress-induced birefringence.

Laboratory (See Appendix J)

6.1 Exploring Polarized Light

Glossary of Terms

analyzer A polarizer used to analyze polarized light or the second of two polarizers used to control the intensity of transmitted light.

birefringence Splitting of light into two rays by anisotropic materials having two indices of refraction. Double refraction.

circularly polarized light Light composed of two waves of equal amplitude, differing in phase by 90°.

Brewster's angle Angle of incidence (or reflection) for which the reflected light is totally polarized.

dichroic Materials that absorb light whose **E**-field vibrations are in a certain direction.

elliptically polarized light Light with an **E**-field vibration that rotates as the light travels through space.

half-wave plate Birefringent material of the right thickness to retard one ray 180° with respect to the other so that the plane of polarization is rotated.

Malus's law Intensity of polarized light transmitted through an analyzer is the incident intensity times $\cos^2 \theta$, where θ is the angle between the axes of the polarizer and analyzer.

Nicol prism A calcite prism used to produce or analyze polarized light. Two halves of a calcite crystal are cemented together with Canada balsam.

optical activity Rotation of the plane of polarization of transmitted light (clockwise in some materials, counterclockwise in others).

photoelasticity Some materials become birefringent under stress.

plane polarized waves Transverse waves (such as light) with vibrations oriented in one plane.

polarizer Used to polarize light, or the first of two polarizing filters used to control light intensity.

Polaroid Synthetic polarizing material developed by Edwin Land that consists of long chains of molecules that absorb light polarized in a certain plane.

quarter-wave plate Birefringent material of the right thickness to retard the phase of one ray by 90° with respect to the other so that plane polarized light is changed to elliptical and vice versa.

Rayleigh scattering Atmospheric scattering of sunlight, which depends on the size of the scattering molecules and the wavelength of the light.

wave plate or retarder A thin plate of a birefringent material with the optic axis parallel to the surface so that it transmits waves having their **E**-fields parallel and perpendicular to the optic axis at different speeds.

Further Reading

Falk, D. S., Brill, D. R., & Stork, D. G. (1986). *Seeing the Light*. New York: John Wiley & Sons.

Hewitt, P. G. (2015). *Conceptual Physics*, 12th ed. Boston: Pearson.

Jewett, J. W. (1994). *Physics Begins with an M ... Mysteries, Magic and Myth*. Boston: Allyn and Bacon.

Light Sources and the Particle Nature of Light

<div style="text-align: right">7</div>

The more important fundamental laws and facts of physical science have all been discovered, and these are now so firmly established that the possibility of their ever being supplanted in consequence of new discoveries is exceedingly remote.

—Albert A. Michelson

7.1 Unsettling Discoveries

As the nineteenth century was coming to a close, Newtonian mechanics could explain and predict the motion of objects ranging in size from pebbles to planets while Maxwell's theory of electromagnetism unified electricity, magnetism, and optical phenomena. Kinetic molecular theory provided an explanation of the behavior of gases, successfully linking the microscopic and macroscopic worlds. For these reasons, and others, many scientists felt that the end of physics was near. In the words of Sir William Thomson: "There is nothing new to be discovered in physics now. All that remains is more and more precise measurement."

That view would be short-lived, for in 1895 W.K. Rontgen produced a form of invisible radiation, today known as X-rays, capable of penetrating the human body and affecting a photographic plate. Shortly thereafter, Henri Becquerel discovered naturally occurring radioactivity emanating from uranium salts. Just a few months later, J.J. Thompson observed evidence for the electron, the first known subatomic particle. And then there were the lingering problems regarding the transmission of electromagnetic waves through the void of space and discrete nature of light emitted by atoms.

Not only was classical physics unable to explain these discoveries and enigmas, it was also incapable of explaining a rather vexing problem involving thermal radiation, namely, how to explain the spectrum of electromagnetic radiation emitted from a hot object.

© Springer Nature Switzerland AG 2019
T. D. Rossing and C. J. Chiaverina, *Light Science*,
https://doi.org/10.1007/978-3-030-27103-9_7

Few expected that the solution to these problems would give birth to a new physics. However, the period that started with the late 1800s and extended through the 1920s produced such an upheaval in how the physical world was perceived that it has been referred to as 30 years that shook physics.

The radical new paradigm that resulted from a solution to the thermal radiation problem became known as quantum physics. What made the tenets of this "modern physics," as it is often called, initially hard to accept was its central premise that light, and all other forms of electromagnetic energy, comes in the form of particle-like bundles, or quanta, rather than in continuous waves. This flew in the face of everything that was known about light at the time. It took two famous scientists, Max Planck and Albert Einstein, to provide irrefutable evidence in support of the quantum hypothesis.

7.2 Blackbody Radiation

A closed box with a small hole in it and a glowing filament in an incandescent light bulb each approximate an object known as a *blackbody*. A blackbody is an ideal absorber of light; all radiation falling on a blackbody, irrespective of wavelength or angle of incidence, is absorbed. A blackbody is also an ideal emitter. No object at the same temperature can emit more radiation at any wavelength than a blackbody. One of the rather remarkable features of blackbody radiation is that the blackbody spectrum depends only on the temperature of the object, and not on what it is made of.

The spectral distribution of power emitted by blackbodies at several temperatures is shown in Fig. 7.1. Note that only a portion of the emitted power lies within the visible spectrum, which extends from about 400 to 700 nm (0.4–0.7 μm).

Blackbody behavior is approached, in practice, by blackened surfaces and by small apertures in cavities, as shown in Fig. 7.2. This is true regardless of whether the interior is black or white. Another good example of this is the human eye; the pupil looks black because most light entering it is trapped and absorbed (An exception is light from a photographic flashlamp that is reflected by the retina so that it exits the pupil and results in "red eye" on the photograph.). The surface of sharp edges of a stack of razor blades pretty well approximates a blackbody, interestingly enough, because the array of blade edges effectively traps incident light, resulting in almost complete absorption.

A newly developed material called Vantablack, "Vanta" being an acronym for "vertically aligned nanotube array," is the closest thing to a blackbody on Earth. A Vantablack sample is shown in Fig. 7.3. Developed by Britain's Surrey NanoSystems, Vantablack absorbs virtually all the light incident upon it, 99.965 percent to be precise. Consisting of a microscopic forest of densely packed, extremely thin rods of carbon, the ultra-absorbent material reflects only a tiny

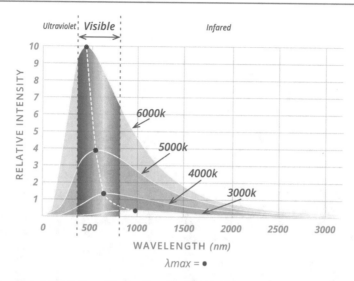

Fig. 7.1 Spectral distribution of light radiated by blackbodies at several temperatures. Raising the temperature shifts the maximum to shorter wavelength (to the left). Visible range is shown in color

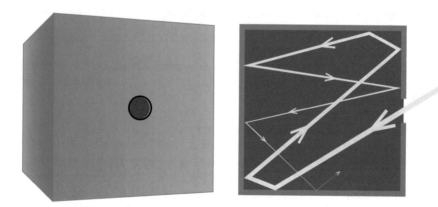

Fig. 7.2 The black hole in the box's center suggests that the inside of the box is black; however, it can be any color. Light entering the box is absorbed before it can leave through the hole

fraction of the light that strikes it. The remainder of the light bounces back and forth between the nanotubes' vertical surfaces, ultimately being converted into thermal energy.

Additional interesting facts about blackbody radiation are:

1. The total radiation (represented by the area under the spectral distribution curve) is proportional to the fourth power of the absolute temperature.

Fig. 7.3 Experiencing Vantablack has been likened to looking into a black hole (Courtesy of Surrey Nanosystems)

2. The wavelength at which the peak in each spectral distribution curve occurs (indicated by the dashed line in Fig. 7.1) is inversely proportional to the absolute temperature.

The first fact about blackbody radiation in the preceding list is usually expressed mathematically by the Stefan–Boltzmann law: $E = \sigma T^4$, where $\sigma = 5.67 \times 10^{-8}$ W/m^2K^4 is the Stefan–Boltzmann constant and T is the temperature of an object in degrees above absolute zero. In describing light sources, as in many areas of physics, it is logical to use the *absolute temperature scale*, in which temperature is expressed in *kelvins* (K) or degrees above absolute zero. On the absolute scale, which uses the same size of degrees as the Celsius scale, the freezing point of water is 273 K and the boiling point of water is 373 K (as compared to 0 and 100 degrees on the Celsius scale). Room temperature is about 300 K, the filament of an incandescent light bulb is about 2700 K, and the surface of the Sun is about 6000 K. The conversion from Celsius to absolute temperature merely requires adding 273 (273.16, to be exact).

It should be noted that the radiation from real (nonideal) surfaces, always less than from a blackbody, can be described by their *emissivity* ϵ, which is the ratio of the radiant power E to that of a blackbody E_{bb} at the same temperature: $\epsilon(T) = E/E_{bb}$. The emissivity of the tungsten wire filament in a light bulb, for example, is about 0.4–0.5. The *color temperature* of a light source is the temperature of the blackbody with the closest spectral power distribution.

According to the Stefan–Boltzmann law, a surface at temperature T in an environment at temperature T' will emit and absorb radiation equal to $E = \epsilon \, \sigma T^4$ and $E = \epsilon \, \sigma T'^4$, respectively. Thus the net radiation from the system equals:

$$E = \epsilon \sigma (T^4 - T'^4). \tag{7.1}$$

▲ **Example**

Determine the net radiant power per unit area radiated by a human being with a body temperature of 37 °C (310 K) in a room at 20 °C (293 K). Assume the emissivity ϵ of the human body to be 0.97.

Solution With an emissivity ϵ of 0.97, the skin covering the human body closely approximates an ideal blackbody. Thus, the Stefan–Boltzmann law (Eq. [7.1]) may be used to obtain the net radiant power per unit area.

$$E = \epsilon \sigma (T^4 - T'^4) = (0.97)(5.67 \times 10^{-8} \text{W/m}^2 \cdot \text{K}^4)[(3.10 \times 10^2)^4 - (2.93 \times 10^2)^4]$$
$$= 1.02 \times 10^2 \text{W/m}^2.$$

For a person with a surface area of 1.8 m^2, the net radiant power would be equal to the radiant power, E, times the surface area of the body, A. In this situation, $EA = (1.02 \times 10^2 \text{ W/m}^2) \times (1.8 \text{ m}^2) = 1.84 \times 10^2$ W or 184 W. This is a bit more than the thermal radiation produced by a 150 W incandescent light bulb. However, as the following example illustrates, the human body emits very little radiation in the visible region of the spectrum.

The second fact is expressed by the Wien displacement law:

$$\lambda_{\max} T = 2898 \, \mu\text{m} \cdot \text{K}. \tag{7.2}$$

Both of these laws are clearly illustrated in Fig. 7.1. Note that raising the temperature greatly increases the total radiated power E, and it also shifts the peak wavelength λ_m of the radiation distribution curve toward the blue (short wavelength) end of the spectrum.

Wien's law may be applied to find the peak wavelength of light radiated by objects ranging from the human body to stars, as the following example illustrates. Alternately, knowing the wavelength of the light emitted by a blackbody, it is possible to determine the radiating object's temperature.

▲ **Example**

Determine the peak wavelength of light radiated from the human body.

Solution Taking the temperature of the human body to be 37 °C, the peak wavelength is calculated from Wien's displacement law as follows:

Fig. 7.4 Thermographic image of a human face showing different temperatures in a range of colors from blue showing cold to red showing hot (Anita van der Broek/Shutterstock.com)

$$\lambda_{peak} = \frac{2.898 \times 10^{-3}\,\text{m} \cdot \text{K}}{T} = \frac{2.898 \times 10^{-3}\,\text{m} \cdot \text{K}}{(273 + 37)\,\text{K}} = 9.41 \times 10^{-6}\,\text{m} = 9350\,\text{nm}.$$

Thus, the radiation from the human body is primarily in the infrared region of the electromagnetic spectrum and cannot be perceived by the human eye. While our eyes are not sensitive to light of this wavelength, there are cameras that are. Infrared thermographic cameras produce colored images in which each color corresponds to a particular temperature, typically blue indicating cold to red indicating hot (see Fig. 7.4).

The spectral distribution of light radiated by blackbodies, embodied in the two aforementioned laws, could not be explained by classical physics. On classical grounds, there should be no limit to the energy of the light produced at short wavelengths. This failure of classical physics is called the ultraviolet catastrophe because the breakdown between theory and experiment occurs at short wavelengths.

The distribution of electromagnetic radiation from blackbodies remained an enigma until 1900 when German scientist Max Planck arrived at a completely unorthodox solution. Even though he had no basis for his assumption, he proposed that blackbodies consist of atomic oscillators that emit and absorb electromagnetic energy only in discrete amounts he called quanta. Central to Planck's postulation was that each individual packet possesses an energy equal to nhf, where n is a positive integer, f is the frequency of the oscillator, and h, now called Planck's constant, is equal to 6.626×10^{-34} J·s. This ad hoc solution to the blackbody problem, for which it is said that Planck was never comfortable, was what was needed to bring theory in line with the experiment.

7.3 Einstein and the Photoelectric Effect

In 1887, Heinrich Hertz, while performing experimentswith with electromagnetic waves, found that he could increase the sensitivity of his apparatus by shining ultraviolet light on the metal spheres that served as antennae. Later, J.J. Thompson, the discoverer of the electron, proposed that electrons in the atoms in the spheres were being shaken free from the metal by electromagnetic waves. Thompson concluded, correctly, that the freed electrons increased the conductivity between the spheres.

The liberation of electrons when light shines on a metal surface is known as the photoelectric effect, and the freed electrons as photoelectrons. The process, shown in Fig. 7.5, by which this occurs remained a mystery until Albert Einstein realized that light was made up of discrete bundles of energy, later called photons. This was seen as the only way to make sense of the photoelectric effect.

Prior to Einstein's quantum hypothesis, it was thought that electromagnetic waves, that is, light incident on a metal, jostle surface electrons, providing them with the energy needed to break away from the metal. It was reasoned that the time required for the ejection of the first electrons would be dependent on the intensity of the incident light. Therefore, brighter light of any color should result in higher energy photoelectrons. However, these ideas did not agree with the experiment.

According to Einstein's explanation, light quanta behave like particles, each having an energy proportional to frequency of the light: $E = hf$, where h is the proportionality constant introduced by Planck as part of his treatment of blackbody radiation. This is a departure from the wave theory that posits that light energy and intensity are related. Based on the photon theory of light, an electron will leave a metal only if the photon energy absorbed by the electron is equal to or greater than the minimum energy needed to pull an electron from the metal's surface. This minimum energy, known as the work function, depends on the nature of the metal and the condition of the metal's surface.

▲ Example

Determine the energy of a photon of ultraviolet light with a wavelength of 296 nm.

Fig. 7.5 The photoemission of electrons from a metal plate

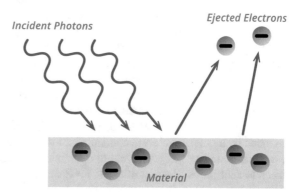

Solution The energy of a photon may be calculated using the relationship $E = hf$, where E is the photon energy, h is Planck's constant equal to 6.626×10^{-34} J·s, and f is the frequency of the light. Before determining E, it is necessary to find f. Using the relationship $c = f\lambda$, the frequency is calculated as

$$f = \frac{c}{\lambda} = \frac{3.00 \times 10^8 \text{m/s}}{2.96 \times 10^{-7}\text{m}} = 1.01 \times 10^{15}\text{s}^{-1}.$$

It follows that the energy of the photon is

$$E = hf = (6.63 \times 10^{-34}\text{J} \cdot \text{s})(1.01 \times 10^{15}\text{s}^{-1}) = 6.69 \times 10^{-19}\text{J}.$$

Photons possessing energies of this magnitude are capable of breaking molecular bonds and altering DNA molecules, the result, in some cases, being skin cancer.

7.4 Spectra of Light Sources—Optical Fingerprints

When listening to an orchestra, it is possible to focus on a particular instrument and listen to what that instrument is playing. This demonstrates the human ability to analyze, or dissect, a composite sound into its component parts. This rather amazing capability explains what is sometimes referred to as "the cocktail party effect." Most people can zero in on a particular conversation in a room even though there are many people speaking.

Our ability to analyze complex sounds is quite astounding. And while human vision is equally remarkable, it isn't quite so analytical. When you look at a white light bulb, you have no reason to suspect that the light actually consists of virtually every color in the rainbow. Likewise, light from a red neon sign does not reveal its spectral composition. In order to breakdown light into its constituent colors, it is necessary to extend our sense of vision by using optical tools such as prisms or diffraction gratings, optical elements found at the heart of devices called spectroscopes.

From Fig. 7.1 it is clear that an ordinary incandescent lamp (with a filament temperature of about 2700 K) is not a very efficient light source, since most of its radiated power or energy is at wavelengths too long to be seen (we call such radiation *infrared*, since it lies outside the red end of the spectrum). Some photographic films will record infrared radiation, but we experience it mainly as "radiant heat." Raising the temperature of an incandescent lamp filament to increase the efficiency is not too practical, since the metal evaporates rapidly at the higher temperature, coating the interior of the glass with an opaque layer and greatly shortening the life of the filament. In "quartz-halogen" bulbs, the filament is surrounded by a quartz enclosure containing a little iodine gas, which inhibits filament evaporation and makes it possible to operate at a higher temperature than ordinary incandescent bulbs. Even at 4000 K, however, there is little power radiated at the

short-wavelength (blue) end of the spectrum, and all incandescent lamps are considerably richer in red and orange than sunlight.

An important class of light sources makes use of radiation from gas discharge, the conduction of electricity through an ionized gas contained in a glass tube or bulb. The light from such gas discharges has a characteristic color (e.g., red from neon, green from argon, blue from krypton), familiar to us from outdoor advertising signs. If we analyze the spectrum of light from a gas-discharge tube (by means of a prism or a diffraction grating) , we will find that it consists of a series of spectral lines, each having a different wavelength. Each of these spectral lines corresponds to some transition between energy levels in the gas ion (atom). In fact, analytical chemists examine such spectra to detect small traces of gaseous impurities. It is interesting to photograph the gas-discharge tubes in signs through an inexpensive diffraction grating in order to see the various spectral colors displayed individually.

Viewing the blue light from a mercury vapor discharge tube through a diffraction grating reveals strong yellow, green, and blue spectral lines, and weaker ones in the red and violet portions of the spectrum. In addition to these lines in the visible portion of the spectrum, there are strong lines in the ultraviolet portion (wavelengths shorter than violet) that are not visible to the eye (but which can produce

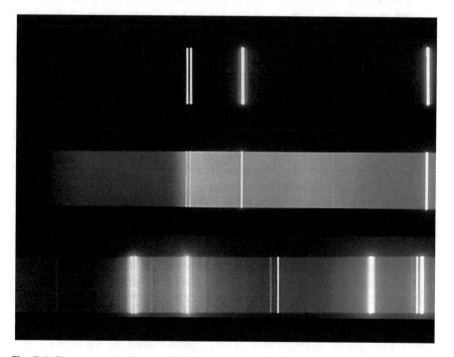

Fig. 7.6 Top: spectrum of mercury (low pressure); center: spectrum of fluorescent lamp showing mercury lines in addition to continuous spectrum from the fluorescent coating; bottom: spectrum from a high-pressure mercury vapor lamp, showing line spectrum and a continuous spectrum at the blue end (Courtesy of Kodansha, Ltd.)

sunburn). Fluorescent tubes are mercury-discharge tubes that have been coated on the inside surface with a phosphor to convert the ultraviolet light into visible light. Atoms of the phosphor absorb the ultraviolet radiation and reradiate some of this energy as visible light. This is quite an energy-efficient process, and fluorescent lamps give greater efficiency or *efficacy* (more lumens per watt) than incandescent bulbs. Under high pressure, mercury produces both a line and continuous spectra. Figure 7.6 shows the spectra that can be produced by mercury vapor under various conditions.

Other gas-discharge lamps, such as those filled with sodium vapor, are very efficient, but their spectrum of color is not so satisfactory, especially for viewing paintings and other objects with color.

7.5 Atoms

What happens when an electric current passes through a gas-filled tube (such as a neon-filled sign or the mercury vapor in a fluorescent tube) and causes it to produce light? Physicists in the nineteenth century were puzzled by this question. The simple element hydrogen was studied in great detail in the hope that understanding its spectrum would lead to understanding the spectra of more complex elements. In 1884, a Swiss schoolteacher, Johann Balmer, found that the wavelengths of some of the lines in the spectrum of hydrogen could be represented by the simple formula: $\lambda = (346.6 \text{ nm}) \, m^2/(m^2 - 4)$, where m takes on the values 3, 4, 5, ... for different spectral lines; we now call these lines the *Balmer series* of hydrogen. Other series of spectral lines were found in hydrogen, and they all fit into the general formula:

$$\lambda = 364.6(nm) \frac{m^2}{m^2 - n^2}. \tag{7.3}$$

When $n = 2$, this formula gives the wavelengths corresponding to the Balmer series; other series result for other values of n.

This orderly arrangement of spectral lines in hydrogen led to the understanding of the structure of the hydrogen atom. Early in the twentieth century, Ernest Rutherford and his colleagues in England developed the idea of a planetary structure of the atom with an extremely dense nucleus surrounded by orbiting electrons, somewhat as the planets of the solar system orbit the Sun. In 1913, Danish physicist Niels Bohr developed a quantum model for the planetary atom that explained the spectral series. The *Bohr model*, in its simple form, has the electrons moving stably in "allowed orbits" or "quantum levels," each with a definite amount of energy, as shown in Fig. 7.7. If an atom is excited, by the passage of electric current, for instance, electrons might take on extra energy and move to a higher level. Such an excited electron would normally fall back to a lower level, radiating its excess energy as light. The Balmer series consists of electrons falling from various higher levels into the $n = 2$ level, as shown in Fig. 7.7.

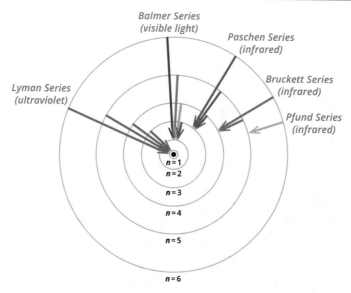

Fig. 7.7 Spectral series in a hydrogen atom correspond to transitions to a quantum level from a higher level

▲ Example

Determine the wavelength of light produced for a transition in the hydrogen atom from the fourth level ($n = 4$) to the second level ($n = 2$).

<u>Solution</u> The wavelength of the spectral lines of hydrogen may be calculated using the Balmer formula (Eq. 7.3). For the transition from the fourth level ($n = 4$) to the second level ($n = 2$),

$$\lambda = 364.6(\text{nm})\,[16/(16-4)] = 486.1 \text{ nm}.$$

This corresponds to blue light. Other transitions in the Balmer series give red, blue-green, and violet light.

The energy levels in a hydrogen atom, according to the Bohr model, are given by $E_n = -(13.6 \text{ eV})/n^2$, where the energy levels are negative with respect to the reference level of a highly excited electron that is able to "escape" from the atom. Energy levels are often expressed in a unit called the *electron volt* (eV), which is the energy that an electron would acquire in traveling from the negative to the positive terminal of a 1-V battery. Based on Einstein's theory, light is emitted from an atom as *photons* or quanta of light, each photon having an energy given (in eV) by $E_\lambda = hc/\lambda = 1240/\lambda$, where λ is the wavelength in nanometers, h is Planck's constant, and c is the speed of light.

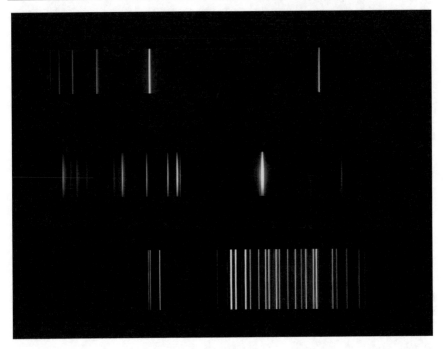

Fig. 7.8 Top: spectrum of hydrogen; the strong lines are from hydrogen atoms (Balmer, Lyman, and other series); center: spectrum of helium; bottom: spectrum of neon (Courtesy of Kodansha, Ltd.)

Although Bohr's simple quantum model is quite successful in explaining the spectrum of hydrogen, more sophisticated models are required for atoms having more than one electron. The basic idea still remains, however: Atoms have definite energy levels, and when electrons change levels they radiate (or absorb) photons of light. Atoms can be excited (so that one or more electrons move to higher levels) in several ways, such as through the passage of an electric current, collisions with other atoms, absorption of radiation, and so on. As is shown in Fig. 7.8, the energy level structure is different in different atoms (or molecules), so each atom produces a distinctive spectrum when it is excited. Analytical chemists make use of this fact to identify traces of elements. By exciting atoms of paint in a painting so that they radiate their characteristic spectra, for example, much can be learned about the type of pigments used.

The spectra of the light from distant stars tell astronomers a great deal about the character of the stars. It is possible to determine, with a fair degree of certainty, what chemical elements are in the star. By determining small shifts in the wavelengths of familiar elements (known as Doppler shifts, see Sect. 2.7), it is possible to determine the speed at which distant stars are moving toward us or away from us (much the same way police officers use the Doppler shift of reflected radar to

determine the speed of a moving automobile). It is remarkable how much we know about our universe just by analyzing the light from distant stars, some of which was radiated millions of years ago and has been traveling through space ever since!

7.6 Fluorescence and Phosphorescence

In a gas-discharge lamp, such as those filled with gaseous mercury or sodium, the atoms are excited by atomic collisions due to an electric current. Atoms can also become excited (i.e., their electrons move up to higher quantum levels) by absorbing light. In some cases, the atoms then radiate a photon of longer wavelength (lower energy) as they return to their normal state. This process is called *fluorescence.*

The most familiar example of fluorescence is the fluorescent lamp, which is filled with mercury vapor. Along with visible light (consisting of blue, green, yellow, and other colors), a mercury-discharge tube emits strong ultraviolet light, whose wavelength is too short to be seen by our eyes. However, the inside of the lamp is coated with fluorescent material that absorbs the ultraviolet light and reradiates it as visible light. If the coating is chosen carefully, the fluorescent light will be essentially white. It is possible to make fluorescent coatings that give blue-rich ("cool") white, red-rich ("warm") white, lots of violet for plant growth, yellow to repel insects, or other special tints.

Material whose atoms decay very slowly back to their normal state is called *phosphorescent.* Phosphorescence is really delayed fluorescence. Phosphorescent materials with long decay times are used to paint watch dials and safety tape that glow for hours in the dark.

Luminescence is a term that includes both fluorescence and phosphorescence. A prefix is sometimes attached to describe the way in which atoms are excited, such as electroluminescence, chemiluminescence, thermoluminescence, or bioluminescence (e.g., the firefly).

Fluorescent paints are used to create posters that glow brightly under "black light." A so-called black light is a mercury lamp that has been coated with a material that strongly absorbs visible light while allowing much of the ultraviolet light to pass through. Many natural materials, such as human teeth, are strongly fluorescent under ultraviolet light. Tonic water appears clear and colorless under normal light, but, as Fig. 7.9 shows, the liquid appears blue under ultraviolet radiation. This is due to the quinine it contains.

Fluorescent dyes are sometimes added to laundry soap so that clothes will absorb ultraviolet light from the Sun and "glow." Objects that glow white in sunlight, due to fluorescent dyes, can correctly be described as "whiter than white" because they emit more white light than the most efficient white paint reflects. These same dyes cause some white clothing to glow in black light.

Fig. 7.9 Light from a blue-violet laser produces fluorescence as it passes through tonic water

Examples of spectra from incandescent and fluorescent lamps are shown in Fig. 7.10. The spectra of fluorescent lamps include discrete spectral lines from the mercury gas combined with continuous spectra due to the phosphorescent coating on the inside of the tube. The peak output from an incandescent lamp lies in the infrared part of the spectrum (not shown), and the visible light output increases toward the red end of the spectrum.

A type of fluorescent lamp, the compact fluorescent lamp or CFL, emerged commercially in 1985 as a convenient and efficient replacement for the conventional incandescent bulb. In essence, a CFL is a standard fluorescent lamp bent into a helical shape capable of fitting into a light fixture designed to accommodate a standard incandescent bulb. In addition to its compact size, the CFL's advantages include substantially less power consumption (one-fifth the electrical power of an incandescent lamp producing the same visible light) and a much longer life (up to 15 times).

Fig. 7.10 Spectra of: **a** cool white fluorescent lamp; **b** warm white fluorescent lamp; **c** incandescent lamp. The spectral lines of mercury gas are seen in the spectra of the fluorescent lamps

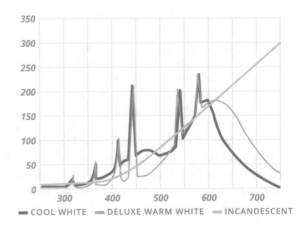

While a boon to energy conservation, the CFL has its detractors. Many users, accustomed to the light produced by incandescent lamps, find the light produced by some CFLs unpleasant due to its spectral content. Concern has been voiced about the possible environmental and health consequences of the mercury contained in CFLs. As a result, many governmental agencies have instituted recycling schemes that insure safe disposal of mercury.

With improvements in brightness and drop in price, light-emitting diodes (LEDs) have become the lighting option of choice. As a result, General Electric and other manufacturers have begun phasing out CFL production.

7.7 Light-Emitting Diodes

Luminescent light sources produce practically no heat. A widely used form of this type of light source is the light-emitting diode (LED) . When current flows through an LED, electrons combine with virtual positive charges called "holes." In the process, electrons drop to a state of lower energy. The energy change produces a photon. The color of light produced depends on the materials used to create the LED.

At the heart of an LED are materials known as semiconductors. Virtually all materials in our world can be categorized as conductors, insulators, or semiconductors. Electrons move freely through conductors and with considerable difficulty through insulators. Semiconductors fall in the middle of these two conductive extremes. As the name implies, they have electrical properties that lie between low-resistance conductors and high-resistance insulators. The elements silicon, selenium, and germanium as well as the compounds copper oxide, zinc oxide, and lead sulfide are common semiconductors.

A typical LED is shown in Fig. 7.11. The semiconductor chip, typically a cube 0.25 mm on each side, is mounted on one of the electrical leads. A clear epoxy dome serves as a lens to focus the light as well as to protect the semiconductor.

An LED consists of two semiconducting materials placed back to back. Each of the semiconductor materials has trace amounts of certain impurities added to enhance their conductivity. One type of "doping" leaves one of the semiconductors with what are called "holes." Holes result from the absence of electrons and behave like free positive charges. This semiconductor is called a positive or p-type material. The other semiconductor has had an impurity added that produces an abundance of free electrons and is referred to as a negative or n-type semiconductor.

When p- and n-type semiconductors are sandwiched together, a p-n junction is created. At this junction, some free electrons from the n-type region drift into the p-type region and some holes from the p-type region drift into the n-type region. As a result, a neutralization of positive and negative charges occurs. In the neutral region between the n- and p-type semiconductors, a kind of electrical barrier, called the depletion layer, is formed. The neutralization process does not continue

(a)
CLEAR EPOXY DOME

(b)

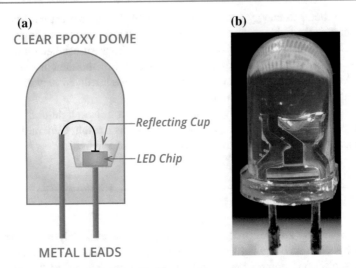

Reflecting Cup

LED Chip

METAL LEADS

Fig. 7.11 **a** Drawing of a typical LED lamp. The LED chip is mounted in a reflecting cup attached to one of the leads. Clear epoxy acts as a lens. **b** Enlarged image of an LED (Grapetonix (https://commons.wikimedia.org/wiki/File:Uvled_highres_macro.jpg), "Uvled highres macro", https://creativecommons.org/licenses/by/3.0/legalcode

indefinitely. An electric field develops between the two semiconductors that limit further charge movement.

If the positive terminal of a battery is connected to the p-type semiconductor and the negative terminal to the n-type, the charges in each of the two semiconductors will be repelled toward inward, thus reducing the width of the depletion layer. With sufficient voltage applied to the junction, charges will move across the depletion layer. When this occurs, electrons and holes will combine and in the process the electrons will lose energy. The energy given up by the electron appears in the form of a photon of light. Hence the p-n junction functions as a light source—a light-emitting diode. This process is shown in Fig. 7.12.

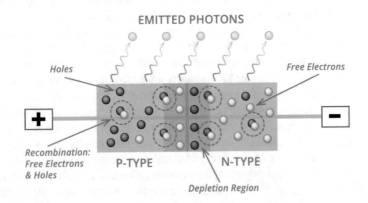

Fig. 7.12 Electrons and holes combine and in the process produce light

Because the first LEDs weren't very bright, they were primarily used as indicators in devices such as electronic calculators. Early LEDs also had another drawback: prior to 1996, they were only available in a limited number of colors. Blue or white LEDs were not available. Things have changed dramatically since then. LEDs now come in virtually every color and produce light with extreme efficiency.

The range of applications of LEDs continues to grow rapidly as diodes with ever greater efficiency, greater range of color, and lower cost are developed. LEDs are now widely used in such common consumer items as clocks, radios, TV-channel remote controls, toys, holiday lighting, and flat screen televisions. Outside the home, LEDs are used in street lighting, traffic signals, and automotive tail lights and turn signals. A prominent use for LEDs is in large-area outdoor displays, the so-called "jumbotrons." These displays may be as large as several meters high and wide. Visible in even bright sunlight, these large-scale screens are well suited for use in concert venues, for advertising, and at sporting events.

Today, it is almost impossible to find an electronic or lighting device that doesn't employ LEDs. LEDs have replaced incandescent and fluorescent lights in most applications. One is hard pressed to find incandescent bulbs or CFLs in stores anymore.

While LEDs have only been commercially available since the 1960s, the history of the LED can be traced to a 1907 discovery. It was then that British engineer H. J. Round, while working with radio pioneer Guglielmo Marconi, found that a crystal detector that he was using in a radio receiver emitted light when a current was passed through it. This is the first time light was produced by a process known as electroluminescence, the emission of light by a material in response to an electric current.

Starting in 1924, Russian engineer Oleg Vladimirovich Losov published several papers describing his research on light emission from zinc oxide and silicon carbide crystal rectifiers. In his writings, Losov detailed a variety of aspects of these diodes, including their spectra. He is often credited with the creation of the first LED.

While LED research and development continued throughout the twentieth century, it wasn't until 1962 that red GaAsP LEDs were first introduced commercially by General Electric. They had efficiencies of only 0.1 lumens/watt (1/100 that of an incandescent lamp) and were used mainly as indicator lights on equipment. In the mid-1970s, it was discovered that by adding nitrogen, red-orange, yellow, and green LEDs with performance in the range of 1 lumens/watt could be produced. By 1990, efficiencies had increased to 10 lumens/watt, greater than filtered incandescent lamps, and they began to replace light bulbs in many outdoor lighting displays.

7.8 Blue, Ultraviolet, and White LEDs

Although red and green LEDs had been around for many years, blue LEDs continued to be a challenge for scientists until 1993 when bright blue LEDs were demonstrated by Shuji Nakamura of Japan's Nichia Corporation. The event revolutionized LED lighting, making high-power, highly efficient blue light sources practical. The breakthrough was based on the use of gallium nitrate growth process and lead to the development of technologies such as Blu-ray.

Nakamura and collaborators Hiroshi Amano and Isamu Akasaki were awarded the Nobel Prize in Physics in 2014 for the invention of the blue LED. According to the Nobel Award Committee, the technological advance ushered in a "fundamental transformation of lighting technology."

Using compounds of AlGaN and AlGaInN, even shorter wavelengths are achievable. Ultraviolet LEDs in a range of wavelengths are available. Near-UV emitters at wavelengths around 375–395 nm are inexpensive and are frequently used in lieu of so-called black lights often used in security applications.

Many common lighting applications require white light. However, LEDs only emit light in a very narrow range of wavelengths, emitting light of a color characteristic of the semiconductor material used to make the LED. To produce white light, some means of producing a much broader band of colors must be employed.

One approach to the problem is to place red, green, and blue LEDs in close proximity and properly adjust the intensity of each. This additive mixing approach makes the production of white light and virtually all other colors possible. This method is commonly used in large video displays.

White light may also be produced by using phosphors in conjunction with short-wavelength light. By including appropriate phosphors in a blue LED, yellow light may be produced through the process of fluorescence. The yellow light combines with the blue light not absorbed by the phosphors to produce white.

7.9 Laser Light

The laser is one of the most important technological achievements of the twentieth century. *Laser* is an acronym that stands for **l**ight **a**mplification by the **s**timulated **e**mission of **r**adiation. The key words are *amplification* and *stimulated emission*. Einstein predicted stimulated emission in 1916, and the principle was applied to light in 1958 by Arthur Schawlow and Charles Townes when they proposed the optical maser, or laser.

The first laser was constructed by Theodore Maiman in 1960. Maiman's laser used a ruby crystal, excited by a xenon-filled flashtube, as the amplifying medium, and the laser emitted intense flashes of red light with a wavelength of 694.3 nm. Ruby is a transparent crystal of Al_2O_3 with a small amount (about 0.05 percent) of chromium. It appears red because the chromium ions have strong absorption bands

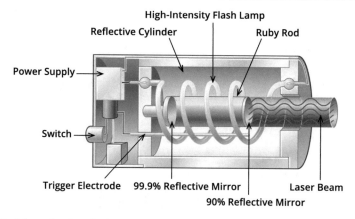

Fig. 7.13 Schematic of a ruby laser

in the blue and green regions of the spectrum. A schematic diagram of a ruby laser is shown in Fig. 7.13.

When the flashtube is fired, light is absorbed and atoms are raised from the ground state to a short-lived excited state, as shown in Fig. 7.14. They then quickly relax, giving up a portion of their energy to the crystal lattice by nonradiative transitions (i.e., transitions that don't give off light) to a longer-lived, metastable state (i.e., a state in which atoms can remain for a small fraction of a second). Eventually, they decay from the metastable state back down to the ground state by emitting photons with an energy of 1.79 eV and a wavelength of 694.3 nm. In addition, some of these photons stimulate other atoms to emit photons with the same energy and wavelength.

In a system of many atoms (solid, liquid, or gas), most atoms occupy the lowest available energy levels. If a large number of atoms end up in a metastable state, a *population inversion* occurs in the numbers of atoms in the metastable and ground

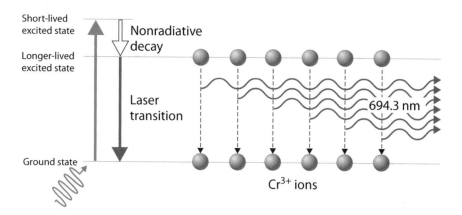

Fig. 7.14 Transitions between energy levels in ruby laser

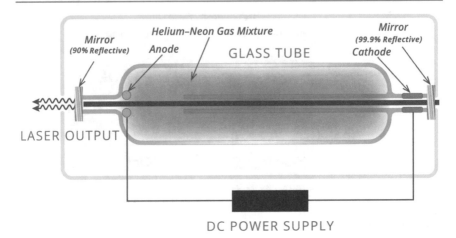

Fig. 7.15 HeNe laser components include a gas-discharge tube, two mirrors, and a power supply

states. This is a nonequilibrium condition, like balancing a concrete block on the top of a stick; anything that disturbs the block will cause it to fall. A photon of the right wavelength striking the atom does just that; it causes the atom to "fall" to its ground state, emitting a photon of the same wavelength (i.e., it *stimulates* radiation). Now we have two photons that can, in turn, stimulate two more atoms to radiate, and the light builds up very rapidly.

As Fig. 7.13 indicates, both ends of the ruby crystal are silvered, such that one end is almost totally reflecting (about 99.9 percent) and the other end reflects about 90 percent of the light. If the mirrors are parallel, standing waves of light are set up, and an intense beam of coherent light emerges through the partially silvered end. During each pass through the crystal, the photons stimulate more and more atoms to emit, so the light becomes very intense. The light is *coherent* because all the photons have the same phase and the same wavelength.

A few months after Maiman's ruby laser was announced, Javan, Bennet, and Herriott developed the first gas-filled laser, a helium-neon laser that emitted continuous light in both the visible ($\lambda = 632.8$ nm) and infrared ($\lambda = 1150$ nm) portion of the electromagnetic spectrum. TheHeNe laser, which has been widely used for the past 30 years, includes a gas-discharge tube with a mixture of 15 percent He and 85 percent Ne, two mirrors, and a high-voltage power supply (see Fig. 7.15).

Populationinversion inversion among the atomic states is achieved somewhat differently in the HeNe laser than in the ruby laser. Helium atoms are excited by the electrical current, and these excited helium atoms excite neon atoms by collisions. This leads to an excess of neon atoms in the excited states, and these atoms decay back to a lower level by emitting photons. The light is not nearly so intense as that from a ruby laser because the density of atoms is much lower in a gas than in a solid crystal; however, the emission is continuous rather than intermittent.

Fig. 7.16 In a diode laser, light is produced in a narrow p-n junction

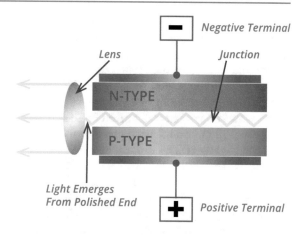

Diode lasers, using semiconducting materials similar to those used in LEDs and transistors, are the most efficient type of lasers. In a ruby or HeNe laser, a concentrated light beam is produced by repeatedly reflecting the light emitted from atoms between two mirrors to create a population inversion. In a laser diode, an equivalent process happens when the photons bounce back and forth in a roughly 1-μm wide junction between p-type and n-type semiconductors, as shown in Fig. 7.16. The amplified laser light eventually emerges from the polished end of the gap in a beam parallel to the junction.

Diode lasers are inexpensive and very compact, and thus they have found their way into many commercial and consumer products, such as optical pickups for reading compact discs, pointers, and barcode readers in stores. Diode lasers emit light with wavelengths throughout much of the visible spectrum and beyond.

7.10 Gas-Filled Arc Lamps

In a gas-discharge lamp, electrical current flowing through the ionized gas provides the energy to excite the gas atoms so that they emit light. The process can be made to be very efficient. A modern sodium arc lamp, for example, produces about seven times as many lumens per watt as an incandescent lamp. A modern high-pressure sodium arc lamp radiates yellowish light (2100 K color temperature) with a broad enough spectrum to be acceptable for street lighting. A sealed ceramic tube contains a liquid amalgam of sodium and mercury, as well as a starting gas, xenon. When the arc is started by a pulse of about 2500 volts, the light first appears bluish-white due to the discharge in mercury and xenon and then shifts to yellow-orange as the sodium atoms become excited. As the sodium warms and its pressure increases to atmospheric, the spectrum broadens.

Mercury arc lamps also offer long life and high efficiency. The mercury, together with a starter gas, argon, is enclosed in a quartz tube. The lamp is started by applying a high voltage between one of the main electrodes and a starting electrode nearby; the arc heats and vaporizes the mercury, which then carries the main discharge. It takes several minutes for the mercury to heat up so that the arc is stable. High gas pressure in a gas-discharge lamp broadens out the spectral lines (due to the Doppler effect described in Sect. 2.7), which gives a more usable light for general illumination. High-pressure mercury lamps give a broad continuous spectrum slightly slanted toward the blue end.

A xenon arc lamp is still another example of a discharge lamp. In this type of arc lamp, shown in Fig. 7.17, a high-voltage power supply is used to ionize xenon gas contained within a glass tube, resulting in the production of positively charged ions and negatively charged electrons. These charges move in opposite directions along the tube, with electrons being attracted to the positive electrode and ions moving to the negative electrode. The collision of these charged particles with each other and the electrodes produces light.

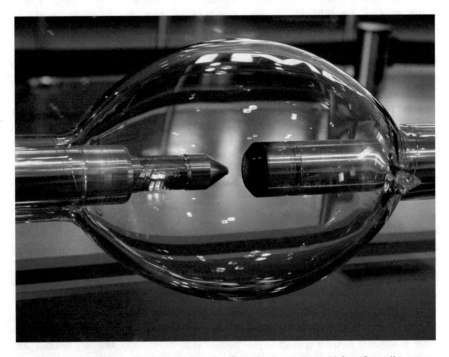

Fig. 7.17 A 15-kW xenon arc lamp used in movie projection systems (Atlant (https://commons. wikimedia.org/wiki/File:Xenon_short_arc_1.jpg), "Xenon short arc 1", https://creativecommons. org/licenses/by/2.5/legalcod)

In addition to a line spectrum, high-pressure xenon arc lamps have a broad continuous spectrum closely resembling sunlight. This makes them useful in a variety of applications that include use in movie projectors and situations requiring simulated sunlight.

When short, high-intensity bursts of light are required, a capacitor, which gives a short pulse of high current, is used to produce ionization. For this reason, capacitor-energized xenon arc lamps are used in photography, as high-intensity stroboscopic light sources, and as exciters for pulsed lasers.

7.11 Nanoscale Light Sources

Richard Feynman, Nobel laureate in physics, once said, "There's plenty of room at the bottom." Feynman's prophetic statement made over a half century ago referred to the possibility of manipulating individual atoms and molecules, something that is now routinely being done. Known as nanotechnology, this relatively new field of research and development represents the design, production, and application of devices and systems at the nanometer scale.

One area where nanotechnology shows great promise is in the production of light, for researchers have found ways to produce light with devices in many cases not much bigger than a small cluster of atoms. These miniature nanophotonic devices include light-producing nanocrystal quantum dots, carbon nanotubes, and carbon nanowires.

A quantum dot is a nanostructure made from a semiconducting material such as silicon, cadmium selenide, cadmium sulfide, or indium arsenide. Quantum dots are sometimes referred to as artificial atoms, since a quantum dot has bound, discrete energy states, such as those found in atoms and molecules. As in an ordinary LED, a quantum dot produces light when an electron and a positively charged hole combine. There is one big difference, however: size. Quantum dots have diameters ranging from 2 to 10 nm. These dimensions correspond to the size of a bundle of 10–50 atoms.

The wavelength of light emitted by a quantum dot is related to their size: the smaller the quantum dot, the shorter the wavelength of the emitted light. This enables the production of a wide range of wavelengths merely by changing the size of the quantum dot. The quantum dot samples shown in Fig. 7.18 range in size from 2 nm (blue light emitter) to 4.2 nm (red light emitter).

The ability to fine tune the size of and, therefore, the color emitted by quantum dots is a particularly useful feature when it comes to creating monochromatic light sources and vivid color displays such as those found in quantum light-emitting display (QLED) televisions. Beyond display applications, quantum dots are predicted to provide a way of increasing the efficiency of solar cells, detecting and treating cancer, and serving as switches in quantum computers.

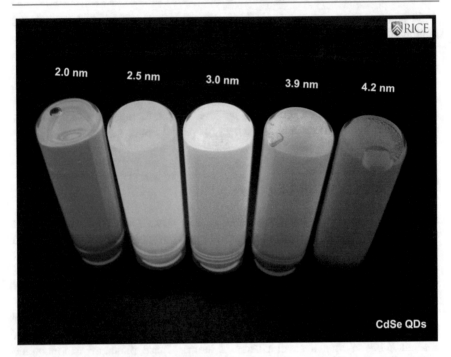

Fig. 7.18 Cadmium selenide (CdSe) quantum dots (Prof. Michael S. Wong (https://commons. wikimedia.org/wiki/File:CdSe_Quantum_Dots.jpg), "CdSe Quantum Dots", https:// creativecommons.org/licenses/by-sa/3.0/legalcode)

Carbon nanotubes are long, extremely thin cylinders of carbon that can be thought of as a single layer of carbon atom rolled into a cylinder. The diameter of a nanotube is on the order of only a few nanometers; however, they can be up to several millimeters in length. An artist's rendering of a nanotube's hexagonal structure is shown in Fig. 7.19.

Considering their size, nanotubes have amazing physical properties. When produced from pure carbon, they are extremely strong (about 100 times stronger than steel!), and exhibit diverse electrical and thermal conductivity properties. Depending upon its diameter, a pure carbon nanotube can conduct an electrical current as if it were a metal or it can act as a semiconductor.

Carbon nanotubes are seen as a replacement for silicon in the production of highly efficient semiconductors. This application has been demonstrated by scientists at Japan's Tohoku University who have developed a light source using carbon nanotubes whose power consumption is about 100 times lower than that of a conventional LED.

Unlike other semiconductor-based light sources that are assembled by forming p-n junctions, the single-nanotube device doesn't require doping or fabrication. The nanotube serves as a semiconducting channel, capable of carrying both electrons

Fig. 7.19 A carbon nanotube can function as a metal or semiconductor (Leonid Andronov/Shutterstock.com)

Fig. 7.20 Semiconductor nanowires that emit ultraviolet light are part of a project to make prototype nanolasers and other devices (By National Institute of Standards and Technology (Nanowires that Emit UV Light) [Public domain], via Wikimedia Commons)

and holes. When these two charge types are introduced into the nanotube, they combine and, in the process, produce light.

What appear to be dense-packed thin rods in the photograph in Fig. 7.20 are actually nanowires, wires with diameters on the order of a few nanometers. Nanowires can function as insulators, semiconductors, or metals depending on the material from which they are made. The photograph is of a color-enhanced electron micrograph of gallium nitride wires growing on a silicon substrate. Demonstrated to be capable of producing infrared and ultraviolet light, these highly efficient devices are envisioned to have applications in telecommunications and optical computing.

7.12 Illumination

Radiometry is the measurement of the energy content of electromagnetic radiation, including visible light, infrared and ultraviolet radiation, radio waves, microwaves, X-rays, and so on. The unit of energy in the standard international (SI) system of units is the *joule*, which is the energy required to lift 1 kg of mass a distance of 10.2 cm.

The *radiant flux* is the amount of radiation that leaves an object or is received by an object each second, and it is measured in *watts*; 1 W is equal to 1 joule per second. A 100-W light bulb radiates approximately 100 joules of energy per second. However, it might radiate only 5 W of this as visible light, the remainder being radiated mainly as infrared radiation or radiant heat. The *irradiance*, expressed in W/m^2, is a measure of the radiation intensity on a surface.

Photometry is concerned with measuring radiation energy and other quantities in the visible portion of the electromagnetic spectrum. It takes into account the sensitivity of the eye to different wavelengths of light. The *luminous flux*, expressed in *lumens*, scales the radiant flux up or down at each wavelength, according to the sensitivity of the eye to that wavelength. The *illuminance* expresses the eye-weighted intensity of visible light striking a surface in lumens/m^2 (lux) (In English units, the illuminance is expressed in lumens/ft^2 [foot-candles]. One foot-candle is equal to 0.0929 lx.) Photographers use illuminance meters, also called *photometers*, to determine the proper exposure time. Photometers are generally fitted with a filter to tailor the spectral response to match that of the CIE (Commission Internationale).

7.13 Summary

A blackbody is an ideal absorber and emitter of light to which other light sources can be compared. The total radiation of a blackbody is proportional to the fourth power of its absolute temperature, and the wavelength of its maximum radiation is inversely proportional to the absolute temperature. The color temperature of a light

source is the temperature of the blackbody with the closest spectral distribution. The spectral sensitivity of the eye is well matched to the spectral distribution of sunlight.

An ordinary incandescent lamp is not a very efficient light source; since its radiation peak lies in the infrared, it radiates more heat than light. Fluorescent tubes, which convert radiation from a mercury discharge tube to visible light by means of a phosphor coating on the inside of the tube, are much more efficient light sources.

The Bohr model of the atom, inspired in part by earlier work of Balmer and Rutherford, explains spectral lines as being due to transitions between energy levels in the atom. The Bohr model is quite successful in explaining the radiation from hydrogen atoms, although more sophisticated models are required for atoms and molecules with more than one electron. Lasers, which use stimulated emission from atoms to create intense, monochromatic, coherent light, have found their way into many commercial and consumer products.

Light-emitting diodes (LEDs) are very efficient sources of light and are finding many new applications, such as instrument displays, automobile tail lights, and large outdoor displays ("electronic billboards"). Blue LEDs, which were developed in the early 1990s, have many applications including being the central component in white LEDs.

Gas-filled arc lamps, especially sodium and mercury, are also very high-efficient light sources, and xenon-filled strobe lamps are useful in photography and as exciters for pulsed lasers.

Nanotechnology is involved with the design, production, and application of devices at the nanometer scale. Optical devices at the nanoscale include light-producing nanocrystal quantum dots, carbon nanotubes, and carbon nanowires.

Radiometry is the measurement of the energy content of electromagnetic radiation, including visible light. The luminous flux, expressed in lumens, scales the radiant flux up or down at each wavelength, according to the sensitivity of the eye to that wavelength.

◆ **Review Questions**

1. What is a blackbody? Sketch a typical blackbody spectral distribution curve.
2. Describe how you would construct a simple device that approximates a blackbody.
3. What is the approximate temperature of something that is "white hot"?
4. What is meant by the term *color temperature*?
5. When an electric range is turned on, it becomes red; the filament in an incandescent light bulb appears white. Which is hotter? Use Wien's law to explain your answer.
6. An incandescent lamp filament having a temperature of 2700 K radiates its maximum spectral power at a wavelength of 1070 nm (compare Fig. 7.1). Is radiation of this wavelength visible to the eye?
7. Given a choice of light bulbs having color temperatures of 3000, 4000, 5000, and 6000 K, which one would you choose to provide illumination most like sunlight?

8. When you look at most people's eye pupils, they appear black. Use your knowledge of blackbody radiation to suggest an explanation for this phenomenon.
9. Why are different types of color film used for indoor and outdoor photography?
10. Discuss the Bohr model of the atom. What are some successes of this model? What are its shortcomings?
11. What is the difference between line spectra and continuous spectra?
12. What type of light sources produce continuous spectra? Line spectra? Both?
13. What is fluorescence? What is phosphorescence?
14. If light from different gas-discharge tubes is viewed through a diffraction grating, what differences will be apparent?
15. Why are sodium vapor lamps generally not used for indoor lighting?
16. What is the difference between photometry and radiometry?
17. Provide a detailed description of a ruby laser's light production process.
18. What are some differences between laser light and light from a fluorescent lamp?
19. What is the relationship between the size of a quantum dot and the light it emits?

▼ Questions for Thought and Discussion

1. Window glass is transparent to visible light but opaque to most infrared radiation. Use this information and your knowledge of blackbody radiation to explain why the interior of a greenhouse becomes hot.
2. If you were in charge of selecting the lighting system for an art gallery, what characteristics would you want your light sources to possess?
3. List some uses of atomic and molecular spectra.
4. Discuss the advantage (if any) of a 100-W red heat lamp over a 100-W white heat lamp.
5. Describe a situation where the color of an object appears to change as the light used to illuminate the object is changed.

■ Exercises

1. State the Stefan-Boltzmann law and Wien's law in words and as formulas.
2. The peak in the spectral distribution curve for radiation from "radio stars" occurs in the microwave region of the electromagnetic spectrum ($\sim 10^{-2}$ m). Assuming that this radiation originates mainly from thermal emission, determine the approximate surface temperature of such stars.
3. What is the peak wavelength radiated by a blackbody at room temperature (~ 300 K)? Is this wavelength visible to the eye?
4. **a.** Calculate the total power radiated per unit area by an incandescent lamp filament at 2700 K.
 b. Determine the surface area of the filament if the lamp radiates 100 W (mostly as infrared radiation).

5. Use Balmer's formula to calculate the wavelengths of the first three spectral lines of the Balmer series.
6. Compute the energy of a photon of red light ($\lambda = 650$ nm) and a photon of ultraviolet light ($\lambda = 400$ nm). Why is ultraviolet light potentially more harmful to the skin than red light?
7. When a food containing sodium spills into an open flame on a stove, a characteristic orange color is produced. Determine the difference in energy between the two levels in a sodium atom responsible for the emission of this light (Use 589.6 nm as a representative wavelength for this light.).

● **Experiments for Home, Laboratory, and Classroom Demonstration**

Home and Classroom Demonstration

1. **Dissecting fluorescent light**. The inside of a fluorescent light tube is coated with a variety of phosphors that produce different colors. The combination of these colors is perceived as white light. Each phosphor absorbs ultraviolet light and emits visible light, but they do it at different rates, so the intensity of different colors varies slightly. To see the component colors, examine fluorescent light reflected from the blades of an electric fan as you turn the fan on and off so that its speed changes. When the blade passage rate of the fan coincides with the flash rate of the fluorescent lamp (120 times per second) , colors can be seen (the effect is subtle, so look carefully). Similarly, a vibrating guitar string illuminated with fluorescent light may reflect colors.
2. **Compact disc diffraction grating**. The tracks of pits on a compact disc, by acting as a grating, can produce colorful interference effects (see Sect. 5.9). In fact, a CD can be used to observe the spectra of everyday light sources, such as incandescent bulbs, fluorescent tubes, compact fluorescent bulbs, LEDs, and even sodium and mercury street lamps. To observe this, hold a CD as close as possible to the source and note the interference colors of the reflected light. Which sources show a continuous spectrum? Line spectra? If you have a laser pointer, bounce the light off the CD onto a white wall or screen. Do you see interference colors? What does this suggest about the laser light?
3. **Fluorescent plastics**. Fluorescent dyes are sometimes added to clear plastic objects to give them a vibrant "neon" appearance. Examples include plastic cups and clipboards. Examine a fluorescent plastic object in light from a variety of sources. Is the fluorescence more pronounced in a particular type of light? If so, why does this occur? The fluorescent clipboards have another interesting feature: They act as "light pipes." Due to total internal reflection, a portion of the light that enters the clipboard is piped to the edges of the board, making them appear bright. A similar effect may be noticed around the rim of a plastic cup.
4. **Invisible graffiti**. Many liquid laundry detergents contain fluorescent dyes. These dyes serve as whitening agents that are intended to make yellowed clothing look whiter and brighter. When illuminated with ultraviolet light, these liquids fluoresce, giving off a cool blue light. By mixing roughly equal parts of

liquid detergent and water, you can produce a "paint" that is invisible in white light but fluoresces dramatically under black (ultraviolet) light. You may write a message or produce some art work with your finger tip or brush on a tabletop, wall, or sheet of paper. Once it has dried, your painting will be invisible most of the time but readily visible in ultraviolet light.

5. **Detecting ultraviolet light**. The human eye does not detect ultraviolet radiation. However, certain dyes that change color when exposed to ultraviolet can be used to detect UV radiation. The dyes are not affected by visible light and remain white until exposed to ultraviolet. Inexpensive ultraviolet detecting beads, nail polish, and T-shirts are available from several suppliers of science education materials. You can use the dyes to look for UV output from TV screens, computer monitors, incandescent and fluorescent light sources, and camera flashlamps. Observe the change in dye color when taken outdoors. Do the dyes have to be in direct sunlight for a color change to occur? (What does this imply about getting a suntan or sunburn on a cloudy day?) Use the UV-sensitive dyes to determine whether sunglasses offer UV protection. Does the window glass on your car transmit UV radiation? Use the dyes to test suntan lotions for UV protection.

6. **Blacker than black**. Find the blackest sheet of paper you can and cut out a four-inch square. With a sharp pencil make a tiny hole in the center of the square and place it on top of a coffee cup that is all white inside. Observe that the hole clearly is blacker than the paper! Light entering the tiny hole can exit only after undergoing so many reflections inside the cup that almost no radiation escapes even though the surface of the cup is quite a good reflector.

7. **Whiter than white**. Compare a white sheet of paper with paper that has been coated with invisible paint (laundry detergent and water), as in Experiment 4. Make the comparison in different types of light. What makes the coated paper appear whiter than white?

8. **Spectrum as a function of temperature**. Remove the shade from a dimmer-controlled lamp (preferably with a clear incandescent light bulb). View the lamp filament through a diffraction grating as you slowly increase the brightness of the bulb. What do you observe? Which colors are visible through the grating when the bulb is glowing dull red? Bright red? Which colors do you see when the filament is white hot? How do you explain these observations?

9. **Spectra of common sources**. Use a diffraction grating to observe the spectra of light sources you encounter daily. Sources to consider include incandescent bulbs, fluorescent lamps, sodium street lamps, neon signs, and so on. **Do not look directly at the Sun!** Viewing a street scene at night may reveal a variety of spectra. Which light sources appear to have continuous spectra? Which have discrete spectral lines?

10. **Photography through a grating**. Take color pictures through a diffraction grating and notice how spectra of various light sources appear.

11. **Making infrared radiation visible**. The unaided human eye is sensitive to a very limited range of the electromagnetic spectrum. However, it is possible to detect radiation that lies beyond our normal vision by using a digital camera or smartphone. Use either device to view the infrared LED at the end of a remote control unit while depressing any button on the remote. What do you see?

Laboratory (See Appendix J)

7.1 Spectrum Analysis with a Diffraction Grating

Glossary of Terms

absolute temperature Temperature on a scale that begins at absolute zero and measures temperature in kelvins (K). Celsius temperature is converted to absolute temperature by adding 273 K.

blackbody An ideal absorber and emitter of light.

Bohr model Model of the atom in which electrons move in stable orbits around the nucleus.

coherent light Light in which all photons have the same phase and wavelength (such as laser light) .

color temperature The temperature of the blackbody with the closest spectral energy distribution to a given light source.

efficacy Measure of the power efficiency (lumens per watt) of a light source.

electron volt Unit of energy equal to the energy that an electron would acquire traveling from the negative to positive terminal of a 1-volt battery.

emissivity Ratio of the radiant energy from a nonideal surface to that of a blackbody at the same temperature.

fluorescence Absorption of light and subsequent reemission at a longer wavelength.

illuminance Measure of the light intensity striking a surface in lumens/m^2 (lux) .

irradiance Measure of the radiation intensity on a surface.

joule Unit of energy in SI system.

kelvin One degree on the absolute temperature scale.

laser Coherent monochromatic light source that utilizes the stimulated emission of radiation.

light-emitting diode (LED) A very efficient semiconductor light source used especially in outdoor displays, radios, TVs, home appliances, and automobile tail lights.

lumen Unit for measuring luminous flux or output of light sources.

luminescence Absorption of energy and emission of light; includes fluorescence and phosphorescence.

luminous flux Radiant flux scaled according to the sensitivity of the eye at each wavelength.

nanoscale light source Light-emitting device having dimensions on the order of 10 to 100 nm.

phosphorescence Absorption of light and delayed emission at longer wavelength.

photometer Illuminance meter used by photographers, illumination engineers, and others.

photometry Measurement of energy content in the visible portion of the electromagnetic spectrum.

photon A particle of light having an energy hc/λ.

population inversion A condition in which more atoms are in the higher energy state than in the lower one (a nonequilibrium condition).

quantum dot A nanoscale semiconductor that emits light in wavelengths that are determined by its size.

radiometry Measurement of radiant energy of electromagnetic radiation.

stimulated emission of radiation A photon triggers an atom to emit a photon of the same wavelength (as in a laser).

watt Unit of power in SI system.

Further Reading

Bloomfield, L. A. (2017). *How Everything Works: Making Physics Out of the Ordinary.* Hoboken, NJ: John Wiley & Sons, Inc.

Craford, M. G., & Steranka, F. M. (1994). "Light-emitting diodes." In George L. Trigg, ed., *Encyclopedia of Applied Physics,* Vol. 8. New York: VCH Publishing Co.

Falk, D. S., Brill, D. R., & Stork, D. G. (1986). *Seeing the Light.* New York: John Wiley & Sons.

Pedrotti, S. J., & Pedrotti, L. S. (1993). *Introduction to Optics,* 2nd. ed. Englewood Cliffs, NJ: Prentice Hall.

Serway, R. A., & Jewett, J. W. (2014). *Physics for Scientists and Engineers,* 10th ed. Boston: Cengage Learning.

Sources of Color

<div style="text-align: right">8</div>

Color surrounds us. It is a sensation that adds excitement and emotion to our lives. Everything from the clothes we wear to the pictures we paint revolves around color. In this chapter, methods of producing and manipulating color through the use of paints, dyes, filters, and lighting will be explored.

8.1 Spectral Color

In the 1660s, English physicist and mathematician Isaac Newton performed a series of experiments with sunlight and prisms. He allowed a narrow beam of sunlight formed by a hole in a window shade to pass through a triangular glass prism. Newton found that the prism produced an elongated patch of multicolored light on the opposite wall as shown in Fig. 8.1. While this phenomenon had been known at least since the time of the Egyptians, Newton was the first person to provide a satisfactory explanation of the production of the spectral colors. This phenomenon is known as *dispersion* of light.

Proof that the spectral colors are not added by the glass prism but actually exist in the white light came from an experiment in which Newton added a narrow slit that allowed only a single spectral color to fall on a second prism, as shown in Fig. 8.2. Spectrally pure red light falling on the second prism, for example, remained red after it passed through the second prism. Newton described such light from a narrow portion of the spectrum as "homogeneal"; today we call it *monochromatic* (meaning "one color").

The modern *spectroscope* is an instrument that measures the power (in watts) of the components of light at various wavelengths. Light entering the spectroscope is spread into a spectrum by a prism (or a diffraction grating; see Sect. 5.9). A detector

© Springer Nature Switzerland AG 2019
T. D. Rossing and C. J. Chiaverina, *Light Science*,
https://doi.org/10.1007/978-3-030-27103-9_8

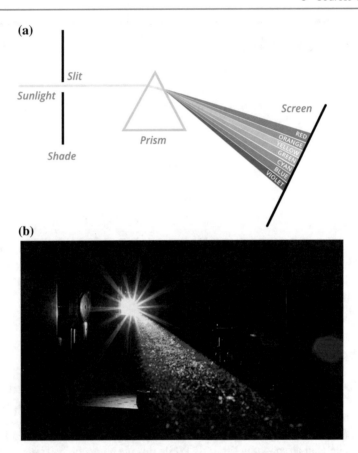

Fig. 8.1 **a** Diagram of Newton's famous prism experiment. **b** A recreation of Newton's experiment using a prism and an incandescent source in place of the Sun (Peeter Piksarv (https://commons.wikimedia.org/wiki/File:Valge_valguse_spekter.jpg), "Valge valguse spekter", https://creativecommons.org/licenses/by-sa/3.0/legalcode)

moves across the screen to measure the power at each wavelength, known as the *spectral power distribution* or SPD. Figure 8.3 shows SPDs for the blue, green, and red portions of the spectrum. The response of our visual system to a particular SPD can generally be predicted using our knowledge of the human visual system. However, it is more difficult to deduce the SPD of light from the visual response it produces, as we shall see, because a given response can often be produced by different SPDs.

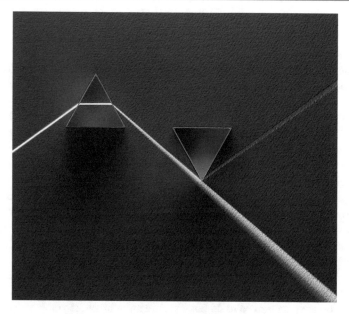

Fig. 8.2 Newton's experiment with two prisms showing that spectral colors (red in this example) cannot be further subdivided into other colors (David Parker/Science Source)

Fig. 8.3 Spectral power distribution (SPD) for the blue, green, and red portions of the spectrum

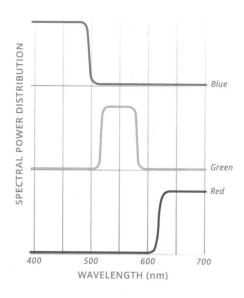

8.2 Additive Color Mixing

It is possible to mix red, green, and blue light in the right proportions to obtain nearly any desired color. We can even obtain white light. While it is possible to use other combinations of three colors, the range of colors obtainable by additive mixing may then be smaller. To be more specific, the "best" red, green, and blue lights to use have wavelengths of 650, 530, and 460 nm, respectively. The phosphors used in color television (which works by additive mixing) are the additive primaries, as saturated as phosphors will allow.

Additive color mixing is easily accomplished by projecting nearly monochromatic lights from two or more projectors onto a white screen. When a beam of red light is projected so that it overlaps a beam of green light, the result is yellow; red and blue lights produce magenta; blue and green lights produce cyan. An additive mixture of red, green, and blue (with proper luminant intensity) produces white, as shown in Fig. 8.4. The complementary pairs in additive mixing are red/cyan, green/magenta, and blue/yellow.

Three beams of light having wavelengths around 650 nm (red), 530 nm (green), and 460 nm (blue) can be used to obtain almost any desired color by additive mixing. You are encouraged to do this experiment yourself, if you have not already done so, by using color filters with slide projectors, colored LEDs, or a commercial light box (see Experiment 8.1 in Appendix J).

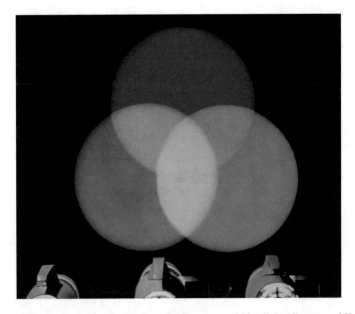

Fig. 8.4 Additive color mixing by overlap of red, green, and blue light (Courtesy of Kodansha, Ltd.)

Fig. 8.5 A magnified image of a computer screen revealing colored pixels. The eye additively mixes the small picture elements to produce virtually any color

Three colors that can produce white light (or light of any color) are called *primary* colors. They need not be monochromatic, although they often are. There is no unique set of primaries, although some choices will provide a wider range of colors than others. The most widely used primaries for additive color mixing are red, green, and blue.

Fig. 8.6 The Crown Fountain, by contemporary Spanish artist Jaume Plensa, in Chicago's Millennium Park uses partitive mixing to form colored images (Serge Melki from Indianapolis, USA (https://commons.wikimedia.org/wiki/File:Chicago_-_Crown_Fountain_-_Millennium_Park_(271 3868085).jpg), "Chicago—Crown Fountain—Millennium Park (2713868085)", https://creativecommons.org/licenses/by/2.0/legalcode)

Any two colors that produce white light when added together are called *complementary*. The complement of a primary color is called a *secondary* color. Thus, cyan (blue + green) is the complement of red, magenta (blue + red) is the complement of green, and yellow (green + red) is the complement of blue. Note that yellow and cyan can also be spectral or monochromatic colors, thus illustrating the fact that the same visual response can result from different SPDs.

Additively mixing colors can also be achieved by placing separate sources so close to each other that the eye cannot see them as separate (how close is this was discussed in Chap. 5). This type of additive mixing, sometimes called *partitive mixing*, is used in television screens and computer monitors (see Fig. 8.5).

Partitive mixing is also widely used in large-scale electronic displays that are often found at sporting events, concerts, in transportation hubs, and in artistic installations. The Crown Fountain in Chicago, shown in Fig. 8.6, employs partitive mixing through the use of closely spaced LEDs.

As was discussed in Chap. 5, partitive mixing was also used by the Pointillist painters, who put small dabs of different colored paints near each other (see Fig. 5.23). When the painting is viewed close up, the individual dots can be seen; but at normal viewing distance, the colors fuse to give an additive color. Textiles

Fig. 8.7 Different hues may be produced by adjusting colored sectors on a color wheel (Fouad A. Saad/Shutterstock)

Fig. 8.8 **a** Newton's color circle shows the range of spectral colors. **b** The result of adding two colors (blue and green here) is represented by a point on the line joining the two colors; its hue is indicated by where a line from the center through the point meets the circle

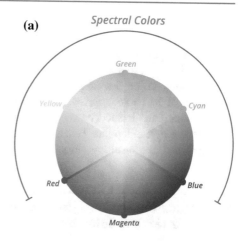

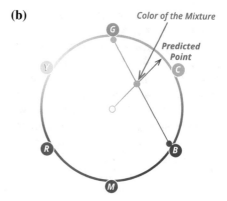

often achieve their colors by partitive mixing, using a tight weave of two different colors in the warp and weft.

Another way of mixing colors additively is to display them in rapid succession so that the afterimage of one mixes with the image of the next. A simple device using this effect is the rotating color wheel, shown in Fig. 8.7. By adjusting the size of the colored sectors, different hues can be obtained, including a neutral gray (the luminance is generally insufficient to make the gray appear white).

The additive relationships between colors can be illustrated using *Newton's color circle*, shown in Fig. 8.8. The three primary colors are arranged around a circle with the complementary secondary colors placed directly opposite them. Thus, the colors red through blue are in the same relative positions as they fall in the spectrum (violet at the extreme end of the spectrum is included with blue). Note that magenta (or "purple") is not a spectral color. Magenta cannot be produced by monochromatic light; it can be seen only when the spectral power distribution contains both short and long wavelengths (by combining red and blue light or by subtracting green from white light). Newton closed the color circle with magenta

because it logically fits there, opposite to its complement, green, not because this position represents a physical aspect of light.

This arrangement allows us to predict the result when two colors are added together. We need to draw only a line connecting two colors, as shown in Fig. 8.8b. The resulting color lies somewhere on that line, depending upon the relative brightness of the two colors, and the hue of this color is represented by a position on the circumference located by drawing a second line from the center of the circle outward through this point. When blue and green lights of nearly equal brightness are combined, the resulting color comes close to cyan, as shown in Fig. 8.8b.

8.3 Transmission and Reflection of Colored Light: Subtractive Color Mixing

Subtractive color mixing occurs when light passes through two or more selectively absorbing materials, such as two color filters. Dyes or pigments can be mixed together to form a single color agent that will absorb selectively. The process is called subtractive because each filter or pigment absorbs certain portions of the spectrum, leaving the light with a hue complementary to that subtracted. A piece of glass that absorbs the blue and green wavelengths of white light appears red because it transmits only the longer wavelengths.

The appearance of a colored filter may give little indication of its spectral absorption curve. Two filters that appear to have the same color may transmit light of different colors when combined with another colored filter. To predict the result of combining two filters (or mixing two pigments), the transmittance curves must be known. Transmittance curves tend to have rather complicated shapes; to better understand color mixing, we consider ideal filters that transmit 100% at some wavelengths and totally absorb all others. Transmittance curves of ideal blue, green, and red filters are shown in Fig. 8.9a–c.

For subtractive mixing, it is instructive to consider filters that pass the complements of the additive primaries. For example, yellow is the complement of blue, so it can be made by absorbing the blue in white light. Similarly, magenta results from absorbing the green in white light, and cyan results from absorbing the red. Thus, yellow, magenta, and cyan may be considered the three *subtractive primaries*, and their idealized transmittance curves are shown in Fig. 8.9d–f. Combining the three filters (d–f) will absorb all colors and produce black; similarly, combining any *two* of the filters (a–c) will produce black. Combining two of the filters (d–f), however, will give one of the additive primaries. For example, passing white light through the magenta filter (f) will subtract the green primary, leaving red and blue, as shown in Fig. 8.9g; a cyan filter will remove the red, leaving blue.

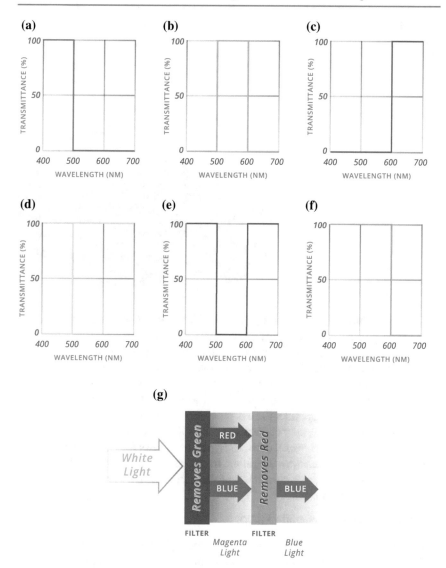

Fig. 8.9 Transmittance curves of ideal filters: **a** blue, **b** green, **c** red, **d** yellow, **e** magenta, **f** cyan; **g** illustrates passage of white light through a magenta filter (which removes green) and then a cyan filter (which removes red)

Simple subtractive mixing is illustrated in Fig. 8.10. The figure shows the effect on white light of three partially overlapping broadband filters that produce subtractive mixing. A subtractive mixture of cyan and magenta gives blue; a subtractive mixture of cyan and yellow gives green; a subtractive mixture of yellow and magenta gives red; a subtractive mixture of yellow, cyan, and magenta gives black.

Fig. 8.10 Simple subtractive
mixing. R = red; G = green;
B = blue; C = cyan;
M = magenta; K = black

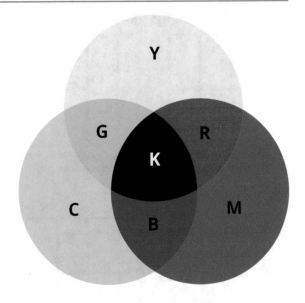

Primary colors are simply hues you start with to mix others. Designating certain hues as primaries is an arbitrary convention that depends on who makes the selection. Red, yellow, and blue are generally considered the artist's primaries; by mixing appropriate amounts of these pigments, almost any other hue can be produced. We have seen, however, that yellow, magenta, and cyan (the complementaries of blue, green, and red) also work well as subtractive primaries.

Manufacturers of light filters often provide a spectral transmittance curve for each filter that indicates the percentage of light that is transmitted at each wavelength (called simply the *transmittance*). Figure 8.9 shows the transmittance curves for "ideal" filters. At each wavelength the transmittance is either 0 or 100%. In real life, no such ideal filters exist; more realistic transmittance curves for stage light filters are shown in Fig. 8.11.

Spectral and Monochromatic Filters

It is common practice to label a filter by the hue it produces from a beam of white light. This is useful but is imprecise and sometimes misleading. On the other hand, the transmittance curve of a filter completely describes its effect. Transmittance curves for three different types of yellow filter are shown in Fig. 8.12. The common non-spectral filter used in colored stage lights, for example, transmits a rather broad range of wavelengths from green through red. Yellow light can also be obtained from a *spectral* filter that transmits a rather narrow range of wavelength or by a *monochromatic* filter with an extremely narrow range of wavelength.

The colors from the nonspectral, spectral, and monochromatic filters in Fig. 8.12 may produce light with the same hue (yellow), but they will differ in saturation. The spectral filter produces greater saturation than the non-spectral one but at the expense of brightness. Spectral and monochromatic filters are not commonly used on the stage because they pass such a narrow portion of the spectrum.

Fig. 8.11 Transmittance curves for stage light filters: **a** light red; **b** medium yellow; **c** Kelly green; **d** sky blue (Courtesy of Roscoe Laboratories)

A filter that has the same transmittance for all wavelengths is called a *neutral density filter*. Neutral density filters are useful in photography. A 50% neutral density filter transmits 50% of the original beam power at each wavelength and 50% of the overall light intensity.

Spectral Power Distribution of Filtered Light

In Chap. 7 we discussed the spectral power distribution of light from different light sources, including blackbodies, incandescent lamps, fluorescent lamps, and gas-discharge tubes. If we wish to know how light from one of these sources will appear after it passes through a filter, we can combine the spectral power distribution (SPD) of the light source with the transmittance curve of the filter, as shown in Fig. 8.13. The SPD of the emerging light will exhibit features that are characteristic of both the light source and the filter.

Fig. 8.12 Transmittance curves for three different types of yellow filter

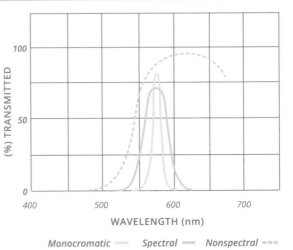

Monocromatic ━━ Spectral ━━ Nonspectral ▪▪▪

Fig. 8.13 The SPD of light emerging from a filter combines the SPD of the light source with the transmittance of the filter (After Williamson and Cummins 1983)

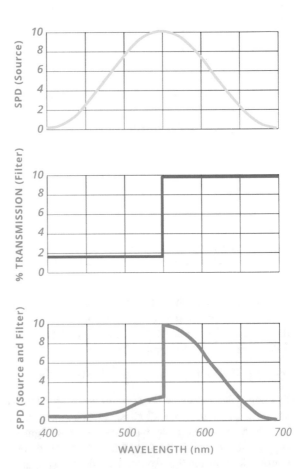

Spectral Reflectance

The way in which a surface affects the SPD when reflecting light is described by its *spectral reflectance curve*. This gives the percentage of light reflected at each wavelength and it determines the color an object appears to have when viewed in white light. Spectral reflectance curves of three common food products are shown in Fig. 8.14. Note that butter reflects a higher percentage in the red portion of the spectrum than a ripe tomato. It has a yellow hue, however, because it also reflects in the green portion of the spectrum, while a tomato does not.

The SPD of light reflected from an object will be determined by the SPD of the incident light combined with the spectral reflectance curve, much in the manner of transmitted light, as illustrated in Fig. 8.13. Careful attention must be applied to selecting the light source to be used to display paintings of various types in a museum, for example. In fashion magazines, much attention is given to the effect of illumination on the color of lipstick, eye shadow, and dress color.

Figure 3.11 illustrates the difference between regular or *specular* reflection and *diffuse* reflection. A surface that provides mostly specular reflection is called a *glossy surface*, whereas one that provides mostly diffuse reflection is called *matte*. Reflection from most surfaces is partly specular and partly diffuse. The interplay between the two can be quite fascinating because the proportions change with the direction of illumination and viewing angle. Artists often make use of this in painting, including areas suggesting specular reflection to emphasize form and enhance depth.

The Spanish painter El Greco sometimes used generous areas of white to highlight robes and faces in portraits. This can be seen in his *The Burial of the Count of Orgaz* (Fig. 8.15). Several areas of this painting seem to shimmer. As art historian Jonathan Brown observes, "Each figure seems to carry its own light within or reflects the light that emanates from an unseen source."

The nature of the reflecting surface distinguishes "flat" paint from "glossy" paint. Glossy paints produce specular reflection, in one direction at least, and the colors that reflect from a glossy surface are generally more saturated than those

Fig. 8.14 Spectral reflectance curves for butter, lettuce, and tomato (After GE publication TP-119)

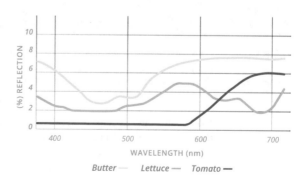

Fig. 8.15 El Greco's *The Burial of the Count of Orgaz* demonstrates the interplay between diffuse and specular reflection. Careful inspection reveals an image produced by specular reflection from the Count's armor (El Greco [Public domain], via Wikimedia Commons)

reflected from matte surfaces. Artists realize that the texture of a surface can be suggested by the degree of saturation of its color. Photographers know that moistening a surface with water darkens the area and provides more saturated colors. A similar effect is seen when wood is varnished to enhance the colors of the grain texture.

8.4 Pigments and Dyes

Paint pigments and dyes are the traditional sources of color available to the artist. A pigment is a finely divided, colored substance that imparts its color effect to another material either when mixed with it or when applied over its surface in a thin layer. Paint pigments, such as shown in Fig. 8.16, are usually powders that can be suspended in a medium such as oil or acrylic to form the paint. Pigments may be derived from a variety of natural sources including vegetables, animals, and minerals. They may also be synthesized.

Colored substances that dissolve in liquids and impart their color to materials by staining are classified as dyes. When dissolved in a solvent, the individual molecules of the dye become separated within the solvent. These individual molecules absorb colors selectively. Plastic filters for stage lighting and photography consist of dyes dissolved in clear plastic or gelatin. Dyes dissolved in water or other solvents are used in color fabric and paper.

Between soluble dyes and insoluble paint pigments is another category of coloring agents known as *lakes*, which are pigments prepared from dyes. They are essentially particles of translucent colorless alumina (aluminum oxide) whose color is determined by the dyes applied to them. In fabric dyeing, lakes are useful when the dye itself will not adhere to the fabric. The alumina particles suspended in water adhere to the fabric and react with the dye to form a fast color. Lakes have been used for centuries to enrich coloration in paintings.

Pigments used by painters illustrate the principles of subtractive color mixing. In oil painting, for example, the pigment is generally suspended in a binder, such as linseed oil, which dries to provide a protective cover. Light shining on the binder

Fig. 8.16 Pigments appear colored because they selectively reflect certain wavelengths of light (Dan Brady (https://commons.wikimedia.org/wiki/File:Indian_pigments.jpg), "Indian pigments", https://creativecommons.org/licenses/by/2.0/legalcode)

Fig. 8.17 Numerous
interactions between light and
pigments determine paint
appearance

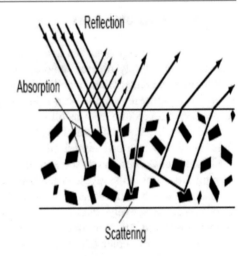

surface is partially reflected; the remaining light enters the binder and strikes the
particles of pigment, which act like tiny mirrors and filters. If the particles are
opaque, the light will be selectively reflected and absorbed. Transparent particles
will reflect, absorb, and transmit incident light. These processes occur many times
as the light makes its way through the binder (Fig. 8.17).

8.5 Painting Materials

Through the ages, master painters have worked with a variety of materials. Some
readers of this book would already have studied the techniques of painting and will
be quite familiar with them. Others, however, who are using this text to gain as an
understanding of light and color, or to enhance their appreciation of the visual arts,
may appreciate a brief discussion of materials in paintings.

Traditional paints consist of pigments plus a suitable binder. Encaustic paintings
combine pigment with wax, fresco paintings combine pigment in aqueous solution with
plaster, tempera paintings combine pigment with egg yolk, pastel paintings combine
dry pigment with a weak solution of gum Arabic, watercolor paintings combine pig-
ment with an aqueous solution of gum Arabic, and oil paintings combine pigments with
oil. The pigment may be ground finer or coarser in one type of paint or another.

Painters over the centuries have been very attentive to the demands of particular
materials. The composition of their paintings has often been adapted to best accom-
modate the materials used. Sometimes paintings incorporate more than one binder
because the artist wishes to use different pigments, some of which are compatible with
one binder but not with others. Painters often select materials to give a desired texture to
their paintings. Most serious painters have carefully studied the works of the great
masters and understand the materials they used. However, artists also experiment with
new materials and develop new techniques to incorporate them.

In the twentieth century, science has given painters a number of new materials with which to work. Among them are polymer colors, acrylic colors, synthetic organic pigments, and luminescent pigments. Synthetic media have a number of advantages over traditional materials: they can be less expensive, they are fast drying, they are long lasting, they can be built up to greater thickness, they adhere to a wide variety of surfaces, and coloring agents other than pigments can be used with them. Although adopting new materials always calls for the painter to learn new skills, the new synthetic materials have probably made the techniques of painting easier for artists.

An in-depth examination of both traditional and synthetic painting media may be found in Appendix G.

8.6 Printing

Color printing in books and magazines makes use of both additive and subtractive color mixing. Before we discuss this topic, let us consider how black-and-white pictures are printed.

Halftone Printing

A photograph with a continuous range of brightness (from black to gray to white) is called a *continuous tone* in the printing trade. In contrast, the *halftone process* commonly used for printing photographs consists entirely of black dots on a white background, as shown in Fig. 8.18. To print a region of gray, the paper is printed

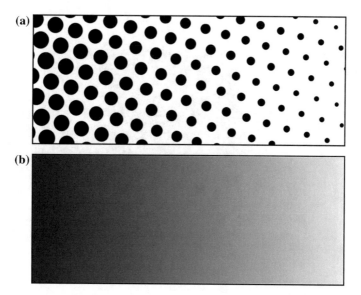

Fig. 8.18 a A halftone consists of black dots on a white background. **b** Very small dots are undetectable at normal viewing distance

with black dots of such a size and spacing that the area is half dots and half white space (hence the name *halftone*). If the dots are sufficiently small, visual fusion makes them undetectable at the normal viewing distance, and the area is seen as a uniform gray. These dots can be seen when a halftone-printed photograph is viewed with a magnifying lens.

Four-Color Printing

Most modern four-color printing procedures produce four screened positive films of the picture: one for the magenta parts, one for the yellow, one for the cyan, and one for black. (Theoretically, three should suffice, but experience has shown that printing inks do not perfectly represent subtractive primaries, so when the three colors are superimposed they produce dark brown rather than black.) Figure 8.19 shows an example of what is seen when looking at a printed color image through a magnifying (convex) lens.

When making the screened separations, the lines of dots are rotated by about 30° between one color and the next to avoid unwanted geometric dot patterns in the final plate. Because of the partial overlap of the dots, both subtractive and additive color mixing play a role. Where the dots overlap, the color is produced by subtractive mixing; where they are adjacent, additive (partitive) mixing applies.

A color photocopier or inkjet printer makes four copies of the original, the first three as viewed through yellow, cyan, and magenta filters. Yellow, cyan, magenta, and black toner or inks are applied to the paper in more or less continuous layers, so no dots are seen through a magnifying lens (unless the original was printed, in which case the colored dots may be copied, more or less).

Fig. 8.19 Magnified four-color printing on white paper (Peter Hermes Furian/Shutterstock)

8.7 Colored Glass

Glass can be colored by the addition of chromium, manganese, iron, cobalt nickel, or copper ions. Ions are atoms that have gained or lost electrons so that they carry an electrical charge. In the case of the "transition metals" listed, the atoms have lost either two or three electrons so they carry a++ or +++ charge. These transition metal atoms have a partially filled shell of electrons (called the 3d shell) that have rather low excitation energies, and therefore they absorb in the visible region of the spectrum (see Sect. 7.2). In common soda-lime silica or window glass, for example, chromium (Cr+++) ions absorb in the red and blue regions of the spectrum and thus give a green color to the glass, whereas cobalt (Co+++) ions give glass a reddish-blue color.

Stained glass became an important art material in the Middle Ages in Europe during the building of the great cathedrals. The glass used in the great cathedral windows came from many shops, such as the Murano glassworks in Venice. The monk Suger, abbot of the monastery of Saint-Denis near Paris, made stained glass the centerpiece in rebuilding the monastery church, which in turn inspired its use in other great cathedrals at Chartres and elsewhere (see, e.g., Fig. 8.20).

Fig. 8.20 Stained glass windows in the Cathedral of Bayeux, Calvados, Normandy, France (Public Domain via Wikimedia Commons)

The range of colors in glass that can be obtained with metal ions is somewhat limited in that it does not include red. Reds and yellows can be obtained by adding small particles of gold, copper, or silver to the glass. Such a suspension of one substance in another is called a *colloid*. When the metal particles in glass are smaller than 50 nm, they scatter light of short wavelengths more effectively than light of long wavelengths (Rayleigh scattering; see Sect. 1.5), so the light that passes through the glass tends to look red, like the color of the setting Sun. Gold and copper, which absorb in the blue and green, produce bright red; silver, which has only a weak absorption in the blue, produces a yellow color. Scattering may also arise from tiny air bubbles within the glass.

8.8 Glazes and Enamels

The hardening of wet clay by heating it to high temperatures has been known for many years. The resulting material is known as pottery. During the heat treatment, colors appear due to impurities depending on the conditions in the oven or kiln. For example, in a nearly airtight kiln allowing little oxygen to enter, iron-bearing clay (as found in ancient Greece) generally turns black due to the formation of magnetite (Fe_3O_4) at temperatures around 1000°. If air is allowed to circulate, however, the iron combines with more oxygen to form hematite (Fe_2O_3), and the color changes to reddish-brown.

Before firing, a design can be applied with a water paint (a *slip*) bearing particles of materials such as iron oxide or manganese oxide. Various slips and the underlying clay absorb oxygen at different rates, and by careful firing, the various slips can be altered to produce different colors.

An important use of glass, both clear and colored, is in producing a *glaze* for pottery. Glass is ground to a fine powder, mixed with a liquid binder, and painted on the pottery. During firing, the glaze melts and fuses together to form a thin liquid layer that solidifies on cooling to form a coat of solid glass. By using powdered glass of various colors, a pattern can be worked into the glaze. For tableware, the glaze forms a smooth glass surface that is more hygienic than porous, unglazed pottery. However, lead glass should be avoided, since the lead can be leeched out of the glaze.

A thin layer of glass fused to a metal, called *enamel*, can provide decoration and prevent corrosion. As in glazing, a powdered glass suspended in a liquid binder is spread over the metal surface, and the object is fired briefly to fuse the powder to the surface. The final color of the enamel is very sensitive to the firing conditions and can be dramatically affected by impurities at the surface of the metal. Porcelain enamel is commonly applied to iron for kitchenware, sinks, and bathtubs.

8.9 Light as the Medium

It's not about light or a record of it, but it is light. Light is not so much something that reveals, as it is itself the revelation.

—Artist James Turrell

There is possibly no element in the creation and appreciation of art more important than light. Artists have long manipulated light to establish both mood and meaning as well as provide visual information regarding shape and depth. In the early twentieth century, the role of light in art expanded dramatically when it was realized that light itself could be used as an artistic medium. This understanding ushered in what is commonly known alternately as light art, light sculpture, or luminism.

Hungarian artist László Moholy-Nagy is considered to be the first to use light as a sculptural element. His 1930 creation, titled *Light-Space Modulator*, was a kinetic sculpture consisting of 70 flashing lights mounted on a rotating platform. Later, another light sculpture pioneer, American abstract artist Charles Biederman, used red, blue, and yellow fluorescent light tubes to illuminate a static, partially painted wood and glass geometric relief construction he titled *#9, New York, 1940*. While artificial lighting was integrated into the piece, it was not the sole medium.

In the 1960s, Dan Flavin started using commercially produced lamps and fixtures as the only components in his art. His first work, *Diagonal of May 25, 1963*, consisted of a single yellow fluorescent tube mounted at an angle on a wall. This seminal work made light both the subject and the medium. Flavin went on to create dozens of additional light sculptures and installations, including the one shown in Fig. 8.21 In his *Structure and clarity,* Flavin expanded the use of fluorescent tubes using a palette of red, blue, green, pink, and yellow.

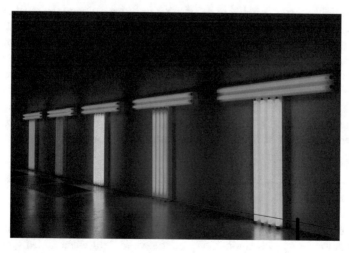

Fig. 8.21 Dan Flavin's *Structure and clarity* (Grand Parc—Bordeaux, France from France (https://commons.wikimedia.org/wiki/File:Dan_Flavin_-_Structure_and_clarity_-_Tate_Modern_Museum_London_(9671384931).jpg), "Dan Flavin—Structure and clarity—Tate Modern Museum London (9671384931)", https://creativecommons.org/licenses/by/2.0/legalcode)

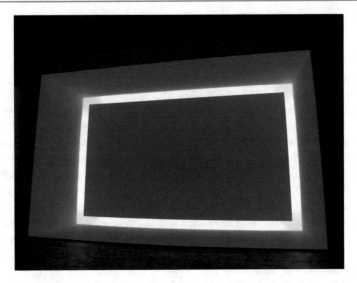

Fig. 8.22 James Turell's *Raemar Magenta* (Mikenorton (https://commons.wikimedia.org/wiki/File:Raemar_Magenta.JPG), https://creativecommons.org/licenses/by-sa/4.0/legalcode)

Later, artists who include Robert Irwin, Bruce Nauman, Doug Wheeler, and James Turrell began investigating the relationship among the viewer, light, visual perception, and space. These artists are considered to be part of the so-called "Light and Space" movement that flourished in California during the 1960s. Like Flavin, many in this influential group incorporated fluorescent as well as neon lighting in their works.

Of the light artists, Turrell's body of work is perhaps among the most expansive and diverse. Using only light and environment, Turrell's creations run the gamut from extremely simple, yet powerfully evocative, light projections to large-scale environmental works. One of his earlier works, *Raemar Magenta*, is shown in Fig. 8.22. With a focus on perceptual experiences, many of Turrell's installations allow, in his words, "visitors to enter the light." His most ambitious work is *Roden Crater* in Arizona, where he is transforming an extinct volcano into a celestial observatory. When completed, visitors will enter the volcano, where they will experience the nexus of light, space, and astronomical events.

8.10 Summary

Three colors that can produce white light (such as red, green, and blue) are called primary colors. Any two colors that produce white light when added together are called complementary. The complement of a primary color is called a secondary color. Additive relationships between colors can be represented on Newton's color

circle. Additive mixing may be obtained by superposition, by partitive mixing, or through visual persistence.

Yellow, magenta, and cyan are considered the three subtractive primaries; combining filters (or pigments) of these colors will generally produce black. The transmittance curve of a filter completely describes its effect, but filters with different transmittance curves can produce the same hue. A spectral filter produces greater saturation than a nonspectral one but at the expense of brightness.

Dyes and paint pigments are the two main sources of color available to the artist; however, some artists use light itself as an artistic medium.

◆ Review Questions

1. The secondary colors, cyan, magenta, and yellow, can each be obtained by subtracting a primary color from white light. Which primary color is subtracted in each case?
2. **a.** What is meant by a spectral color?
 b. Which two of the secondary colors can also be spectral colors?
3. What are the two main sources of color available to the artist? How are they different?
4. What is a lake? Describe an application for lakes.
5. Describe three methods of additive color mixing.
6. What is a neutral density filter?
7. Explain the difference between monochromatic, spectral, and nonspectral filters.
8. List some of the advantages of using synthetic painting media.

▼ Questions for Thought and Discussion

1. White light first passes through a magenta filter, then a cyan filter. Describe the color of the light that emerges from the filter combination.
2. Is it possible to produce black using additive color mixing? Explain your answer.
3. Explain why colored fringes appear around objects when viewed through a lens. This defect is called chromatic aberration, a problem that prompted Newton to investigate light and color.

● Experiments for Home, Laboratory, and Classroom Demonstration

Home and Classroom Demonstration

1. **Mixing colored light I**. The eye retains an image for a short time after the removal of the stimulus that produced it. It is therefore possible to combine colors by presenting them to the eye in rapid succession. If, for example, a flash of red light impinges on the retina, the sensitive cones that are activated by the light continue sending signals to the brain for a fraction of a second. If a source

of green light strikes the retina within this time, the brain will perceive yellow, the additive combination of red and green. A device referred to as the color mixing turbine provides a simple way to achieve additive color mixing. To construct a color mixing turbine, bend two opposite corners of a small black cardboard square in opposite directions to produce "turbine blades." Attach a green sticker to the center of one side of the card. Repeat with a red sticker to the opposite side. Gently hold the card's two unbent corners between your index finger and your thumb. Blow on the blades to make the turbine spin. The alternating colors act as flashing red and green lights, the combination of which produces the sensation of yellow.

2. **Mixing colored light II**. To convince yourself that only the three additive primary colors are responsible for the myriad hues you see on your television screen or computer monitor, hold a magnifying glass close to the screen. Once the proper viewing distance is achieved, you will see an array of small red, blue, and green dots or rectangles. If you are watching a television program, note that the intensity of each colored dot is constantly changing. Why?

3. **Selective reflection**. The color of an object depends in part on the color of the light shining on it. To observe this phenomenon, all you need is a cardboard box with a lid (a shoebox is perfect) and sheets of colored cellophane (red and green work well). Cut a square opening, roughly $4'' \times 4''$, in the box lid. Cover the opening with a single sheet of cellophane. Finally, cut a viewing hole in one end of the box. You are now ready to experiment. Place various colored objects in the box and examine their appearance under the colored light. How do the objects appear? Do some of them look strange? Why does the color of some objects appear to change when viewed in the box?

4. **Subtractive color mixing I: Overlapping filters**. Hold cyan and magenta filters together so that white light passes through both filters before entering the eye. Carefully observe the color that is visible through overlapping filters. Repeat this procedure with combinations of cyan, magenta, and yellow filters. What do you see when you overlap all three filters?

5. **Subtractive color mixing II: Combining inks**. Place two drops of yellow ink and two drops of magenta ink on a sheet of wax paper. After slowly mixing the two inks together with a Q-tip, use the Q-tip to draw a line or other figure on a piece of white paper. What color appears? Repeat the procedure with combinations of yellow and cyan inks, then cyan and magenta inks. Finally, mix two drops of all three inks together. Each time use a clean Q-tip. What conclusions can you make regarding the various combinations of the subtractive primaries cyan, magenta, and yellow? (Note: Dr. Ph. Martin's yellow, magenta, and teal Bombay India Inks work well.)

6. **Viewing paintings in colored light**. Observe the effect of illuminating paintings with various colors of light.

Laboratory (See Appendix J)

8.1 Exploring Color.
8.2 Mixing Pigments: Subtractive Color Mixing

Glossary of Terms

complementary colors (of light) Two colors that produce white light when added together.

complementary colors (of pigment) Two colors that produce black when added together.

dye A solution of molecules that selectively absorbs light of different colors.

enamel A thin layer of glass fused to a metal.

glaze A thin layer of glass covering the surface of pottery.

halftone process Printing with black dots of various sizes to represent shades of gray.

hue Color name; what distinguishes one color from another.

lake Coloring agent consisting of alumina particles covered with dye.

monochromatic filter Filter that allows only one wavelength (color) to pass through.

neutral density filter Gray filter that reduces the intensity of light without changing its spectral distribution (color).

Newton's color circle Three primary colors arranged around a circle with the complementary secondary colors directly opposite.

paint pigments Color-absorbing powders suspended in a medium such as oil or acrylic.

primary colors (additive, of light) Three colors that can produce white light.

primary colors (subtractive, of filters or pigments) Three colors that can produce black.

saturation Purity of a color; spectral colors have the greatest saturation; white light is unsaturated.

spectral filter Filter that passes a distribution of wavelengths of light.

spectral reflectance curve Graph indicating the portion of light reflected at each wavelength.

spectroscope Instrument that measures the power (in watts) of light at each wavelength.

spectral power distribution (SPD) Power of light as a function of wavelength.

Further Reading

Coren, S., Porac, C., & Ward, L. M. (1984). *Sensation & Perception*. San Diego: Harcourt Brace Jovanovich.

Eckstut, J., & Eckstut, A. (2013). *The Secret Language of Color*. New York: Black Dog and Leventhal Publishers, Inc.

Finlay, V. (2014). *The Brilliant History of Color in Art*. Los Angeles: Getty Publications.

Franklin, B. (1996). *Teaching about Color and Color Vision*. College Park, MD: American Association of Physics Teachers.

Goldstein, E. B. (1989). *Sensation and Perception*, 3rd ed. Belmont, CA: Wadsworth.

Judd, D. B., & Kelly, K. L. (1965). *The ISCC-NBS Method of Designating Colors and a Dictionary of Color Names*. U.S. National Bureau of Standards Circular 553, 2nd ed. Washington, DC: U.S. National Bureau of Standards.

Overheim, R. D., & Wagner, D. L. (1982). *Light and Color*. New York: John Wiley & Sons.

Williamson, S. J., & Cummins, H. Z. (1983). *Light and Color in Nature and Art*. New York: John Wiley & Sons.

Color Vision

<div align="right">

9

</div>

> *Color does not occur in the world, but in the mind.*
> —Diane Ackerman

Color, like pitch in music, is a perceived quality. Just as pitch depends upon the frequency of a tone, color depends strongly on the frequency (or wavelength) of the light that reaches our eyes. However, that is not the whole story. In music, the perceived pitch also depends upon such things as the intensity of the sound and the presence of other sounds. Likewise, perceived color depends upon such things as brightness and context.

Because color is a perceived quality, we depend on human observers to describe it. Even the keenest and most artistic observer really has no way to specify a color in an absolute sense. We all pretty much agree on the meaning of "red," and "yellow," and "green," but how do you describe the color of a new coat to a friend over the telephone? Most likely, you do it by comparing it to some other piece of clothing or something in nature that is familiar to both you and your friend (like blue sky or green grass).

In Sect. 1.2 we considered the question, what is color? We observed that instead of specifying the intensity distribution (spectrum), it is generally more profitable to specify three qualities of colored light that determine how the light appears: hue, saturation, and brightness.

Hue, you recall, refers to the color name or what distinguishes one color from another; all reds differ in hue from all blues regardless of other qualities. Hue is specified as a dominant wavelength in the visible spectrum that best matches the perceived color, even though light of that particular wavelength may not be present.

Saturation corresponds to the "purity" of the color; a saturated color has its intensity concentrated near the dominant wavelength, while an unsaturated color includes contributions from other wavelengths as well. Spectral colors have the greatest saturation; white light, which consists of all colors, is unsaturated. Artists

T. D. Rossing and C. J. Chiaverina, *Light Science*,
https://doi.org/10.1007/978-3-030-27103-9_9

sometimes use the terms *chroma* or *color intensity* to mean something similar to saturation.

Brightness (or *lightness*) refers to the sensation of overall intensity, ranging from dark, through dim, to bright. Other terms used to describe brightness are *value*, *brilliance*, and *luminosity*. To change the brightness of a light, we can adjust the intensity of the source; to change the lightness of a surface, we can make it less reflecting. Reducing the overall illumination on a sheet of white paper doesn't necessarily make it appear gray; however, it may continue to look white.

9.1 Photoreceptors in the Eye

The retina is covered with two basic kinds of photoreceptors: *rods* and *cones*, named for the shapes of their tips. Typically, there are about seven million cones (sensitive to high light levels) and 120 million rods (sensitive to low light levels). Rods sense only brightness, but cones sense both brightness and hue. Color-sensitive cones are interspersed with the more numerous rods, but near the center of the retina is an area (the *fovea*) consisting almost entirely of cones. At the fovea, each cone is connected to its own optic nerve fiber; elsewhere in the retina, about 80 receptors are connected to a single nerve fiber. Figure 9.1 shows the density of rods and cones as a function of angle measured from the fovea.

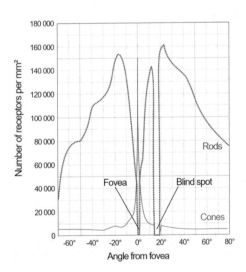

Fig. 9.1 Density of rod (red line) and cone (blue line) photoreceptors along a line passing through the fovea and the blind spot of a human eye versus the angle measured from the fovea (Cmglee (https://commons.wikimedia.org/wiki/File:Human_photoreceptor_distribution.svg), "Human photoreceptor distribution", https://creativecommons.org/licenses/by-sa/3.0/legalcode)

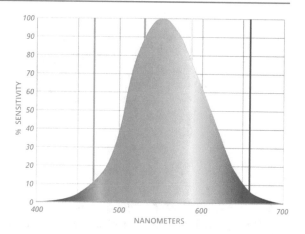

Fig. 9.2 The sensitivity of cones in the human eye varies with wavelength of light (Skatebiker at English Wikipedia [Public domain], via Wikimedia Commons)

Color vision, *photopic* vision, which depends on cone cells, does not operate at very low levels of illumination; by moonlight, hues vanish and only shades of gray remain. Unlike the cones, rods can adapt to very dim light by increasing their sensitivity; thus they provide useful vision even by starlight. In very dim light, one may detect an object out of the corner of the eye (where *scotopic* or rod vision predominates) that cannot be seen by looking directly at it.

Figure 9.2 shows how cone sensitivity varies with wavelength of light. As the graph illustrates, the human eye is sensitive to wavelengths of light roughly between 400 nm (violet) and 700 nm (red). Notice how the eye is most sensitive to green light, with maximum sensitivity occurring at 555 nm. As a result, a green light source producing the same amount of power as a red source will appear much brighter.

The photosensitive material in rods and cones is *rhodopsin*, a purplish derivative of vitamin A and the protein opsin. When light strikes a molecule of rhodopsin, electron motion causes the molecule to change shape and generate an electrical signal that can be transmitted to the brain. The molecule in its new shape is unstable and decays through a series of steps that result in loss of color or bleaching. Since sensitivity of the photosensors depends upon the amount of rhodopsin (visual purple) present, it must be regenerated. This regeneration occurs most rapidly in the dark and requires a supply of vitamin A. Lack of vitamin A retards the regeneration process and leads to night blindness.

Although the two systems of photosensors, rods and cones, provide two different "film speeds" to deal with different light levels, each system adjusts its sensitivity as the light level varies. The changing sensitivity is called *adaptation*, and it takes place over minutes, as shown in Fig. 9.3. When you enter a dark room, your cone sensitivity begins to increase. When it can increase no more, you switch to rods, and their sensitivity will also increase if necessary. Switching from cones to rods results

Fig. 9.3 Adaptation, the
eye's transition from photopic
to scotopic vision, takes place
over several minutes

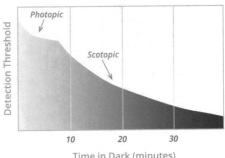

in loss of color; however, under scotopic conditions, the world is seen as black, white, and gray (just as the fastest photographic films record only in black, white, and gray).

There is another difference in the behavior of rods and cones; rods are most sensitive at the short wavelength (blue) end of the spectrum, whereas cones are most sensitive at the long wavelength (red) end. Thus, at light levels high enough that the cones are operating, a red object may appear brighter than a blue object, but at low levels (where only the rods operate), the same blue object may appear brighter than the red one. This change, called the *Purkinje shift*, is useful to astronomers, who may need their precise cone vision for reading meters but shortly afterward need their rod vision for sensitive observing. To allow this rapid change, they use red lights for illumination. The red stimulates mainly the cones, leaving the rods adapted to more dark.

The dark adaptation of each eye tends to be independent of the other. If one eye is closed when a light is turned on in a dark room, it remains dark adapted for maximum sensitivity when the light is turned off.

9.2 Color Perception

Most theories of color perception, including those of Thomas Young (1801) and Hermann von Helmholtz (1852), assume at least three different types of cones that respond preferentially to light of different wavelengths. We could call them S, M, and L to designate short, medium, and long wavelengths; their response curves overlap considerably, so that at any wavelength at least two types of cones respond to any given wavelength, as is shown in Fig. 9.4.

How we perceive the color of an object is strongly influenced by its surroundings, how long we observe the color, and by the nature of the illumination. We briefly consider some of these effects.

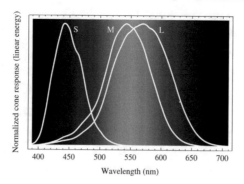

Fig. 9.4 Response curves for S, M, and L cones (Bhutajata (https://commons.wikimedia.org/wiki/File:Normalized_response_spectra_of_human_cones.png), https://creativecommons.org/licenses/by-sa/4.0/legalcode)

How Many Colors Can We See?

One approach to answering this question is to start at one end of the visible spectrum and slowly change the wavelength until the observer sees a difference in color. Most observers can discriminate about 150 steps between 380 and 700 nm. However, we can obtain many more discriminable steps by changing the saturation and brightness as well. Taking into account that each of the 150 discriminable colors can have many values of saturation and brightness, it is estimated that we can discriminate over seven million different colors.

Another approach is to ask how many color names there are. The advertising world has invented thousands of color names, such as strawberry, azure, Kelly green, Ferrari red, and so on. One compilation lists 7500 different color names. Color scientists generally prefer to deal with a much smaller number of basic colors. Hurvich states that we can describe all the discriminable colors by using red, yellow, green, blue, and their combinations, which he arranges in a circle (see Fig. 9.5), plus white and black. If we begin at red at 12 o'clock and move clockwise

Fig. 9.5 According to Hurvich, all distinguishable colors can be described in terms of the 16 colors displayed on the above circle

Fig. 9.6 After staring at the red circle, white areas appear blue–green

around the circle, the colors become increasingly yellowish until reaching yellow at 3 o'clock. Continuing on, colors become greener, until pure green is reached at 6 o'clock, and so on.

Afterimages

If you stare at one color for some time and then quickly shift your attention to a white sheet of paper, you will generally see a *negative* afterimage in a complementary color. This is a type of adaptation; after a period of stimulation, the receptors become less sensitive to further stimulation and are thus fatigued. If you stare at the red circle in Fig. 9.6 for a few seconds, for example, the red receptors become fatigued. When you shift your gaze to the white area on either side of the circle, the blue and green receptors are fully stimulated and the paper appears blue-green. Try it!

Even after a color stimulus is removed from the retina, the receptors continue to be active for a short time, and this leads to a *positive* afterimage. To observe a *positive* afterimage, close your eyes for several minutes and cover them with your hands so that the residual effects of previous light have died away. Open your eyes for a second or two and stare at some brightly lighted patch of color. Then close your eyes again, and you should see an afterimage of the object with its original color. The same type of positive afterimage occurs when a flashbulb flashes in a dark room.

If you stare at the center of Fig. 9.7 for a while and then look at a white piece of paper, you should see an afterimage of a famous face. Is this a positive or negative afterimage?

Simultaneous Contrast

Two colors that appear to be identical when viewed separately may appear quite different when viewed side by side. Helmholtz explained simultaneous contrast as due to afterimages; ordinarily you do not stare at a single spot but rather roam the visual field, and you thus create weak overlapping afterimages of which you are unaware. If you are presented with two adjacent areas of different color, your eyes will flick back and forth between these two areas, and each color you see will be a combination of the true color of that area and the afterimage of the adjacent area.

Fig. 9.7 Staring at this image and then looking a sheet of white paper should reveal a rendering of a well-known painting. Blinking should restore the afterimage if it should begin to fade

Simultaneous contrast was first formally discussed by French chemist Eugene Chevreul in his treatise *Principles of Harmony and Contrast of Colours*. As a director of dying at a French tapestry company, Chevreul observed that colors would be become more vibrant and saturated, when placed next to other colors. For example, when blue and yellow are juxtaposed, they both become more intense (see Fig. 9.8). Staring at the boundary separating the two colors reveals the effect. Chevreul's studies had a major impact on the art world, for they led to the development of impressionism and, later, the Pointillist technique of painting as practiced by Seurat and Signac.

A second dramatic example of simultaneous contrast, created by artist Josef Albers, is seen in Fig. 9.9. Although both X's have exactly the same color (which can be seen at the point where they join), the X on top looks yellow while the one on the bottom looks gray or brown.

Fig. 9.8 Contrast increases when colors are placed side by side. The effect can be seen along the boundary between the blue and yellow squares

Fig. 9.9 Simultaneous
contrast makes the top X
appear yellow and the bottom
X appear gray or violet

Albers once said, "Simultaneous contrast is not just a curious optical phenomenon, it is the very heart of painting." It comes as no surprise then that he spent a large portion of his life exploring the effects of simultaneous contrast through a series of hundreds of paintings titled *Homage to the Square*, all of which had a compositional theme of three or four squares set inside each other.

In addition to simultaneous contrast, there is also a successive contrast effect. If you look for a period of time at an area of one color and then look quickly at an area of a different color, the color of the second area will be modified. For example, if you stare at an orange piece of paper for a while and then look at a green piece of paper, the green paper will take on a definite blue-green appearance for a period of time.

Professor Robert Greenler (University of Wisconsin, Milwaukee) illustrates this beautifully in a program available on the internet called "Whiter Than White, Blacker Than Black, and Greener Than Green: The Perception of Color." You are asked to look intently at a saturated green and its complement (magenta) side by side. Then the slide is changed so that the same green is seen on both halves; the side that was previously magenta now appears "greener" due to successive contrast with the magenta that was there previously.

Color Constancy

Objects tend to retain the same perceived color even though the coloration of the illumination may change. The light from the blue sky is quite different from the light of a bonfire, yet the same object seen under these two different illuminations may appear to have essentially the same color. The so-called *color constancy* apparently also involves chromatic lateral inhibition. For example, an overall excess in red illumination is ignored because the increased stimulation at the center of the receptive field and inhibition in its surroundings cancel each other.

There is a limit to color constancy, of course. If we view a blue object in illumination that has no blue light whatsoever (such as the yellow light from a sodium lamp), it will appear black. However, it is surprising how very little blue light needs to be present in order for us to identify it as being blue. The remarkable ability to adapt to the color quality of the prevailing illumination is sometimes called general color adaptation.

Color Vision Deficiency

Color vision deficiency, or simply color deficiency, occurs when light-sensitive cells in the retina fail to respond appropriately to wavelengths of light that normally enable people to see a full array of colors. Color deficiency affects more males than females, with roughly 8% of males and 0.5% of females having problems seeing or differentiating colors. While the condition may result from injury or disease, the majority of cases are hereditary. Men are much more likely to be color-deficient than women because the genes responsible for the most common, inherited form of the deficiency, known as red–green color deficiency, are on the X chromosome.

Most color-deficient individuals are able to see things as clearly as other people but may be unable to differentiate between red, green, or blue. This is why the term "color blind" is a misnomer. Extremely rare is the case where a person is unable to see any color at all, a condition known as *monochromacy*.

The two most common types of color deficiency are *protanopia* and *deuteranopia*. In individuals with protanopia, also known as blue–yellow color deficiency, the retina fails to respond to the color red. Red appears as black. Certain shades of orange, yellow, and green all appear as yellow. In males with deuteranopia, or red–green color deficiency, retinal photoreceptors are insensitive to green. These individuals tend to see red as brownish-yellow and green as beige. Deuteranopia is the most common form of color deficiency.

There are various tests to diagnose color deficiency, one of the most common being the Ishihara Color Test. The test, specifically designed for those with red–green color deficiency, consists of a series of colored circles, called Ishihara plates. Within each circle are dots that form a figure visible to those with normal color vision, but invisible or difficult to see for those red–green color deficiency. An example of an Ishihara Color Test plate is shown in Fig. 9.10.

Chromostereopsis

Looking at Fig. 9.11, viewers often report seeing what appears to be a red circle hovering above a blue square (image on the left) and a recessed blue circle surrounded by a red square (image on the right). Owing to a phenomenon known as chromostereopsis, red objects can appear closer to the observer than blue or green objects. Some individuals will find the opposite to be true, while still others don't perceive any three-dimensionality whatsoever.

The effect of color on depth perception was first noted by Goethe over 200 years ago. While the cause of this illusion is still not fully understood, many studies indicate that it results, in part, from chromatic aberration, an optical distortion that

Fig. 9.10 An Ishihara Color Test plate used to detect red–green color blindness (Public Domain via Wikimedia Commons)

Fig. 9.11 Chromostereopsis can result in red objects appearing closer to the observer than blue or green objects (Courtesy of Akiyoshi Kitaoka)

occurs because of the failure of a lens to bring all colors to the same point of convergence. In the case of the eye, this means that different colors fall on different areas of the retina. As shown in Fig. 9.12, the shorter wavelengths are focused more toward the nose while the longer ones are focused more toward the ear. This mimics ordinary depth perception, in which closer objects are focused more toward the ear and farther ones more toward the nose.

Chromostereopsis is often observed on computer screens. Sometimes the illusion is meant to enhance the screen image, but most often the effect is unintentional. An artistic use of the phenomenon can be seen in some paintings and stained glass

Fig. 9.12 Different colors fall on different areas of the retina. Some studies suggest that this produces a sense of depth

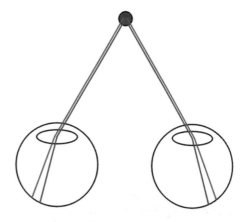

Fig. 9.13 This stained glass window provides an example of chromostereopsis. To many observers, the red appears closer than the blue, producing a sense of depth (Bielsko-Biała Museum and Castle [Public domain, GFDL (http://www.gnu.org/copyleft/fdl.html) or CC-BY-SA-3.0 (http://creativecommons.org/licenses/by-sa/3.0/)]

windows. A rather striking example of this is seen in Fig. 9.13 where the strategic use of red and blue create a sense of depth.

As discussed in Sect. 5.10, ChromaDepth® glasses produce a stereoscopic effect by exaggerating chromatic aberration. Like chromostereopsis observed with the naked eye, the glasses give the illusion of different colors taking up different positions in space, with, once again, red appearing in the foreground.

9.3 Theories of Color Vision

A comprehensive explanation of how the eye responds to color has to address the mechanisms responsible for color mixing, color contrast, and afterimages. While each of the following three theories successfully explains some aspects of color perception, none provides a complete picture of how we experience color.

In 1801 Thomas Young, an English physician noted for his work on the interference of light, proposed that the sensation of any color could be produced by a mixture of three "primary" colors. This *trichromatic theory* was championed by Hermann von Helmholtz (1852) and later came to be known as the Young–Helmholtz theory. According to this theory, light of a particular wavelength stimulates three receptor mechanisms to different degrees. Each receptor mechanism has a different spectral sensitivity, and the ratio of activity in the three mechanisms is coded into the nervous system and results in the perception of color. The response curves of the three receptor mechanisms are similar to the CIE color-matching functions in Fig. 9.18.

An *opponent-process theory* of color vision was proposed by Ewald Hering in 1878. Hering was not completely satisfied with the trichromatic theory of color vision. It seemed to him that when human observers are presented with a large number of color samples and asked to choose those that appear to be pure, they tend to select four, rather than three, colors. These colors include red, green, and blue, as predicted by trichromatic theory, but they also include yellow.

Hering noted that certain color combinations, such as yellowish-blue and greenish-red, are never reported by observers, which led him to suggest that the four primaries are arranged in opposing pairs, each with an associated receptor mechanism. The red–green mechanism responds positively to red and negatively to green; the blue–yellow mechanism responds positively to yellow, negatively to blue. A third opponent mechanism, the black–white mechanism, responds positively to white, negatively to black. These positive and negative responses, according to Hering, represent the buildup and breakdown of a chemical in the retina. White, yellow, and red cause the buildup of the chemical, whereas black, blue, and green cause breakdown.

Modern physiological research shows us that color vision is based on the simultaneous operation of both the trichromatic and opponent mechanisms. At the level of the retinal receptors, the Young–Helmholtz theory appears to be adequate; however, it appears that further along the visual pathway there is strong evidence for processing in an opponent manner. Some nerves transmit continuously at a certain frequency. Such nerves can either be stimulated (in which case their pulse frequency increases) or inhibited (in which case it decreases); thus, two types of opposing information can be transmitted. Zone theories take the view that although the individual receptors behave in a trichromatic fashion, nerve cells farther along the visual pathway process the information in a way that resembles Hering's opponent-processing theory.

The *retinex theory* was proposed in 1959 by Edwin Land, founder of the Polaroid Corporation. Land's theory proposes that long-wavelength (L) cones, middle-wavelength cones (M), and short-wavelength cones (S) are organized into three independent systems, which he calls *retinex systems*, and that each system forms an independent achromatic picture of the visual field. Each retinex system selects the area in the field of view that appears brightest and compares this to the other areas; thus, if the illumination changes, the relative brightness should stay the same.

Retinex theory suggests that the eye is very sensitive to changes in light yields over the edges of objects in the field of view, but tends to ignore changes in intensity that take place over the body of the objects.

9.4 Color Systems

Although no color dictionary can describe the full range of distinguishable colors (see Sect. 9.2), several attempts have been made to systematically specify colors. The importance of being able to quantify the response of the human visual system cannot be overstated, for precise color description and matching are essential for color printing, paint and textile manufacturing, graphic design, and broadcasting.

The science of defining, measuring, and communicating color is known as *colorimetry*. Colorimetry replaces qualitative, subjective classifications, such as light blue, canary yellow, and dark purple, with objective and, sometimes, numerical descriptions of color.

A first step toward this goal was the realization that color needs to be expressed in terms of a three-dimensional model, often referred to as a color space. In one such model, colors are arranged, according to hue, saturation, and lightness, in a *color tree*, as shown in Fig. 9.14. The "trunk" of the tree consists of unsaturated colors ranging from black through gray to white. The degree of saturation is indicated by the distance out from the trunk, and the hue by different directions around the tree. While a beginning, the specificity needed to accurately describe a color was still missing.

The Munsell and Ostwald Color Systems

There are essentially two approaches to achieving a quantitative description of color. One method involves the use of colored samples against which other materials can be compared; the other analyzes the spectrum of light reflected from a surface. The former was developed by Albert H. Munsell, a painter and art teacher, at the turn of the twentieth century.

Munsell used three color variables: *hue, chroma*, and *value* (corresponding to hue, saturation, and lightness in Fig. 9.14). The axis of the circle is a ten-step value scale, from black at the bottom, to white at the top. The ten basic hues of the *Munsell color system* are red, yellow, green, blue, and purple, and combinations of these in pairs (yellow–red, green–yellow, blue–green, purple–blue, and red–purple).

Fig. 9.14 Schematic drawing of a color tree. The vertical axis is lightness, the distance from the axis represents saturation, and angle represents hue

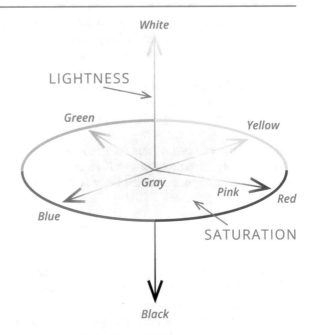

For each basic hue, there are ten gradations, making 100 distinct hues. Each basic hue is number 5 on its gradation scale: number 10Y is followed by 1 GY, for example. Chroma scales are of different lengths, depending on the particular hue and value. To completely specify a color in this system, it is only necessary to give three numbers: 5PB4/7, for example, would specify a purple–blue hue with a value of 5 and chroma of 7 (Fig. 9.15).

Early versions of the Munsell system were collections of hand-painted swatches, which were used as physical standards for judging other colors. As Fig. 9.16 shows, these swatches can be displayed on a tree.

A major improvement to the Munsell system occurred in 1943 when observers visually assessed paint samples, which resulted in a set of 2745 Munsell colors. Using a color measuring device known as a spectrophotometer, color can be identified quantitatively in terms of hue, value, and chroma. Any two swatches with the same three coordinates will have identical colors, even if they are made from different paint mixtures. By interpolating between the 2745 colors, any color can be uniquely identified.

The *Ostwald color system* uses color samples similar to those of Munsell. The Ostwald system uses the psychophysical variables of *dominant wavelength*, *purity*, and *luminance*, as shown in Fig. 9.17. Ostwald arranged his system with hues of maximum purity forming an equatorial circle and with complementary colors opposite. The axis of the circle graduates from white at the top down to black. Six-sided samples are arranged in 30 color triangles with a base of lightness and with the most saturated (highest purity) hue at the apex. Each sample is identified

Fig. 9.15 The Munsell color system, showing a purple–blue hue with a value of 5 and a chroma of 7 (jacob rus (https://commons.wikimedia.org/wiki/File:Munsell-system.svg), "Munsell-system", https://creativecommons.org/licenses/by-sa/3.0/legalcode)

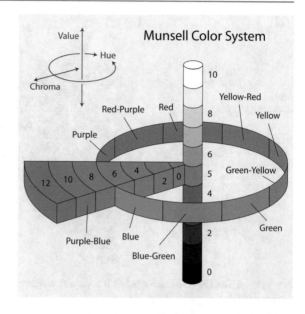

Fig. 9.16 Munsell color tree (Hannes Grobe (https://commons.wikimedia.org/wiki/File:Munsell_color-tree_hg.jpg), https://creativecommons.org/licenses/by-sa/4.0/legalcode)

by three numbers representing the proportion of black, white, and full color, adding up to a total of 100%.

A *chromaticity diagram*, developed by the CIE (Conseille International d'Eclairage or International Commission of Illumination) , makes it possible to describe color samples mathematically and to represent the dominant wavelength and purity of the sample on a diagram. To develop the CIE system, data was needed on the color-matching characteristics of the eye. Using a colorimeter, a number of observers matched colors against a spectrum of primary colors.

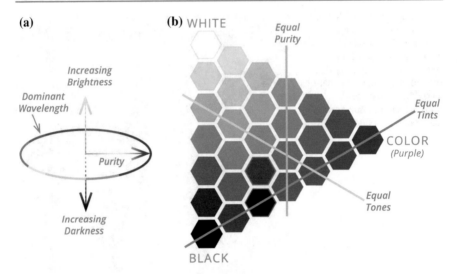

(a)

(b) WHITE

Equal
Purity

Increasing
Brightness

Dominant
Wavelength

Equal
Tints

COLOR
(Purple)

Purity

Equal
Tones

Increasing
Darkness

BLACK

Fig. 9.17 a The Ostwald color system; **b** a vertical section

Based on the results, the three color-mixture curves in Fig. 9.18 were produced; these represent the relative amount of each of the primaries needed by the average observer to match any part of the spectrum. These curves are labeled \bar{z}, \bar{y}, and \bar{x}, and they correspond to the "red," "green," and "blue" primaries. The \bar{y} curve is identical to the sensitivity curve of the human eye, so multiplying the \bar{y} curve times the spectrum to be analyzed gives the brightness of the spectrum.

Corresponding to the color-matching functions in Fig. 9.18 are three *tristimulus values* of the spectrum: X, Y, and Z. These are found by multiplying the \bar{x}, \bar{y}, and \bar{z} curves times the spectrum in question. For example, X gives the amount of "red" primary needed to match the spectrum being analyzed. To construct a chromaticity diagram, the color coordinates x, y, and z are defined as follows:

Fig. 9.18 The CIE
color-matching functions
(Public domain via
Wikimedia Commons)

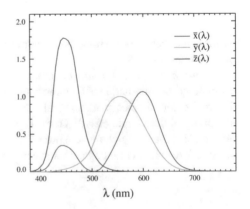

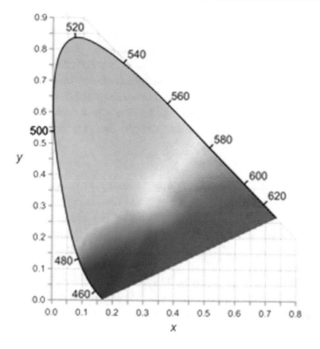

Fig. 9.19 A CIE-type chromaticity diagram. The entire spectrum of fully saturated hues (from 400 to 700 nm) lies on the smooth outer curve ([Public domain])

$$x = \frac{X}{X+Y+Z} \quad y = \frac{Y}{X+Y+Z} \quad z = \frac{Z}{X+Y+Z}$$

From the definitions, it follows that $x + y + z = 1$. This means that if two of the coordinates are given, the third is automatically determined. It is customary to use the coordinates x and y in constructing chromaticity diagrams, as shown in Fig. 9.19.

The CIE chromaticity or tristimulus diagram shows colors determined by the CIE graphs and equations. The CIE system works on formulas, not on color samples. The entire spectrum of fully saturated hues lies on the perimeter of the curve, with more space for greens because the eye is more sensitive to them.

Purples lie on a straight line, known as the "purple line," connecting the red and blue ends of the curve. Except for these endpoints of the line, colors on the line are nonspectral, that is, no monochromatic light source can generate them; rather, every color on the line is a mixture in a ratio, unique to that color, of fully saturated red

and fully saturated violet, these two spectral colors being the endpoints of visibility on the spectrum of pure hues. Colors on the line and spectral colors are the only ones that are fully saturated in the sense that, for any point on the line, no other possible color being a mixture of red and violet is more saturated than it.

All other colors are represented by points enclosed by the curve. Colors increase in saturation with their distance from the achromatic point (white). Thus, oval zones around this point represent colors of equal saturation. An additive mixture of two colors is represented by a point on the straight line connecting the points corresponding to these two colors.

9.5 Summary

Color is a perceived quality of light, and we depend upon human observers to describe it. Three qualities of colored light that determine how light appears are hue, saturation, and brightness.

The retina is covered with two basic types of photoreceptors: rods and cones. Rods sense only brightness, but cones sense both brightness and hue. Both types can adapt to different levels of illumination by changing their sensitivity. It is possible to dark-adapt one eye independent of the other one.

How we perceive the color of an object is strongly influenced by its surroundings, how long we observe the color, and by the nature of the illumination. Afterimage and contrast effects emphasize the pairing of colors, for very often the removal of stimulation produces the complementary hue, and the contrast effect is most notable between complementary colors.

Color vision deficiency occurs when light-sensitive cells in the retina fail to respond appropriately to wavelengths of light that normally enable people to see a full array of colors. The condition affects more males than females.

Trichromatic theories of color perception, such as the Young–Helmholtz theory, assume three different types of photoreceptors. Hering's opponent-process theory assumes that receptors transmit information about color pairs (blue–yellow, green–red, black–white) by increasing or decreasing neural activity. It is possible for both mechanisms to cooperate at different stages of the visual pathway. Land's retinex theory proposes that long-wavelength, middle-wavelength, and short-wavelength cones are organized into retinex systems and that each system forms an independent achromatic picture of the visual field.

Colors can be arranged, according to hue, saturation, and lightness, in a color tree or color chart, as in the color systems developed by Munsell and Ostwald. The CIE chromaticity diagram makes it possible to describe color samples mathematically and to represent the dominant wavelength and purity of the samples on a diagram.

◆ Review Questions

1. What are three other terms closely related to *brightness*?
2. Why can we often describe a color as "reddish-blue" but almost never as "reddish-green"?
3. What is the significance of the "purple line" in the CIE chromaticity diagram (Fig. 9.19)?
4. In very dim light, why can one detect an object out of the corner of the eye that cannot be seen by looking at it directly?
5. Why does eating carrots help to prevent night blindness?
6. Why is the Purkinje shift useful to astronomers?
7. How does simultaneous contrast depend upon afterimages, according to Helmholtz?
8. Of the three color systems, which is based on (a) hue, chroma, and value and (b) formulas?
9. Name and discuss the function and location of the two basic kinds of photoreceptors in the eye.
10. Which photoreceptors are most sensitive to low levels of light? To color? To black and white only?
11. What is an afterimage? Give an example.
12. What is color constancy? When does it no longer work?
13. Do pink and red differ in hue, saturation, or brightness?
14. Where are monochromatic colors found on the CIE diagram?

▼ Questions for Thought and Discussion

1. Does "red" mean the same to everyone, or do we have our own individual color catalogs?
2. How dim can the illumination be so that a sheet of paper still appears to be white?
3. Explain what is meant by "whiter than white" (see Sect. 7.6).
4. How might you produce something that is "blacker than black"? (see Sect. 7.6).
5. Name and discuss three theories of color vision.
6. Based on your knowledge of afterimages, suggest a reason why surgeons wear cyan-colored smocks in the operating room.
7. In terms of hue, saturation, and brightness, compare the Sun as it appears at noon and at sunset.

■ Exercises

1. What are the wavelengths of the peaks in each color matching curve in Fig. 9.18?
2. From Fig. 9.19, what are the values of x, y, and z for light with a 540-nm wavelength? For light with a 600 nm wavelength?

● **Experiments for Home, Laboratory, and Classroom Demonstration**

Home and Classroom Demonstration

1. **Adapting to red**. Brightly illuminate a red sheet of paper and look at it for about 30–45 seconds with your left eye alone (close your right eye). At the end of this time, look around the room first with your left eye and then with your right. The reds and oranges viewed with the left eye should look less saturated and less bright than those viewed with the right eye. You have changed your color perception by means of *chromatic adaptation*.

2. **Masking the surroundings**. Look at a green sheet of paper when it is brightly illuminated with an incandescent lamp; then look at it when it is illuminated with daylight. (In each case, look at close range or through a hole in a sheet of paper, so that you don't see the surroundings.) Most people perceive the green area to be slightly yellower in incandescent light than in daylight. Try this experiment with other colors.

3. **Changing afterimages**. In a dimly lit room, stand one or two feet from an unlighted incandescent light bulb. With your eyes trained on the light bulb, turn it on. After staring at the lighted bulb for approximately 2–3 s, turn off the light and close your eyes. The succession of colored afterimages that follow has to be experienced to be believed! Images of bulbs with centers and borders of different colors will slowly come and go. These ever-changing afterimages will persist for many minutes. The colors depend, in part, on your personal sensory apparatus. You may wish to compare your experiences with those of others. The brightness of the bulb and the duration of your exposure to the light will also affect the afterimages.

4. **Benham's disc**. See Activity 3 in Laboratory Experiment 9.1, Appendix J.

5. **Bezold-Brucke effect**. Brightly illuminate a white sheet of paper and cast a shadow over half of it. Looking through a red filter, you will notice that the hue of the red seen on the bright half of the paper is noticeably yellower than the hue seen on the shadowed portion. Looking through a green filter should produce a similar effect. When looking through a yellow filter, however, there will be little or no difference in hue. Thus, the brighter one makes a red or a green, the more yellow it appears. This hue shift with intensity is called the *Bezold-Brucke effect*.

6. **Painter's puzzle**. Two slightly different shades of the same color may look different if there is a sharp boundary between them, but if the boundary is obscured the two shades may appear identical. Take a paint sample strip from a paint or hardware store and place your index finger or a pencil over a boundary between two shades of paint. With the boundary obscured, the two shades may look indistinguishable. Try boundaries between other shades of paint. What do you observe?

Laboratory (See Appendix J)

9.1 Color Perception

Glossary of Terms

adaptation Adjustment of rod and cone sensitivities to deal with different light levels.

afterimage Image that occurs after a stimulus is removed. Afterimages may be either positive (same color) or negative (complementary color).

brightness Sensation of overall intensity, ranging from dark, through dim, to bright.

chroma Color intensity; a term used by artists to mean something similar to saturation.

chromatic lateral inhibition Ability of one part of the retina to inhibit color perception at another part.

chromaticity diagram A diagram on which any point represents the relative amount of each primary color needed to match any part of the spectrum.

chromostereopsis A visual illusion whereby the impression of depth is conveyed in two-dimensional color images, usually of red–blue or red–green colors.

color constancy Objects tend to retain the same perceived color even though the coloration of the illumination may change.

color tree A diagram whose vertical axis represents lightness, the distance from the axis represents saturation, and the angle represents hue.

complementary colors (of light) Two colors that produce white light when added together.

complementary colors (of pigment) Two colors that produce black when added together.

cone Photoreceptor that is sensitive to high light levels and differentiates between colors.

deuteranopia Color blindness resulting from insensitivity to green light.

fovea Area at the center of the retina that consists almost entirely of cones.

hue Color name; what distinguishes one color from another.

Ishihara Color Test A common test used to diagnose color deficiency.

luminance Term used in the Ostwald color classification system; similar to brightness.

monochromacy The lack of ability to distinguish colors.

Munsell color system A color system using ten basic hues, each of which has ten gradations, Chroma scales are of different lengths, depending on the particular hue and value.

opponent-process theory Receptors transmit information about color pairs (blue–yellow, green–red, or black–white) by increasing or decreasing neural activity.

Ostwald color system A color system that uses the variables of dominant wavelength, purity, and luminance. Colors are arranged so that hues of maximum purity form an equatorial circle with complementary colors opposite.

photopic Conditions of high light level under which cone vision predominates.

primary colors (additive, of light) Three colors that can produce white light.

primary colors (subtractive, of filters or pigments) Three colors that can produce black.

protanopia Color blindness resulting from insensitivity to red light.

purity A term used in the Munsell color system; similar to saturation.

Purkinje shift At high light levels a red object may appear brighter than a blue object, but at low light levels the same blue object may appear brighter than the red one.

purple line The straight line connecting the violet and red ends of the CIE diagram.

retinex theory Theory originated by Edwin Land; receptors in three retinex systems are sensitive to long-, medium-, and short-wavelength light.

rhodopsin Photosensitive material in rods and cones.

rods Photoreceptor that is sensitive to low light levels but does not differentiate colors.

saturation Purity of a color; spectral colors have the greatest saturation; white light is unsaturated.

scotopic Conditions of low light level under which rod vision predominates.

value A term meaning brightness.

Further Reading

Albers, J. (1975). *Interaction of Color*. New Haven, CT: Yale University Press.

Coren, S., Porac, C., & Ward, L. M. (1984). *Sensation & Perception*. San Diego: Harcourt Brace Jovanovich.

Eckstut, J., & Eckstut, A. (2013). *The Secret Language of Color*. New York: Black Dog and Leventhal Publishers, Inc.

Franklin, B. (1996). *Teaching about Color and Color Vision*. College Park, MD: American Association of Physics Teachers.

Goldstein, E. B. (1989). *Sensation and Perception*, 3rd ed. Belmont, CA: Wadsworth.

Hurvich, L. (1981). *Color Vision*. Sunderland, MA: Sinauer Associates.

Judd, D. B., & Kelly, K. L. (1965). *The ISCC-NBS Method of Designating Colors and a Dictionary of Color Names*. U.S. National Bureau of Standards Circular 553, 2nd ed. Washington, DC: U.S. National Bureau of Standards.

Livingstone, M. (2014). *Vision and Art: The Biology of Seeing*. New York: ABRAMS.

Overheim, R. D., & Wagner, D. L. (1982). *Light and Color*. New York: John Wiley & Sons.

Williamson, S. J., & Cummins, H. Z. (1983). *Light and Color in Nature and Art*. New York: John Wiley & Sons.

Photography

<div style="text-align: right">

10

</div>

The debate regarding whether or not photography is a form of art is long over. Photographs are found in art museums and private collections throughout the world. Many institutions, such as the George Eastman House in Rochester, NY, and the Museum of Contemporary Photography in Chicago are dedicated solely to photography. Owing to his love of the art form, singer and composer Elton John is the curator of a collection of over 8000 vintage photographs. And like other works of fine visual art, photographs often bring millions of dollars at auction.

Modern technology has given the photographer a wide range of tools for creating photographic images. We will consider some of these tools and the physical principles that make them work; others go beyond the scope of this book. The photographic art provides us with an opportunity to apply many of the principles of light and color that you have already learned. Modern cameras, tablets, and smartphones are so easy to use that it is tempting to merely "point and shoot." Nevertheless, understanding photography and careful consideration of both scientific and artistic principles will result in much more satisfying photographs.

10.1 A Brief History of Photography

The earliest device for projecting and copying images was the pinhole camera or *camera obscura*, which we discussed in Chap. 3 (see Fig. 3.4). Although a sharp image could be produced by such a camera by making the pinhole small, the image was so dim that only the brightest subjects could be traced. In the sixteenth century, Girolamo Cardano added a lens to the camera, which allowed it to gather much more light and greatly increased the image brightness.

In 1826, French inventor Nicéphore Niépce succeeded in recording images of bright objects on a varnished pewter plate coated with asphaltum, a natural tar-like substance. The asphaltum that received less light could be dissolved with a solvent such as oil of lavender, and the plate was etched and engraved to form a permanent

© Springer Nature Switzerland AG 2019
T. D. Rossing and C. J. Chiaverina, *Light Science*,
https://doi.org/10.1007/978-3-030-27103-9_10

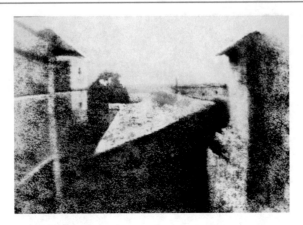

Fig. 10.1 *View from the Window at Le Gras,* the first successful permanent photograph created by Nicéphore Niépce in 1826 in Saint-Loup-de-Varennes (Joseph Nicéphore Niépce [Public domain], via Wikimedia Commons)

record, which Niépce called a *heliograph* (see Fig. 10.1). About a century earlier, John Schulze, a German physicist, had discovered that certain silver salts darken when exposed to sunlight.

A major step forward was made when French painter Mandé Daguerre coated a copper plate with silver and exposed it to iodine vapor so that the surface became covered with a thin layer of silver iodide. Light striking the plate converted some of the silver iodide to small particles of silver. The plate was then developed by exposing it to mercury vapor so that the silver particles united with mercury to form an amalgam of silver and mercury. Finally, the plate was washed in a solution of sodium thiosulfate to remove the unexposed silver iodide. Daguerre called the images on his plates *daguerreotypes*. An early daguerreotype is shown in Fig. 10.2.

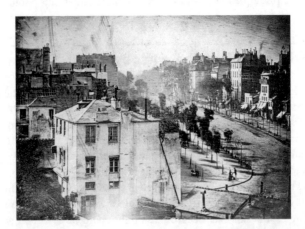

Fig. 10.2 The first surviving picture of a living person, taken in 1838 by French painter Mandé Daguerre. The image shows a busy street, but due to exposure time of more than 10 min, the traffic was moving much too fast to appear (Louis Daguerre [Public domain] via Wikimedia Commons)

Daguerreotypes could show considerable detail, but exposure times were very long. Nevertheless, they were commercially successful. A number of daguerreotypes can be seen in museums around the world.

English amateur scientist William Fox Talbot is given credit for inventing the negative–positive process that made it possible to produce multiple prints of a photographic image. He coated paper with silver chloride to make it light-sensitive. After exposure, the paper was washed in a solution of sodium chloride or potassium iodide. Although the tones were reversed, he could reverse them again by photographically copying the negative image on a second sensitized paper.

In 1851, another Englishman, Frederick Archer, invented the collodion wet plate negative. Glass plates were coated with a mixture of iodine and bromine salts dissolved in collodion. Some 20 years later, collodion wet plates were superseded by gelatin dry plates, which consisted of glass plates coated with gelatin mixed with potassium bromide and silver nitrate.

In 1884, George Eastman invented a new photographic system that used roll film with a paper base and a roll film holder. Then, in 1889, the Eastman Kodak Company developed a transparent flexible film that used cellulose nitrate as a base. A small box camera with a roll film holder was also developed. Box cameras remained popular for many years (see Fig. 10.3).

Kodak is also responsible for the 35 mm film that remains in use today. The format, which Kodak introduced in 1913, was later adopted by Leica in the 1920s for use in a camera they developed for still photography. For reasons of fire safety and durability, the 1920s saw Kodak and other companies transition from nitrate to celluloid-based film. Since the 1960s, the use of plastic-based film has been the norm.

Over a period from 1910 to the mid-1930s, color photography evolved from taking individual photos with red, blue, and green filters then overlapping them, to the much simplified and convenient use of a three-emulsion "sandwich." Referred

Fig. 10.3 Bulls-Eye Kodak box camera, circa 1898 (Eastman Kodak Co. [Public domain], via Wikimedia Commons)

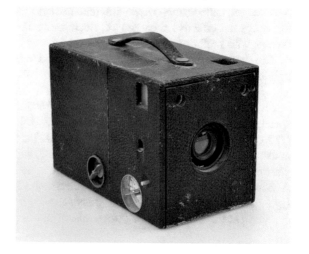

to as a "tripack," the new format, marketed by Agfa-Ansco, allowed picture taking with a snapshot camera. Available in a roll, the film offered convenience, if not the sharpest color images.

In the early 1940s, Kodak revolutionized color picture taking with the introduction of Kodachrome. The film was the first to use dye-coupled colors in which a chemical process connects the three dye layers together to create an apparent color image. Taking quality color photographs with Kodachrome was so simple that Kodak proudly proclaimed, "You press the button, we do the rest."

Everything changed in 1986 when Japanese company Nikon introduced a commercially available digital camera. Fourteen years later the world's first digital camera phone, also known as a smartphone, was marketed by Sharp. In the same year, digital camera sales exceeded those of film cameras. Now dedicated digital cameras have taken a backseat to smartphone cameras, which now number in the billions.

10.2 Cameras

Cameras may be categorized as compact, or point and shoot, and *single-lens reflex* (SLR). Compact and SLR cameras come in both film and digital models. Digital SLRs are referred to as DSLRs. Today, the most used digital cameras are found on smartphones.

The essential parts of a camera are the lens, the shutter, the diaphragm (or iris), and film or an electronic sensor. The purpose of the lens is to focus an image on the film. A single convex lens will do this (see Sect. 4.7), but most cameras have multi-element lenses in order to minimize distortion and produce the sharpest possible image. In "point-and-shoot" cameras, the lens is fixed in one place, but in more sophisticated cameras the lens can be moved closer to or farther from the film in order to sharply focus either distant or close subjects. With lenses of variable focal length, called *zoom lenses*, different elements are moved relative to each other to change the effective focal length. Such lenses are very convenient for photographers who prefer not to change lenses.

The shutter controls the length of the exposure in order to accommodate different lighting conditions. Shutter speed is the amount of time the shutter remains open. The slower the shutter speed, the longer the film or image sensor is exposed to light.

Shutter speeds are expressed in seconds or fractions of a second. Typical shutter speeds, measured in seconds, include 2, 1, 1/2, 1/4, 1/8, 1/15, 1/30, 1/60, 1/125, 1/250, 1/500, 1/1000, 1/2000, 1/4000, 1/8000. Each speed increment halves the amount of light. Fast shutter speeds have the effect of freezing motion in the scene you are photographing. Conversely, slow shutter speeds will blur motion in a scene.

Shutters may either be mechanical or electronic. Mechanical shutters are of two types: the leaf shutter at the lens ("between-the-lens" shutter) and the moving curtain near the film or sensor ("focal-plane" shutter).

A leaf shutter employs a small number of identical overlapping metal blades called leaves that open and close. The leaves are relatively light and only have to travel a short distance. This allows fast shutter speeds. Unlike most focal-plane shutters, a leaf shutter provides synchronization with flash at all shutter speeds.

A focal-plane shutter consists of a pair of curtains. One curtain, which initially covers the focal plane, moves away, exposing the light-sensitive medium. After the desired exposure time, the second curtain, moving in the same direction, closes the aperture. When the shutter is cocked, the shutter curtains move back to their starting positions. An advantage of the focal-plane shutter is that all parts of the frame receive light for the same amount of time.

Unlike the leaf shutter, that covers a round aperture, the focal-plane shutter typically covers a rectangular area, immediately in front of the film or sensor. Cameras with interchangeable lenses tend to use a focal-plane shutter to avoid the expense of having a leaf shutter on each of the lenses.

Smartphone cameras, and many digital cameras, use electronic shutters. With this type of shutter there's no physical barrier. Instead, an electrical pulse tells the sensor when to record. The sensor does not take light onto its surface all at once; rather the image is built up over time by stacking pixels row by row. The advantages of this type of shutter are that it is silent and capable of much higher shutter speeds than mechanical shutters. Speeds of 1/32,000th of a second are not uncommon. A downside to this arrangement is that it can produce what are known as "rolling shutter" effects, distortions in the images of fast-moving objects and rapidly flashing lights. This situation results from subject movement as the image is being captured.

Canon and Sony have each developed an electronic sensor that doesn't suffer from the rolling shutter effect. This type of shutter, referred to as a global shutter, exposes all of the sensor's pixels at the same time, thus eliminating distortions and blurring.

Most traditional DSLR cameras use a mechanical shutter, while the majority of mirrorless cameras have an electronic shutter. An increasing number of DSLRs have both.

In SLR cameras the exposure time can be determined automatically, a feature that has disadvantages as well as advantages. However, cameras have an override feature so that the photographer can set the exposure time manually, a feature preferred by most serious photographers. To aide in determining proper length of exposure, SLR cameras have a built-in light meter and an electronic readout displayed on a backlit LCD screen at the bottom of the viewfinder. Other cameras display the readout on the back or top of the camera.

With compact and some digital cameras, framing a subject is accomplished with a direct-vision viewfinder. The viewfinder, which is situated to the side or on top of the camera's lens, provides a view of the subject slightly different from that seen through the lens. This gives rise to what is known as parallax error, which can make it difficult to properly frame the subject. The discrepancy between the two views is most pronounced for short subject distances.

An SLR camera is shown in Fig. 10.4; a cutaway drawing of an SLR camera
appears in Fig. 10.5. A noteworthy advantage of SLR cameras, as well as DSLR
cameras, is that focusing and framing the picture can be done with great accuracy
by looking directly through the lens. The mechanism that makes this possible is
rather complicated. During focusing, the diaphragm aperture is usually fully
opened, and a mirror drops down to direct the light from the lens onto a
ground-glass screen where it is viewed through a doubly reflecting pentaprism, as

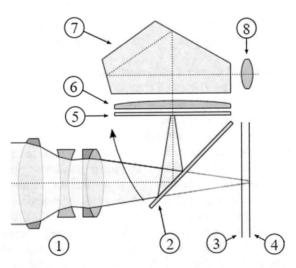

Fig. 10.5 Cross-section view of SLR system: 1—Front-mount lenses. 2—Reflex mirror at
45-degree angle. 3—Focal-plane shutter. 4—Film or sensor. 5—Focusing screen. 6—Condenser
lens. 7—Optical glass pentaprism (or pentamirror). 8—Eyepiece (en:User:Cburnett (https://
commons.wikimedia.org/wiki/File:SLR_cross_section.svg), "SLR cross section", https://
creativecommons.org/licenses/by-sa/3.0/legalcode)

shown. When the shutter release is pressed, the mirror flips out of the way, and the aperture stop closes down to its preset size; then the shutter opens, and the picture is recorded. All this must happen in a fraction of a second.

Some digital cameras don't employ a mirror. In these "mirrorless" cameras, light passes directly through the lens onto the image sensor. The captured image is displayed on screen on the rear of the camera, which takes the place of an optical viewfinder. These cameras have the advantage of lighter weight and simpler construction.

The focal length of a camera lens determines the field of view. The "standard" lens on most SLR cameras has a focal length of 50 or 55 mm. A *wide-angle lens* having a focal length of 28 or 35 mm allows a larger field of view, a feature that is useful for photographing tall buildings in a city or for taking photographs in a small room. On the other hand, a *telephoto lens* narrows the field of view so that distant subjects appear much larger than they would with the standard lens. One of the advantages of SLR cameras is the ease with which lenses can be interchanged. Because the lens is used both as the viewfinder and rangefinder, no adjustment is needed in the viewing and focusing mechanisms when the lenses are interchanged.

Fixed-focus cameras have no mechanism that allows for focusing. Such cameras are not well suited for close-up photography and require that the photographer be some minimum distance from the subject for a sharp image. However, most cameras allow for manual or automatic focusing.

Some focusing systems employ a pair of prisms (a biprism) often mounted in the center of the SLR screen. The prisms, slanted in opposite directions, produce a split image. The two halves of the image appear to be displaced if the image is not in focus.

Today, most cameras have autofocus (AF) mechanisms that rely on one or more sensors to determine correct focus. Autofocus systems may either be active or passive. Active systems employ a method of ranging based on a time-of-flight. With this approach, light from an LED or laser is directed toward the subject. The time required for the light to reach and travel back to the camera is used to calculate distance. Once the distance is computed, the lens is directed to adjust focus accordingly.

Passive autofocusing occurs electronically within the camera. Focusing is based on the difference between light and dark areas within an image. Since an image tends to be in focus when the contrast between these areas is the greatest, the camera uses input from sensors to adjust the focus until the contrast between adjacent areas is maximized.

10.3 Focal Lengths, *f*-Numbers, and Field of View

The *aperture stop* in cameras is designated by the *f-stop number*, which is defined as the ratio of the focal length to the diameter. Thus, the diameter of an *f*/4 lens is twice that of an *f*/8 lens, and so it lets in four times as much light (because its area is

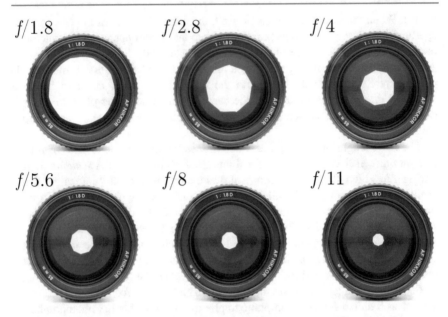

Fig. 10.6 Lenses with apertures ranging from $f/1.8$ to $f/11$ (KoeppiK [GFDL (http://www.gnu.org/copyleft/fdl.html) or CC BY-SA 3.0 (https://creativecommons.org/licenses/by-sa/3.0)], from Wikimedia Commons)

four times as large), other things being equal. An $f/2$ camera lens may typically be provided with the following aperture stops: $f/1.8$, $f/2.8$, $f/4$, $f/5.6$, $f/8$, $f/11$, $f/16$. Some of these apertures are shown in Fig. 10.6. Note that each of these numbers is $\sqrt{2}$ times the preceding one, so that the area of the aperture is halved each stop. If the exposure time is halved, the f-number should be increased by $1/\sqrt{2}$ (one stop), provided the light conditions don't change. For example, $f/4$ with 1/100 s would be used under the same conditions as $f/2.8$ with 1/200 s. Note that the diameter of an $f/4$ telephoto lens having a focal length of 100 mm is twice that of an $f/4$ standard lens having a focal length of 50 mm.

The field of view, as we discussed in the previous section, is determined by the focal length of the lens and the size of the film. Table 10.1 gives the angle of view for various lenses used on a 35 mm camera. Doubling the focal length will halve the length and width of the field of view. Figure 10.7 shows a scene photographed with focal lengths ranging from a 17 mm wide-angle lens to a 200 mm telephoto lens.

When a camera is focused for a particular distance, objects at a slightly greater and slightly smaller distance also will appear to be in focus. The distance range over which this will be true is called the *depth of field*. The depth of field depends upon the aperture stop. The depth of field for a large f-number (small lens aperture) will be greater than for a small f-number. Thus, photographers often "stop down" a camera lens in order to obtain a large depth of field. On the other hand, it is sometimes desirable to have the background slightly out of focus ("soft" focus); this

Table 10.1 Angle of view for various lenses on a 35 mm camera

Focal lengths of camera lens	Wide angle			Normal	Telephoto		
	17 mm	28 mm	35 mm	50 mm	85 mm	135 mm	300 mm
Diagonal angle	104°	75°	63°	47°	29°	18°	8.2°
Horizontal angle	93°	65°	54°	40°	24°	15°	6.9°
Vertical angle	70°	46°	38°	27°	16°	10°	4.6°

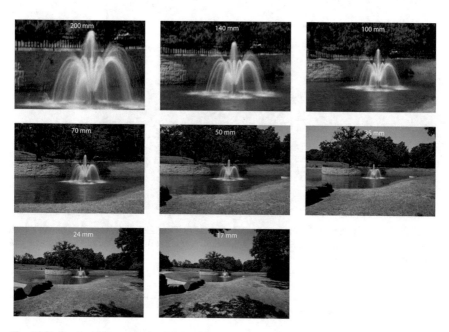

Fig. 10.7 Scene photographed with lens having focal lengths ranging from 17 to 200 mm (Courtesy of Jim Hamel Photography)

is accomplished by using a small *f*-number (large lens aperture). This is frequently the case in portrait photography. Photographs of the same scene with increasing aperture stops are shown in Fig. 10.8. Note how close and distant objects fall out of focus as the depth of field decreases.

Most inexpensive point-and-shoot cameras do not make a provision for focusing the lens. At the same time, these cameras usually have fairly small lens openings (large *f*-numbers), so the depth of field is quite large. Nevertheless, they cannot be used for close-up photography. A typical 35 mm point-and-shoot camera has a lens with a 38 mm focal length, which means that it has a wide field of view. The short focal length also makes such cameras very compact, and the combination of size and convenience has made them very popular.

Fig. 10.8 Photographs of the same scene with decreasing *f*-number (increasing apertures): **a** *f*/22; **b** *f*/4; (c) *f*/2.8 (Alex1ruff (https://commons.wikimedia.org/wiki/File:Dof_blocks_f1_4.jpg), https://creativecommons.org/licenses/by-sa/4.0/legalcode)

10.4 Digital Photography

In many respects, digital cameras are like traditional film cameras. In their simplest form, both consist of a light-tight enclosure that contains a lens for gathering light, a focusing device, and an opening and a shutter, which together determine how much light enters the enclosure. However, they differ in one very significant way: digital cameras use electronic photodetectors, referred to as image sensors, to capture images rather than photographic film.

Digital photography has revolutionized picture taking by making it possible to take virtually unlimited images inexpensively and view the results immediately. While widely popular by 2005 as a stand-alone device, digital cameras soared in number with the advent of the smartphone, a cellular phone that functions as both a computer and a high-resolution camera. It is estimated that 2.5 billion people currently have digital cameras in one form or another. At one time, using an entire 24-exposure roll of film to photograph an event might be considered liberal; today taking hundreds of digital photos is not considered excessive.

It should be emphasized that the digital camera is far more than a consumer item. Digital cameras play an important role in astronomy, medicine, security, and television broadcasting. Improvements in digital imaging technology have led to high-definition television, the discovery of distant galaxies, and advanced approaches to medical diagnosis and treatment.

The Evolution of Digital Photography

In a period of a little over 50 years, digital imaging has evolved from humble beginnings to a process used by billions of people around the globe. There are few technologies that have affected so many in such a short time span.

The first digital image was produced in 1957 by Russell Kirsch and his colleagues at the United States National Bureau of Standards. Kirsch and his team used a scanning apparatus to transform a picture of his son into the binary language of computers (Fig. 10.9). Unbeknownst to the group, their work would lay the groundwork for digital imagery used in a broad range of applications such as those mentioned previously.

In 1969, the first digital image sensor was invented by scientists at Bell Telephone Laboratories. Three years later, Texas Instruments patented an electronic camera that did not require film. The year 1973 also brought the release of the first large image forming CCD chip by Fairchild Semiconductor.

A big leap in the development of digital photography occurred in 1975 when Steve Sasson, working at Eastman Kodak, created the first digital camera. Weighing eight pounds and recording only black and white images to a cassette tape, the camera took 23 seconds to capture an image. Needless to say, this prototype did not immediately lead to a commercially viable device.

Additional important advances in digital photography include the 1975 development of the Bayer filter mosaic pattern by Bryce Bayer at Kodak, which allows

Fig. 10.9 The first scanned image, produced in 1957, of Walden Kirsch, son of the leader of the team that developed the image scanner (Russell A. Kirsch [Public domain], via Wikimedia Commons)

CCD sensors to capture color images. In 1981, Sony introduced the Mavica (magnetic video camera) still camera, which produced images that were stored on a two-inch floppy disc. The year 1986 brought the invention of the first megapixel sensor by scientists at Kodak.

In 1994, the Apple QuickTake 100 digital camera came into the market, followed a year later by Kodak's DC40. The release of these cameras was important, for they were relatively inexpensive and simple to use. This was the boost that digital cameras needed. Within a decade of the introduction of these cameras, digital picture taking would surpass film photography.

By the early 2010s, almost all smartphones had an integrated digital camera. Many smartphone cameras provide performance that rivals, and in some instances, surpasses that of dedicated DSLRs. Smartphones are convenient, allow for instant image viewing and correction, and connect easily to the internet for picture sharing.

Smartphones also have the ability to take high-quality video. It is therefore not surprising that the use of smartphone cameras has soared in recent years.

How a Digital Camera Records an Image

All digital cameras have an imaging sensor, approximately the size of a postage stamp, that uses light to free electrons through the photoelectric effect. There are basically two types of image sensors in use today, the charge-coupled device (CCD) and the complementary metal oxide semiconductor (CMOS). Both types of sensors consist of millions of tiny light-sensitive silicon photodiodes called photosites. While both CCD and CMOS sensors rely on the photoelectric effect to generate electrons, they differ in how the electrons are transferred from the photosites to an electronic storage system and where electrons are converted to a voltage. As a result, each type of sensor has unique characteristics that affect power consumption, processing speed, cost, and image quality.

The CCD Sensor

In a CCD, electrons are collected in each photosite's electronic storage mechanism called a potential well. The number of electrons in each well corresponds directly to the amount of light incident upon the photosite. A magnified image of the surface of a CCD is shown in Fig. 10.10. The small colored dots mark the positions of the CCD's photosites.

A CCD's architecture allows charge to be moved from the array of potential wells to the camera's memory system without using external wires. This is accomplished by transferring the electrons in each well to its neighbor, bucket-brigade style. This sequential, or serial, movement of charge in the CCD circuit is achieved by manipulating the voltages on the wells. The last well in the array deposits its charge into a charge amplifier, which converts the charge into a voltage. By repeating this process, the entire contents of the semiconductor's array of photosites is converted into a sequence of voltages. These voltages are then digitized and stored in memory.

Fig. 10.10 A greatly magnified surface of a CCD showing photosites (Serych at cs.wikipedia [Public domain], from Wikimedia Commons)

The CMOS Sensor

Like CCDs, CMOS sensors consist of myriad photo-sensitive elements. However, the CMOS sensor takes a different approach in processing the charges from the millions of photosites. Whereas charges in CCD photosites are sent to external electronics for processing, a CMOS sensor has circuitry at every photosite. This circuitry includes charge to voltage converters as well as amplifiers and digitization circuits. This means that all charges can be processed, in parallel fashion that is, at the same time, clearing the photosite for the next exposure. This results in faster processing speeds.

In addition to faster processing speeds, CMOS sensors use less power and have lower manufacturing costs. For this reason, the CMOS sensor has become the choice of imager for use in smartphones and scanners. That said, CCD sensors remain a popular choice for applications where high efficiency is required.

Capturing Color

Both the CCD and CMOS sensors are only capable of detecting light intensity, that is, brightness. This is useful for recording black and white images, but not for capturing color. One method of designing a digital camera capable of recording color employs a combination of prisms or filters coupled with three separate sensors. Each of the three sensors receives light corresponding to one of the primary colors, red, green, or blue. A color image is created when the output from the three sensors is combined. While this approach produces high-quality color images, it tends to be costly. Fortunately, a more cost-efficient solution exists.

Instead of using three separate sensors, most digital cameras use something called the Bayer filter system in conjunction with a single sensor. Named after its inventor, the Bayer filter consists of a mosaic of red, green, and blue filters arranged on a grid of photosites with each filter covering a single site (Fig. 10.11). Small lenses are used to concentrate the light at each site. A red filter only allows the passage of red light and blocks both green and red light. Similarly, green and blue filters only allow green and blue light, respectively, to pass. Thus, the charge

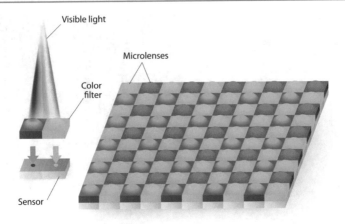

Fig. 10.11 Bayer array on sensor (Studio BKK/Shutterstock.com)

collected in each site is representative of the amount of red, green, or blue light striking that site.

In a Bayer array, the color filters cover individual photosites in a 2×2 grid pattern. Green is used twice in the quartet of pixels to accommodate for the human eye's greater sensitivity to green. Since each photosite is behind a color filter, the output is an array of values, each indicating the intensity of one of the four filter colors. Thus, it takes four photosites to gather each pixel's information regarding color and intensity.

The Image Signal Processor: The Core Component in the Image Processing Chain

At the heart of all digital cameras is the image signal processor (ISP) . The primary function of an ISP is demosaicing, the process of translating the Bayer array of primary colors into a final image that contains full color information at each pixel, the smallest unit of brightness and color in a digital image. To do this, the ISP collects and averages the values from neighboring photosites to determine the true color of a single pixel.

In addition, the ISP does a variety of other essential tasks. It controls autofocus, exposure, noise reduction, and, in some cases, face and object detection. It also manages image stabilization. When gyroscopic sensors detect shaking, the camera responds by using small motors to move either the lens, the image sensor, or both, to produce enhanced stability.

Digital Camera Resolution

A digital camera is often categorized based on its resolution, or how many pixels its sensor can capture. Camera resolution is usually given in *megapixels*. One megapixel equals one million pixels. Resolution is a measure of how large a photograph can be made without becoming unacceptably blurry or grainy. As a rule of thumb,

larger prints require more megapixels. A two- or three-megapixel camera can produce some very good quality prints up to about 4 × 6 inches, whereas an 8 × 10 inch or larger print will generally require a resolution of four or five megapixels.

Today's budget camera's sensors typically have resolutions of five megapixels or less; professional cameras may employ sensors having 20 megapixels or more. It should be noted that just having more megapixels doesn't guarantee that a camera will produce better quality images than a camera with fewer megapixels. The number of megapixels is only one factor to consider when choosing a digital camera. The quality of a camera's lens system and image processing capabilities are of equal importance.

Image Storage

After an image is captured and broken down into pixels, the image data is transferred to the camera's storage device. The method of storage is often a small, removable flash memory card. Data stored on such a device is not lost when disconnected from a power source. Flash memory may be erased and reused thousands of time. Smartphone cameras generally employ nonremovable internal data storage.

The most common format for data storage in flash or other types of solid-state storage is JPEG, abbreviation for Joint Photographic Experts Group, a consortium of digital imaging authorities. Data in this format has been compressed to save storage space, the compression being accomplished by the removal of nonessential data. The reduction in data allows more efficient storage and transfer of data.

A second format that does not involve compression is the tagged image file format, or TIFF for short. Because no data is eliminated, this type of file tends to be much larger than a JPEG file.

Photo Editing

Adobe Photoshop remains one of the best photo-editing applications available, but it is relatively expensive and learning to use it can be challenging. Thankfully, there are many free photo-editing programs available that provide much of the same functionality as Photoshop but are much easier to use. Programs such as GIMP, PAINT.NET, and PIXR.COM can perform basic functions such as cropping, correcting exposure, and image resizing, as well as carry out more advanced photo editing.

The Magic of Smartphone Cameras

At first blush, it would seem that producing high-quality photographs with a camera confined to a space not much bigger than a thin matchbox would be impossible. The major obstacle is sensor size. A bigger sensor will capture more detail with wider dynamic range (the detail in dark and light areas), offer superior low-light performance, and focus more sharply on moving objects. However, with few exceptions,

smartphone and tablet cameras have tiny sensors. The magic is in the way this limitation is overcome.

Among the remedies used to deal with the constraints imposed by sensor size is backside illumination (BSI). This modification moves wiring to the back of the sensor, maximizing the surface area upon which light can hit the sensor's photosites. Wider apertures, made possible with improved lens quality, also aids in light gathering. Working in concert with sensor and aperture improvements, the camera's ISP not only massages data received from the sensor but also provides stabilization to compensate for camera shake.

Many new phones offer two or more rear-mounted cameras in addition to the front-facing selfie camera. The added cameras not only help in enhancing the depth of field through the use of different focal lengths but also allow the ability to shoot in low light. One camera delivers typical shots while the other may work as a zoom or wide-angle lens. Some phones use the two cameras together to produce a *bokeh* effect, which blurs the background while leaving the subject in sharp focus.

Some multiple camera phones come with a monochrome module. This feature is designed to take two shots simultaneously, with one of them being black and white. The photo processing software on the smartphone then combines both images to produce a sharper single image with enhanced color rendering.

It should be noted that not only are today's smartphones capable of producing photos of remarkable quality, they also support sophisticated in-camera editing through the use of a wide variety of applications, many of which are available at no cost. Among the highly regarded editing "apps" are Adobe's Photoshop Express and Lightroom CC.

As a result of the above, and other, innovations, today's smartphone cameras have the ability to produce sharp enlarged prints, work in low light, often without the use of a flash, and take high-definition video, a feature made possible by stabilization.

10.5 Film

Modern black and white film is based on Talbot's negative–positive process (Sect. 10.1), but the silver halide coating is applied to a plastic base. Sensitizers are added to the emulsion to make it sensitive to a wide range of colors (panchromatic film). An antihalation backing is generally applied to the reverse side of the plastic base to prevent the reflection of any light that isn't completely absorbed by the emulsion. This light would otherwise be reflected at the back of the base to return to the emulsion and form a halo around the picture. This backing is removed during development.

Light striking the silver halide crystals generates one or more silver nuclei. The chemical developer converts (reduces) all of the silver halide, but the developer will work faster where there are already silver nuclei. Thus, the developer will first convert those crystals that have been exposed to light. The trick is to remove the

film before the unexposed silver halide crystals are reduced (and the film becomes "overdeveloped" and totally dark). In order to stop the development before the unexposed crystals are reduced to metallic silver, the developer is washed away in the *stop bath*, generally an acid that makes the developer inactive. To prevent further conversion of silver halide to silver, the film is fixed with hypo (generally sodium thiosulfate $Na_2S_2O_3$), which converts the insoluble silver halides into water soluble compounds that can be washed out of the emulsion.

To obtain a positive print, a sheet of photographic print paper is exposed, by contact or projection, to the negative image of a photographic negative. The print is developed in the same way as the negative. A large number of prints can be made from one negative, if desired. Contact printing results in prints of the same size as the negative, while enlargements are made by projecting an image of the negative through the lens of an enlarger. During the enlargement process, filters and masks can be used to change the photograph, correct areas of overexposure, and so on.

The *film speed* indicates the reaction rate of the emulsion, which determines the exposure necessary to create an image. Film speeds may be rated according to three speed indexes: ISO (International Standards Organization), ASA (American Standards Association), or DIN (Deutsche Industrie Norm). The ISO and ASA ratings, determined by different procedures, give almost the same film speed, and film speeds often do not say which standard is used. Color films, for example, are usually rated 100 (slow), 200 (medium), or 400 (fast). ISO (or ASA) 400 film is twice as fast as 200; it requires half the exposure time under the same conditions. In the DIN system, an increase of three indicates a doubling of speed (DIN 21 film has twice the speed of DIN 18).

To expose the film properly, the photographer should consider three things: film speed, lens aperture (*f*-stop number), and exposure time. Many cameras do this automatically. With a given film speed, increasing the lens opening by one-half (using the next lower *f*-stop number) allows one to decrease the exposure time by one-half. Doubling the film speed, on the other hand, allows one either to reduce the exposure time by one-half or to reduce the lens opening by one-half (use the next higher *f*-stop number).

Why, then, would one not always choose the fastest film available? There are two reasons: First, fast films generally cost more than slower films. Second, fast films usually have fairly large silver halide crystals or grains, while slow films have fine grains. If enlargements are to be made, it is desirable to use film with as small a grain size as possible. Some films have a variety of grain sizes and thus have a wide latitude for exposure.

10.6 Color Film

We have seen, in Chap. 8, how almost any color can be matched by combining three primary colors. It should be possible, then, to combine three images recorded on three emulsions sensitive to red, green, and blue to construct a color image. It

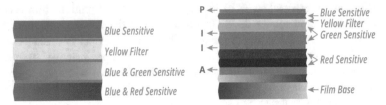

Fig. 10.12 a Cross-section of a tripack color film; **b** actual film includes a protective layer P, interlayers I, and an antihalation layer A

would be nice if these separation negatives, as they are called, could be made with light-sensitive dyes, but unfortunately only silver compounds are sensitive enough to light to be practical. Thus, the three separation negatives and positives are really three black and white recordings of the red, green, and blue light that reached the film.

Color film consists of three emulsions plus a yellow filter on a common base, as shown in Fig. 10.12. The top emulsion has the basic blue sensitivity typical of all silver halide film. The next emulsion contains sensitizers that make it sensitive to green light; the bottom emulsion is sensitized for red. Because the green- and red-sensitive emulsions retain their sensitivity to blue light, a yellow filter is placed above them to prevent blue light from reaching them.

After the blue, green, and red records have been obtained, the black silver images must somehow be changed to color and combined into one color picture. This can be done either by additive or subtractive color mixing, although additive systems are rarely used today.

Additive mixing is conceptually the simplest method and was the first to be used. In principle, light could be projected through three black and white positives with color filters and combined on a screen, as done in projection color television, although this would lead to problems with registration. Historically, the first successful color films were mosaics; they combined black and white film with a mosaic of tiny red, green, and blue filters. The film behind each of them was exposed to just one color, and when projected or viewed in transmitted light the colored images combined additively.

In subtractive color mixing, used in nearly all present-day films, the developed silver is replaced by a dye of a color complementary to the color of the record. Then the three records can be combined subtractively. The dye destruction process, invented by Herbert Kalmus in 1932, places complementary dyes in the emulsion during manufacture. During development, the dye is chemically removed in the vicinity of exposed silver halide, thus forming a positive image. Unfortunately, the dyes absorb light during exposure, so the film's sensitivity is reduced, and so this process is practical only in color print paper where high sensitivity is not important. The *dye transfer process* depends on the absorption of dyes by matrixes of chemically hardened gelatin in the separate emulsions containing the red, green, and blue records.

The most common method for forming the dye image is the *dye coupling process*, in which the oxidized developer couples with a chemical to form a dye, thus producing a negative color image. The superposition of three color negatives transmits the colors complementary to those of the original image. To make color prints, the colors are reversed by exposing a three-layer emulsion coated on the paper to light through a color negative. To make positive transparencies, the color reversal is performed in a film consisting of three sensitive layers separated by gelatin; each layer contains crystals sensitized to one of the primary colors: red, green, or blue.

10.7 Instant Cameras

After their popularity being in decline for several years, instant cameras have made somewhat of a comeback. There seems to be something special about hearing the clicking sound of a shutter, watching a print emerge from the camera, and seeing a color image appear before your eyes.

Instant cameras use the same type of film described in the previous section, but the film carries a pod of viscous chemicals ahead of each frame that perform the function of both developer and fixer. After exposure, the film is pulled through rollers that squeeze it and break open the pod, spreading its contents between the film and support paper to develop it. The unexposed silver halide crystals converted into soluble silver by the fixer diffuse out of the emulsion toward the support paper. The originally unexposed regions become dark on the support paper, while in the exposed regions the metallic silver is not dissolved by the fixer, so no ions diffuse through and the support paper remains white. The result is a "positive" image created in just a few seconds.

The first instant color film was developed by the Polaroid Corporation and marketed under the name Polacolor. It was designed to be used in Polaroid cameras in place of black and white instant film. This film does not use couplers, but the dyes are incorporated into the film at the time of manufacture. Above each color-sensitive recording layer is an appropriate dye layer as well as a developer. The actual process of developing and printing the final image is quite complicated, and it will not be discussed here.

Due primarily to its failure to make the transition from analog to digital technology, the Polaroid Corporation filed for bankruptcy protection in 2001. However, Polaroid enthusiast Dr. Florian Kaps saved the day by his decision to fund The Impossible Project in the same year. In 2010, the company began selling film for use in the Polaroid SX-70, 600, and Spectra cameras, allowing instant photography aficionados to once again use their vintage cameras.

Today, fans of instant photography have several options. In addition to Polaroid, Fujifilm produces cameras in two film formats: Instax Wide and Instax Mini. Some companies, including Polaroid and Lomography, have produced cameras compatible with Fujifilm's Instax film.

10.8 Lighting for Color Photography

Lighting is much more critical in color photography than in black and white photography. In addition to having the right intensity, the right color balance is needed. The eye adapts to changes in illumination (see Sect. 9.1), but the camera cannot do so. Hence, photographs of the same object taken with the same color film or digital camera setting in sunlight and in incandescent light will appear quite different.

Ideally, with film photography one would use a film that is color-balanced to the particular light being used. Practically, this is not always possible, and color-correcting filters must sometimes be used. Color film is generally available in two different types: daylight and indoor (or type A). Daylight film is color-balanced for sunlight, while indoor film is balanced for incandescent lighting. If daylight film is exposed indoors, the colors will be too reddish, because incandescent light is richer in reds (and deficient in blues) as compared to sunlight. Likewise, if indoor film is used outdoors, the colors will appear bluish. Most strobe flashes are color-balanced to resemble daylight, so daylight film can be used indoors with strobe flashes. Fluorescent lighting presents a problem, since it matches neither daylight nor incandescent light. Filters that correct for fluorescent light are available.

Some photographers use LEDs; however, their use is not yet widespread. Their favorable attributes include higher efficiency, which results in less heat production. They are usually fully dimmable and offer adjustable color temperature, making it easier to precisely match natural light. However, their power output is often below that of incandescent and fluorescent lights, making it difficult to shoot with smaller apertures or to capture stop action.

When using a digital camera, changing the *white balance setting* permits adjustment for differences in lighting. The human eye automatically takes into account different lighting situations, but a camera needs to be adjusted for accurate color reproduction. White balance is a camera setting that ensures that what appears white to the human eye will also appear white in the recorded image for any given type of light.

Digital cameras allow white balance to be controlled both automatically and manually. Automatic balance pre-settings include daylight, shade, cloudy, tungsten, fluorescent, and flash. In the manual mode a photo is taken of a white object such as a sheet of white paper under existing lighting conditions. Using that image as its white balance reference ensures that all photos taken under those conditions will come out correctly balanced.

Color balance in digital photography can also be controlled using imaging software. The programs described in Sect. 10.4 all have color correction capabilities.

10.9 High-Speed Flash Photography

The Evolution of High-Speed Photography

Capturing events that occur too fleetingly for the unaided eye to observe remained out of reach until 1851. It was then that Henry Fox Talbot used an electrical spark to "stop time." Talbot attached a newspaper article to a rotating wheel. In a darkened room, he exposed the newspaper to light produced by an electrical discharge. The resulting image captured on a wet plate revealed readable text.

Stop action photography was later put to use in the 1870s when Eadweard Muybridge was challenged to address a question posed by wealthy entrepreneur and horse racing enthusiast Leland Stanford. Stanford wondered if racehorses ever had all four hooves off the ground simultaneously. To learn the answer, Muybridge used a system consisting of 24 cameras and a set of tripwires. In order to capture the full range of a horse's gallop, each trip wire was attached to trigger a different camera. As the photos in Fig. 10.13 indicate, Stanford's question was answered in the affirmative.

Most of us have admired photographs that capture events such as a bullet passing through an apple, the impact of a tennis ball with a racket or a foot with a football, and a bursting balloon. It was MIT professor Harold Edgerton who invented devices such as the stroboscope and the electronic flash tube that make it possible to witness such events. Edgerton said the strobe allows us "to chop up time into little bits and freeze it so that it suits our needs and wishes."

Among other things, Edgerton's research gave the world the electronic flash for cameras, slow motion photography, remote-controlled deep-sea cameras, and high-intensity flashlamps used in World War II to take nighttime aerial reconnaissance photographs. Modern extensions of his pioneering work continue to have applications in science, technology, industry, and national defense.

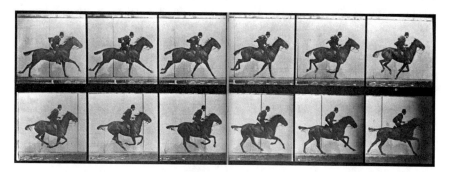

Fig. 10.13 Eadweard Muybridge's stop action photographs of a galloping horse (Eadweard Muybridge [Public domain] via Wikimedia Commons)

Fig. 10.14 Simple sound
trigger using a piezoelectric
buzzer element as a
microphone.
A silicon-controlled rectifier
(SCR) triggers the flash
(Schematic courtesy of Loren
Winters)

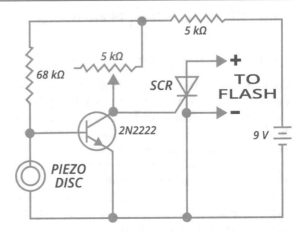

Low-Cost, Do-It-Yourself High-Speed Photography

You may not have realized that photographs such as those taken by Edgerton can be
taken with ordinary electronic flash units. The trick is to synchronize the unit so that
it flashes at exactly the right time. Techniques for doing this with very inexpensive
equipment have been developed by a talented high school physics teacher, Loren
Winters.

Many electronic flash units have durations as short as 30 µs, which is short
enough to record most high-speed motion. Winters uses sound triggers, photogate
triggers, or mechanical switches to trigger one or more electronic flash units.
A sound trigger senses the sound of impact and triggers the flash. The simple sound
trigger circuit, shown in Fig. 10.14, can be constructed for less than $10.

When an electronic flash unit undergoes a full discharge, the flash of light lasts
for several milliseconds, which is much too long for high-speed photographs. For
the latter, the flash power must be reduced, as this also reduces the duration of the
burst of light. Therefore, it is best to use a flash unit that has a feature to adjust the
flash power. For most situations, one sets the power at the lowest setting.

Photographs are usually made in a darkened room. The camera need not have a
high shutter speed, because the duration of the exposure is determined by the flash
rather than the shutter. The shutter is typically set for one or two seconds so that it
will be open in the dark before the flash. Examples of Winters' high-speed pho-
tographs are shown in Fig. 10.15.

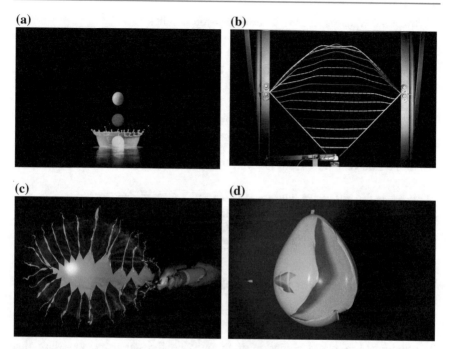

Fig. 10.15 High-speed flash photographs: **a** Milk droplet taken with multicolored sequential triggered flash; **b** plucked string using sixteen sequentially triggered flashes; **c** balloon burst by overpressure; **d** bullet bursting a balloon (Photographs by Loren Winters)

10.10 Summary

The evolution of photography from heliographs and daguerreotypes to digital imaging is an interesting story. Cameras may be categorized as compact, or point and shoot, and single-lens reflex (SLR). Compact and SLR cameras come in both film and digital models. The essential parts of a camera are the lens, the shutter, the diaphragm (or iris) , and film or an electronic sensor. Digital cameras use sophisticated optics and electronics to capture, edit, and store images. Color films create images in three different emulsions, and these are combined to produce color positives or negatives. High-speed flash photographs can be made by using simple trigger circuits with relatively inexpensive photoflash equipment.

◆ **Review Questions**

1. To focus a camera, you move the lens back (closer to the film) or forward (farther from the film). When the lens is closer to the film, are you focused on a near or a far object?
2. List the components in a simple camera and describe their functions.
3. What is depth of field and how is it controlled in a camera?

 4. State the equation used to determine f-stop number.
 5. Verify that the following f-stops and shutter speeds all give the same exposure: $f/2$ at 1/200 s; $f/2.8$ at 1/100 s; $f/4$ at 1/50 s; and $f/5.6$ at 1/25 s.
 6. Why do professional photographers often carry more than one lens for their cameras?
 7. A student notices that 38 mm $f/11$ appears near the lens of an inexpensive camera. What is the focal length of the lens? What is the diameter of the diaphragm opening?
 8. If a camera is focused for a distance of 20 m, should the lens be moved closer to the film or farther from the film to focus on an object 5 m away? Explain why.
 9. What is the difference between a CCD and a CMOS detector?
10. What is the function of the white balance setting on a DSLR?
11. Explain how a digital camera records color.
12. What are the relative advantages and disadvantages of fast and slow film?

▼ Questions for Thought and Discussion

1. What are several advantages of a single-lens reflex camera over a "point-and-shoot" type?
2. Why might a photographer wish to override the automatic exposure time feature?
3. Under what conditions might you wish to decrease the depth of field?
4. In what ways has digital photography revolutionized picture taking?
5. Why are color negative films more often used to make color prints than color reversal films?
6. Why should a flash unit be used in its automatic mode in taking high-speed flash photographs?
7. Describe how a sound trigger works.

■ Exercises

1. If $f/8$ and 1/125 s gives the proper exposure, what f-stop number should be used with 1/500 s under the same light conditions?
2. Compare the diameter of an $f/4$ lens with a focal length of 50 mm to that of an $f/8$ telephoto lens having a focal length of 200 mm.
3. A photograph is taken at $f/4$ and 1/250 s using ISO 100 film; what f-number should be used with ISO 400 film at 1/500 s in order to obtain the same results?
4. If a bullet moves at 200 m/s, how far does it move during 30 μs? Could you "stop" it with an electronic flash?
5. A zoom lens has a focal length that varies from 30 to 200 mm. Which setting will make the subject look largest? Which setting will include the widest angle of field?

6. **a.** What is the diameter of an $f/4$ lens with a focal length of 50 mm? **b.** What is the diameter of an $f/8$ lens with a focal length of 200 mm?
7. Which of the lenses in Exercise 6 might be considered a telephoto lens?

● **Experiments for Home, Laboratory, and Classroom Demonstration**

Home and Classroom Demonstration

1. **Field of view of camera lenses**. Open the camera back of an SLR camera and place a piece of ground glass (or plastic with a rough surface) at the location of the film. Determine how much of a meter stick can be seen at various distances. The field of view should fit the following relationship: *field of view/object distance = width of film/image distance*. (With a single-lens reflex camera, this experiment can be done by looking through the viewfinder.)
2. **Using a digital camera's white balance setting**. Take digital photographs of a particular scene using different white balance pre-settings. Notice how settings affect each photograph's color balance.
3. **Observing the rolling shutter effect**. You can use your smartphone to observe what is known as the rolling shutter effect by taking a photo of a moving fan, a toy "spinner," or an airplane propeller. Try taking photos with the smartphone held both vertically and horizontally.
4. **Measure shutter time using an oscilloscope**. Connect a photodiode (a "solar cell" will work) to an oscilloscope and place the diode at approximately the film position in an SLR camera; shield it from room light with a black cloth. Aim the camera at a bright light and press the shutter. Note the width (duration) of the pulse on the oscilloscope.

Laboratory (See Appendix J)

10.1 Exploring a Single-Use Camera with Built-In Flash.
10.2 Field of View and Depth of Field of a Camera Lens.

Glossary of Terms

aperture stop (iris) A device that varies the size of the lens opening.
backside illumination (BSI) Placing wiring behind sensor to increase light reaching photosites.
Bayer filter A mosaic of red, green, and blue filters arranged on a grid of photosites with each filter covering a single site.
bokeh effect The blurring of the background while leaving the subject in sharp focus.
camera obscura An early type of pinhole camera.
charge-coupled device (CCD) An electronic light sensor used in place of film in a digital camera.

complementary metal oxide semiconductor (CMOS) A light sensor consisting of millions of photo-sensitive elements, each of which includes a charge-to-voltage converter as well as an amplifier and digitization circuit.

color negative film Film that produces a negative image in complementary colors.

color reversal film Film that is exposed to light during development in order to produce a transparency (slide) with true colors.

daguerreotype Permanent image on a light-sensitive plate using a process invented by Louis Daguerre.

demosaicing The process of translating the Bayer array of primary colors into a final image that contains full color information at each pixel.

depth of field Range of distance over which objects are in focus in a photograph.

digital single-lens reflex camera (DSLR) A digital camera in which focusing and composition can be done while sighting through the lens.

dye coupling process Chemical process for producing a dye image during color development.

dye transfer process Photographic process that depends on absorption of dyes by chemically hardened gelatin in three separate emulsions.

film speed Measure of how fast an image can be recorded.

f-stop number Focal length divided by lens diameter.

fixing bath, fixer Solution that dissolves undeveloped silver halides in an emulsion.

focal length Distance from a lens to its principal focus.

ISP (image signal processor) A specialized digital signal processor used for demosaicing and a variety of other essential tasks such as controlling autofocus, exposure, noise reduction, and, in some cases, face and object detection.

JPEG (Joint Photographic Experts Group) A computer file format for the compression and storage of digital images.

single-lens reflex (SLR) camera A camera in which focusing and composition can be done while sighting through the lens.

smartphone A mobile phone that performs many of the functions of a computer, typically having a touchscreen interface, a camera, internet access, and an operating system capable of running downloaded applications.

stop bath Weak acid solution used to halt development prior to fixing.

TIFF (tagged image file format) A computer file format for non-compressed storage of digital files.

telephoto lens Lens with long focal length used to create a larger than normal image.

white balance setting A digital camera feature used to accurately balance color under a wide range of lighting situations.

wide-angle lens Lens with short focal length used to expand the field of view.

zoom lens Lens with variable focal length.

Further Reading

Falk, D. S., Brill, D. R., & Stork, D. G. (1986). *Seeing the Light.* New York: John Wiley & Sons.

Johnson Jr., C. S. (2017). *Science for the Curious Photographer: An Introduction to the Science of Photography.* 2nd ed. Abingdon-on-Thames, England: Routledge.

Mitchell, E. N. (1984). *Photographic Science.* New York: John Wiley & Sons.

Newhall, B. (1964). *The History of Photography.* New York: Museum of Modern Art.

Watson, R., & Rappaport, H. (2013). *Capturing the Light: The Birth of Photography.* New York: St. Martin's Griffin.

Holography

11

Looking at holographic images is exciting! Some appear to float in space; some appear in full color; some change color as you move your head; some even show subjects that move. No wonder that artists are using holograms to create a new art form. In this chapter we will explore the physics of holography and try to learn what makes holographic images so unusual.

11.1 What Is a Hologram?

With photography, a recording of an object is made in the form of a two-dimensional picture on light-sensitive film. A lens, or a system of lenses, is used to capture the variation in brightness of the object, which in turn produces a corresponding variation in exposure on the film.

Unlike making a photograph, creating a hologram does not require a lens. There is no reproduction of the object on film. Instead, the film is used to record the distribution of light energy in space. As a result, without suitable lighting, a hologram reveals nothing of the visual information contained within. However, with proper illumination, the hologram's image will appear, as if by magic, with virtually all the optical properties of the object itself.

The basic technique used to create a hologram was developed by Dennis Gabor in 1947 primarily as a means for improving electron microscopy, and it eventually won him the Nobel Prize in Physics. Gabor's wavefront reconstruction process led to recorded patterns that he called *holograms* from the Greek word *holos*, meaning "whole." His process went more or less unused, however, until after the invention of the laser in 1960, when Emmett Leith and Juris Upatnieks (United States) and Yuri Denisyuk (Russia) adapted Gabor's technique to produce optical holograms.

A hologram is a two-dimensional recording of an interference pattern capable of producing a three-dimensional image. It does that by recording the whole wave field, including both the *phase* and *magnitude* of the light waves reflected from an

© Springer Nature Switzerland AG 2019
T. D. Rossing and C. J. Chiaverina, *Light Science*,
https://doi.org/10.1007/978-3-030-27103-9_11

object. The phase information is converted into intensity information (which can be recorded on film) by using a *reference beam* of *coherent light*, monochromatic light in which electromagnetic waves maintain a fixed phase relationship with each other over time. Light from sources such as the Sun, a candle, or a light bulb does not have these properties; laser light does.

The most striking feature of a hologram is the three-dimensional image that it forms. A hologram, such as the one of physicist Gabor in Fig. 11.1, appears to be a window through which a three-dimensional, lifelike image is seen. Moving the head from side to side or up and down allows the viewer to look around the object.

Furthermore, if a hologram is broken into small pieces, the entire image can be seen through any piece, although the viewing window becomes much smaller. This is because a hologram records information about the whole scene in each small piece of the film. As Fig. 11.2 indicates, each piece of the broken hologram provides a view of the recorded object from a different perspective.

There are two basic types of holograms: reflection and transmission. A *reflection hologram* can be viewed with a spotlight or a point light source (the Sun works particularly well) as if it were a three-dimensional painting. A *transmission hologram* is illuminated from behind by a monochromatic light source (laser light works well) . The way in which interference patterns are formed in the photographic emulsion in these two cases is shown in Fig. 11.3. Holograms can provide either real or virtual images.

Fig. 11.1 A hologram of Dennis Gabor, the inventor of holography (Courtesy of The Jonathan Ross Hologram Collection)

Fig. 11.2 Photograph of two different sections of a broken hologram. Each piece offers a view of the object from a different angle (Epzcaw (https://commons.wikimedia.org/wiki/File:Broken_hologram.jpg), "Broken hologram", https://creativecommons.org/licenses/by-sa/3.0/legalcode)

(a) **(b)**

Fig. 11.3 a The interference of two plane waves traveling toward the same side to create a transmission hologram; **b** the interference of two plane waves traveling toward opposite sides to create a reflection hologram

In addition to basic transmission and reflection holograms, there are many special types, such as: volume holograms, "rainbow" holograms, true color holograms, multiplex holograms, embossed holograms, integrams, motion holograms, and holographic interferograms. Digital signal processing has led to TV holography, in which holograms are created electronically in digital computers.

Virtual and Real Images

When a hologram is illuminated by a replica of either of the two original beams alone, both of the original beams will emerge. Thus, if you place the hologram back in the original reference beam, both this beam and a replica of the original object beam will emerge. If you look along the reconstructed object beam, you see a replica of the object; because it appears that the light had originated from the object, this image is called a *virtual image*. In contrast to the virtual image, an image that light has actually passed through is called a *real image*; it can be projected on a screen.

When a hologram is illuminated in a backward direction using a reference beam in reverse, a real image is produced in the location of the original object. This image has some unusual properties. Its perspective is reversed; parts of the image that should be at the rear appear at the front (the image of a ball, for example, looks like a hollow cup and vice versa). Moreover, parts in the image that appear to be in the rear cast shadows on parts that appear to be in front. The image is thus called a *pseudoscopic image*, in contrast to an *orthoscopic image* having normal perspective. A hologram can be made to produce both an orthoscopic and a pseudoscopic image by turning it through 180 degrees on a horizontal axis ("flipping" it).

11.2 Transmission Holograms

The basic arrangement for recording and viewing a transmission hologram is shown in Fig. 11.4. The object and a nearby photographic plate are both illuminated by laser light. The portion of the laser light that goes directly to the plate is called the *reference beam R*, while the portion that illuminates the object is called the *object beam O*. The film records the interference pattern between the light scattered by the object S and the reference beam R; this record is the hologram of the object. To view the finished hologram, place it back where it was made, look through it toward the object, and remove the object.

A slightly better way to record a hologram is shown in Fig. 11.5a. A plane mirror M in the laser beam directs some of the laser light to the photographic plate (reference beam R) while the balance of the light illuminates the object (object beam O) . The main advantage is better lighting of the side of the object facing the photographic plate. The holographic image can be viewed by replacing the developed plate in the reference beam and blocking off the object beam as shown in Fig. 11.5b; the image will appear in the same place as the original object.

Two-Beam Transmission Holograms

Both the setups for recording transmission holograms shown in Figs. 11.3a and 11.4 might be called one-beam systems because the same beam of laser light, spread out by a lens, serves as the reference beam and the object beam. It is difficult to change the relative intensities of the reference and object beam, which is a

Fig. 11.4 Basic setup for recording a transmission hologram

Fig. 11.5 a Another setup with a mirror used to record a transmission hologram; **b** viewing the holographic image

Fig. 11.6 a Two-beam system with a beam-splitting mirror. **b** The image can be viewed with the reference beam

disadvantage if the object changes from light to dark, for example. For this and other reasons, a beam-splitting mirror is often used to produce independent reference and object beams, as shown in Fig. 11.6a. Since the amount of light transmitted and reflected by the beam splitter can be adjusted, the relative intensities of the reference and object beams can be optimized. As Fig. 11.6b indicates, the image can be viewed with the reference beam.

11.3 Reflection Holograms

The simplest type of reflection hologram is the single-beam or *Denisyuk hologram* in which the beam falls on the emulsion from one side, acting as the reference beam, and passes through the emulsion to be reflected back by the subject matter on the other side to form the object beam, as shown in Fig. 11.7. The fringes formed are more or less parallel to the surface of the emulsion, spaced a half-wavelength apart, so that *Bragg reflection* (see below) controls the image formation. Thus, the image can be viewed with white light, and the image appears to have a certain color, which may not be that of the original laser beam.

(a) **(b)**

Fig. 11.7 Arrangement for single-beam reflection hologram. The reference beam RB passes through the emulsion and illuminates the object to form the object beam OB. The hologram is replayed by a reconstruction beam RB on the same side as the viewer

Bragg Reflection

In a single-beam (Denisyuk) reflection hologram, the reference beam and the object beams come from opposite directions and meet in the emulsion. There they interfere (or set up standing waves) so that, after processing, planes of varying absorption (or refractive index) occur in the emulsion. During reconstruction these planes act as weak mirrors, each partially reflecting the light beam. When these planes are a half-wavelength apart, the partial reflections add up, and the reflected beam is strong. Since the distance the light travels between planes depends on the angle of incidence, each color of light will have its maximum at a slightly different angle.

The relationship between the wavelength λ, the distance between planes d, and the angle θ of maximum light intensity is given by Bragg's law: $2d \sin \theta = m\lambda$. This law was first derived by Nobel laureate William L. Bragg to describe the behavior of X-rays in a crystal. (In a crystal, the atoms are arranged in planes that diffract the X-rays so that reflection occurs.) Bragg reflection allows white light to be used for image reconstruction from a reflection hologram. As the hologram is tipped so that the angle of incidence changes, the color of the reconstructed image also changes.

Bragg reflection also explains why the virtual image in a transmission hologram is brighter than the real image unless the hologram is "flipped" (see Sect. 11.1).

11.4 Transfer Holograms

A hologram can record anything that can be seen under laser light, including the image produced by another hologram. A *transfer hologram* uses the real image from another hologram as its object. The image from the first hologram can be situated behind or in front of the new hologram, which makes it possible to create very dramatic effects. To make a hologram of the real image, the master hologram is

flipped, a second holographic emulsion is placed in the plane of the real image, and a suitable reference beam is applied. The final image can be made brighter by masking down the master of a reflection transfer hologram so that it is narrower in a vertical direction.

Rainbow (Slit-Transfer) Holograms

In 1968, Stephen Benton showed that the horizontal parallax in a hologram can be eliminated by making a transfer hologram in which the master is masked by a narrow horizontal slit. (Since binocular vision operates in a horizontal plane, the vertical parallax in a holographic image is not very important.) This led to a *slit-transfer* or *rainbow hologram* in which a change of viewpoint in a vertical direction results in a change in image hue but not in image perspective.

An arrangement for making and viewing a rainbow hologram is shown in Fig. 11.8. The master H_1 (a) is masked off to a narrow horizontal slit. This produces an image hologram H_2 in which the vertical information is replaced by a "diffraction grating" produced by interference between the image beam IB and the reference beam RB. When H_2 is flipped (b), the image of the slit is projected close to the eye of the viewer, and when H_2 is illuminated with white light, the image of the slit varies in its position according to the wavelength. The viewer sees the image in a spectral hue that depends on the height of the viewpoint.

A viewer moving up or down in front of a rainbow hologram sees changing spectral colors rather than different vertical perspectives. The holograms used on credit cards, paper currencies, and other documents to prevent forgery are examples of rainbow holograms. The rainbow hologram shown in Fig. 11.9 can be found on a 50 euro note.

Rainbow holograms can be produced using inkjet printers. A team of scientists from ITMO University in Saint Petersburg have developed a colorless ink made from a form of titanium dioxide that can be loaded into an inkjet printer. When deposited on specially treated paper, rainbow holograms of virtually any size can be produced in a matter of minutes, a process that normally requires hours if not days.

Perhaps one of the most unusual uses of rainbow holograms can be found on chocolate products. Morphotonix, a Swiss company located in Lausanne, has devised a way to create microstructures on the surface of chocolate (Fig. 11.10a). It

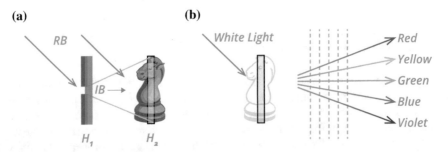

Fig. 11.8 a Making a rainbow hologram by masking the master H_1 off to a narrow slit; **b** viewing a rainbow hologram in white light

Fig. 11.9 A rainbow hologram on a 50 euro note (Heike Löchel (https://commons.wikimedia.org/wiki/File:Hologram.jpg), "Hologram", https://creativecommons.org/licenses/by-sa/3.0/legalcode)

is these microstructures that diffract light, producing the holographic effect. They first etch microstructures into a metal master mold, which they then use to make the plastic molds for shaping the chocolate. The final step involves injecting liquid chocolate into the plastic mold. The resulting product is a delicious edible hologram (Fig. 11.10b).

Fig. 11.10 **a** A scanning electron microscope image of the microstructures on the surface of a piece of chocolate. **b** A piece of Morphotonix's holographic chocolate (Courtesy of Morphotonix)

11.5 Phase Holograms

A hologram developed and fixed using conventional photographic processing methods is called an *absorption* or *amplitude hologram* because the recorded fringes modulate the amplitude of the transmitted beam. Viewed under a microscope, the developed silver grains have the appearance of opaque black mopheads. They absorb most of the light that falls on them and reflect only 3 percent or less.

However, if the hologram is *bleached*, the silver particles are changed back into transparent silver bromide and the reconstructed image becomes much brighter. The refractive index of silver bromide is very high, and so the fringes form a multi-layered interference mirror. The bleached hologram is called a *phase hologram* because the recorded fringes now modulate the phase of the transmitted beam during image reconstruction.

11.6 Color Holograms

An important goal in holography has been to make holograms in full natural color. Although various special techniques have allowed for the production of holograms exhibiting several different colors, in most cases the colors in these holograms are not the original colors of the object. Such holograms, often referred to as *pseudocolor* or *multicolor holograms*, give an impression of true color, although the recordings could well have been made from objects having completely different colors.

Fig. 11.11 True color
(panchromatic) reflection
hologram of Chinese vase
(Hologram courtesy of Hans
Bjelkhagen)

Making a true color hologram, such as the one shown in Fig. 11.11, generally requires three beams of monochromatic light, and these beams need to follow precisely the same path. This can be accomplished by using a laser with several spectral lines and a tunable cavity, but it is more commonly done with three different lasers. The earliest color holograms were transmission holograms, and the images were reconstructed using the original laser wavelengths following the same path as the original reference beam. In essence, three different holograms were recorded and reconstructed so that colors were created by additive color mixing.

A major problem in color holography is that the three sets of fringes formed by the three beams occupy the same volume in the emulsion, and this leads to cross-talk. That is, in addition to the light of the wavelength used to record it, each hologram diffracts the other two wavelengths as well. The set of fringes formed by the red laser reconstructs not only the true red image but also spurious images from the fringes formed by the green and blue laser beams. The same thing happens for the green and blue beams, leading to six sets of spurious images in addition to the three genuine images.

One way to deal with the cross-talk difficulty, in part, is by using a thick emulsion and a large angle of incidence for the reference beam. When such a hologram is illuminated with the original multiwavelength reference beam, each wavelength is diffracted with maximum efficiency by its original set of fringe

planes, producing a multicolored image, but the cross-talk images are attenuated since they do not satisfy the Bragg condition.

The highest wavelength selectivity is obtained with thick-emulsion ("volume") reflection holograms; such holograms can even reconstruct a monochromatic image when illuminated with white light. Thus, they work well with color holography.

To produce a multicolor image, a volume reflection hologram is recorded with three wavelengths so that one set of fringe planes is produced for each wavelength. When such a hologram is illuminated with white light, each set of fringe planes diffracts light of the color (wavelength) used to record it.

Two other difficulties occur in color holography: color distortion due to shrinkage of the emulsion during processing and scattering of blue light in the emulsion. These difficulties appear to be minimized by the use of photopolymeric materials in place of photographic emulsions.

The process of making color holograms has recently been greatly simplified. The Litiholo company has developed a process using red, green, and blue laser diodes and a self-developing film that obviates the need for developing chemicals. The color hologram shown in Fig. 11.12, which can be viewed in white light, was produced in just minutes.

Lippmann Color Holograms

About the turn of the century, Gabriel Lippmann developed an experimental technique for making color photographs that made use of Bragg reflection and showed striking similarity to holography. A photograph using this method is shown in Fig. 11.13. In 1908, Lippmann won the Nobel Prize for his invention, but it never became very practical partly because of the unavailability of fine-grain photographic emulsions in his day. His idea of recording interference fringes throughout the depth of the emulsion was used by Denisyuk when he introduced the technique of recording single-beam reflection holograms in the early 1960s. Some holographers refer to single-beam reflection holograms as *Lippmann holograms*, while others reserve that term for color reflection holograms only.

Fig. 11.12 A color hologram produced using red, green, and blue laser diodes and self-developing film (Courtesy of Litiholo)

(a) (b)

Fig. 11.13 a Lippmann photograph of Abby Gardens, Bury St. Edmunds. **b** Detail from photograph (Lippmann photograph courtesy of Hans Bjelkhagen)

For a Lippmann hologram, the recorded interference fringes are quite narrow, and hence a recording material with extremely high resolution is necessary to obtain a satisfactory image. Although silver halide emulsions are satisfactory for recording holograms with red light, some holographers have found it better to use a dichromated gelatin plate for the blue and green components. The two plates are then combined to produce the final hologram.

Multicolor Rainbow Holograms

To produce a multicolor rainbow hologram, three primary holograms are made using red, green, and blue laser light. The transfer of the images (see Sect. 11.4) from these three primary holograms to a single hologram can be done sequentially through a narrow slit using red, blue, and green laser light, or it can be done with a single laser. When this multiplexed hologram is illuminated with white light, three reconstructed images are superimposed, as well as three images of the viewing slit. However, these slit images or spectra are displaced vertically with respect to each other, so that each component of the hologram reconstructs an image in its original position in the color with which it was made, and the observer sees three super-imposed images in the colors with which the primary holograms were made.

Pseudocolor Through Shrinkage

Another way to produce color, or more properly "pseudocolor," in a reflection hologram is to "tune" the thickness of the recording medium by selective shrinkage. Suppose that the red component hologram is recorded first, using a red He–Ne laser, with the emulsion side of the plate toward the reference beam. This plate is bleached and treated to eliminate emulsion shrinkage. Then the green component is recorded on another plate, again using the red beam from the He–Ne laser, but with the emulsion side toward the object beam. The emulsion is soaked in a solution of

triethanolamine, a chemical swelling agent, and dried in darkness; the blue component is then recorded on the swollen emulsion. Normal bleach processing eliminates the triethanolamine and produces the usual shrinkage. The first exposure yields a green image and the second one a blue image. After drying, the red and the green/blue plates are cemented together with their emulsions in contact.

Very good pseudocolor images can also be produced from contact copies of three master holograms made on photopolymer film. Two of the copies are swollen during processing so that they reconstruct green and red images. DuPont makes a single-layer three-color photopolymer.

11.7 Multiple Scenes

One of the most dramatic features of a hologram is that it is capable of recording more than one independent scene, either by multiple exposure or by making transfer holograms from several masters. These images can be viewed independently by changing the angle between the plane of the hologram and the reference beam.

To record multiple scenes, one exposes the film with the first object, stops the exposure, changes to a second object, changes the angle between the reference beam and the film, and exposes the film a second time. To create multiple images by transfer from master holograms, the masters are generally masked down to narrow slits either horizontally or vertically, and they are all transferred at once.

Recording multiple scenes is, in general, practical only in transmission holograms. The smaller and farther the objects are from the hologram, the more channels you can record. It is usually not possible to record multiple scenes using reflection holography.

11.8 Holographic Stereograms

An ordinary photographic image is two-dimensional. Recreating a three-dimensional scene requires two photographs taken from slightly different angles (a "stereo" pair), each viewed with one eye. In the old-fashioned stereopticon, the two images were viewed through two lenses separated by a wooden barrier. In modern 3D movies, the two images are viewed through polarized glasses so that each eye sees only one of them. In parallax stereograms, once popular as postcards, two photographic images are printed in narrow vertical strips and mounted under a fine lenticular screen that allows only one image to be seen by each eye.

A holographic stereogram, also often referred to alternately as an integral hologram or multiplex hologram, reconstructs a three-dimensional image from a series of two-dimensional views of an object recorded from different angles. A camera is used to record a subject from equally spaced positions along a horizontal line. A hologram is then made from each frame. An obvious advantage of

Fig. 11.14 *The Kiss II* by Lloyd Cross. As you walk by the hologram, a woman is seen blowing you a kiss. She then winks at you (Courtesy of The Jonathan Ross Hologram Collection)

this technique is that a laser is not required for the initial photographs, which is especially advantageous for recording large scenes or human subjects. Another advantage of the process is that the final product can be viewed using white light.

The first holographic stereogram was produced in 1974 by Lloyd Cross. He combined traditional filmmaking with holography to produce moving three-dimensional images, one of his best known being *The Kiss II*, shown in Fig. 11.14. Illuminated by a white light bulb, the hologram is mounted in a semicircular display. As an observer walks by, a three-dimensional image of a woman, seemingly floating behind the surface of the hologram, is seen blowing a kiss and winking.

Full-color stereograms are particularly impressive. The first stage in creating such a stereogram is to make a set of color-separation positives in black and white from the original color transparencies or negatives. From these, three masters are made, one for the red-separation original, one for the green, and one for the blue. The transfer hologram is exposed to the real image of each hologram, in turn, each film being positioned appropriately along the transfer slit.

11.9 Embossed Holograms

Although holograms can be copied photographically, mass production by this method is not economical. The wide use of holograms in advertising, in books, on credit cards, and even on money requires an inexpensive way of reproduction such as embossing copies in plastic. Although it appears reflective, an embossed holo-gram should really be thought of as a *transmission hologram* with a mirror behind it.

Master holograms for embossing are made on photoresist material, which records the primary holographic fringes in relief. The photoresist master may be recorded directly on the photoresist, or it may be copied from the original hologram

by using a high-power laser. The surface of the photoresist is sprayed or vacuum-coated with a conductive coating, which is then electroplated to the desired thickness. The electroformed coating is separated from the photoresist to be used as the metal master. Second-generation masters can be made from the original master by electroforming.

Giveaway holograms for advertising and adorning cereal boxes are usually hot pressed on polyvinyl chloride (PVC) or polyester. After pressing, the embossed side is aluminized to convert the transmission hologram into a reflection hologram. Holograms for credit cards, banknotes, and magazines are usually produced by hot stamping to give a flush surface so that the hologram cannot be removed without destroying it.

11.10 Holographic Interferometry

In addition to the primary fringes that appear in all holograms due to interference between the object and reference beams, much larger secondary fringes may appear if the object has moved during the exposure. These secondary fringes have been used to study stress, motion, and vibration, for example. Since its discovery by Powell and Stetson in 1965, holographic interferometry has become one of the most important research and industrial applications of holography.

Real-Time Interferometry

If the photographic plate is processed in the plate holder or replaced in the exact position it was during exposure, the object will coincide with its own image. If the object has moved ever so slightly, however, interference fringes appear, and these fringes can be used to determine precisely how much the object has moved or changed. Unlike other interferometric techniques, which require optically polished surfaces, holographic interferometry works with rough surfaces as well.

Real-time interferometry can be used to view the normal modes of a vibrating body. The hologram is carefully adjusted to minimize the real-time fringes with the object at rest, and then the object is made to vibrate at each of the modal frequencies of interest. Fringe patterns produce a sort of contour map of the displacement in each normal mode.

Time-Averaged Interferometry

A vibrating object is instantaneously stationary at the two extremes of its motion while it moves at maximum speed somewhere near the center. On the average, therefore, it spends more time near the turning points, and so a hologram of it with a long exposure will show a pattern of interference fringes that indicates its displacement difference at the two turning points. Time-averaged interferograms of a handbell and guitar are shown in Fig. 11.15. The photographs show a reconstruction of normal modes of vibration. Nodes appear as bright lines, and antinodes as bull's eyes. Each bright fringe surrounding the antinodes represents an amplitude change of one-quarter of the wavelength of light, so an accurate contour map of the vibrational motion is obtained.

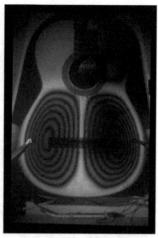

Fig. 11.15 Time-averaged hologram interferograms of a handbell (Photograph courtesy of Professor Thomas Rossing, Stanford University) and guitar (Photograph courtesy of Dr. Bernard Richardson, Cardiff University)

11.11 TV Holography

Although holograms recorded on film generally have the highest possible resolution, the use of film is somewhat time-consuming. It is much more convenient to create the holographic images electronically so that they can be viewed as soon as they are created. In the 1970s, video techniques to record holograms or speckle patterns, as they are sometimes called, developed. TV holography, or electronic speckle pattern interferometry (ESPI), allows real-time fringes to be presented on a TV monitor without any photographic processing.

A modern TV holography system, such as the one shown in Fig. 11.16, uses a sensitive CCD (charge-coupled device) camera, and incorporates image processing using digital computers and techniques such as phase stepping. TV holography has become popular in engineering laboratories and in industry to study vibrations, deformations, and sound fields, and is used in nondestructive testing. One of its first applications in the arts has been the study of vibrations in musical instruments. It has not yet been widely used by visual artists to create real-time holographic images, however.

An optical system for TV holography is shown in Fig. 11.17. A beam splitter (BS) divides the laser light to produce a reference and an object beam. The reference beam illuminates the CCD camera via a phase-stepping mirror (PS) and an optical fiber (see Fig. 4.15), while the object beam illuminates the object to be studied. Reflected light from the object reaches the CCD camera where it interferes with the reference beam to produce the holographic image. The speckle-averaging mechanism (SAM) in the object beam alters the illumination angle in small steps in

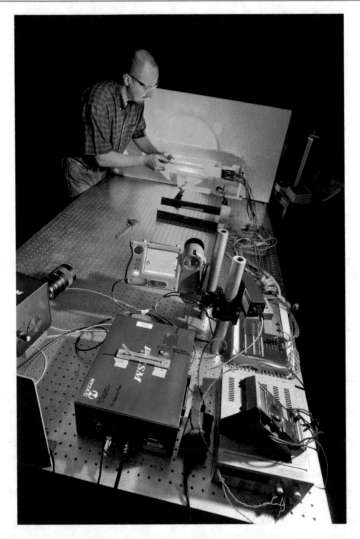

Fig. 11.16 TV holography distortion measurement system at Lawrence Berkeley National Laboratory (U.S. Department of Energy from United States [Public domain], via Wikimedia Commons)

order to reduce laser speckle noise in the interferograms. The system in Fig. 11.17 is designed to detect small deformations or vibrations of the object in the direction of the laser beam. Other systems are designed to detect deformations parallel to the surface of the object.

An interferogram of a vibrating square plate is shown in Fig. 11.18. The plate is driven by a force that oscillates at the frequency of one of the plate's vibrational modes.

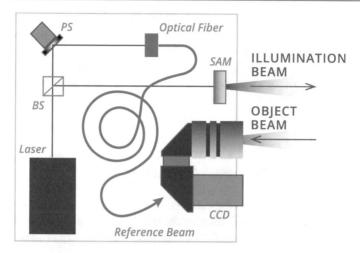

Fig. 11.17 Optical system for TV holography. BS = beam splitter; PS = phase-stepping mirror; SAM = speckle-averaging mechanism; CCD = video camera

Fig. 11.18 Electronic speckle pattern interferometry (ESPI) fringes showing a vibration mode of a clamped square plate (Epzcaw [Public domain], from Wikimedia Commons)

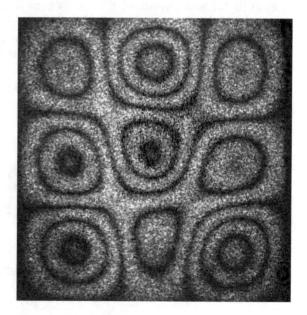

11.12 Photopolymers

A *photopolymer* is a material that changes its chemical composition upon exposure to light: in particular, simpler molecules called *monomers* are coaxed to form complex polymers. Photopolymers can record photographic or holographic images,

and they require no development. In recording, the material is first exposed to the information-carrying light. Then the material is exposed to regular light of uniform intensity until the remaining monomers also polymerize.

Photopolymers generally require longer exposure times than photographic films and they have relatively short shelf life. They can be made to respond to light of almost any color. DuPont has developed a photopolymer called OmniDex that is intended for holography.

11.13 Computer-Generated Holograms

Theoretically, computers can be used to produce holograms with any desired amplitude and phase distribution. In practice, this is easier said than done. Nevertheless, a lot of research has been directed to advancing this very promising field of imaging.

The first step in generating a hologram by computer is to calculate the complex amplitude of the object wave at the hologram plane, which is generally taken to be a mathematical (Fourier) transform of the complex amplitude in the object plane. This was done in the production of the hologram shown in Fig. 11.19. If the object wave is sampled at a sufficiently large number of points, this can be done with no loss of information. The second step is to produce a transparent hologram that will reconstruct the object wave when suitably illuminated. To do this, the computer is used to control a plotter that produces a large-scale version of the hologram that is photographically reduced to produce the required transparency.

Fig. 11.19 A computer-generated hologram (Alexander Macfaden (https://commons.wikimedia.org/wiki/File:CGH_XmasTree.jpg), "CGH XmasTree", https://creativecommons.org/licenses/by-sa/3.0/legalcode)

11.14 Holography in the Arts

Can holography be considered an art form? This question has been asked ever since the revolutionary method of recording three-dimensional images became widely available in the late 1960s. Initially viewed by the art community as a scientific curiosity, holography later became seen by many visual artists as a medium with unlimited potential. Today, holographic images can be found in art galleries around the world, demonstrating the continuing marriage of art and science.

Salvador Dali is credited as one of the first artists to enthusiastically embrace holography as an artistic medium. Dali's interest in optics, and its application in his art, preceded the arrival of holography. Throughout his career he had experimented with moiré patterns and stereoscopic imagery, so it is perhaps not surprising that the artist became fascinated with the new three-dimensional canvas. Dali's enthusiasm for holography is evident from the following quote: "With the genius of Gabor, the possibility of a new Renaissance in art has been realized with the use of holography. The doors have been opened for me into a new house of creation."

From 1971 to 1976, Dali produced seven holographic works that were to become some of the most important art holograms of the twentieth century. It is this body of work that most certainly inspired others to use laser light as a brush.

Fig. 11.20 *Aleph 2* by Eric Leiser (Eric Leiser (https://commons.wikimedia.org/wiki/File:Aleph2.jpg), "Aleph2", https://creativecommons.org/licenses/by-sa/3.0/legalcode)

In the decades following Dali's monumental contributions to the creative use of holography, scores of visual artists have become devotees of the art form. Among them is filmmaker and holographer Eric Leiser. One of his holographic creations, *Aleph 2*, is shown in Fig. 11.20.

11.15 Summary

Optical holography is a technique for the recording and reconstruction of three-dimensional images using photographic film or digital storage. Unlike a conventional photograph, there is no reproduction of the object on film. Instead, the film is used to record an interference pattern. An observer looks through a hologram as if it were a window and sees a three-dimensional image on either side or even straddling this window. A reflection hologram can be viewed with a spotlight or a point light source as if it were a three-dimensional painting. A transmission holo-gram is illuminated from behind by monochromatic light. In addition to basic transmission and reflection holograms, there are many special types such as volume holograms, rainbow holograms, multiplex holograms, and holographic interferograms.

Recording a hologram requires a reference beam and an object beam, while reconstructing the image requires a reference beam only. Mass production of holograms is made possible by embossing them in plastic from a master. Color holograms require three beams of monochromatic coherent light to record three different holographic images. The three reconstructed images are viewed together, so they combine additively to give a color image.

Holographic interferometry is widely used to measure distortion or vibration of an object. Time-averaged interferometry records the modes of vibration with a very high resolution. TV holography allows the viewing of electronically produced interferograms in real time.

Holography is seen by many visual artists as a medium with limitless possi-bilities. Now accepted as an exciting new art form, holograms can now be found in galleries and private collections.

◆ Review Questions

1. How is it possible for a two-dimensional hologram to produce a three-dimensional image?
2. Why is a laser required in the production of a hologram?
3. If a hologram is broken into two pieces and the two pieces are viewed at the same time, what will be seen?
4. Could two different lasers be used to produce the object beam and reference beam? Why?
5. Why can a reflection hologram be viewed in sunlight but a transmission hologram cannot?

6. Explain why vibration must be avoided when making a hologram.
7. What is a holographic stereogram?
8. What type of hologram is produced by shining light through the film to illuminate the object? How can this approach be used to produce a full color image?
9. Is an embossed hologram a transmission or reflection hologram? Explain your answer.
10. How is a holographic stereogram produced?

▼ Questions for Thought and Discussion

1. How is it possible to produce a holographic image that projects in front of the hologram?
2. How are multiple scenes recorded on a single hologram?
3. Is it possible to determine what is recorded on a hologram without actually reconstructing the image? Explain.
4. Discuss problems associated with making a hologram of a person. Suggest how these difficulties might have been overcome in the creation of the hologram of Dennis Gabor (Fig. 11.1).

● Experiments for Home, Laboratory, and Classroom Demonstration

Home and Classroom Demonstration

1. **Reflection hologram**. Examine a simple reflection hologram in different types of light (including sunlight).
2. **Make a reflection hologram**. Create a reflection hologram using a Holokit™ hologram kit available from Integraf (https://www.integraf.com/) or a Litiholo hologram kit (https://litiholo.com/). The Litiholo kit simplifies the holographic process by employing a self-developing film, thus eliminating the need for chemicals. See Experiments 11.1 and 11.2 for detailed instructions on making both reflection and transmission holograms.
3. **Holography Museum**. Visit a holography museum. How many different kinds of holograms can you identify?
4. **Bright stripe in front of a rainbow hologram**. Hold a rainbow hologram very flat and illuminate it from above with a monochromatic source at least 2 m away. With your head about 1 m in front of the hologram, look for a glowing horizontal stripe floating about half a meter in front of the hologram. (The stripe can be located by bobbing your head up and down and positioning a finger in space until there is no relative motion between it and the stripe.) If you bring your eyes into this glowing stripe, you will suddenly see the entire 3D image. You can "look around" as you move from side to side, but do not "look under or over," because the image disappears.

Now illuminate the hologram with a point-like source of white light and view the hologram through an interference filter to see the glowing stripe in front of it in whatever color the filter transmits. Tilt the interference filter so that its transmission color shifts toward the blue, and note that the stripe location moves downward. Without the filter, you should see a spectrum hanging in front of the hologram with red on top and blue on the bottom. (This experiment was suggested by Stephen Benton, inventor of the rainbow hologram; see *Optics and Photonics News*, July 1991.)

4. Project real and virtual images from a transmission hologram and determine whether the images are orthoscopic or pseudoscopic. Determine the depth of field for each image.

Laboratory (See Appendix J)

11.1 Making a Reflection Hologram
11.2 Making a Transmission Hologram

Glossary of Terms

amplitude hologram A hologram that modulates the reference beam through absorption.

bleaching Dissolving silver particles to make the emulsion more transparent and the reconstructed image brighter. Bleaching changes an amplitude hologram into a phase hologram.

Bragg reflection Strong reflection at certain angles by diffraction of light from planes of recorded fringes. Bragg's law shows how the angle depends upon the spacing of the planes and the wavelength of the light.

coherent light Light having a fixed relationship between the phase of light waves of a single wavelength.

Denisyuk hologram A reflection hologram in which a single beam serves as both reference beam and object beam by passing through the emulsion twice.

hologram A recording of interference fringes from which a three-dimensional image can be reconstructed.

holographic interferogram A holographic recording using two or more images to show motion or some other time-dependent phenomenon.

Lippmann photography A technique for making color photographs that makes use of Bragg reflection.

object beam Portion of the laser beam that illuminates the object.

orthoscopic image A holographic image that has normal front to back perspective.

phase hologram A transparent hologram in which the fringes modulate the phase of the reference beam during image reconstruction.

pseudocolor hologram A hologram in which the emulsion thickness is varied to produce colors different from the light used to record it.

pseudoscopic image An image that is reversed front to back.

rainbow hologram A hologram whose image changes color as the viewpoint is moved up and down.

real image An image that can be projected on a screen.

real-time holographic interferometry Creating an interference pattern between an object and its hologram in order to see how much the object has moved or changed.

reference beam Portion of the laser beam that goes directly to the film or camera.

reflection hologram A hologram that can be viewed from the front as if it were a painting.

time-average interferogram Combining many holograms in the same image; in the case of a vibrating object, the nodes appear as bright lines and fringes of equal amplitude occur in the antinodal regions.

transfer hologram Hologram that uses the real image from another hologram as its object.

transmission hologram A hologram that is viewed by illuminating it from behind with monochromatic light.

TV hologram A hologram that is created by electronically comparing the reference beam and the object beam.

virtual image An image that cannot be projected on a screen.

Further Reading

Bjelkhagen, H. I., & Brotherton-Ratcliffe, D. (2013) *Ultra-Realistic Imaging, Advanced Techniques in Analogue and Digital Colour Holography*. Boca Raton, FL: CRC Press.

Harper, G. D. J. (2010). *Holography Projects for the Evil Genius*. New York: McGraw-Hill Education TAB.

Hariharan, P. (2002). *Basics of Holography*. Cambridge: Cambridge University Press.

Hubel, P., & Klug, M. A. (1992). Color holography using multiple layers of DuPont photopolymer. In S. A. Benton (Ed.), *Practical Holography V* (pp. 215–224). Proceedings of the SPIE 1667, Bellingham, WA: SPIE.

Jeong, T. H. (1987). *Laser Holography*. Southfield, MI: Thomas Alva Edison Foundation. Reprinted and distributed by Integraf, Box 586, Lake Forest, IL 60045.

Kasper, J. E., & Feller, S. A. (2001). *The Complete Book of Holograms: How They Work and How to Make Them*. Mineola, NY: Dover Press.

Saxby, G., & Zacharovas, S. (2015). *Practical Holography*, 4th ed. Boca Raton, FL: CRC Press.

Computer Imaging

12

Artists using computers are capable of creating images of captivating power and beauty. Electronic collage, animation, and image transformation blend with traditional form, color, and shading. Computer imaging, the integration of computer graphics systems into the creative process, has transformed art in previously unimaginable ways.

Although the first computer-aided artistic experiments took place less than 70 years ago, computers have since been applied to many areas of art, such as painting, drawing, photography, print-making, textiles, environmental art, ceramics, metalwork, sculpture, kinetics, movie production, and laser imagery. New directions in visual expression continue to emerge as artists integrate computing systems into the creative process.

In Sect. 1.9 we learned how the development of new pigment colors profoundly influenced the progress of painting. Today, pigment is not even necessary; computer systems offer palettes of thousands of colors. Entire compositions can be recolored in seconds, and lighting and positioning can be transformed with the touch of a stylus or finger. Live video images can be transformed by electronic paint, and pictures can be saved at any stage of their creation for later reference or restructuring.

12.1 Evolution of Computer Imaging

Among the first graphic images generated by an electronic machine were the "oscillons" created by mathematician-artist Ben Laposky in 1950. He used a cathode ray oscilloscope and sine wave generators to create patterns that he then photographed through filters. Laposky's oscillons, one of which is shown in Fig. 12.1, were done on analog equipment.

© Springer Nature Switzerland AG 2019
T. D. Rossing and C. J. Chiaverina, *Light Science*,
https://doi.org/10.1007/978-3-030-27103-9_12

Fig. 12.1 *Oscillon #1043*
(1950) (Courtesy Sanford
Museum, Cherokee, IA USA)

The Whirlwind, built at the Massachusetts Institute of Technology in 1949, was one of the first digital computers to have a display screen like a television monitor. Its graphic capabilities were presented to the public in 1951 when it was featured on Edward R. Murrow's popular television program "See It Now." Among the demonstrations was a simulation of a bouncing ball losing energy with each bounce.

A few years later, a method for scanning pictures on a rotating drum with a photoelectric cell and feeding the data into a computer was developed at the National Bureau of Standards. According to Russell A. Kirsch at NBS, this was "the first time that a computer could see the visual world as well as process it." The first image-processed picture produced on this system was of Kirsch's baby son (see Fig. 10.9).

The CalComp digital plotter, introduced in 1959, ushered in the era of computer graphics. This plotter used a rotating drum and a movable pen, both controlled by specifying numerical coordinates, to make two-dimensional drawings. Later models offered flatbed plotting and pens of different colors that could be selected by the computer. Programs were developed for representing three-dimensional objects on two-dimensional plotters.

An interactive computer graphics system using a light pen was developed by Ivan Sutherland in 1962. Sutherland's "sketchpad" system enabled the user to draw directly on an oscilloscope screen using a pen-like device with a photocell inside. Although Sutherland's system was developed mainly for engineering drafting, it found immediate applications in industry and the military, and later in art.

The first exhibition of computer-generated art was held in Stuttgart, Germany, in 1965, and that same year an exhibition of digital graphics was shown at the Howard Wise Gallery in New York. Included in that exhibition were photographic enlargements of microfilm plotter output conceived by A. Michael Noll and Bela Julesz of Bell Telephone Laboratories, which became a center for research in computer graphics as well as computer music. One of Noll's works, remarkably similar to Piet Mondrian's *Composition with Lines*, is shown in Fig. 12.2.

Fig. 12.2 *Computer
Composition with Lines* by A.
Michael Noll (© 1965 A.
Michael Noll). This image
was intended to approximate
Mondrian's *Composition with
Lines* (1917)

One of the first artists with a traditional background to become involved in computer graphics was Charles Csuri, an artist at the Ohio State University, who in 1966 produced some of the first examples of computer-generated representational art. Csuri scanned his pencil drawings to convert them into digital information, transformed them, and plotted them. One of his best-known computer-generated works is *Transformation*, in which a girl's face gradually dissolves into old age.

In 1963, artist Robert Rauschenberg and physicist Billy Klüver teamed up to create a number of works of art in which common technological objects were activated by electronic systems. In 1968, Andy Warhol adopted an inexpensive Amiga computer as his latest tool. He worked extensively with image-processing effects, only a step removed from the photographic silkscreen technique used in his famous portraits of Marilyn Monroe and Elizabeth Taylor. Other well-known artists who have worked with digital paint systems include David Hockney, Keith Haring, Peter Max, Larry Rivers, and Jack Youngerman.

Mathematical modeling of many of the random and complex shapes found in nature has been accomplished by fractal geometry, conceived in 1975 by mathematician Benoit Mandelbrot at IBM's Thomas J. Watson Research Center. The central principle on which *fractals* are modeled is that of *self-similarity*, by which large forms are composed of smaller, virtually identical units. Fractals lend themselves well to computer graphics, and they have been adopted by a number of computer artists. An example of computer-generated fractals is shown in Fig. 12.3.

Robert Mallary was one of the earliest sculptors to use *computer-aided design* (CAD) and computer-aided manufacturing (CAM) for sculpture (see Sect. 12.8). TRAN2, his first program for the computer-aided design of abstract sculpture, was developed in 1968. He used this program to design his plywood sculpture *Quad III*, shown in Fig. 12.4.

Fig. 12.3 Partial view of computer-generated Mandelbrot set fractal. (Wolfgang Beyer (https://commons.wikimedia.org/wiki/File:Mandel_zoom_11_satellite_double_spiral.jpg) , "Mandel zoom 11 satellite double spiral", https://creativecommons.org/licenses/by-sa/3.0/legalcode)

Fig. 12.4 *Quad III* by Robert Mallary (1968). This sculpture was constructed by stacking layers of plywood shapes that were drawn by a computer sculpture design program, TRAN2 (Robert Mallary [CC BY-SA 4.0 (https://creativecommons.org/licenses/by-sa/4.0)], via Wikimedia Commons)

12.2 What Is a Computer?

The development of the digital computer ranks with the discovery of fire, the invention of the wheel, and the domestication of animals as events that changed the world forever. Just as the development of machines relieved humans from arduous physical tasks, the computer frees us from tedious mental tasks. Today, the computer has become virtually indispensable to us. Microprocessors have become so small and powerful that they are incorporated in thousands of products we use every day, including automobiles, toys, home appliances, smartphones, and tablets.

A computer is a device that is capable of receiving data, storing instructions for processing the data, and generating output with great speed and accuracy. At the heart of computers are miniature integrated circuits often consisting of over a billion transistors. Peripherals generally include display monitors, keyboards, printers, various types of data storage units, and other devices. The ability of computers to follow instructions and process data, whether numbers or letters, is what makes them such useful servants.

Although computers come in many sizes, we generally talk about them in families (from small to large). These include microcomputer, more commonly known as a personal computer (PC), workstation, mainframe computer, and supercomputer.

PCs are relatively inexpensive machines designed to either operate on desktops or be portable. Hybrid tablet/laptop devices, called surface computers, offer the flexibility as well as portability. PCs generally store data and programs on magnetic hard drives or solid-state drives, receive input data primarily from a keyboard, mouse, or touch screen, and supply output via a display monitor or printer. PCs are especially suitable for home and office use and travel.

High-performance computers, sometimes called *workstations*, are widely used for scientific and engineering applications. Many of them are also very useful for creating and processing computer images. They are often based on a design called *reduced instruction set computers* (RISCs), which gives them additional speed and computing power.

Mainframe computers may serve hundreds of users at the same time. They usually include several printers, optical character scanners, disk storage units, and a large main memory section. Even larger computers, which often carry on many data processing tasks in parallel, are sometimes referred to as *supercomputers*.

The main subsystems in a computer are: input, central processing unit (CPU), random access memory (RAM), also referred to as primary memory or just memory, permanent read-only memory (ROM), secondary memory or secondary storage, and output, as shown in Fig. 12.5. The input system receives data from a keyboard, a magnetic storage device such as an external hard drive or flash memory drive, touch screen, an optical scanner, or the internet and routes it to the central processor.

Fig. 12.5 Simplified computer architecture

The *central processing unit* (CPU) is the heart of the computer; it integrates and coordinates overall operation. The CPU in a PC is a single integrated semiconductor chip. Early chips carried such designations as 286, 386, 486 (from the last three digits in the Intel model number), or Pentium. Today, the primary computer processor is the Intel Core.

The CPU has three principal functions. They include: performing mathematical operations, such as addition, subtraction, multiplication, and division, retrieving and transferring data to memory, and receiving input from devices such as a keyboard and producing output to be printed or displayed on a monitor. The latter function is commonly referred to as input/output (I/O).

The speed at which the CPU can handle its many tasks is dependent on several factors, one of the most important of which is the amount of random access memory, or RAM. When a computer runs a program, the CPU transfers the executable file from the program into the computer's RAM. Insufficient memory can cause the computer to run slowly. Thus, the more RAM, the better.

RAM is used to store the programs and data being used by the CPU in real time. The data on RAM can be read, written, and erased an unlimited number of times. However, when power to the computer is cut off, data stored in the RAM is lost immediately.

As the name implies, a second type of memory, ROM, can generally only be read; it cannot be written to. The data on ROM is usually recorded at the time of a computer's manufacture and is, for all practical purposes, permanent. ROM is nonvolatile, that is, unlike RAM, data is not lost when the power to the computer is turned off. ROM is used to store system-level programs that are available to the PC at all times. Among other things, ROM has the vital role of storing the instructions needed for "booting up," that is, starting a computer.

Processed data is generally stored in secondary memory. Devices used for secondary memory include internal and external magnetic hard-disk drives, solid-state drives, and portable storage devices such as flash drives. Like ROM, secondary memory is not lost when the computer is turned off, and is capable of being written to as well as being read. Optical storage mediums, such as compact discs (CDs) , digital video discs (DVDs) , and even magnetic hard-disk drives, have to a great extent been replaced by solid-state drives, which offer large storage capacity without the need for moving parts.

12.3 Software

The term *software* has come to designate the programs—sets of instructions, codes, operating systems, and languages—that enable a computer to perform its functions. Many software companies have been very successful in developing and selling both system and applications programs for computers, large and small. System software, such as Windows, is designed to manage the operations of a computer, to enable programs to be copied from one device to another, or to keep a log of jobs handled by the computer. Applications software, such as Word, PowerPoint, or Excel, are designed to carry out specific tasks, such as word processing, creating and delivering presentations, or computation on a spreadsheet. A considerable amount of imaging software has been developed for microcomputers, tablets, smartphones, workstations, and mainframe computers.

One of the most popular software packages for computer imaging is Adobe Photoshop. Photoshop is a suite of programs for creating and transforming images. It can be used to paint, draw, clean up photos, create collages, change colors, modify the size and scale of an image, and perform countless other useful functions. Other imaging programs include Corel's Painter, ArtRage 5, and Clip Studio Paint.

A considerable amount of software is available for no charge. Such software is sometimes referred to as *shareware* or *freeware*. Image-processing programs in the public domain include GIMP, Krita, and Artweaver Free. These programs allow the user to do many of the things that paid options offer.

Free ray-tracing programs such as Persistence of Vision Raytracer (POV-Ray) create realistic images of objects by simulating rays of light to produce realistic reflections and shading. To create a scene, the computer is told the locations of the object, the camera, and the light source. The computer then traces rays of light between the camera and the light source one at a time and builds an image using these rays. The level of realism possible with ray-tracing programs is seen in Fig. 12.6.

Fig. 12.6 This realistic image was produced using Persistence of Vision Raytracer software (User Martinkb on en.wikipedia [Public domain or Copyrighted free use], via Wikimedia Commons)

12.4 Smartphones and Tablets

A smartphone is a mobile phone with an internal processor, memory, and a touch screen display. Simply put, a smartphone is a handheld personal computer with communications capabilities. A smartphone's advanced operating system, such as Apple's iOS and Android from Google, makes possible a diversity of function not found in basic cell phones. Downloadable software applications, commonly referred to as "apps," allow a smartphone to do most of the tasks performed by a desktop or laptop computer. Among other things, a smartphone can serve as a web browser, camera, calculator, calendar, clock, navigational tool, media player, address book, and flashlight. Not so obvious perhaps are the many sensors found in a typical smartphone. They include an accelerometer, gyroscope, barometer, and proximity sensor.

One of most popular uses of smartphones is photography. No longer is it necessary to carry a camera for picture taking since a smartphone's photographic capabilities are, in many instances, superior to low-cost point-and-shoot as well as some more expensive digital cameras. Pre-loaded and downloadable software provide essential editing tools, in many cases eliminating the need for uploading images to a computer for massaging.

A tablet computer, or simply tablet, is another portable personal computer with many of the features found in smartphones. One obvious difference between a smartphone and a tablet is size, tablet screens being larger than smartphones. Like smartphones, network connectivity is built into most tablets.

Tablets and smartphones have changed the platform and scope of digital art, for they provide artists with the freedom to draw and paint digitally wherever and whenever they choose. The cost and versatility of both devices vary greatly. That said, relatively reasonably priced drawing instruments, such as the iPad, iPhone, and Microsoft Surface, coupled with numerous drawing applications that include Brushes, Sketchbbok Pro, and Corel's Painter, allow the visual artist to draw, sketch, and paint with the touch of a finger or stylus. Using programs such as the free 123D Creature or TrueSculpt, it is even possible to do three-dimensional sculpting.

Both amateur "finger painters" and professional artists are embracing both smartphones and tablets as artistic instruments. Among the well-known artists using these devices are comic-book illustrator Jim Lee, animator Goro Fujita, and renowned British artist David Hockney. Hockney's iPhone drawings provide examples of how consumer electronics and inexpensive painting applications are transforming the creative process.

12.5 Computer Terminology: Bits, Bytes, and Pixels

Bits and Bytes: Binary Notation

Computers work with *binary notation*, which is based on only two digits, 0 and 1, in contrast to decimal notation, which relies on the digits 0 through 9. Binary notation is well suited to computers since it can represent a switch or transistor that is on or off, or one of two residual states of a magnetic storage medium. Binary digits are called *bits* and a group of eight bits is called a *byte*.

Although it is not necessary to use binary numbers to converse with computers (these days computers "understand" decimal numbers; they convert them to binary numbers internally), it is interesting to become a little familiar with binary notation to appreciate what is happening inside the computer, where all the arithmetic is done with binary numbers.

We understand the number 931 to be $9 \times 100 + 3 \times 10 + 1$ or written another way: $931 = 9 \times 10^2 + 3 \times 10^1 + 1 \times 10^0$ (recalling that any number raised to the zeroth power equals one). Similarly, the binary number 101001 is understood to be $1 \times 32 + 1 \times 8 + 1$ or decimal 41. Written as powers of two: $101001 = 1 \times 2^5 + 0 \times 2^4 + 1 \times 2^3 + 0 \times 2^2 + 0 \times 2^1 + 1 \times 2^0$. To convert a binary number to decimal notation, we write out (or mentally follow) an algorithm such as this one. To convert a decimal number to binary, we begin with the highest power of two contained therein ($32 = 2^5$ in the case of the number 41); after

subtracting 32 from 41, we look for the highest power of two in the remainder ($8 = 2^3$ when the remainder is 9); subtracting 8 from 9 leaves 1, which is the remaining digit.

Storage capacity in a computer is generally expressed in units of 1024 bytes, which is called a *kilobyte* or KB. (This is a slight distortion of the metric system in which the prefix *kilo-*, abbreviated *k*, means 1000.) Roughly two kilobytes are needed to store a page of text.

There was a time when a kilobyte of memory was considered substantial. However, this changed as computer data processing speed and storage capacity grew. The following are some of the units currently used to describe computer memory.

- A *megabyte* (MB) is 1024 kilobytes or 1,048,576 bytes. One minute of MP3 audio requires about 1 megabyte. A 10-million-pixel image from a digital camera typically takes up a few megabytes.
- One *gigabyte* (GB) is about 1 billion bytes, or 1000 megabytes. A computer might have 4 GB of RAM. A flash memory card used in a camera might store 16 GB.
- One *terabyte* (TB) is about 1000 gigabytes, or roughly 1 trillion bytes. It is now common to see terabyte hard drives.

Resolution: Pixels

The resolution in graphic displays, devices to be discussed in Sect. 12.6, is expressed in terms of *pixels* (short for "picture elements") or individual dots in the display. In computers, resolution is the number of pixels contained on a display monitor, expressed in terms of the number of pixels on the horizontal axis and the number on the vertical axis, for example, $640 \times 480 = 307,200$ pixels. The sharpness of the image on a display depends on the resolution and the size of the monitor. The same pixel resolution will be sharper on a smaller monitor and gradually lose sharpness on larger monitors because the same number of pixels are being spread out over a larger number of inches.

Early PCs generally came equipped with color graphics adapter (CGA) 320×200-pixel four-color graphics. The CGA graphics mode requires only 16,000 bytes of memory to store a graphic image. Using CGA graphics artists had to draw using only four colors: black, white, cyan, and magenta. Making graphics look good using such a limited palate was almost impossible. With the advent of 256-color super visual graphics array (VGA) 1024×768-pixel graphics, which require 786,000 bytes of memory, beautiful full-color images became the norm.

Over the years, with the increase in memory dedicated to graphics, display resolutions have increased dramatically. In 2012, the most commonly used resolution in America was 1920×1080. Since 2014, a number of high-end desktop monitors have been released with resolutions that include resolutions of 2560×1080, 3440×1440, and 3840×1600. Recently, several ultra-high

definition (UHD), so-called 4 K, monitors with a resolution of 4096 × 2160 have become available.

When discussing resolution, it is equally important to take into consideration the ratio of the width to the height of a screen, known as the aspect ratio. Typical aspect ratios include 4:3, 5:4, 16:10, and 16:9. Only specific resolutions can be paired with each aspect ratio. Resolutions of 1024 × 768 and 1600 × 1200, common until 2003, match the 4:3 aspect ratio of analog TV and nonwidescreen standard-definition television (SDTV). Since 2008, high-definition television (HDTV) and widescreen SDTV, with resolutions ranging from 1366 × 768 to 1920 × 1080, have aspect ratios of 16:9.

12.6 Displays

Electronic visual displays play a central role in our lives. It is estimated that the average American now spends more than 10 hours each day looking at screens of some sort. Televisions, computers, residential and automobile controls, and smartphones currently provide us with our principal means of acquiring information and entertainment. It's perhaps not surprising that numerous artists have turned to electronic displays as a means of conveying their thoughts, observations, and emotions.

Artists now have many options when it comes to displaying their work. However, that has not always been the case. For centuries, visual artists were limited to displaying their drawings and paintings on material substrates such as canvas, paper, wood, ceramics, and glass. The advent of electronic displays, printers, and plotters has changed all that. As we have already seen, these new media have opened up an array of options for the visual artist.

What follows is an overview of visual display technology. It is by no means comprehensive, but is offered to provide some idea as to how displays have evolved over time.

Early Displays

The earliest electronic display was the cathode ray tube (CRT), which was invented in 1897 and became available commercially in 1922. At first, CRTs, such as those found in early televisions and oscilloscopes, were only capable of producing black and white or monochromatic images. It was not until the 1950s that color CRTs became available, making possible color television. As shown in Fig. 12.7, colored CRTs employ three electron guns, each of which corresponds to one of the primary colors. After being focused by deflecting coils, electrons from the three guns are selected by a mask to hit appropriate RGB phosphors on the screen.

The use of CRTs in televisions and other displays ended as a result of the development of flat screen devices that take advantage of electroluminescence, the phenomenon in which the passage of an electric current through a material results in the emission of light.

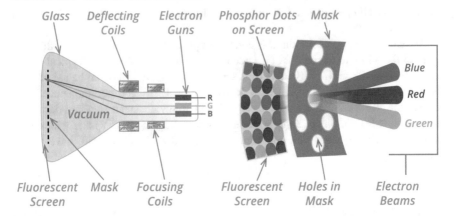

Glass Deflecting Electron Phosphor Dots Mask
 Coils Guns on Screen

Blue

Red

Vacuum

Green

Fluorescent Mask Focusing Fluorescent Holes in Electron
Screen Coils Screen Mask Beams

Fig. 12.7 A color CRT employs three electron guns, each of which corresponds to a primary color

Plasma Displays

A plasma display consists of an array of millions of very small gas-filled cells, or pixels, encased between two glass plates, as shown in Fig. 12.8. The cells can be thought of as being miniature fluorescent tubes. These cells, which contain a noble

A Schematic Matrix Electrode Configuration in an AC PDP

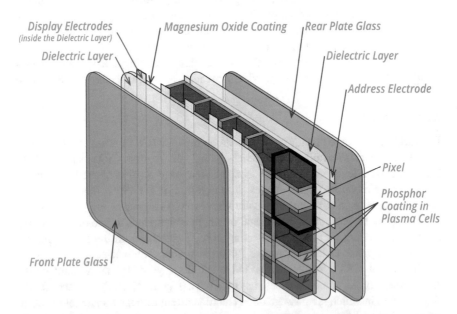

Display Electrodes *Magnesium Oxide Coating* *Rear Plate Glass*
(inside the Dielectric Layer)

Dielectric Layer *Dielectric Layer*

Address Electrode

Pixel

Phosphor
Coating in
Plasma Cells

Front Plate Glass

Fig. 12.8 In a plasma screen, cells that are filled with a noble gas such as xenon or neon are further divided into red, green, and blue phosphor-lined subcells (Jari Laamanen [FAL], from Wikimedia Commons)

gas such as xenon or neon, are further divided into red, green, and blue phosphor-lined subcells. The subcells are contained within a network of electrodes located above and below the cells.

A voltage applied to a subcell's electrodes results in an electric discharge, causing the gas within the cell to ionize. The ionized gas, or plasma, consists of negatively charged electrons and positively charged ions. Ultraviolet light is emitted when the voltage is removed and the opposite charges combine.

Visible light is produced when the ultraviolet light excites the red, green, or blue phosphor in a subcell. The melding of these three colors creates the color of the pixel.

Liquid Crystal Displays

The liquid crystal display (LCD) sounded the death knell of the CRT in the 1990s and, in the mid-2000s, it had a similar effect on plasma displays. Liquid crystal displays were initially used in devices such as wristwatches and calculators; however, today LCDs are ubiquitous, being the dominant means of visual display in televisions, desktop and laptop computers, tablets, smartphones, a variety of household appliances, and automobiles.

An LCD is a flat panel display device that utilizes a substance called a liquid crystal. Liquid crystals are organic substances that can flow like a liquid, but have molecules that may be oriented in a crystal-like manner.

One of the useful properties of liquid crystals is their ability to affect light. In its normal state, the molecules in the type of liquid crystal used in an LCD are twisted. This structure rotates the plane of polarized light. Applying an electric field to the crystal straightens the molecules, leaving polarized light unaffected.

As shown in Fig. 12.9, an LCD display consists of several layers that include a white backlight, two crossed polarizing filters, and the grid containing millions of pixels, each pixel being made up of smaller areas called subpixels. Each subpixel is assigned its own liquid crystal.

If an LCD is to display color, each pixel must have three subpixels with red, green, and blue color filters. Through the careful control of the voltage applied, the intensity of each subpixel can range over 256 shades. Combining the subpixels produces a possible palette of thousands of colors.

Before reaching a subpixel, light from the backlight is polarized by the first polarizing filter. When no electric field is applied to the area of the crystal covering the subpixel, the crystal's molecules remain twisted, as shown in Fig. 12.10, rotating the plane of polarization of incident light. This aligns the light's plane of polarization with that of the second filter, allowing light to pass. When an electric field is applied to the crystal, the light is blocked since the plane of polarization of the light is unchanged. In essence, the liquid crystal acts as a shutter controlling the light that passes through each subpixel.

LCDs do not emit light and therefore must be illuminated from behind or from the side by some sort of external light source, referred to as backlighting. Early LCDs employed CCFLs, or cold-cathode florescent lamps, as their backlight. CCFLs have been replaced by LEDs as a means of backlighting.

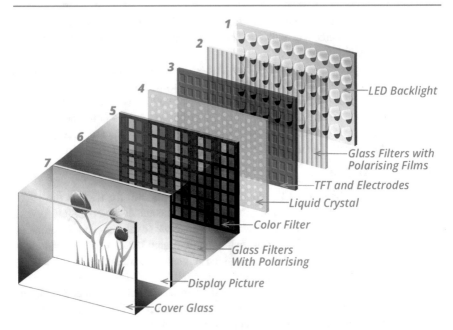

1 — LED Backlight

2

3 — Glass Filters with Polarising Films

4 — TFT and Electrodes

5 — Liquid Crystal

6 — Color Filter

7 — Glass Filters With Polarising

— Display Picture

— Cover Glass

Fig. 12.9 A cross section of a typical LCD display (Studio BKK/Shutterstock.com)

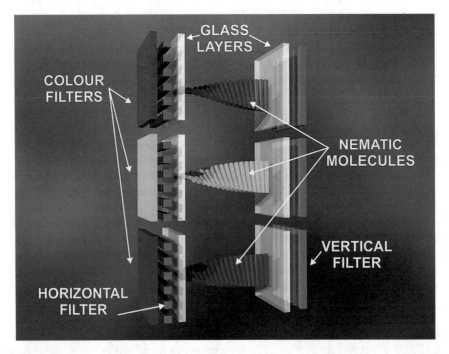

Fig. 12.10 Liquid crystals in an LCD display act as shutters by controlling the polarization of incident light (LCD_subpixel_(en).png: Marvin Raaijmakers, modified by ed g2s · talk derivative work: Angelo La Spina [CC BY-SA 2.5 (https://creativecommons.org/licenses/by-sa/2.5)], via Wikimedia Commons)

It is important to note that televisions and monitors portrayed as LED devices actually use LCDs with LED backlighting. Unlike some very large displays, LEDs are not themselves used as pixels.

Organic Light-Emitting Diode Displays

An organic light-emitting diode (OLED) consists of a layer of organic material sandwiched between two electrodes, a negatively charged cathode and a positively charged anode (Fig. 12.11). Voltage applied across the OLED produces a flow of electrons from cathode to anode. When positively charged holes from the hole injection layer combine with the electrons in a layer of organic light emitters, they produce visible light. An OLED cell consists of a matrix of red, green, and blue pixels, each color corresponding to a different organic light-emitting compound.

The advantages of using OLEDs in displays are many. Perhaps one of the most noticeable is improved contrast ratio. The fact that OLED displays function without the use of backlighting means that an OLED screen can achieve a true black not possible with an LCD display.

OLED displays produce a much wider range of colors than attainable with LCDs. They also offer an incredibly high refresh rate, having the capability of displaying new images 1000 times faster than what is attainable with backlit LCDs. Furthermore, the removal of backlights means that displays can be made much thinner.

Fig. 12.11 An OLED consists of a layer of organic material sandwiched between two electrodes (Pro_Vector/Shutterstock.com)

OLEDs have found applications in virtually every technology that uses digital displays. They are used in televisions, mobile phones, digital cameras, automotive displays, and computer monitors. Flexible OLEDs, which are bendable, ultra-thin, and transparent, are on the verge of wide-scale usage.

Quantum Dot Displays

Quantum dots are semiconductor nanoparticles that fluoresce after being exposed to blue or UV light. As we saw in Sect. 7.11, the property that makes quantum dots special is their "tunability." The color produced by a quantum dot depends on the material from which it is made and its size; larger dots emit longer wavelengths and smaller dots emit shorter wavelengths. Ranging in diameter from 2 to 10 nm, quantum dots are made from a wide range of semiconducting materials that include zinc selenide, indium phosphide, and cadmium sulfide.

The tunable electronic property of quantum dots makes them perfect candidates for a variety of applications. Their ability to produce a full spectrum of bright, pure colors coupled with high efficiency and long lifetimes make them well suited for use in displays. Many of today's televisions, referred to as QLEDs, use quantum dots to improve colors produced by liquid crystal displays (LCDs) , backlit by light-emitting diodes (LEDs).

Light-Emitting Diode Displays

As was discussed in Sect. 7.7, light-emitting diodes (LEDs) are very efficient semiconductor light sources whose number of applications has grown dramatically over the last two decades. One area where LED technology has flourished is its use in graphic displays.

An LED flat panel display uses an array of light-emitting diodes as pixels. Owing to their brightness and programmability, LED displays are widely used in informational and entertainment applications. They are now routinely seen at daytime sporting events and concerts where, due to their brightness, they are visible in sunlight.

Sometimes LED displays can be immense. Such is the case in Las Vegas, NV, where a 1500-foot display envelops the Fremont Street Experience, a downtown entertainment and gaming venue. Shown in Fig. 12.12, the display, consisting of 12.5 million programmed LEDs, is said to currently be the world's largest.

The use of LEDs in the arts has grown substantially since they offer a relatively inexpensive, yet evocative, means of expression. Artists employing LEDs in their creations include Jenny Holzer, Leo Villareal, and Jim Campbell. Light artist Titia Ex uses light from a variety of sources, including LEDs. She has received international recognition for her creations such as *The Walk*, a 2.5-m diameter sphere consisting of 35,000 LEDs. The sphere acts as a spherical screen showing a 7.5-min long video loop. Figure 12.13 shows three of the images from the video loop displayed on the sphere.

Fig. 12.12 The 1500-ft (460-m) long LED display in the Fremont Street Experience in Downtown Las Vegas, NV, is currently the largest in the world (City of Las Vegas - Public Domain via Wikimedia Commons)

Fig. 12.13 *The Walk* by Titia Ex is a 2.5-m diameter sphere comprising 5000 pixels with a total of 35,000 LEDs (Titia Ex [CC BY-SA 3.0 (https://creativecommons.org/licenses/by-sa/3.0)], from Wikimedia Commons)

Interactive Displays

The ability to interact with displays first became possible as the result of the work of E.A. Johnson at the Royal Radar Establishment in England in the mid-1960s. Described as a finger-driven input device for computers, Johnson's rather primitive

approach to touch-capable machines was first put to use by U.K. air traffic controllers and, surprisingly, remained in service until the 1990s.

In 1974 the first touch screen incorporating a transparent surface was developed by Sam Hurst at Elographics. By the late 1980s touch screens started to become available in consumer items. Now, over 30 years later, the touch screen has evolved into the most desirable user-interface component. Found in computers, smartphones, ATMs, video games, and airport terminals, it's now hard to imagine electronic devices without touch screens.

A second approach to interactivity, often not involving touch, is the near-eye display (NED), also sometimes referred to as a head-mounted display (HMD). These displays, which come in a variety of forms, offer a range of options for interactivity.

NEDs may be broken down into two categories: see-through and immersive. As the name suggests, see-through displays are small enough so they don't completely obscure the outside world entirely. Immersive displays cover most, if not all, of the user's field of view. This type of display replaces the real world with a computer-generated alternative environment.

Quite often, when people think of immersive displays, they think of virtual reality, or VR. Virtual reality provides three-dimensional images of a contrived world that the user can manipulate through body movement or with some sort of handheld controller. In essence, virtual reality replaces the real world with a computer-generated substitute. In addition to visual immersion, experiences generally include an auditory component. So fully experiencing VR requires wearing a wraparound headset as well as headphones.

One of the first of these displays released for the retail market was Samsung's Gear VR. Shown in Fig. 12.14, the headset, designed to work with Samsung's smartphones, is well suited for playing games and watching videos. Over the years, other manufactures have released similar devices.

Fig. 12.14 Samsung's Gear VR headset (https://www.flickr.com/people/pestoverde/ [CC BY 2.0 (https://creativecommons.org/licenses/by/2.0)], via Wikimedia Commons)

Augmented reality, commonly abbreviated as AR, may be thought of as a form of virtual reality in which the real world is enhanced through the use of computer-generated content. With AR, virtual elements are superimposed on a view of the real world through the use of a visual device such as a smartphone, glasses, or a headset.

Augmented reality became well known to the public with the arrival of Pokemon Go, an interactive game played using a smartphone. Released in 2016, the application allows a player to find and catch animal-like creatures called Pokemon ("pocket monsters") in real time. The mobile game uses a smartphone's camera, gyroscope, and GPS to produce a location-based reality experience that overlays computer-generated figures on the player's surroundings.

Augmented reality and virtual reality technologies appear to have almost limitless potential. Both have already found applications in medicine, education, entertainment, public safety, tourism, and marketing. The military, one of the first to use augmented reality in pilot training, continues to use the technology in a wide array of applications on and off the battlefield.

Not surprisingly, virtual reality has made its way into the world of contemporary art. Artists such as Anish Kapoor, Jeff Koons, and Marina Abramović have presented works employing virtual reality at exhibitions and in art institutions around the world.

Nonelectronic Methods of Display

In addition to electronic displays, common output devices include printers and plotters. Laser printers generally produce the highest quality printed pages. Laser printers, like photocopying machines, make use of *xerography*, first developed by the Xerox company. Pictures or printed matter are imaged on an electrically charged photoconductive drum on which the latent image is developed by using a black powder called *toner*. Inkjet printers spray ink onto paper, as the name implies, and create documents that rival laser printers in quality. Plotters literally draw pictures and graphs with computer-controlled pens in a wide range of colors.

12.7 The Imaging Process

The imaging process requires the synthesis of creativity and computing. The actual process can be quite simply described as consisting of three steps: input, processing, and output.

The input may be supplied by a visual source, by the hand of the artist, or by numerical data from a sensor, or it may be calculated by means of a computer program. Visual sources include film and digital cameras, the internet, video cameras, and optical scanners. Optical scanners allow the copying of drawings or photographs in full color, if desired. Devices that allow the artist to paint or draw by hand include the touch-sensitive screen, the tablet and stylus, and, of course, the familiar mouse.

Sanjay Kothari's *Nocturne*, shown in Fig. 12.15, is a perfect example of how photographic images can be transformed to create beautiful art. The model was photographed with pale makeup and shadowless lighting against a black background. All jewelry was shot separately on black velvet. After these elements were digitally combined, transformations were made to form, color, and texture to produce the final image.

Numerical data obtained by sampling sound waves, light waves, motion sensors, and even biosensors can be used as a basis for synthesizing images. This data can also be used to control the processing of images from other sources. Graphic images can also be created by representing lines and colors with mathematical expressions or symbolic language in the computer.

To artists, the computer's most valuable capability may be its ability to process or transform images in a wide variety of ways. These include changing size, form, color, and texture. Artists such as Joan Truckenbrod distort and transform figures as

Fig. 12.15 *Nocturne* by Sanjay Kothari (Courtesy of the artist)

Fig. 12.16 *Precursor Solutions*, created on a computer by Joan Truckenbrod (Courtesy of the artist)

if they were on elastic sheets, pushing and pulling various parts of a figure to create unique new images. The image in Fig. 12.16 is an example of her work.

Computer graphics systems allow artists to create negatives of images by reversing black and white and by changing colors to their complementaries. These transformed images bear the same relationship to each other as do photographic negatives and positives (see Chapter 10). Images, or portions of them, can be rotated by any given angle or they can be reflected as if by a mirror (horizontal, vertical, or oblique). Portions of images can be moved or repeated. To realize the wide range of image transformations that can be done by a computer, one only has to watch the special effects on television and in movies.

Colors can be changed or added very rapidly using computers. Many old black and white movies have been "colorized" in recent years. One method for choosing colors involves the use of a notation system specifying color by hue, value, and saturation or by percentage of red, green, and blue. The other method is to choose colors directly from a color menu or color palette displayed on the computer screen. Some systems allow mixing of colors from the palette much as a painter does. Electronic filters can increase or decrease the contrast between light and dark in an image, blend or sharpen boundaries, and detect and subtract unwanted background or noise.

12.8 Computer-Aided Design

Besides being one of the largest two-engine airplanes ever to fly, the Boeing 777 was the first "paperless" aircraft ever to be designed. Employing an interactive three-dimensional computer-aided design system called Catia, Boeing engineers could see all of the parts as solid images on their computer screens and simulate the assembly of those parts on-screen as well. This was important, since as many as 238 different design teams worked on the project simultaneously. At the peak of the design work, over 2200 Catia workstations were networked to a cluster of eight IBM 3090–600 J mainframe computers working on almost three terabytes of data!

Computer-aided design (CAD) has enjoyed enthusiastic reception in all branches of engineering. Most engineering drafting is done these days with one of the commercially available CAD systems. More recently, CAD has been used in the design of three-dimensional objects, such as the aircraft described in the previous paragraph. In engineering circles, CAD is closely associated with computer-aided manufacturing (CAM).

One of the attractive features of CAD systems is the use of interactive graphics; the user generally interacts with the computer via a 3D mouse, keyboard, or touch screen. Another feature of great interest to industry is the ability to store, transmit, and retrieve data. This helps to assure compatibility when many different engineers do design work on the same project.

Although most CAD systems are designed primarily for engineering applications, such systems are also used in the areas of drawing and image creation in general.

12.9 Computer Animation and Imaging

When most people hear the word *animation*, they think of movies and television. Indeed, the entertainment world has made use of animation for many years, first for animated movie cartoons, then for animated feature films. Walt Disney's animated films, such as *Fantasia* and *Snow White and the Seven Dwarfs*, have become classics and will remain so, we hope. However, animation has gone far beyond mere entertainment; it is now widely used in industry, government, and education to inform and persuade. Animation is a universal language that has become part of our cultural tradition. This has largely been due to the evolution of computer animation.

All animation is made from a set of images slightly different from one another, which, when filmed separately and played back at 16–30 frames per second, give the illusion of movement. This illusion depends on our *persistence of vision*. The human visual system does not discern individual images when presented with more than about 10 per second, but rather sees movement as a result of the images blending with one another.

Early animation was done by laboriously painting or drawing thousands of cels, transparent cellulose acetate used as medium for animation, that were photographed sequentially. The transparent cels were generally stacked up, so that only the cels with the characters or objects that moved had to be changed between frames. Still, it was a great task to produce lengthy animation, and scores of artists labored many hours to produce an animated film.

The transition to computer animation can be traced back to the 1960s when computer scientists began working with artists to explore what was to become known as computer-generated imaging, or simply CGI. The first 3D computer-generated imagery was created for the film *Futureworld* in 1976.

The 1980s saw CGI take center stage. The most important milestones include *TRON* (1982), which depicted 15 minutes of fully rendered CGI footage (including the famous light cycle sequence), and the first water 3D CGI effect in the film hit *The Abyss*.

In 1993, Steven Spielberg created the first photo realistic computer-generated creatures in *Jurassic Park*. The 1990s CGI era ended with the blockbuster *The Matrix* (1999), which was the first movie to use the so-called "bullet time effect," a visual effect that allows the audience to see normally imperceptible events.

With the dawn of the twenty-first century, the possibilities for CGI seemed almost limitless, with computer-generated imagery becoming more a part of film-making. The animated film *The Polar Express* (2004) pushed the boundaries of CGI by implementing performance capture, a technique to be discussed in the next section, and CGI on all of its actors.

12.10 Performance Capture

Using data from motion sensors, it is possible to have an animated figure on screen emulate the motion of a live performer on stage. One of the first attempts to demonstrate what is called motion or *performance capture* was Dozo, a computer graphics rock star in 1988, who sang and danced using motion captured from a human dancer. In recent years, performance capture has played a central role in creating computer-generated (CG) characters in films such as *Avatar*, *The Lord of the Rings*, and *Black Panther*.

Performance capture systems use several different types of sensors. Early systems used arrays of magnetic sensors on the performer's body to track the position and angle of key body parts. Other approaches used electromechanical sensors consisting of accelerometers and strain gauges to track key points on the performer's body. The data from these sensors could then be processed in real time or stored for future use in animation. To avoid complicated cable arrays, most systems employed wireless transmission of motion data.

Currently performance capture is achieved using reflective markers located at key points on an actor's body, as shown in Fig. 12.17. A system of cameras track and record the motion of the markers. Data from the cameras is recorded digitally and used to create what are essentially skeletons of the actors. Animators then use computer-generated imagery (CGI) to add flesh and clothing to the figures, transforming them into realistic 3D characters.

Fig. 12.17 Performance capture is achieved using cameras to track and record the motion of reflective markers attached to an actor's body (Jacol Lund/Shutterstock.com)

The *facial capture head rig* takes motion capture one step further by faithfully recording an actor's facial movements. During filming, actors wear a head-mounted camera. The camera, positioned about six inches from an actor's face, captures facial movement, thus allowing a computer-generated character to have authentic facial expression. This extension of motion capture eliminates the need for makeup and prosthetics while capturing the emotional subtleties of an actor's performance.

12.11 Cinematic Visual Effects

In 1895, Alfred Clark created what is commonly accepted as the first-ever motion picture special effect. The beheading of Mary, Queen of Scots, was simulated by stopping filming while a dummy was put in place of the actor playing Mary. When filming resumed it was the head of the dummy that rolled, not the actor's. Techniques such as this dominated the production of special effects for decades. Even Stanley Kubrick's futuristic *2001: A Space Odyssey* was created without the benefit of computer technology. The model of the space station shown in Fig. 12.18 is an example of a prop that was designed without the aid of a computer.

With the advent of digital technology came the distinction between the terms special and visual effects. The designation special effect (SFX) is generally reserved for cinematic illusions created by mechanical or optical means. Visual effects

Fig. 12.18 Space station model in the film *2001: A Space Odyssey* (Public Domain)

(VFX) are considered to involve the integration of live-action footage and computer-generated imagery to create situations that look realistic, but would be too dangerous, expensive, or impossible to capture directly on film.

Perhaps no motion picture illustrates the monumental shift from an emphasis on special to visual effects than director James Cameron's award-winning *Titanic*. Action scenes in the film use combinations of a model ship, real and digital actors, and computer-simulated ocean to give the viewer a you-are-there kind of experience. The brilliant marriage of special and visual effects resulted in a film amazingly convincing in its details.

A little over a decade after the release of *Titanic*, Cameron made *Avatar*, a film that once again raised the filmmaking bar. The movie's success can certainly be attributed, in large part, to pioneering visual effects, refined motion capture, and 3D filming.

Cameron is expected to unveil even more elaborate effects in *Avatar* sequels. However, one need not wait for the release of future films in this franchise to witness what today's masters of visual effects are capable of doing. To sample the state of the art you may wish to see *Ready Player One*, *Interstellar*, or *Avengers: Endgame*, which one reviewer described as visual effects extravaganzas.

12.12 Summary

Computers are capable of creating and transforming images. Since its beginning in the 1950s, computer imaging has developed spectacularly, its progress paralleling the rapid developments in computer hardware and software. Modern computers, ranging in size from microcomputers to super computers, free us from tedious mental work, much as machines spare us from arduous physical labor. Computers

include input and output devices, memory, and a central processing unit (CPU) . Software consists of sets of instructions, codes, operating systems, and languages that enable a computer to perform many tasks. Plasma, liquid crystal, light-emitting diode, organic light-emitting diode, and quantum dot displays are among the technologies that are available to artists. To artists, the computer's most valuable capability is its ability to process or transform images in a wide variety of ways, including changes to size, form, color, and texture. Computer-aided design (CAD) is widely practiced by engineers and scientists. Computers have become essential in the production of animated motion pictures and the creation of visual effects in movies.

◆ Review Questions

1. What are fractals?
2. What are the four main subsystems in a digital computer?
3. How many bits in a byte? In a kilobyte?
4. What are the functions of ROM and RAM?
5. Describe the construction of a plasma display. What is the function of each component in the display?
6. What is the role of liquid crystals in a liquid crystal display?
7. How are quantum dots used to improve liquid crystal display picture quality?
8. How do augmented reality and virtual reality differ?
9. Name three types of sensors that are used in motion capture and performance animation.

▼ Questions for Thought and Discussion

1. Is a computer capable of thinking?
2. Photographic images are easily altered with computers. Is there any way to detect this? Are photographs valid evidence in a court of law? Do you think they should be?

■ Exercises

1. Convert the following numbers from binary to decimal notation: (a) 1101001; (b) 100110; (c) 1010101.
2. Convert the following numbers from decimal to binary notation: (a) 12; (b) 22; (c) 36.
3. How many bytes are there in a terabyte? How many bits?

● **Experiments for Home, Laboratory, and Classroom Demonstration**

Home and Classroom Demonstration

1. **Fractals on the web**. A nice collection of fractal images is available at http://fractalarts.com/ASF/index.html. Examine the images and see if you can detect the self-similarity property.
2. **Alter an image using a computer**. Using available software (of the type available on the web or furnished with digital cameras, for example), alter a photograph or image from the web. Print the unaltered and altered versions for comparison.
3. **Computer graphics**. Using available graphics software, draw a picture with your computer. What type(s) of lines and figures are hardest to draw?

Glossary of Terms

augmented reality A form of virtual reality in which the real world is enhanced through the use of computer-generated content.

binary notation Representation of numbers by 0 s and 1 s.

bit Binary digit.

byte A group of eight bits.

central processing unit (CPU) The section of a computer that integrates and coordinates overall operation.

computer-aided design (CAD) Using a computer to draw graphs and pictures.

computer-aided manufacturing (CAM) Using a computer to control machines.

cathode ray tube A specialized vacuum tube in which images are produced when an electron beam strikes a phosphorescent screen.

facial capture head rig A camera mounted on an actor's head used to capture facial movements.

fractals Shapes or patterns made of parts similar to the whole in some way (i.e., which demonstrate self-similarity under a change in scale such as magnification) Magnification.

kilobyte (KB) 1024 bytes.

megabyte (MB) 1,048,576 bytes.

liquid crystal display (LCD) A flat panel display that uses the light-modulating properties of liquid crystals.

organic light-emitting diode (OLED) A semiconductor consisting of a very thin film of organic carbon-based compound that emits light in response to an electric current.

performance capture A process using sensors or reflective markers to capture the movement of actors.

plasma display A flat display that uses small cells that contain ionized gases to illuminate pixels.

quantum dot display A flat display that uses quantum dots (semiconducting nanocrystals) to produce monochromatic red, green, and blue light.

reduced instruction set computer (RISC) Computer design that reduces the number of instructions necessary to perform operations.

software The sets of instructions, codes, operating systems, and languages that enable a computer to perform its functions.

virtual reality Technology used to create a computer-generated visual environment.

xerography Printing process that uses an electrically charged photoconductive drum on which the latent image is developed by using a powder called *toner*.

Further Reading

Goodman, C. (1987). *Digital Visions*. New York: Harry N. Abrams.

Hainich, R.R., & Bimber, O. (2017). *Displays: Fundamentals & Applications,* 2nd ed. Boca Raton, FL: CRC Press.

King, A., & Stapleton, M. (1989). Computer animation: A personal view. In J. Lansdown and R. A. Earnshaw (Eds.), *Computers in Art, Design and Animation.* New York: Springer-Verlag.

Kojima, H. (1996). *Digital Image Creation*. Berkeley, CA: Peachpit Press.

Truckenbrod, J. (1988). *Creative Computer Imaging*. Englewood Cliffs, NJ: Prentice Hall.

Wegner, T. (1992). *Image Lab*. Corte Madera, CA: Waite Group Press.

Photonics—Light in the Twenty-First Century

13

When first invented, the laser was described as an invention in search of an application. Few predicted that lasers would ultimately have applications in medicine, agriculture, commerce, optical communication, astronomy, manufacturing, and security. With light now having uses in almost every area of human endeavor, it's no wonder that it is said that we have entered the *photonic* age, a time in which photons are used in a manner similar to the way electrons are employed in electronics.

In this chapter, you will learn the science behind the practical applications of optics that have become a part of our daily lives. They include optical data storage, fiber-optic data transmission, optical scanning, and solar energy collection. You will also get a glimpse into the future when such things as optical computing, holographic data storage, and holographic television may become commonplace.

13.1 Optical Data Storage

Optical data storage systems have, in most instances, now been supplanted by hard-disk drives (HDDs), solid-state drives (SSDs), and cloud storage. That said, using light as a means of recording and retrieving data was an innovation that was the first to offer high-capacity data storage and the promise of archival permanence, the ability of a medium to remain stable over a long period of time. The technology involved in optical storage devices is quite sophisticated and, at the time of its introduction, groundbreaking.

Compact Discs

For years the most widely used optical storage system was the *compact disc* (CD), which made its debut in 1982. The CD provided a means for storing music in a digital format, thus achieving a level of high fidelity reproduction never attainable in an analog format. Shortly after the introduction of the CD, the CD-ROM became

© Springer Nature Switzerland AG 2019
T. D. Rossing and C. J. Chiaverina, *Light Science*,
https://doi.org/10.1007/978-3-030-27103-9_13

a valuable data storage option for microcomputers, as did optical laser discs for storing movies for use in home theaters.

Optical storage systems use a focused laser beam to read and write data. The smallest achievable spot size is determined largely by the wavelength of the laser light. For the widely used red/infrared diode laser with a 790-nm wavelength, the minimum spot size is about 1 μm, which allows a maximum storage density of about 10^8 bits/cm^2. Green and blue diode lasers, with shorter wavelengths, allow even greater storage densities.

Only 12 cm in diameter, a compact disc can store more than six billion bits of binary data, which is equivalent to 782 megabytes, or more than the capacity of 390 two-megabyte floppy disks. Over 275,000 pages of text, each holding 2000 characters, can be stored on a compact disc. Used for digital audio, a compact disc stores 74 min of digitally encoded music that can be reproduced with very high fidelity through the full audible range of 20–20,000 Hz. The dynamic range and the signal-to-noise ratios can both exceed 90 dB, and the sound is virtually unaffected by dust, scratches, and fingerprints on the disc.

Recorded information is contained in pits impressed into the plastic surface, which is then coated with a thin layer of aluminum to reflect the laser beam, as shown in Fig. 13.1. The pits are about 0.5 μm wide and 0.11 μm deep, arranged in a spiral track similar to the spiral groove on a phonograph record but much narrower. The track spacing on a compact disc is about 1.6 μm, compared to about 0.1 mm (100 μm) for the groove of a long-play phonograph record.

The track on a compact disc, which spirals from the inside out, is about three miles in length. The track of pits is recorded and read at a constant 1.25 m/s, so the rotation rate of the disc must change from about 8 to 3.5 revolutions per second as the spiral diameter changes. Each pit edge represents a binary 1, whereas flat areas within or between the pits are read as binary 0 s.

Fig. 13.1 Electron micrograph of pits on a compact disc (Gerd Guenther/Science Source)

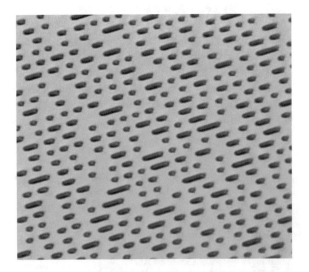

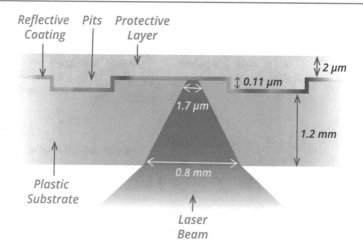

Fig. 13.2 Cross section of a compact disc (not to scale)

The laser beam, applied from below the compact disc as it lies on a turntable, passes through a transparent layer 1.2 mm thick and focuses on the aluminum coating, as shown in Fig. 13.2. The spot size of the laser on the transparent layer is 0.8 mm, but at the signal surface where the pits are recorded, its diameter is only 1.7 μm. Thus, any dust particles or scratches smaller than 0.5 mm will not cause a readout error because the laser/spot is out of focus. Larger blemishes are handled by error-correcting codes.

Pits are made approximately a quarter-wavelength ($\lambda/4$) thick so that the edge can be detected by means of optical interference (see Sect. 5.3). When the laser beam crosses the edge, the light reflected from the pit will be opposite in phase to that reflected from the adjacent area (because it has traveled $\lambda/2$ farther), and destructive interference results. The refractive index of the plastic substrate is about 1.5, so $\lambda/4$ is 790 nm/(4)(1.5) or 0.13 μm, just a little larger than the pit thickness.

The optical pickup used to read a compact disc is shown in Fig. 13.3. A semiconductor laser emits a beam of red/infrared light (790-nm wavelength) that is eventually focused to a tiny spot 1.7 μm in diameter. The reflected beam is directed to a photodiode that generates an electrical signal to be amplified and decoded. Included in the sophisticated optical pickup are a diffraction grating (see Sect. 5.9), a polarization beam splitter, a quarter-wavelength plate (see Sect. 6.5), and several lenses. A semiconductor diode laser (see Sect. 7.9) employs an aluminum–gallium–arsenide (AlGaAs) junction, similar to that in a light-emitting diode.

Recordable Compact Discs

The familiar *compact disc* digital audio (CD) and *compact disc–read-only memory* (CD-ROM) systems used in personal computers are both read-only devices. The pits are built in at the time of manufacture and cannot be altered by the user. Various techniques have been used to provide erasable compact discs. One

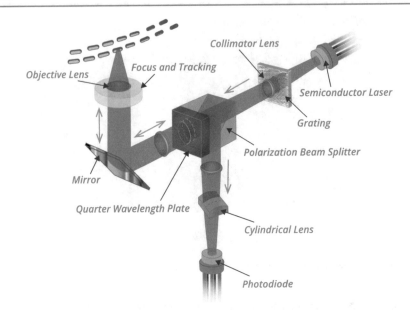

Fig. 13.3 Optical pickup in a compact disc player. Coherent light from a semiconductor diode laser is focused on one recorded track on the disc. The reflected light is directed to a photodiode

technique is to have the laser actually burn a tiny hole in the coating. This type of writing is suitable for data storage discs of the WORM ("write once, read many") type. More convenient, however, are *magneto-optical* (MO) discs.

Introduced in 1992, Sony's *MiniDisc* (MD) system uses either pre-recorded discs or recordable MO discs. MiniDiscs are only 64 mm (2½ in.) in diameter, but they can record the same amount of music (74 min) as a full-size compact disc by making use of adaptive coding to compress the audio signal by about a 4 to 1 ratio. Recording on MO discs is done thermomagnetically, and playback makes use of the *magneto-optical Kerr effect*. In thermomagnetic recording, a small spot is heated by the laser, while a magnetic field is applied by a recording head on the opposite side of the disc. As the spot cools, its magnetization remains in the direction of the field from the recording head.

Playback makes use of the MO Kerr effect, the rotation of the plane of polarization of light when it is reflected from the magnetized surface. The plane of polarization is rotated one direction if the MO layer is magnetized upward, and in the other direction if it is magnetized downward. Although the rotation is less than 1 degree, the sensitive optical pickup can distinguish between these two states, which represent recorded 1 and 0 s. The same optical playback system is used to read pre-recorded discs (as described in the previous section) and recordable MO discs.

Despite popularity among a relatively small following of primarily musicians and audio enthusiasts, the MiniDisc never achieved wide acceptance by the general public and was taken off the market in 2013. Its demise was hastened by the

availability of solid-state digital MP3 audio players that employ a variety of compression schemes and mass storage offered by flash memory.

Digital Versatile Discs

The remarkable precision of the compact disc and its achievements as a data storage system are impressive indeed. But optical technology gave us an even more remarkable storage system. *Digital versatile discs* (DVDs), also 12 cm in diameter and designed to hold a full-length movie in digital video, can store up to 17 GB (gigabytes) of data, more than 20 times the capacity of a compact disc. These systems use red diode lasers (635–650 nm wavelength), allowing higher storage densities than CDs.

A DVD resembles a CD; like a CD, data is recorded on the disc in a spiral trail of tiny pits that are read by a laser beam. The larger capacity is achieved by making the pits smaller and the spiral tighter, and by recording data in as many as four layers, two on each side of the disc. Reading these smaller pits requires lasers with shorter wavelengths as well as more precise tracking and focusing mechanisms, and that is why DVDs use red diode lasers.

DVDs come in four different types with different storage capacities. The single-sided DVD with a single layer, having a storage capacity of 4.7 GB (seven times that of a CD), will hold a 135-min movie. Adding a second layer increases the storage capacity to 8.5 GB, and recording on both surfaces of the disc gives 17 GB. Reading a two-layer disc requires a focusing mechanism so accurate that it can focus on either of the two recorded layers.

DVD for Movies and Video

While any kind of digital data can be recorded on a DVD, its development was largely driven by the need for a high-quality medium for distributing movies using digital technology. In fact, DVD originally was an abbreviation for *digital video disc*, although in light of other applications, this has been changed to *digital versatile disc*.

Television pictures were originally transmitted only in black and white. When color was added in 1954, the National Television Standards Committee (NTSC) devised a standard designed to maintain compatibility with millions of black and white televisions already sold. The NTSC standard essentially grafted color information (chroma) onto the black and white signal (luma) by encoding it on a subcarrier. This was difficult to do within the 6-MHz bandwidth (i.e., the frequency spread) used for television broadcasting. NTSC limits resolution to about 300 lines and restricts color bandwidth. Other countries adopted different standards, and this made color television incompatible around the world (Most of Europe, e.g., uses the PAL standard or a variation called PAL-SECAM.).

Digital video keeps luma and chroma information separate at every stage of transmission from camera to monitor, which results in a much improved image. Viewers are able to see the full resolution that the camera captures with colors that have the same dynamic range as the brightness information. Furthermore, DVD adds digital audio using 5.1 surround sound (six-channel). It is possible for the viewer to seek any location on the disc to begin playing. It can pause, play in slow

motion, or fast forward. These random-access features allow many interesting possibilities, such as selecting from multiple endings for a movie or selecting from multiple cameras to view a sporting event. DVD can support up to eight different languages for a single movie. Because of its compatibility with CD digital audio, home entertainment centers often have a single player for both audio and video.

DVD play/record features remain standard on most of today's desktop computers but, in many cases, are no longer included with laptop devices. As was mentioned previously, solid-state storage has, for the most part, replaced optical media in portable computers.

Blu-ray Discs

Blu-ray is the name of an optical disc format capable of storing considerably larger amounts of data than is possible with either the CD or DVD. Blu-ray technology, which derives its name from the blue-violet laser used to record and read data, was developed jointly by a consortium of companies that included Sony, Panasonic, Phillips, and Samsung. The first Blu-ray recorder became available in 2003, but it was not until 2006 that Blu-ray players entered the commercial marketplace. Uses for the format include storing high definition and ultra-high definition video, home and commercial computer data, video game programs, and HD camcorder recordings.

The advantages of Blu-ray are many. Perhaps first and foremost is Blu-ray storage capacity. Blu-ray discs can store five to ten times more than a DVD. Key to the increased storage capacity of Blu-ray discs is the ability of blue-violet laser light to produce smaller and more densely packed pits on the surface of a disc than is possible with a red laser used with the standard DVD. The blue-violet laser light has a wavelength of 405 nm compared to the 650-nm wavelength of red light. It is this difference in wavelength that allows for a more tightly focused beam and, with it, a higher pit density. The basic single-sided Blu-ray disc can store up to 13 hours of standard video, compared to the 133 minutes possible with single-sided DVD. A comparison of optical disc characteristics is shown in Fig. 13.4.

Dual-Layer DVDs

As the name suggests, dual-layer DVDs have digital information on two recordable layers on one side of a DVD. This increases storage capacity from the standard DVDs 4.7 GB to 8.5 GB. The second, or top, layer on a dual-layer DVD is transparent to permit laser light to reach the lower layer.

There are two formats of DVD dual-layer disc, the DVD-R DL, developed by Pioneer, and the DVD+R DL, created by Mitsubishi and Philips. The latter format, which offers better error correction and hence improved writing to disc, is considered by many to be the better of the two. At first, the two formats were incompatible and each required a dedicated drive. However, hybrid drives and "super multidrives" have been developed that are capable of reading both types of discs.

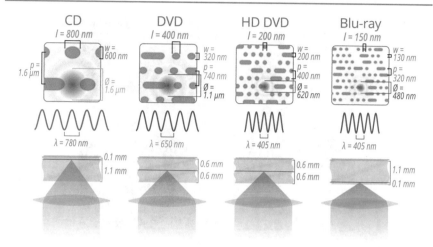

Fig. 13.4 Comparison of various characteristics of a compact disc, and single-layer digital versatile disc, high-definition/density digital versatile disc, and Blu-ray disc. Dimensions indicated are track pitch (p), pit width (w) and minimum length (l), and laser spot size (∅) and wavelength (λ) (Cmglee [CC BY-SA 3.0 (https://creativecommons.org/licenses/by-sa/3.0) or GFDL (http://www.gnu.org/copyleft/fdl.html)], from Wikimedia Commons)

Movies over two hours long must be recorded on dual-layer discs, as do most computer games. Consequently, all but first-generation computer drives and video players are capable of reading dual-layer DVDs. Dual-layer DVD burners are now becoming standard feature in most PCs.

13.2 Optical Communication

An "information superhighway" requires the ability to transmit data over large distances at very high bit rates. The ideal roadbed for such a superhighway is fiber-optic cable, over which large amounts of data can be carried by light waves. The greatest advantage of light waves is their enormous bandwidth, made possible by their very high frequency (5×10^{14} Hz or more), more than 10,000 times greater than microwaves. A single optical fiber can carry thousands of telephone messages along with dozens of TV programs at the same time.

Optical fibers guide light signals by means of total internal reflection, a phenomenon discussed in Chap. 4. An example of total internal reflection is shown in Fig. 13.5, where green laser light is totally internally reflected inside a Lucite rod. When used for communication purposes, fibers are made of fused silica (SiO_2) glass with dopants such as germania (GeO_2) added to produce small changes in the refractive index. A typical fiber shown in Fig. 13.6 has an 8-μm diameter core with

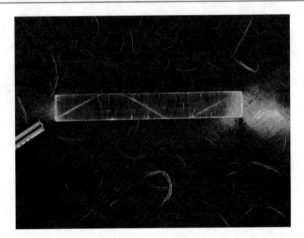

Fig. 13.5 The propagation of light through a Lucite rod models light transmission through an optical fiber (Timwether [CC BY-SA 3.0 (https://creativecommons.org/licenses/by-sa/3.0)], from Wikimedia Commons)

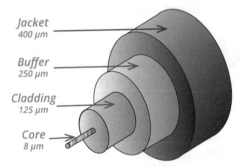

Fig. 13.6 Cross section of an optical fiber. The core material is doped to a higher refractive index than the cladding

a higher refractive index surrounded by a cladding 125 μm in diameter. Modern technology can produce fibers that attenuate the signals less than 0.2 dB (i.e., they lose less than 5% of their power) per kilometer.

Lasers generate radiation of the desired wavelength (typically 1.3 or 1.55 μm) for transmission through the optical fibers. To carry information, the light must be modulated, and this is done by direct modulation or by external modulation. In direct modulation, the drive current to the laser is varied in order to change the intensity of the light that is generated. External modulation is accomplished by passing the laser light through an electro-optic crystal such as lithium niobate ($LiNbO_3$) whose transmission can be varied by means of an electrical signal.

Even though the attenuation of fiber-optic cables is extremely small, there is some attenuation, and optical repeater amplifiers must be used to compensate for this attenuation in long-distance transmission. One type of amplifier makes use of fibers doped with active ions, which are optically pumped so that they add energy to the signals.

Optical receivers generally use either p-i-n photodiodes or avalanche photodiodes to detect the light signal. The detector produces a current that is proportional to the modulation and thus reconstructs the data signal. This signal can then be amplified electronically.

Charles Kuen Kao is attributed with making optical communications possible. Working for International Telephone and Telegraph in the 1960s, he discovered that if impurities are removed from glass, light would pass through it extremely efficiently. Prior to Kao's work, optical fibers were not suitable for communication purposes and were used primarily for decoration and some medical applications.

Kao received the Nobel Prize in 2009, at which time the fiber-optic network was heralded by the Royal Swedish Academy as "the circulatory system that nourishes our communication society." They further stated that "[i]f we were to unravel all the glass fibers that wind around the globe, we would get a single thread over one billion kilometers long… and is increasing by thousands of kilometers every hour." The rate of growth has increased exponentially since then. One result of this expansion is the dramatic increase in the availability of internet service. It is estimated that as of 2017, 3.58 billion people had access to the web as a result of this growth.

In addition to transmission of data and telephone messages, fiber-optic cables are widely used for applications such as file sharing, online gaming, and video-on-demand. High-definition television (HDTV) continues to be the stimulus for the improvement and expansion of fiber-optic communications networks.

A longtime goal of those in the communications industry, "Fiber to The Home," often referred to as FTTH, is becoming a reality in many communities. With FTTH, digital information is carried optically from the source directly to individual residences without intervening electrical conduits. The most important benefits of FTTH are that it provides for far faster connection speeds and carrying capacity than twisted pair conductors, DSL, or coaxial cable.

The implementation of FTTH continues to grow. These broadband connections already exist for more than one million consumers in the United States, more than six million in Japan, and ten million worldwide.

13.3 Optical Scanners

Optical scanners are used to interrogate a field of information for input to a computer and also for image recording, as in a laser printer. In most scanners, a laser beam is swept across the field of view by means of some type of device; in other

scanners, an image is formed on an array of photosensitive elements that are then sequentially interrogated.

In a rotating mirror scanner, the laser beam is reflected from a continuously rotating mirror, often with several faces, so that the beam sweeps across the field of view. In a scanner with an electromagnetic or galvanometer-type drive, on the other hand, the beam can be swept at varying speeds, such as in a sawtooth waveform with very short retrace time, for example. Acousto-optic scanners use an acousto-optic cell in which the light beam is diffracted by a train of acoustic waves.

Barcode readers are found at supermarket checkout counters. To scan the barcode on an item, the clerk or customer moves it through a laser beam and a photodiode senses the reflected light and sends a series of electrical pulses to a microcomputer. The 6–13 digits in the universal product code (UPC) convey information about the brand name, type of article, and so on, which is combined with information about price that the merchant has entered into the computer.

Charge-coupled device (CCD) imagers are widely used in small video cameras as well as in a variety of scientific instruments. In addition to being very compact, CCDs offer low cost and high efficiency, broad spectral bandwidth, low noise, and large dynamic range. As shown in Fig. 13.7, flatbed scanners used to scan documents into computers generally employ one or more CCDs and an extended light source, such as a fluorescent lamp or a row of LEDs, that scans a thin strip of the document as it moves. Light reflected from the document is reflected by a movable mirror to the CCD. The optical resolution of a high-quality flatbed scanner is typically 600×1200 DPI (dots per inch) when scanning an ordinary 8½- \times -11-inch page.

Fig. 13.7 Components found in a flatbed scanner

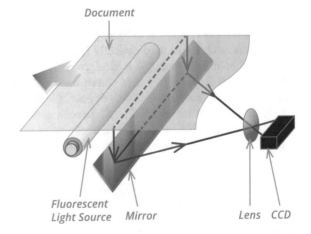

Document

Fluorescent Light Source Mirror Lens CCD

13.4 Optical Trapping and Tweezing

One half of the 2018 Nobel Prize in Physics was awarded to Arthur Ashkin for his invention of what is known as "optical tweezers." As the name suggests, optical tweezers use light to manipulate and trap objects such as microscopic glass and plastic beads, viruses, bacteria, living cells, and even strands of DNA.

The idea that light can exert force on matter is not new. In 1619, Johannes Kepler suggested that a comet's tail is created by solar radiation pressure pushing on particles expelled from a comet's core. Over two centuries later, the existence of light pressure was found to be a consequence of James Clerk Maxwell's theory of electromagnetism.

In 1901, Russian physicist Pytor Lebedev experimentally confirmed the existence of light pressure, but it was Ashkin who, in the 1980s, first used light to move and contain small physical objects. Ashkin found that micrometer-sized transparent

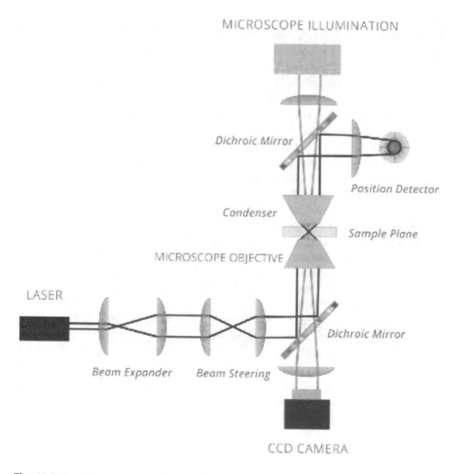

Fig. 13.8 Typical components in an optical tweezers system (public domain via Wikimedia Commons)

particles move to the center of a highly focused beam of laser light. Acted on by the light's electric field, particles can be either attracted or repelled depending on the difference in the indices of refraction between the particle and surrounding medium. The laser light also tends to apply a force on particles in the beam along the direction of beam propagation. By utilizing this force, it is possible to move and trap small particles.

Figure 13.8 shows the basic components found in an optical tweezers system. They include a laser, a beam expander, some optics used to direct the beam, a microscope objective and condenser to create the trap, a photodiode that serves as a position detector, and a microscope illumination source coupled to a CCD camera.

13.5 Photonics-Enabled Fields

Astronomy

Electromagnetic radiation is the source of virtually all that is known about the nature and history of the cosmos. Astronomers rely on optical and radio telescopes to make observations and collect data. In recent years, enormous strides have been made in observational technologies. Most notable among them have been space telescopes and adaptive optics. Both have greatly increased the performance of optical systems and have provided the most significant advance in astronomy since Galileo's telescope 400 years ago.

The largest and best known space observatory is the Hubble Space Telescope. Heralded as one of the greatest achievements of the twentieth-century astronomy, the Hubble orbits Earth at an altitude of 350 miles (569 km) and completes its orbital journey in 97 min. A 2.4-m mirror working in concert with an onboard camera capable of sensing infrared, visible, and ultraviolet radiation has captured light from more than 13 billion light-years from Earth. The combination of superior optics, sensitive detectors, and lack of atmospheric distortion gives the Hubble a view of the universe that exceeds that of most ground-based telescopes.

Electromagnetic radiation normally absorbed by Earth's atmosphere, but observable from space observatories, provides a more complete picture of the universe. In Fig. 13.9, three superimposed images from the Hubble and Spitzer Space Telescopes form a spectacular, multiwavelength view of the starburst galaxy M82. The photo combines visible light, seen as yellow and green, with images produced by infrared and X-ray radiation, which are shown as red and blue, respectively.

Many Earth-bound telescopes are now able to produce Hubble-quality images through the use of adaptive optics systems. Adaptive optics, a technology designed to improve the performance of astronomical optical systems, was first proposed in

Fig. 13.9 Superimposed images from the Hubble and Spitzer space observatories provide a multiwavelength view of starburst galaxy M82 (Smithsonian Institution from United States [No restrictions])

1953; however, it did not come into common usage until advances in computer technology during the 1990s made the technique possible. The use of adaptive optics avoids the enormous expense of launching a telescope into space, a task that can cost 10–20 times more than building the same size telescope on the ground.

Adaptive optics systems compensate for the blurring effect of Earth's atmosphere through the use of a wavefront sensor, which detects incoming light, a deformable mirror, and a computer. The wavefront sensor rapidly measures atmosphere-introduced distortion. From this information the computer calculates the mirror shape needed to correct for the distortion. Within milliseconds, the deformable mirror is reshaped to correct incoming light so that the telescope's images appear sharp (Fig. 13.10).

Fig. 13.10 A deformable mirror in an adaptive optics system is used to correct a distorted wavefronts

Fig. 13.11 Four laser beams are used in an adaptive optics system at the European Southern Observatory's Very Large Telescope in Paranal, Chile (ESO/F. Kamphues [CC BY 4.0 (https://creativecommons.org/licenses/by/4.0)], via Wikimedia Commons)

Because the celestial object being observed is often too faint to be used for measuring the shape of the wavefronts, a nearby, brighter "guide star" is used since light from both objects has passed through approximately the same atmospheric turbulence. When there is not a suitably bright star nearby, astronomers use lasers to create artificial stars. Sodium atoms high in the atmosphere, made to glow by the action of the lasers, form tiny patches of light that simulate actual stars. The use of several lasers, such as shown in Fig. 13.11, allows the atmosphere's properties to be better characterized, resulting in enhanced image quality.

Capturing the first-ever visual evidence of a black hole in 2019 by an international team of researchers, members of the Event Horizon Telescope project, stands out as one of the most important and impressive achievements of modern day astronomy. In order to obtain the resolution needed to observe a black hole 55 million light-years from Earth, a world-wide system of eight synchronized radio telescopes was employed. The array of telescopes, which were located at various locations around the planet, was described as "a virtual telescope dish as large as the Earth itself."

Fig. 13.12 Glowing material surrounding the black hole in galaxy M87 (Event Horizon Telescope Collaboration [CC BY 4.0 (https://creativecommons.org/licenses/by/4.0)])

To be observable from Earth, a super massive black hole was needed, such as one at the center of the Messier 87 (M87) galaxy. The image in Fig. 13.12 shows a ring of super-heated material swirling around the M87 black hole. Since no light can escape from a black hole, what is seen is not the black hole itself, but its shadow and the luminous matter that surrounds it.

Industry

Lasers have revolutionized manufacturing and are now used for anything from fabric cutting to automobile assembly. With industrial applications that include laser cutting, drilling, and welding, as well as optical imaging and analysis of product quality, the laser has become a versatile tool in modern manufacturing.

Lasers have several advantages in materials processing. Lasers obviate the need for contact tools in which the tool bit must be sharpened and often replaced. Brittle or very pliable materials that are very difficult or impossible to machine with tools can be processed using lasers. In addition, fiber optics allow access to previously inaccessible locations. Finally, and very importantly, laser processing is easily controlled by computer.

Light plays an important role in the burgeoning production process known as 3D printing. 3D printers employ an additive process, making things by building them up, a layer at a time, rather than by removing material through cutting, drilling, or machining. During production, ultraviolet light can be used to harden each layer of material as it is deposited. Laser sintering, another example of an additive 3D manufacturing process, uses high-powered lasers to harden powdered plastic, ceramic, or metal into a desired shape. Laser sintering has been increasingly utilized in industrial situations in which small quantities of high-quality parts, such as aerospace components, are needed.

Medicine

Photonics and medicine have partnered for thousands of years. As companions, they have contributed to the treatment as well as the diagnosis of a wide range of medical conditions.

Ancient Hindu writings suggest that sunlight was used for therapeutic purposes. The Greeks also realized that exposure to light could be beneficial to health, unaware of the skin's light-stimulated production of vitamin D. Much later, in the nineteenth century, English scientists found that bacteria died when exposed to sunlight. In 1893, a Danish physician demonstrated the light had beneficial effects in the treatment of a variety of skin conditions. Medical uses of light, both visible and invisible, increased as the century was winding down. In 1895 German physicist Wilhelm Roentgen serendipitously discovered X-rays. The high-energy photons were put to work almost immediately to reveal structures inside the body.

Over the course of the twentieth century, a wide range of noninvasive, photonic-based diagnostic tools were to follow X-rays. These include the use of radio waves in MRI (magnetic resonance imaging) and gamma rays in PET (positron emission tomography) scans.

With the advent of the laser, visible light would take center stage as a versatile tool for both the diagnosis and treatment of physical ailments. The applications of laser light range from dentistry to cancer therapy. Perhaps the most mature applications of lasers are in the field of ophthalmology. Lasers of various wavelengths are used in the treatment of glaucoma, diabetic retinopathy, macular degeneration, retinal breaks, and other ocular disorders. In addition, laser procedures such as LASIK eye surgery can correct vision problems including myopia or nearsightedness, farsightedness, and astigmatism by reshaping the cornea.

As the field of ophthalmic laser treatment has matured, the array of diagnostic tools has grown to include automated refractors, which can determine the correct eyeglass prescription, and fundus cameras, one of which is shown in Fig. 13.13, which are used to examine the eye's interior. Instruments such as the scanning laser ophthalmoscope and optical coherence tomography imagers are in general use to take three-dimensional pictures of the retina.

In dentistry, lasers are used to remove overgrown tissue, shape gums, or whiten teeth. Lasers are also used in filling procedures to remove decay and to kill bacteria. Hard tissue lasers, lasers that produce light absorbable by bone, are often used in the prepping or shaping of teeth for composite bonding, the removal of small amounts of tooth structure, and the repair of certain worn-down dental fillings.

Lasers are also now routinely employed to perform cosmetic surgery. Laser light has been found to be particularly effective in the removal of tattoos, scars, wrinkles, birthmarks, and unwanted hair. When done with a laser, general surgery, such as tumor removal, breast surgery, plastic surgery, and most other surgical procedures have improved outcomes and shortened recovery times.

Fig. 13.13 Image of the interior of a human eye produced by a fundus camera (Ralf Roletschek (talk)—Fahrradtechnik auf fahrradmonteur.de [FAL or GFDL 1.2 (http://www.gnu.org/licenses/old-licenses/fdl-1.2.html)], from Wikimedia Commons)

Solar Energy

As we saw in Chap. 7, electrons are liberated when light shines on the surface of certain materials, such as silicon. This effect is the basis for the operation of photovoltaic cells, often referred to as solar cells, which produce electricity when exposed to light. Collections of such cells form the basis of photovoltaic solar panels, collection devices that serve as sources of sustainable power.

Currently, the vast majority of the world's solar cells are made from thin wafers of crystalline silicon; however, second-generation cells are made from materials such as cadmium telluride and copper indium gallium diselenide. While not as efficient as silicon-based solar cells, the newer solar cells are thin, light, flexible, and therefore well suited for attachment to a wide variety of substrates such as metal, glass, and plastic. The latest solar cell technology combines the best features of silicon and second-generation materials, resulting in higher efficiencies and lower cost.

According to the European Photovoltaic Industry Association, "The total solar energy that reaches the Earth's surface could meet existing global energy needs 10,000 times over." That said, solar energy remains to become widely accepted primarily because it is more expensive than energy produced by burning of fossil fuels. States such as California, North Carolina, and Arizona and countries like Germany and China that enjoy government support are outliers. In these areas the use of solar energy is showing strong signs of growth.

The Military

Photonics is of ever increasing importance in national defense. One key role is sensing. Multispectral imaging, capable of obtaining significantly more information

about an area under surveillance than regular sensors, can be used for tasks such as locating explosives, revealing enemy movements, and determining the depth of hidden bunkers. Functioning as chemical sensors, specialized spectrometers can be used to detect explosives in liquids and solids.

Holographic imagers produce 3D visualizations of urban and mountainous areas. A major advantage of these photonic devices is that they are lightweight and small, making them easily portable for soldiers in the field. As mentioned in Chap. 12, virtual reality (VR) and augmented reality (AR) are important tools in pilot training and support of combat operations. VR and AR are also employed in conjunction with teleoperation, the ability to operate equipment and weapon systems, such as aerial drones, from a distance.

There are a variety of military laser applications. Lasers function as target designators, laser light sources, which are used to indicate a target, or laser sights. They are also used to "blind" sensors on heat-seeking anti-aircraft missiles. In relatively few cases, lasers are used as weapons. Some high-power lasers are under development for potential use on the battlefield or for destroying missiles, projectiles, and mines.

13.6 The Future of Photonics

Optical Computing

Optical computing, or photonic computing, is an area of technology that uses light for processing data. Although electronic digital computers have achieved very high speeds, they are ultimately limited by the time it takes electrical signals to travel from one component to another. Furthermore, electronic currents are affected by electromagnetic fields, so noise and cross-talk problems can become rather serious in high-speed operations.

Substituting light waves for electrical currents avoids such problems. Signals travel from one component to another at the maximum possible speed, that is the speed of light. Light waves can cross each other without interfering (see discussion of linear superposition in Sect. 2.4) , and they have extremely large bandwidths due to their high frequency (see Sect. 13.2). In addition, conventional computers operate in a serial manner with each operation being performed one after another. Optical computers execute instructions in parallel, allowing multiple operations to be performed simultaneously, which allows for more efficient and faster data processing.

While interest in optical computing dates from the 1980s, only limited prototypes have been constructed thus far. Among the challenges to optical computing, the creation of the photonic equivalent of the electronic transistor continues to be one of the most formidable.

It remains to be seen when fully functioning optical computers will become a reality. Researchers are motivated to achieve this goal, for they know when

transistors can no longer be made smaller, an alternative to electronic computing will become necessary if processing speeds are to continue to increase.

Holographic Data Storage

The idea of storing data holographically has been around for decades. While it will be some time before holographic versatile disc (HVD) data storage systems will become commonplace, progress continues to be made. The goal is to develop HVD systems that can store 1000 times more data than a dual-layer DVD, roughly 8.5 terabytes. This level of storage is made possible by depositing information throughout a volume rather than just on the surface, as is the case with other optical storage methods.

The key components of holographic data systems currently under development include a green laser, a red laser, a beam splitter, a liquid crystal display called *spatial light modulator* (SLM), a photosensitive storage medium, such as a lithium-niobate crystal, and a photosensitive semiconductor detector, such as a CMOS or CCD sensor. The argon laser is used for writing and reading data, the red laser for tracking.

Information to be stored in the HVD's photosensitive crystal is first translated into binary code. The code is then displayed as what is known as a "page" of tiny translucent windows on the SLM. These windows can exist in two states, either open or closed, corresponding to a one or a zero. The condition and configuration of the windows at any given time reflect the data being stored on a page.

Following the creation of the data page, the green laser is pulsed and split into two beams. One beam, the signal beam, is directed toward the SLM; the other beam, the reference beam, is sent directly to the photosensitive crystal. After being processed by the SLM, the signal beam meets the reference beam at the crystal. The resulting interference pattern, which contains data carried by the signal beam, is stored in the form of a hologram. Each page of data is stored in a different location within the crystal.

Stored data is retrieved by directing the green laser into the hologram. This produces a diffraction pattern that is an optical replica of the original recorded data. The detector then converts the optical data into the original digital files.

Holographic Television

The dream of having Princess Leia-like images appear on your TV screen may become a reality sooner rather than later. Until now it hasn't been possible to display a succession of holographic images fast enough to realistically convey movement. However, recent developments in laser and screen technology make the projection of moving holographic images without flicker clearly within reach.

One scheme that has been used to capture and display holographic images with a relatively fast refresh rate involves using 16 conventional television cameras focused on a single subject. The camera images are sent to a computer, which combines them to form a holographic image. The computer then relays this image in the form of digital data to a nanosecond pulsed laser. A three-dimensional holographic image is formed when the laser light containing holographic pixels, or

"hogels," is projected onto a photoreactive polymer screen. This approach has reduced the refresh rate from minutes to seconds.

While great strides have been made in projecting images at an acceptable rate, much work is yet to be done. The ability to reduce the refresh rate to a fraction of a second will be needed before holographic television will become a consumer item.

13.7 Summary

Lasers have applications in medicine, agriculture, alternate energy, commerce, optical communication, manufacturing, and security.

Optical storage systems, using focused laser beams to read and write data, are capable of very high storage densities. Optical discs are removable and easily transportable from one drive to another. Only 12 cm in diameter, a compact disc can store more than 780 megabytes (six billion bits) of binary data, which is equivalent to over 275,000 pages of text. Recordable compact discs and MiniDiscs generally make use of the Kerr magneto-optic effect.

Digital versatile discs (DVDs), which are similar to compact discs but have considerably greater storage capacity, are particularly attractive for digital recording of movies and video. Blu-ray discs are capable of storing substantially larger amounts of data than is possible with either the CD or DVD.

Optical fibers guide light by means of total internal reflection A single optical fiber can carry thousands of telephone messages and TV programs with relatively little loss. Modulation of the laser light source is done either directly, by modulating the drive current to the laser, or externally, by passing the laser light through an electro-optic crystal whose transmission can be changed with an electrical signal.

The entire electromagnetic spectrum is employed in the study of the cosmos. Adaptive optics, a technology designed to improve the performance of astronomical optical systems, compensate for the blurring effect of Earth's atmosphere. Optical tweezers use radiation pressure produced by high-intensity laser light to move and trap small particles such as cells, microbes, bacteria, and viruses.

Optical computers use light, rather than electrons, to process data. Holographic data storage uses the entire volume of a crystal to store data, resulting in enormous storage capacity. Holographic television will require a rapid succession of projected holographic images to realistically convey movement.

◆ **Review Questions**

1. Why are pits on a CD made of a quarter-wavelength thick?
2. What is the magneto-optical Kerr effect? How is it used in CDs?
3. Compare the storage capacity of a DVD with that of a CD. How is the DVD's expanded storage capacity achieved?

4. How are light waves transmitted over large distances in an optical communications system? Why are light waves able to transmit much more data than microwaves?

5. What is a photorefractive material? Give an example of a photorefractive material.

6. What are the two advantages of using light waves in a computer rather than electrical signals?

7. Describe the operation of optical tweezers.

8. How is the high level of holographic data storage achieved?

▼ Questions for Thought and Discussion

1. What are the advantages and disadvantages of a CD-ROM as compared to a magnetic floppy disk?

2. How long does it take for a light wave to travel between two components in an optical computer that are 1 cm apart? What frequency of oscillation has a period equal to this time? (The speed of light is 3×10^8 m/s in air.)

3. How do you think the laser beam in a compact disc pickup is kept precisely on the recorded track?

4. Why does the core of an optical fiber have a larger refractive index than the cladding that surrounds it?

■ Exercises

1. Find the frequency of a green laser with $\lambda = 650$ nm.

2. Measure the inner and outer diameters of the recorded area on a compact disc. If the track spacing is 1.6 µm, how many tracks are there? Multiply this times the circumference of the average track (π times the average diameter) to find the total track length from inside to outside.

3. Using the average rotation rate and the data in Exercise 2, estimate the total playing time of your CD.

4. A CD-ROM can store six billion bits. What is the average area taken up by each bit?

5. In Sect. 5.8, we learned that the limit of resolution of the eye is about 1.22 λ/D, where D is the diameter of the eye aperture. Without going into details, the same sort of argument predicts that laser light can be focused to a spot whose minimum size is 1.27 $f\lambda/D$, where D is now the diameter of the laser beam and f is the focal length of the lens used to focus it. Show that if f is roughly equal to D, this predicts a minimum spot size of about 1 µm when the wavelength is 790 nm. What minimum size is predicted for $\lambda = 650$ nm (green laser)?

6. Show that a laser spot size of 1 µm allows a storage density of about 10^8 bits/cm². (Hint: Assuming the bits to be square, what is the length of the square?)

7. Assuming that polypropylene has a refractive index of about 1.55, what is the wavelength in a CD of laser light whose wavelength in air is 780 nm? What fraction of a wavelength is the 0.11-μm pit depth? Why do you think this pit depth was selected?

● **Experiments for Home, Laboratory, and Classroom Demonstration**

Home and Classroom Demonstration

1. **Alexander Graham Bell's photophone**. Remove the bottom of a Styrofoam cup with a utility knife and tape a piece of aluminum foil over the open bottom. A modulated light beam is produced by directing a flashlight or a laser beam at the foil while someone speaks into the top of the cup. Use a solar cell or a photodiode connected to a piezo-electric earphone or an amplifier/loudspeaker to receive the modulated signal.

2. **Music on a beam of light**. With an audio cable, connect an LED to the earphone jack of a portable radio or iPod to obtain a modulated light beam. Use a solar cell or photodiode, connected to a piezoelectric earphone or an amplifier/loudspeaker to receive the modulated signal. Try transmitting the light beam by means of an inexpensive optical fiber.

Glossary of Terms

acousto-optic modulator Acoustic (sound) waves diffract light waves to produce a modulated signal.

adaptive optics A technology designed to improve the performance of astronomical optical systems by compensating for distortions introduced by medium between object and image.

compact disc (CD) Optical storage device that uses a laser to write and read data stored as small pits on a reflecting surface.

compact disc read-only memory (CD-ROM) Compact disc used for computer input.

digital versatile disc (DVD) Optical disc capable of storing full-length movies.

diode laser Semiconductor junction diode that produces coherent light.

hogel A computer-generated holographic pixel.

holographic data storage A data storage system in which information is stored throughout a volume rather than just on the surface, as is the case with other optical storage methods.

light-emitting diode (LED) Semiconductor junction diode that emits light of a particular color when excited by an electric current.

magneto-optical (MO) disc Stores data that can be read out using the Kerr magneto-optical effect.

magneto-optical Kerr effect Rotation of the plane of polarization when reflected by a magnetic surface. Direction of rotation depends on direction of magnetization.

MiniDisc (MD) Miniature compact disc for recording digital audio.

multiwavelength astronomy The study of the universe using a wide range of wavelengths.

optical computer A device that uses visible or infrared light, rather electric current, to perform digital computations.

optical fiber Glass fiber capable of transmitting data optically.

optical tweezers Instruments that employ laser light to manipulate and trap micro particles.

photodiode Semiconductor junction that conducts electricity when illuminated by light. Used to detect reflected signals from an optical storage disc.

photonics A branch of physics and technology that deals with the properties and applications of photons.

spatial light modulator A device used in holographic data storage systems to modulate amplitude, phase, or polarization of light waves in space and time.

Further Reading

Bloomfield, L.A. (2008). *How Everything Thing Works.* Hoboken, NJ: John Wiley & Sons.

Kogelnik, H. (1995). Optical communications. In G. L. Trigg (Ed.), *Encyclopedia of Applied Physics*, Vol. 12. New York: VCH Publishers.

Pohlman, K. C. (1989). *The Compact Disc.* Madison, WI: AR Editions.

Rossing, T. D., Moore, F.R., & Wheeler, P.A. (2001). *The Science of Sound,* 3rd ed. Boston: Pearson.

Tanida, J., & Ichioka, Y. (1995). Optical computing. In G. L. Trigg (Ed.), *Encyclopedia of Applied Physics*, Vol. 12. New York: VCH Publishers.

Visual Perception, Illusions, and the Arts

<div style="text-align:right">

14

</div>

Deceptions of the senses are the truths of perception.
—J. E. Purkinje, psychologist.

To visually perceive a work of art, or for that matter any object, the brain needs information. This information enters the eye in the form of light. The eye's optical system focuses this light, producing images of objects in our environment on the retina. Receptors in the retina convert light into electrical impulses that are carried to the brain along neural pathways. Perception of the external world occurs when electrical signals are processed in the brain. In the end, it's the brain's business to make sense of sensation.

Using sketchy and often flawed information received from the eye, the brain must perform the rather miraculous task of making rapid judgments regarding the true nature of objects in our environment. Through a variety of complex processes, the brain recognizes patterns, ignores nonessential information, fills in missing details, and supplies depth. How does this occur?

There are many theories of visual perception. None of them provides a comprehensive explanation of the perceptual process, but all offer insights into how we experience external reality. One theory proposes that the brain forms perceptual hypotheses by comparing real-time visual data with stored information collected from past experiences. After comparing the two, the brain comes up with a best guess as to what exists in the external world. Usually the hypothesis is correct, and the eye–brain system provides us with an accurate picture of reality. When the hypothesis is incorrect, we experience a *visual illusion*.

© Springer Nature Switzerland AG 2019
T. D. Rossing and C. J. Chiaverina, *Light Science*,
https://doi.org/10.1007/978-3-030-27103-9_14

14.1 Visual Illusions

Which line, **AB** or **BC**, in Fig. 14.1 is longer?

If you said **AB**, you would be incorrect! As you may verify for yourself, **AB** and **BC** are the same length. You may have just fallen prey to a visual illusion: a situation in which visual perception leads to an incorrect interpretation of reality.

If you see an inward spiral in Fig. 14.2, you aren't alone. In fact, you may find it very difficult to convince yourself that what appears to be a spiral is actually a set of concentric circles. If you are skeptical, use a compass to trace out a circle or two.

The visual illusions you have just experienced illustrate that, in some instances anyway, seeing can be deceiving. While we are generally confident that "what we see is what we get," this is obviously not always the case. The information fed to the brain may be insufficient or the brain's interpretation may be faulty. In either

Fig. 14.1 Which line, **AB** or **BC**, is longer?

Fig. 14.2 Twisted cord illusion. Concentric circles seem to form a spiral (Peter Hermes Furian/Shutterstock.com)

case, the eye–brain system may arrive at an incorrect conclusion. The disparity between what we perceive and what actually exists is the basis for all visual illusions.

Because visual illusions can be entertaining, they have long been a source of recreation. Most people simply enjoy trying to understand how an illusion works. However, as you will learn, beyond pure amusement, visual illusions have a surprising number of applications in the visual and performing arts, architecture, the sciences, and our daily lives.

14.2 Everyday Illusions

We unknowingly encounter visual illusions almost every day. The following are some common examples of these visual misperceptions.

Celestial Illusions

To most observers, a full Moon rising at sunset appears larger than the same Moon appearing overhead hours later. This effect is dramatically shown in Fig. 14.3. Both images are of the same size, of course, but the Moon appears larger against the background of the landscape. (You can verify this by holding a penny at arm's length in front of the Moon in both cases.)

No doubt you've noticed that the Moon appears to follow you when you take a walk on a moonlit night, while objects close to you appear to move in the opposite

Fig. 14.3 Full Moon at sunset behind Lick Observatory east of San Jose, CA. The Moon appears much larger than when viewed overhead (Photograph by Rick Baldridge)

direction. Why is this so? Owing to your motion, light rays from nearby objects appear to be coming from ever-changing directions. However, light rays reflected by the Moon are, for all practical purposes, parallel when they reach Earth. Therefore, no matter where you are, moonlight always appears to be coming from the same direction. This makes your lunar companion seem unshakable.

A solar eclipse provides still another opportunity to witness a rather amazing Moon illusion. When the Sun and Moon are side by side, they appear to be of the same size. This, of course, is not the case: The Sun's diameter is almost 400 times greater than the Moon's. Because the Sun is roughly 400 times farther away than the Moon, both objects form approximately the same size image on the retina. They are therefore perceived as having the same diameter.

Illusions in Architecture, Commerce, and Technology

For hundreds of years, architects and artists have put their knowledge of visual illusions to work for them. Perceptual principles may be applied to make a building's interior appear more spacious or its exterior more imposing. One of the earliest, and most celebrated, examples of visual illusion dates back to the Greeks. They understood that distortions introduced by the eye can cause straight columns of a structure to appear bowed. Knowing this, the designers of the Parthenon intentionally modified the shape and slope of the structure's columns so they would appear straight and evenly spaced.

Visual illusion is no stranger to clothing designers or makeup artists. Generally speaking, clothing adorned with vertical stripes has a slimming effect; horizontal stripes make us appear heavier. Because a light-colored object looks larger than a dark object of the same size, wearing dark clothing can also make us look thinner. The use of makeup to modify and enhance facial features dates back thousands of years. Today, a multimillion dollar cosmetic industry thrives on the transformational power of illusions.

We look at our televisions and see a multicolored moving picture. Close inspection of the television screen reveals a collection of thousands of rapidly changing red, blue, and green dots (see Sect. 8.2). However, from across the room our eyes are unable to resolve the closely packed dots and we see a continuous picture. When viewing a movie we are actually seeing a series of still photographs projected in rapid succession, yet we see smooth, continuous motion.

14.3 Classifying Illusions

In an attempt to understand visual illusions, scientists have found it useful to categorize them according to cause and type. The cause of an illusion is usually designated as physical, physiological, or cognitive. Types of illusions include those based on lighting and shadow, depth perception, movement, or on figures that are considered ambiguous, distorted, impossible, or paradoxical.

Physical Illusions

The old saying "It's all done with mirrors" is sometimes used in jest to explain something that has no immediate explanation. While this explanation of phenomena is usually not very satisfactory, interior decorators and magicians often do take advantage of the illusory power of mirrors. We are often led to believe that a room is much larger than it really is through the use of mirrors: Covering a wall with mirrors produces the illusion that the room is twice its actual size. Placing a head on a plate or making an object disappear is trivial for the illusionist familiar with the magic of mirrors.

Mirages caused by atmospheric refraction may give the appearance of water on a dry road or an oasis in a desert (see Sect. 4.3). Under the proper conditions, the image of a car or building may be seen as a mirage over hot pavement. Sometimes mirages can be quite mystical. Perhaps one of the rarest, yet most spectacular, of these is the Fata Morgana. Occurring over bodies of water where cold air hovers over warm water, the Fata Morgana mirage takes the form of ethereal castles rising above the sea.

A classic example of a physical illusion is the apparent bending of a pencil when half immersed in water. A rather extreme version of this refraction effect is seen in Fig. 4.7 in which a man's head and body appear to be separated.

Reflections and refraction effects, both caused by physical processes occurring outside the body, are sometimes referred to as *physical illusions*. Since physical illusions are readily explained by optics, many psychologists do not consider them to be true visual illusions. The term *visual illusion* is usually reserved for a perception that's at odds with external reality.

Physiological Illusions

As the name suggests, *physiological illusions* are due to the functioning of our visual sensory apparatus. Persistence of vision, the tendency of the visual system to hold on to an image after the source of the image has been removed, is an example of this type of illusion. Perhaps the most common manifestation of this phenomenon is the annoying dot that persists long after a camera flash goes off.

Persistence of vision is key to the illusion of movement produced by motion pictures. As mentioned above, a movie projector presents a succession of short-lived still images. Even though the screen goes black for an instant between images, each image persists in the eye–brain system just long enough for the next image to be brought to the screen. As a result, we perceive smooth, continuous motion.

According to neuroscientists, the shimmer or perceived movement experienced when viewing works of optical art, such as British artist Bridget Riley's *Fall*, seen in Fig. 14.4, may be due to the formation of moiré patterns. Moiré patterns are produced when two repetitive, semitransparent patterns, such as those formed by teeth on a comb or wire mesh in a window screen, overlap. When viewing *Fall*, the image formed at a given instant is superimposed on a previous image that persists on the retina. These overlapping images produce a moiré pattern. Your eyes'

Fig. 14.4 Staring at Bridget
Riley's *Fall* creates a sense of
movement (Copyright Bridget
Riley 2018. All rights
reserved.)

constant scanning motion makes the moiré patterns change in time, giving the illusion of movement.

Cognitive Illusions

Psychological or *cognitive illusions* arise from information-processing mechanisms within the brain. According to the model proposed by neuropsychologist R. L. Gregory (1966), the brain often expects to see an object or scene in a particular way. The result is that we see something the way we think it should be rather than the way it really is. According to Gregory, "We not only believe what we see, but to some extent, we see what we believe." A rather remarkable example of the eye–brain system's penchant for selecting a hypothesis that is consistent with previous experience is Italian artist-psychologist Gaetano Kanizsa's illusory triangle shown in Fig. 14.5.

Most people see an inverted white triangle superimposed on an upright dark line triangle. Careful inspection reveals that there is no white triangle, only the effects that a white triangle would have if it were actually there! The nonexistent triangle, called a *subjective contour*, provides the simplest explanation of sensory facts that is consistent with previous visual experience.

The brain's tendency to seek the simplest solution to a perceptual problem is in keeping with organizational principles proposed by Gestalt psychologists. They believe that the brain organizes stimuli according to basic rules. One such rule, the law of Prägnanz or law of "good figure," states that the brain tends to assemble a collection of parts into the simplest whole that is consistent with sensory data. Subjective contours demonstrate this principle.

Fig. 14.5 Kanizsa's triangle is an example of a subjective contour. The white triangle is only an illusion (Yuriy Vlasenko/Shutterstock.com)

Another Gestalt organizational principle, the principle of familiarity, suggests that discrete elements are more likely to be perceived as a pattern if the pattern is familiar or meaningful. Looking at the array of dominoes in Fig. 14.6, you may see something reminiscent of a face. Squinting or moving the page away from your eyes will confirm your impression.

Fig. 14.6 The Pointillist physicist

Because of Einstein's celebrity, we have little difficulty identifying his outline from the meager information provided. The principle of familiarity has been employed effectively by a number of artists, including Salvador Dali.

14.4 Ambiguous Figures

All pictures, by their very nature, are ambiguous. They are two-dimensional representations of three-dimensional objects and consequently may be interpreted in many ways. In compressing a solid object to a flat surface, information is lost. The ability of our perceptual apparatus to correctly identify objects in pictures is truly amazing, considering that an unlimited number of objects can give rise to the same two-dimensional projection (Fig. 14.7).

When the brain is presented with sensory information from a picture that may be decoded in two or more equally satisfactory ways, our perceptual apparatus cannot decide on a "right answer." Alternate representations of reality are entertained by the brain. The brain may lock in on one aspect of the figure for a time, then spontaneously focus on another representation. It is suggested that the first shape seen eventually fatigues neural mechanisms, permitting the other aspect of the figure to be seen.

The first recorded interest in *ambiguous* or *multistable figures* appears in an 1832 letter to David Brewster from Swiss crystallographer L. A. Necker. Necker describes a drawing of a cubic crystal that spontaneously appeared to alternate between two orientations. When the Necker cube in Fig. 14.8 is viewed, the front

Fig. 14.7 An unlimited number of objects gives rise to the same two-dimensional projection

Fig. 14.8 The Necker cube's front and back faces spontaneously change position

and back faces appear to exchange positions. With either orientation of the cube equally plausible, the eye–brain system vacillates between interpretations.

Figure-ground illusions represent another form of visual ambiguity. In this type of illusion, two aspects of a drawing, both of equal perceptual stature, vie for attention. One of the earliest and most famous examples of figure-ground reversal is Gestalt psychologist Edgar Rubin's illustration of the vase and faces (Fig. 14.9). At one instant, the eye–brain system perceives a white vase on a black background, the next, the two silhouettes.

Rubin produced the famous vase–faces pattern in conjunction with his work on visual perception. Shortly thereafter, reversible patterns found their way into the works of important artists. It is believed that many of the works of M. C. Escher were inspired by his interest in visual perception in general and the work of Edgar Rubin in particular. Paraphrasing Rubin, Escher said: "Our eyes are accustomed to fixing on a specific object. The moment this happens everything round about becomes reduced to background."

What determines how we perceive a figure–ground pattern? Experiments demonstrate that a larger area is more likely to be selected as background; a centrally located shape tends to stand out as the figure, especially if it is small and symmetrical. Other studies indicate that the form interpreted as figure often has a horizontal or vertical orientation. Finally, as is generally the case in perceptual organization, meaningful forms are usually perceived as the figure. One theory proposes that our personal method of organizing information predisposes us to select a particular form.

The importance of figure–ground patterns cannot be overstated. Camouflage relies on the inability to separate figure from background. In the animal kingdom, camouflage is often crucial for survival. For example, the fur of snowshoe rabbits turns white in the winter to make them indistinguishable from the snow. In the spring they grow brown fur that blends in with their summer surroundings.

Fig. 14.9 Do you see a vase or faces in Edgar Rubin's illustration (Makc/Shutterstock.com)

The grasshopper's green coloring matches its surroundings almost perfectly. These well-concealed insects are virtually invisible until they jump.

Taking a cue from nature, the military reduces figure–ground disparity by camouflaging troops and equipment. Duck hunters know that covering their boats with mud and grass will increase their odds of sneaking up on their prey. Artists add visual interest by blurring the line between field and ground. Artist Bev Doolitle's work relies heavily on obscuring boundaries between field and ground. Doolitle's signature theme is the illusional blending of animals and human figures into wooded settings.

14.5 Distortion Illusions

Although an awareness of visual illusions has existed for hundreds of years, a desire to understand them is relatively recent. Beginning in the mid-nineteenth century, research to reveal the basis of visual illusions continues to this day. Central to this research is a desire to understand the perception of the simplest of all illusions: those perceived as distorted figures.

Distortion illusions often consist of no more than a few lines drawn on a plain background. One of the first distortion illusions to be investigated is the "horizontal–vertical" illusion shown in Fig. 14.10. The figure consists of two straight lines of equal length arranged to form an inverted "T." When viewed, the vertical line appears longer than the horizontal segment.

Two classic distortion illusions, due to Poggendorff and Zollner, both appeared in 1860. In the Poggendorf illusion (Fig. 14.11a), a straight line appears to become disjointed as it passes through a solid rectangle. Zollner was able to make parallel lines appear oblique by adding fins to the lines (Fig. 14.11b).

Fig. 14.10 "Horizontal–vertical line" illusion

(a) (b)

Fig. 14.11 **a** Poggendorf illusion and **b** Zollner illusion

After 150 years, many visual illusions remain unexplained. However, that is not true for all distortion illusions. Although not universally accepted, a theory proposed by R. L. Gregory has been used to explain a number of distortion illusions, most notably those devised by Ponzo in 1913 and Muller-Lyer in 1889. These well-known illusions are shown in Fig. 14.12.

The Ponzo illusion (also known as the corridor or railroad track illusion) is constructed by placing two line segments, or rectangles as shown in Fig. 14.12a, of equal length between two converging lines. Most observers see a rather startling result immediately: the rectangle located nearer the point of convergence appears longer.

The Muller-Lyer, or arrow, illusion (see Fig. 14.12b) consists of two lines, one with inward, the other with outward, pointing arrowheads. Even though the two lines have the same length (measure them if you don't believe it!), the line between the inward pointing arrowheads appears longer.

Normally we see the size of objects remaining constant as they move closer or farther away from us. This *size constancy* is quite amazing considering that the retinal image depends on the object's distance from us: the image on the retina is halved as the distance of the object from the eye is doubled. However, through previous experience we know that objects do not grow or shrink as they approach or recede from us. Size scaling performed by the brain adjusts the perceived size of objects to compensate for changes in distance. Size constancy usually provides us with a correct version of reality. For example, we see telephone poles at various distances to be the same height. However, under certain circumstances size constancy can lead to erroneous conclusions.

Since the Italian Renaissance, artists having been applying the principle of perspective to give the illusion of depth (see Sect. 14.7). When perspective is employed in a painting, parallel lines converge to an imaginary point known as the *vanishing point*. The converging lines in the Ponzo illusion suggest such depth: the ends of the lines that are closer together are interpreted as being farther away. On

Fig. 14.12 **a** The Ponzo and
b Muller-Lyer illusions

the other hand, both horizontal line segments form images of the same size on the retina. The disparity between these two conflicting pieces of information results in a visual distortion. In order to produce the same retinal image as the nearer line, the brain incorrectly concludes that the line segment at the top of the drawing must be longer.

An explanation of the Muller-Lyer figure is based on similar reasoning. Gregory suggests that the brain interprets the two lines as the inside and outside corners of a room or building. If this is the case, the perspective suggested by the inward-pointing arrows makes the vertical line appear more distant. Similarly, the line connecting the outward-pointing arrows appears closer. The resulting perception: the line with outward-pointing arrowheads appears shorter (Fig. 14.13). The distortion in length of the two vertical lines occurs because the brain treats two equivalent retinal projections as though they were located at different distances.

The trapezoidal, or distorted, room designed in the 1920s by psychologist Adelbert Ames provides a striking illustration of the effect of perspective, size constancy, and previous experience. To an observer viewing the room through an appropriately placed peephole, the apparent heights of two individuals change dramatically as they exchange corners. Of course, the subjects' heights don't change. It's the room that's not normal.

Figure 14.14 shows the rather unusual wall and floor configuration. The walls are actually trapezoidal. At the left corner, the walls are twice as high as those at the right corner. However, the left corner, which is twice as far away, produces the same retinal image as the right corner. With distorted windows, clocks, and floor

Fig. 14.13 The line with inward-pointing arrowheads (**a**) appears longer than a line of equal length sandwiched between the outward-points arrowheads (**b**)

Fig. 14.14 The configuration of the Ames distorted room

tiles to complete the illusion, the room appears completely normal when viewed through the peephole.

When a person walks from the right corner to the left corner, the image formed on the retina of an observer becomes half as large. Under normal circumstances, the observer would see the person as the same height due to size constancy. However, in the distorted room there are no visual cues to tell the observer that the person is twice the distance away. Our belief in rectangular rooms is so strong that we are willing to accept a person growing and shrinking rather than see a distorted room (Fig. 14.15).

Fig. 14.15 Children appear to grow and shrink as they change position in a distorted room (Richard T. Nowitz/Science Source)

14.6 Impossible Figures

The ambiguity inherent in all pictures is purposely accentuated in *impossible*, or *paradoxical, figures*. Impossible figures lack internal consistency and often violate the tenets of geometry. Parts of these figures seem perfectly reasonable, but when viewed collectively, they make no sense at all.

One of the earliest known examples of an impossible figure may be found in the illuminated medieval manuscript *Pericopes of Henry II*, circa 1025, now preserved in the Bayerische Staatsbibliothek in Munich. As seen in Fig. 14.16, the Madonna and Child are shown in front of a central pillar that ought to end in the foreground. If it did, however, it would obscure our view of the virgin. Instead, the top half of the pillar appears in the front pictorial plane, but the bottom half is depicted in the rear, creating an impossible object.

Perhaps one of the better known paradoxical figures is the "impossible triangle." Looking at the triangle in Fig. 14.17a, you immediately have the sense that something's awry: the figure seems to contain three right angles—a physical impossibility. As is seen in Fig. 14.7b, the trick is revealed when the structure is viewed from a different angle.

Swedish artist Oscar Reutersvard, often referred to as "the father of impossible figures," is credited with the first rendering of the impossible triangle. In 1930 he used nine discreet cubes as components in a creation he called an "impossible tribar." Through intentional manipulation of depth cues, an object, impossible to construct in three dimensions, was drawn in a plane. The original painting appeared on a Swedish postage stamp, as did other impossible figures created by the artist. Figure 14.18 shows a replica of Reutersvard's impossible tribar.

Mathematicians Roger and L. S. Penrose discussed the properties of impossible figures in their 1958 article titled "Impossible Objects: A Special Type of Illusion." In the article, the authors introduced their version of the impossible tribar known as the Penrose stairs or, more commonly, the "impossible staircase" (Fig. 14.19).

Fig. 14.16 One of the earliest known examples of an impossible figure shows a pillar with its top half in the foreground of the pictorial plane and bottom half in the rear (Bayerische Staatsbibliothek München, Clm 4452, fol. 18v.)

A person could climb or descend the continuous loop of steps forever without getting anywhere.

Learning of the Penrose stairs, Dutch artist M.C. Escher incorporated the impossible staircase in his lithograph *Ascending and Descending*. In the print, robot-like monks walk around and around on a staircase with no beginning or no end.

Escher went on to base other works on the Penrose drawings. Inspired by Penrose's impossible triangle, *Waterfall* fulfills the dream of medieval philosophers: perpetual motion. As is seen in Fig. 14.20, water appears to violate the principle of conservation of energy as it flows upward, then falls downward, then upward again, circulating in a never-ending cycle.

(a) (b)

Fig. 14.17 **a** What appears to be a three-dimensional triangle containing three 90-degree angles. **b** Viewing the structure from a different vantage point reveals the "triangle's" true nature (Photograph by Alan Brix)

Fig. 14.18 An impossible tribar (DivinHX/Shutterstock.com)

Fig. 14.19 A walk on the impossible staircase always takes you back to where you started (Vitaliken/Shutterstock.com)

Fig. 14.20 M.C. Escher's *Waterfall* shows water circulating via an impossible path (M.C. Escher's *Waterfall* ©2018 The M.C. Escher Company-The Netherlands. All rights reserved.)

14.7 The Grand Illusion: How Artists Produce a Sense of Depth

The image formed on the eye's retina is essentially flat, yet we perceive the world as three-dimensional. Our visual world is imbued with depth due to processing that occurs in the brain. Perceiving three dimensions is greatly enhanced by stereoscopic vision (stereopsis). Each eye provides the brain with a slightly different view of a scene, a phenomenon known as *visual disparity*. Based on two retinal images, the brain constructs a mental image that possesses depth.

Perhaps surprisingly, a person using only one eye also enjoys depth perception by making use of *monocular depth cues*. You can convince yourself of this by covering one eye. Note that your world does not become two-dimensional: You see in 3D even though your eye–brain system is only receiving information from one perspective. Why? A single eye receives many monocular cues that provide information regarding depth. Artists use these same cues to convey a sense of depth on a two-dimensional canvas.

Most of us hold a default assumption that distant objects appear smaller. For example, when a car drives away from us, we associate its diminishing size with its increasing distance from us. Artists therefore use smaller images of known objects if they wish to communicate a sense of distance.

This correlation of size with distance is also used in architecture. Employing a technique known as *accelerated perspective*, architects can make a building look taller by using smaller windows on upper floors. Similarly, a modest home may be made to look larger by using smaller shingles near the top of the roof. One of the most dramatic manipulations of size to convey distance is the colonnade at the Palazzo Spada in Rome (Fig. 14.21). Viewed from one end, a tunnel only 8 m in length appears to be much longer. Looking down the corridor from the other end reveals the illusion. By making one end of the colonnade much smaller than the other (5.8 m × 3.5 m at the larger portal, 2.45 m × 1 m at the smaller entrance), an amazing sense of depth is achieved.

One of the oldest techniques for creating an impression of depth in a painting is to simply superimpose one object on another. When one object obscures a portion of another object, the viewer unconsciously assumes that the obstructing object is closer, as in Fig. 14.22. This simple technique, known alternately as *overlapping*, *occlusion*, or *interposition*, provides information about relative, not absolute depth. Overlapping can be seen in art dating back to prehistoric times.

When looking off into the distance, we notice that objects seem to blend together, becoming less distinct. The facial features of people at a large gathering lose definition when you look toward the rear of the crowd. Artists use the reduction in detail with distance to produce the illusion of depth. This depth cue, know as *detail perspective*, was used by Leonardo da Vinci and other Renaissance painters. Related to this cue is *textural perspective*, as shown in Fig. 14.23. The density of objects, for example sunflowers in a field or stones in a street, increases with distance.

Fig. 14.21 The colonnade at the Palazzo Spada illustrates accelerated perspective. The corridor is much shorter and the sculpture is much smaller than they appear (Livioandronico2013 (https://commons.wikimedia.org/wiki/File:Forced_perspective_gallery_by_Francesco_Borromini.jpg), https://creativecommons.org/licenses/by-sa/4.0/legalcode)

Fig. 14.22 Overlapping objects in *The Old Violin* by William Michael Harnett convey a sense of depth (William Harnett [Public domain])

Fig. 14.23 Textural perspective produces a sense of depth (Kevin George/Shutterstock.com)

Aerial Perspective and Rayleigh Scattering

Rayleigh scattering plays a role in a phenomenon known as *aerial* or *atmospheric perspective*. Distant objects, such as mountains and forests, may take on a hazy, bluish tint. This coloration is due to the scattering of blue light toward the observer by the intervening atmosphere. The humidity in certain densely wooded regions is particularly high due to the release of water vapor from leaves. The water vapor, accompanied by oily residues from the trees, enhances the scattering.

The scattered light by the intervening air results in a reduction in the sharpness and contrast of distant objects. Detail observed in nearer objects is often lacking in more distant scenes. Centuries ago artists realized that a heightened sense of depth might be achieved by capturing the effects of atmospheric scattering on canvas. Aerial perspective continues to be a highly effective means of expressing depth.

It is said that the Cherokee Indians, denizens of the Great Smoky Mountain area, named the area "Place of the Blue Smoke." Other wooded areas such as Mt. Rainier, Olympia, and Crater Lake National Parks in Washington and Maine's Acadia National Park exhibit similar haziness. The Blue Ridge landscape shown in Fig. 14.24 dramatically illustrates the effect.

Because aerial perspective becomes more pronounced with the addition of particulate matter to the atmosphere, city dwellers often misjudge distance when visiting a locale with unusually clean air. Mountain ranges and other distant objects are perceived to be much closer than they actually are.

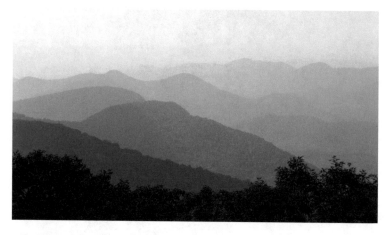

Fig. 14.24 Photograph of Blue Ridge Mountains illustrates aerial perspective (Photograph by John Hardwick)

Shadows and Illumination

Humans are accustomed to overhead illumination. Before artificial lighting, the Sun provided light from above. The advent of gas, and later electrical lighting, further reinforced the notion that light comes from overhead. This assumption is so ingrained in us that we depend on it to interpret the information provided by shadows. In fact, we judge the shape of objects in our environment, at least in part, by the shadows they produce.

Shadows are ubiquitous, but often go unnoticed. We are usually unaware of the ever-present facial shadows created by blockage of overhead lighting by the nose, cheeks, and other facial features. However, children seem to be quite aware of the importance of facial shadows. Have you ever noticed how they delight in scaring one another by directing flashlight beams upward on their faces, producing scary shadow formations not generally seen?

Because shadows reveal much about an object's extension in space, they are often used to heighten the illusion of depth in a painting. A simple example is seen in Fig. 14.25 in which a two-dimensional circle drawn with shading and shadow appears solid and sphere-like. Renaissance artists are attributed with initiating the use of shadows in drawings and paintings. This use of light and shadow in painting became known as *chiaroscuro* ("light and dark").

Changing the direction of illumination can lead to results that even artists cannot anticipate. To the surprise of all those involved, when a bust of Lincoln was moved from one location in our nation's capital, where the lighting was directed downward, to another, where the light came in from the side, the change in shadow formation transformed Lincoln's somber countenance into one of surprise.

Fig. 14.25 Shadow and shading give a circle the appearance of three-dimensionality (fantasyform/Shutterstock.com)

This same effect comes into play in our interpretation of the two faces shown in Fig. 14.26. The two faces may look the same, but they are not. The one on the right protrudes outward, like a normal face; the other is the mold from which the face on the right was produced. Illuminating the concave mold from below produces the same percept as illuminating the convex mask from above. The illusion is heightened by our expectations. We are so conditioned to believe that faces are convex that when we encounter a concave face, we see it in relief.

Fig. 14.26 Are both of these faces convex? (Courtesy of David Seagraves)

The Magic of Linear Perspective

> Perspective is of such a nature that it makes what is flat appear in relief, and what is in relief look flat.

—Leonardo da Vinci

Linear perspective, one of the most powerful ways of representing the three-dimensional on a flat surface, can be thought of as capturing the light that passes from a scene through an imaginary window by painting what is seen directly onto the windowpane. When first introduced, the effect of linear perspective was so compelling that it was likened to magic. It is said that Italian artist Paolo Uccello (1397–1475) was so taken by the new method of representing three-dimensional space that he would stay up all night painting, much to the chagrin of his wife.

Linear perspective represents a marriage of art and science. Because light travels in straight lines, more distant objects subtend a smaller visual angle and, consequently, produce smaller retinal images. This method of depth representation simply reflects the everyday observation that parallel lines appear to intersect at some distant "vanishing point," as in Fig. 14.27.

The familiar fanning out of light rays as sunlight passes through spaces between clouds, trees, and other obstructions offers a beautiful example of the effects of linear perspective in nature. These seemingly divergent rays, alternately referred to

Fig. 14.27 Rows of pews and walls in the Church of the Society of Jesus in Quito, Ecuador, seem to converge at a distant vanishing point (Diego Delso [CC BY-SA 4.0 (https://creativecommons.org/licenses/by-sa/4.0)])

as *crepuscular* ("twilight") *rays* or *rays of Buddha*, are essentially parallel. Their apparent divergence is a direct result of linear perspective. Just as railroad tracks appear to converge at a distant vanishing point, crepuscular rays seem to intersect at the distant Sun.

Italian architect and engineer Filippo Brunelleschi (1377–1446) is believed to have been the first artist to employ linear perspective in his work. To demonstrate the power of this approach to capturing realism on canvas, he employed a mirror to perform a rather dramatic demonstration.

As shown in Fig. 14.28, Brunelleschi made a small viewing hole in the center of one of his paintings. With the painted side of the canvas directed away from the viewer and toward the actual subject of the painting, he carefully positioned a plane mirror in front of the canvas. When looking through the hole, the viewer would unknowingly see a reflection of the painting. The artist would then quickly remove the precisely positioned mirror, revealing the actual scene to the observer. The three-dimensionality of the painting was so convincing that the removal of the mirror reportedly went unnoticed.

After its introduction by Brunelleschi, the acceptance and popularity of linear perspective became widespread. In 1435, Leon Battista Alberti introduced the idea of linear, or geometric, perspective in his book *De Pictura*. The details of perspective were later codified by Leonardo da Vinci in his *Notebooks*.

Masaccio (1401–1428) and Andrea Mantegna (1431–1506) are among the most important Renaissance practitioners of linear perspective. Masaccio is considered to

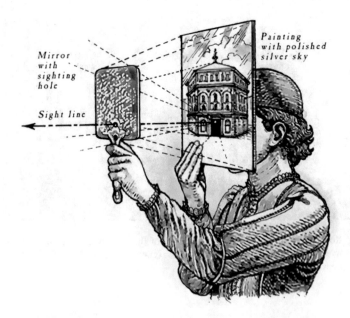

Fig. 14.28 Brunelleschi used a mirror to demonstrate the power of linear perspective

Fig. 14.29 Masaccio's
fresco the *Holy Trinity*, in
Santa Maria Novella, in
Florence creates an illusion of
three-dimensional space on a
flat surface (Masaccio (https://
commons.wikimedia.org/
wiki/File:Masaccio_trinity.
jpg), "Masaccio trinity",
marked as public domain,
more details on Wikimedia
Commons: https://commons.
wikimedia.org/wiki/
Template:PD-old)

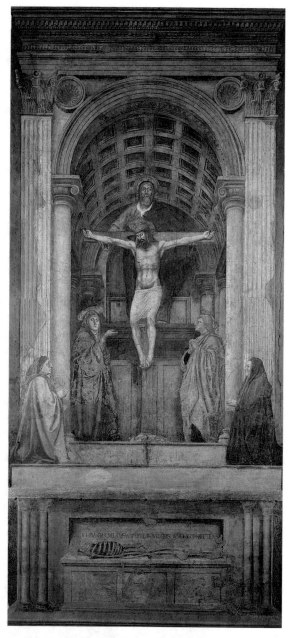

be the first great artist to incorporate Brunelleschi's discovery in a major work of
art. In his fresco the *Holy Trinity*, in Santa Maria Novella, in Florence the power of
linear perspective is fully realized (Fig. 14.29). Masaccio created art of
three-dimensionality unlike any other seen before. Acknowledged as the initiator of
the new style of Florentine realism, he set the standard for others to follow.

Mantegna's *Lamentation of Christ* (Fig. 14.30) illustrates the power of fore-shortening, a technique used to create the appearance of depth. The illusion is the result of visually compressing an object, making it appear shorter than it actually is. When foreshortened, a circle often appears elliptical; a square can become trapezoidal.

At first glance, Mantegna's painting seems to be in proper perspective. However, closer examination reveals that Christ's body has been foreshortened: the artist has reduced the length of Christ's chest and legs in order to produce a sense of depth.

The Use of Depth Cues: From the Sublime to the Impossible

When an artist employs many of the monocular cues just discussed in a particularly skillful manner, observers may be completely deceived by a painting. Such is the case with the ultra-realistic style of painting referred to as *trompe l'oeil* ("to deceive the eye"). Trompe l'oeil artists often create large murals on the ceilings of cathe-drals or on the exteriors of large buildings or bridges. The resulting painted illusions have a realism and solidity that are capable of fooling both humans and animals. It is said that grapes in one Grecian trompe l'oeil painting were so realistic that birds flew up to eat them!

Trompe l'oeil painting dates back to Greek and Roman times. The only exam-ples of work remaining from this period are found at Pompeii. After being out of vogue for over a thousand years, interest in illusionist painting enjoyed a resurgence during the Italian Renaissance. During this period, artists such as Mantegna and

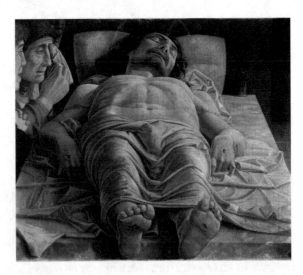

Fig. 14.30 Andrea Mantegna's use of linear perspective in *Lamentation of Christ* produces a dramatic sense of depth and realism (https://commons.wikimedia.org/wiki/File:The_dead_Christ_and_three_mourners,_by_Andrea_Mantegna.jpg), ("The dead Christ and three mourners, by Andrea Mantegna", marked as public domain, more details on Wikimedia Commons: https://commons.wikimedia.org/wiki/Template:PD-old)

Uccello executed magnificent murals that visually transformed the interiors of churches and palaces.

Italian painter and architect Andrea Pozzo's (1642–1709) breathtaking painted ceiling in the Church of St. Ignazio in Rome (Fig. 14.31) represents one of the finest examples of the baroque period's architectural trompe l'oeil. On a flat ceiling, the master of perspective painted *Triumph of St. Ignatius of Loyola*, an allegory of the entry of St. Ignatius into paradise in spectacular perspective. When viewed from a designated spot on the floor of the nave, a mass of figures appears to float upward past a series of columns and arches that seem extend into the heavens.

Escaping Criticism, shown in Fig. 14.32, by the nineteenth-century Spanish artist Pere Borrell del Caso (1835–1910), provides yet another striking example of the trompe l'oeil style. In the extremely realistic painting, a boy seems to be escaping from his usually assigned space. Three-dimensionality is enhanced by realistic shadowing, attention to perspective, and the positioning of the boy's hands, foot, and head on the outside of the frame. The overall effect is somewhat disturbing since the subject, which is expected to reside within the confines of the frame, seems to be emerging into the world of the viewer, thus blurring the boundary between the real and the imaginary.

Trompe l'oeil continues to be as engaging and intriguing as ever. Examples of this art form may currently be found in venues ranging from the sides of buildings to the interiors of businesses, theaters, schools, and museums. A preeminent practitioner of the technique is John Pugh. A renowned trompe l'oeil artist, Pugh focuses on public art. He has received over 250 commissions from institutions and individuals from all over the world. Anyone familiar with his work will understand why.

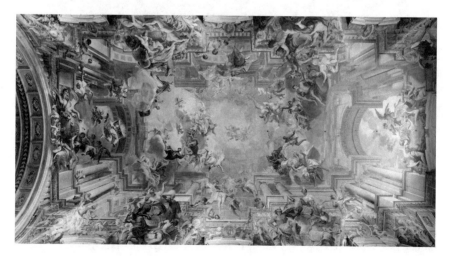

Fig. 14.31 *Triumph of St. Ignatius of Loyola* on the ceiling of the Church of St. Ignazio appears to rise upwards to the heavens, but is actually completely flat (Livioandronico2013 Andrea Pozzo (https://commons.wikimedia.org/wiki/File:The_Triumph_of_St._Ignatius.jpg), https://creativecommons.org/licenses/by-sa/4.0/legalcode)

Fig. 14.32 *Escaping Criticism*, by the nineteenth-century Spanish artist Pere Borrell del Caso, blurs the boundary between the real and the imaginary (Banco de Espana Collection, PereBorrell del Caso, *Escaping Criticism*, 1874, Oil on Canvas, 75.7 × 61 cm)

Fig. 14.33 John Pugh's *Art Imitating Life Imitating Art Imitating Life* integrates his art with the existing environment (Photograph courtesy of John Pugh, artofjohnpugh.com)

A stunning example of Pugh's work is *Art Imitating Life Imitating Art Imitating Life*, a mural that originally adorned the wall of a café, but now resides in the Lindsay Public Library in Lindsay, CA. The installation, seen in Fig. 14.33,

Fig. 14.34 William Hogarth's *False Perspective* illustrates how distortions arise when depth cues are misapplied (Charles Deering McCormick Library of Special Collections, Northwestern University Libraries)

consists of Pugh's mural and real brick work. Can you tell where the mural ends and the real bricks begin?

Whereas the creators of trompe l'oeil art stress realism, many artists intentionally transport us to the realm of the impossible. Since pictures are only representations of the real world, they do not have to abide by the rules of nature. The very depth cues that can make a two-dimensional painting seem amazingly realistic can also be manipulated to produce a situation that cannot exist in our three-dimensional world.

False Perspective (Fig. 14.34), by eighteenth-century artist William Hogarth, illustrates how distortions may arise when the laws of perspective and other depth cues are misapplied. Distances become confused as objects in normally distinct

planes intermingle: A shop sign extends across a bridge to a nearby hill while a traveler gets a light from a person in a distant window. How many additional visual paradoxes can you find in the engraving?

14.8 Summary

The disparity between what we perceive and what actually exists is the basis for all visual illusions. Beyond pure entertainment, visual illusions have a surprising number of applications in the visual and performing arts, architecture, and the sciences. Causes of illusions are usually designated as physical, physiological, or cognitive. Illusions may be further classified as ambiguous, distorted, or paradoxical figures. Physical illusions result from physical processes that occur outside the body. Physiological illusions are due to the functioning of our visual sensory apparatus. Psychological or cognitive illusions arise from information processing mechanisms within the brain.

Ambiguous figures present the brain with sensory information that may be decoded in two or more equally satisfactory ways. Some of the simplest of all illusions are those perceived as distorted figures. Some of the most interesting and perplexing of these distortion illusions consist of collections of straight lines. The ambiguity inherent in all pictures is purposely accentuated in impossible figures. Impossible figures lack internal consistency; they may be drawn but not constructed.

Monocular cues such as superposition of objects, perspective, texture, and shadow are used by the artist to convey a sense of depth on a two-dimensional canvas.

◆ Review Questions

1. List three types of illusions and give an example of each.
2. State three Gestalt rules of perceptual organization.
3. List four monocular depth cues artists use to convey depth in a painting.
4. Give an explanation for the Muller-Lyer and Ponzo illusions based on size constancy and linear perspective.
5. What is a moiré pattern? Give at least two examples from everyday life.
6. How does the Necker cube illustrate ambiguity?
7. What is the connection between camouflage and figure-ground segregation?
8. What is linear perspective? What is observed in a painting that employs linear perspective?
9. What is accelerated perspective and how is it employed by architects?

▼ Questions for Thought and Discussion

1. What does psychologist R. L. Gregory mean by the statement, "We not only believe what we see, but to some extent, we see what we believe?"
2. How do optical artists create the illusion of shimmer or movement in their works?
3. Explain the illusion produced by the Ames room.
4. Describe three illusions that you encounter daily. Try to use examples not discussed in the chapter.

● Experiments for Home, Laboratory, and Classroom Demonstration

Home and Classroom Demonstration

1. **Camouflage and common fate**. Certain objects and living things become almost invisible when they blend in with their surroundings. Nature abounds with animals that use camouflage as a means of defense. However, a camouflaged animal often exposes itself when it moves. When all parts of an object move together, many animals, including humans, sense this common movement of the parts. In an attempt to understand how the brain organizes stimuli, Gestalt psychologists arrived at the notion of common fate. That is, the brain tends to combine parts that move in unison, or have a common fate, into a single entity.

 You can demonstrate camouflage and common fate by cutting a small animal or any other shape from a sheet of giftwrap. For the demonstration to work, the giftwrap should consist of a very simple pattern such as small dots on a monochrome background. When the animal shape is placed on top of a larger sheet of the same paper, it will virtually disappear. However, the camouflage loses its effectiveness when you slide the animal shape across the surface of the paper. The animal cutout almost jumps out at you!

2. **Seeing the expected**. Make three photocopies of a photograph of yourself or a friend. If you have three actual photographs that are expendable, so much the better. Cut the eyes and mouth from one photograph, turn them upside down, and glue them over the eyes and mouth in one of the remaining photographs. Mount the pictures with inverted features alongside the last intact picture on a piece of posterboard. Turn the mounted photos upside down and present them to an unsuspecting friend. They will most likely not find anything wrong with the modified photograph. Now rotate the posterboard and watch your friend's reaction! People are simply not accustomed to seeing upside-down faces and, consequently, perceive what they expect exists: two normal faces.

3. **A contextual illusion**. The context in which an object is viewed often influences our perception. This may be illustrated with a commercially available elastic ponytail band. The band consists of a short length of elastic cord whose

ends are connected with a crimped piece of metal. With your fingers holding the band on either side of the metal connector, view the unstretched band and note the size of the connector. Now stretch the band and watch what happens to the apparent size of the connector. Does it appear to shrink as the band is stretched? What causes this illusion?

4. **A distortion illusion**. Due to certain perceptual assumptions made by the brain, objects can become distorted when viewed in a particular way or in a certain context. On a sheet of plain paper, draw six to eight straight lines that fan out from a common point. The lines should be five or six inches long. On a piece of glass or on a clear plastic sheet, carefully draw a square that will fit within the diverging grid lines. Now place the square on the grid. Do the sides of the square appear to be the same length? Which line appears to be the shortest? Why do you think this distortion occurs? Does the effect seem to depend on the location of the square on the grid? Now use a coin to draw a circle on the clear plastic sheet. How does the circle appear when placed on the grid? Draw other figures and observe how they appear when superimposed on the grid.

5. **Image melding**. The brain normally fuses sensory information from each eye into a single three-dimensional image. While this synthesis usually produces a useful picture of our world, combining binocular visual data may lead to some rather strange perceptions. With both eyes open, hold a cardboard tube from a roll of paper toweling or aluminum foil up to one eye. While looking straight ahead, bring your free hand up next to the tube with open palm facing your uncovered eye. For maximum effect, the side of your hand should be touching the tube. Do you see what appears to be a hole in the palm of your hand? Slide your hand along the length of the tube. At what distance is the effect most pronounced?

6. **Color depth cues**. Seen on a computer screen, colored letters or figures on a dark background can produce a striking sense of depth; the letters seem to rise above the background. If you encounter this 3D effect, which is often used in graphic displays on the internet, you will surely be taken by its effectiveness. Which colors seem to be closest to you? Farthest away? Why do we perceive this illusion of depth, known as chromostereopsis (see Sect. 9.2) on a flat screen?

7. **Persistence of vision: The magic wand**. Your eye has a tendency to hold on to an image for a fraction of a second after the stimulus is removed. This can be demonstrated nicely by holding a white rod in front of a slide or video projector in place of a screen. If the rod is moved rapidly back and forth across the field of the projected image, the full image is seen due to the persistence of vision.

8. **Persistence of vision: The thaumatrope**. Another illustration of persistence of vision is the spinning thaumatrope (Greek *thauma*, "marvel," plus *tropos*, "turn"), said to have been invented by English physician J. A. Paris in 1826. Attach strings or rubber bands to two opposite edges of a small cardboard disk, and draw complementary pictures on the two sides (a bird and a cage, for example). When the disk is rapidly rotated by pulling on the strings, the two pictures will appear to be combined due to the persistence of vision.

9. **Size constancy: Are your hands the same size?** With one eye open, look at your hands, one at arm's length, and the other at half this distance. Provided that their images don't overlap, they should look the same size, even though the retinal image of the further hand will only be half the size of the nearer one. If the images overlap, however, they will look very different in size. The overlap defeats size constancy, showing what perception would be without it.
10. **Reverse corner.** Cut an L-shaped piece of paper consisting of three segments about two inches square. Fold at the two lines joining the squares and join them with transparent tape to make half a cube. With one eye closed, hold the concave cube corner at arm's length and orient it so that it appears to be *convex*. That is, at some orientation, the concave cube corner appears to reverse itself. Once you have achieved reversal of the corner, rotate it in your hand and note that the cube appears to turn in the opposite direction.

Glossary of Terms

accelerated perspective A spatial configuration designed to suggest a distance or depth longer than the actual one.

aerial perspective The depth cue that allows us to judge the distance of an object by the appearance of its color.

ambiguous figure A picture that may be interpreted in two or more equally valid ways.

chiaroscuro The use of light and shadow in painting.

cognitive illusion A visual illusion that arises from information-processing mechanisms within the brain.

distortion illusion A visual illusion in which lines or figures appear distorted due to context.

figure-ground illusion An illusion in which two aspects of a drawing, both of equal stature, vie for attention.

impossible figure Figures that lack internal consistency and do not represent actual physical objects.

monocular cues Visual information that allows a person with one eye to perceive depth. Artists frequently use monocular cues to convey depth in drawing or painting.

linear perspective A system for representing three-dimensional objects and space on a two-dimensional surface.

physical illusion A visual illusion that results from physical phenomena outside the body.

physiological illusion A visual illusion that is caused by the functioning of our visual sensory apparatus.

size constancy The tendency to see the size of objects remaining constant as they move closer or farther away.

stereopsis The ability of both eyes to see the same object as one image, resulting in a perception of depth.

trompe l'oeil A style of painting in which objects are depicted with photograph-
ically realistic detail.

visual disparity Two different views of the same scene resulting from binocular
vision.

visual illusion A situation in which visual perception leads to incorrect interpre-
tation of reality.

Further Reading

Cole, K. C. (1978). *Vision in the Eye of the Beholder*. San Francisco, CA: Exploratorium.
Goldstein, E. B. (1989). *Sensation and Perception*. Belmont, CA: Wadsworth Publishing.
Gregory, R. L. (1970). *The Intelligent Eye*. New York: McGraw-Hill.
Levine, M. W., & Shefner, J. M. (1991). *Fundamentals of Sensation and Perception*. Pacific
 Grove, CA: Brooks/Cole.
Luckiesh, M. (1965). *Visual Illusions*. New York: Dover Publications.
Rodgers, B. (2017). *Perception: A Very Short Introduction*. Oxford: Oxford University Press.
Snowden, R., Thompson, P., & Troscianko, T. (2012) *Basic Vision: An Introduction to Visual
 Perception* (Revised Edition). Oxford: Oxford University Press.
Solso, R. L. (1996). *Cognition and the Visual Arts*. Cambridge, MA: The MIT Press.

Correction to: Light Science

Correction to:
T. D. Rossing and C. J. Chiaverina, *Light Science*,
https://doi.org/10.1007/978-3-030-27103-9

In the original version of the book, belated corrections provided by the author for most of the chapters have now been incorporated.

The updated version of the book can be found at
https://doi.org/10.1007/978-3-030-27103-9

Appendix A
Numerical Answers to Odd-Numbered Exercises

2.3	(a) 3.33×10^{-6} s; (b) 2.92 s
2.5	474 Hz
3.7	(a) 3, (b) 5, (c) 7, (d) 11
3.9	3.5 cm
3.11	−6 cm
4.1	0.34, 0.05, 0.71, 0.87, 0.94, 0.98, 1
4.3	46°
4.5	37°
4.9	(a) 60 cm, (b) real, (c) m = 3; 15 cm
4.11	6 cm
5.1	125 nm
5.3	1.31 m; it will be diffracted passing through a doorway
5.5	red line at 1.58 mm; blue line at 1.12 mm
5.7	4.4 cm
6.1	55.8°
6.3	37.5%
7.3	9.66 μm; no, this is in the infrared region of the spectrum
7.5	656 nm, 486 nm, 434 nm
7.7	3.37×10^{-19} J
9.1	450 nm, 555 nm, 600 nm
10.1	$f/4$
10.3	$f/5.6$
10.5	subject largest: 200 mm; widest angle: 30 mm
10.7	200 mm lens
12.1	(a) 105; (b) 38; (c) 85
12.3	10^{12}; 8×10^{12}
13.1	4.62×10^{14}
13.3	74 min

© Springer Nature Switzerland AG 2019
T. D. Rossing and C. J. Chiaverina, *Light Science*,
https://doi.org/10.1007/978-3-030-27103-9

13.5 0.83 μm for green light. If $\lambda \approx D$, then the minimum spot size is approximately $1.27 f \lambda/D = 1.27 f = 1.27$ (790 nm) $= (1.27)(7.9 \times 10^{-7}$ m$) \approx 10 \times 10^{-7}$ m $= 10^{-6}$ m $= 1$μm. The minimum spot size for red light is approximately $1.27 f \lambda/D = 1.27 f = 1.27$ (650 nm) $= (1.27)(6.5 \times 10^{-7}$ m$) \approx 8.25 \times 10^{-7}$ m $= 0.826$ μm

13.7 503 nm; the pit depth is roughly a quarter of a wavelength. This depth was selected so that when the laser beam encounters a pit, the part of the beam reflected from the pit and part from the flat region between the pits are approximately out of phase and therefore interfere destructively. The wavelength in polypropylene is given by the wavelength of the light in air, 780 nm, divided by the index of refraction of polypropylene, 1.55. That is, 780 nm/1.55 = 503 nm ≈ 0.5 μm. Thus, the pit depth, 0.11 μm, is roughly a quarter of this wavelength. This means that destructive interference will occur at the edge of a pit since it will be opposite in phase to the that reflected from the adjacent area (because it has traveled $\lambda/2$ father)

Appendix B
Standard International (SI) Units of Measurement

Nearly all the world uses SI (Système Internationale or standard international) units of measure. The United States is one of the few remaining countries in which British units (feet, inches, pounds, miles, etc.) are still in common use; even the British abandoned them several years ago. In the United States, SI units are almost exclusively used in scientific work, and it is worthwhile for every student to become familiar with them, to learn to think in meters, kilograms, and seconds.

The fundamental units in the SI system are the *meter, kilogram, second,* and *ampere* (the ampere is a unit for electrical current). The meter was originally defined as one ten-millionth the distance from the Earth's equator to either poles, and a platinum rod representing this distance was kept at the International Bureau of Weights and Measures near Paris. (Modern measurements of the Earth's circumference reveal that the intended length is off by 1/50 of a percent.) In 1960, the meter was redefined as 1,650,763.73 wavelengths of a particular orange light emitted by krypton 86. In 1983, the meter was redefined again as "the distance traveled by light in a vacuum during 1/299,792,458 of a second." It is a tribute to the precision of light science that both of the latter definitions relied on the measurement of light!

In addition to these fundamental units, there are a number of derived units in the SI system, such as the Newton (for weight), the joule (for energy), and the watt (for power). Some conversions from British units to SI units are:

length or distance (meter):	1 m = 39.4 in. = 3.28 ft
(kilometer):	1 km = 0.621 mi
force or weight (Newton):	1 N = 0.225 lb
energy (joule):	1 J = 0.738 ft lb = 1/4.18 calorie
power (watt):	1 W = 1/746 hp

The kilogram is a unit of mass, and the proper unit for mass in the British system is the *slug* which is rarely used in everyday life. Rather, we prefer to use the *pound*, which is the unit that expresses the force of gravity (somewhere on Earth, at least) on 1/32 slug. The force of gravity on one kilogram is 9.8 N, but for most purposes it is sufficient to use 10. Thus, the weight of (force of gravity on) 1/10 kg (100 g) is close to one Newton. One Newton, appropriately enough, is approximately the

© Springer Nature Switzerland AG 2019
T. D. Rossing and C. J. Chiaverina, *Light Science*,
https://doi.org/10.1007/978-3-030-27103-9

weight of an apple. (Sir Isaac Newton is said to have discovered the law of gravity when an apple fell on his head you may recall.)

One of the most attractive features of the SI system is that standard prefixes can be attached to the basic units to create other useful units of measure. For example, the wavelength of light is very small, and instead of expressing it as 0.000000640 m (or 6.40×10^{-7} m), it is more convenient to express it as 640 nm, where 1 nm (nanometer) is 10^{-9} m (meter). A list of prefixes is given below. The ones in boldface are particularly useful to remember because they are used so frequently.

Factor	Prefix	Symbol
10^{18}	exa	E
10^{15}	peta	P
10^{12}	tera	T
10^{9}	giga	G
10^{6}	**mega**	**M**
10^{3}	**kilo**	**k**
10^{2}	hecto	h
10	deka	da
10^{-1}	deci	d
10^{-2}	centi	c
10^{-3}	**milli**	**m**
10^{-6}	**micro**	**μ**
10^{-9}	**nano**	**n**
10^{-12}	pico	p
10^{-15}	femto	f
10^{-18}	atto	a

Appendix C
Scientific or Exponential Notation

It is convenient to write very large or very small numbers using what is known as scientific or exponential notation. In scientific notation, a number is expressed as the product of a number from 1 to 10 (but not including 10) times a power of 10.

Example: 34,000 is written as 3.4×10^4.

In converting 34,000 to scientific notation, the decimal point that follows the last zero is moved four places to the left until a number between 1 and 10 is obtained: 3.4, in this case. Since the decimal point is moved four places, the exponent of 10 is 4. Forming the product of the coefficient and the power of 10 gives 3.4×10^4. This number is entered into most calculators by keying in "3.4 EXP 4."

A number less than one may also be expressed in scientific notation.

Example: 0.000018 is written as 1.8×10^{-5}.

This time, the decimal point is moved to the right until a number between 1 and 10 is obtained. Since the decimal point is moved five places to the right, the exponent of 10 is −5. To enter this number on a calculator, one would generally press "1.8 EXP 5" followed by the +/− key, which converts 5 to −5.

The advantage of scientific notation is easily seen by writing the speed of light as 3×10^8 m/s rather than 300,000,000 m/s, or by writing Planck's constant as 6.6×10^{-34} J s rather than 0.00000000000000000000000000000000066 J s.

Some Basic Facts About Exponents

1. Any number to the first power is equal to that number.
 Examples: $10^1 = 10$, $x^1 = x$
2. Any number to the zero power is equal to one.
 Examples: $10^0 = 1$, $(1/4)^0 = 1$, $x^0 = 1$
3. Negative exponent: $x^{-n} = 1/x^n$
 Examples: $10^{-3} = 1/10^3$, $y^{-2} = 1/y^2$
4. Multiplication: $y^a \times y^b = y^{a+b}$
 Examples: $10^3 \times 10^2 = 10^5$ (in other words $100 \times 1000 = 100,000$), $10^3 \times 10^{-2} = 10$
5. Division: $x^a/x^b = x^{a-b}$
 Examples: $10^5/10^2 = 10^3$, $10^5/10^{-2} = 10^7$, $10^{-5}/10^{-2} = 10^{-3}$

© Springer Nature Switzerland AG 2019
T. D. Rossing and C. J. Chiaverina, *Light Science*,
https://doi.org/10.1007/978-3-030-27103-9

6. To multiply two numbers expressed in scientific notation, multiply the coefficients, but add the exponents of 10.

 Example: $(2.1 \times 10^2) \times (3.4 \times 10^4) = 7.14 \times 10^6$; $(1.2 \times 10^3)^2 = 1.44 \times 10^6$

7. To divide two numbers expressed in scientific notation, divide the coefficients, but subtract the exponents of 10.

 Example: $(7.8 \times 10^8)/(1.6 \times 10^5) = 4.88 \times 10^3$

Appendix D
Mathematical Helps

D.1 Solving Simple Equations

Go slow; do one step at a time. Remember, you can add or subtract the same term from both sides of the equation or you can multiply or divide each side of the equation by the same factor.

Example 1: x − 4 = 7. Add 4 to each side to obtain: x = 7 + 4 = 11.
Example 2: 4x = 2. Divide each side by 4 to obtain: x = 2/4 = ½.
Example 3: 3y− 7 = 5. Add 7 to each side to obtain: 3y = 12. Divide by 3 to obtain: y = 4.

D.2 Solving Equations with Trigonometric Functions

You needn't understand trigonometry to solve equations with trigonometric functions. Remember that taking the inverse of a trigonometric function gives you the numerical value of an angle.

Example: cos θ = 0.54: enter 0.54 on your calculator and press [inv][cos] to obtain θ = 57.3°
Example: sin θ/sin 45 = 1.2: multiply by sin 45 to obtain sin θ = 1.2 sin 45 = 0.85; now press [inv][sin] to obtain θ = 58°.

Use a calculator to find trigonometric values. Google and digital assistants such as Alexa and Siri may also be used.

© Springer Nature Switzerland AG 2019
T. D. Rossing and C. J. Chiaverina, *Light Science*,
https://doi.org/10.1007/978-3-030-27103-9

Appendix E
Graphs

A picture is worth a thousand words, it is said, but a good graph can be worth two thousand. In physics, you will encounter graphs with linear scales (equally spaced numbers; same distance from 4 to 5 as from 1 to 2) and graphs with compressed scales (same distance from 10 to 100 as from 1 to 10, for example). The first thing to do when reading a graph is to look at both the horizontal and vertical scales to determine what quantities they represent and whether each scale is linear or compressed. Generally, there will be subdivisions or "ticks" between the main numbers on the scales. You should determine how big each tick is so that you can properly read values off the graph. Sometimes you will have to interpolate (i.e., estimate the exact value by where it lies between two ticks).

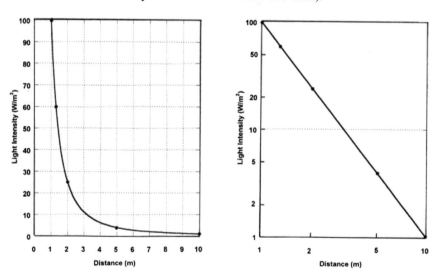

The two graphs on the previous page illustrate how the intensity of light from a point source (or any quantity that follows the "inverse-square law") varies with

© Springer Nature Switzerland AG 2019
T. D. Rossing and C. J. Chiaverina, *Light Science*,
https://doi.org/10.1007/978-3-030-27103-9

distance from the source. They are both plots of the relationship $I = 100/d^2$ but note how different they look. On the first graph, which has linear scales, the relationship is a curve. On the second graph, which has compressed (actually logarithmic) scales, the relationship is a straight line. For practice, try writing down the I and d values for each of the five data points as read from each graph. Which is easier to read?

Appendix F
Glossary

absolute temperature Temperature on a scale that begins at absolute zero and measures temperature in kelvins (K). Celsius temperature is converted to absolute temperature by adding 273°K.

acousto-optic modulator Acoustic (sound) waves diffract light waves to produce a modulated signal.

adaptation Adjustment of rod and cone sensitivities to deal with different light levels.

additive primaries Three colors of light (generally red, green, and blue) that can be mixed together to obtain any other desired color.

afterimage Image that occurs after a stimulus is removed. Afterimages may be either positive (same color) or negative (complementary color).

ambiguous figure A picture that may be interpreted in two or more equally valid ways.

amplitude Maximum displacement from equilibrium in a wave.

amplitude hologram A hologram that modulates the reference beam through absorption.

analyzer A polarizer used to analyze polarized light or the second of two polarizers used to control the intensity of transmitted light.

anamorphosis (anamorphic art) Artistic use of distorted images that require special mirrors to make them intelligible.

antinode Point of maximum amplitude due to constructive interference.

aperture stop (iris) A device that varies the size of the lens opening.

astigmatism An aberration in a lens or mirror that causes the image of a point to spread out into a line.

© Springer Nature Switzerland AG 2019
T. D. Rossing and C. J. Chiaverina, *Light Science*,
https://doi.org/10.1007/978-3-030-27103-9

binary notation Representation of numbers by 0s and 1s.

birefringence Splitting of light into two rays by anisotropic materials having two indices of refraction. Double refraction.

bit Binary digit.

blackbody An ideal absorber and emitter of light.

bleaching Dissolving silver particles to make the emulsion more transparent and the reconstructed image brighter. Bleaching changes an amplitude hologram into a phase hologram.

Bohr model Model of the atom in which electrons move in stable orbits around the nucleus.

Bragg reflection Strong reflection at certain angles by diffraction of light from planes of recorded fringes. Bragg's law shows how the angle depends upon the spacing of the planes and the wavelength of the light.

Brewster's angle Angle of incidence (or reflection) for which the reflected light is totally polarized.

brightness Sensation of overall light intensity, ranging from dark, through dim, to bright.

byte A group of eight bits.

camera obscura An early type of pinhole camera.

central processing unit (CPU) The section of a computer that integrates and coordinates overall operation.

chlorophyll The material in leaves that strongly reflects green light.

chroma Color intensity; a term used by artists to mean something similar to saturation.

chromatic lateral inhibition Ability of one part of the retina to inhibit color perception at another part.

chromaticity diagram A diagram on which any point represents the relative amount of each primary color needed to match any part of the spectrum.

cognitive illusion A visual illusion that arises from information-processing mechanisms within the brain.

coherent light Light in which all photons have the same phase and wavelength (such as laser light).

color constancy Objects tend to retain the same perceived color even though the coloration of the illumination may change.

color negative film Film that produces a negative image in complementary colors.

color reversal film Film that is exposed to light during development in order to produce a transparency (slide) with true colors.

color temperature The temperature of the blackbody with the closest spectral energy distribution to a given light source.

color tree A diagram whose vertical axis represents lightness, the distance from the axis represents saturation, and the angle represents hue.

compact disc (CD) Optical storage device that uses a laser to write and read data stored as small pits on a reflecting surface.

compact disc read-only memory (CD-ROM) A disc that stores data in optical form to be read by a laser.

complementary colors (of light) Two colors that produce white light when added together.

complementary colors (of pigment) Two colors that produce black when added together.

computer-aided design (CAD) Using a computer to draw graphs and pictures.

computer-aided manufacturing (CAM) Using a computer to control machines.

concave surface A surface curved like the inside of a ball.

cone Photoreceptor that is sensitive to high light levels and differentiates between colors.

converging lens Lens that is thicker in the center; it causes parallel rays to converge and cross at the focus.

convex surface A surface curved like the outside of a ball.

critical angle The maximum angle of incidence for which a ray will pass from a slow medium (such as glass) to a faster medium (such as air); the minimum angle of incidence for which total internal reflection will occur.

daguerreotype Permanent image on a light-sensitive plate using a process invented by Louis Daguerre.

Denisyuk hologram A reflection hologram in which a single beam serves as both reference beam and object beam by passing through the emulsion twice.

depth of field Range of distance over which objects are in focus in a photograph.

dichroic Materials that absorb light whose E-field vibrations are in a certain direction.

diffraction The spreading of waves when they pass through an opening or around a barrier.

diffuse reflection Reflection of rays from a rough surface. The reflected rays scatter and no image is formed.

digital versatile disc (DVD) Optical disc capable of storing full-length movies.

diode laser Semiconductor junction diode that produces coherent light.

dispersion Variation in the speed of a wave with frequency (or wavelength). The spreading of light into a spectrum of different colors.

distortion illusion A visual illusion in which lines or figures appear distorted due to context.

diverging lens Lens that is thinner at the center; it causes parallel rays to diverge and appear as if they came from the focus.

Doppler effect Change in the frequency of waves due to motion of the source, the observer, or both.

dye A solution of molecules that selectively absorbs light of different colors.

dye coupling process Chemical process for producing a dye image during color development.

dye transfer process Photographic process that depends on absorption of dyes by chemically hardened gelatin in three separate emulsions.

efficacy Measure of the power efficiency (lumens per watt) of a light source.

electron volt Unit of energy equal to the energy that an electron would acquire traveling from the negative to positive terminal of a 1-V battery.

emissivity Ratio of the radiant energy from a nonideal surface to that of a blackbody at the same temperature.

figure-ground illusion An illusion in which two aspects of a drawing, both of equal stature, vie for attention.

film speed Measure of how fast an image can be recorded.

fixing bath, fixer Solution that dissolves undeveloped silver halides in an emulsion.

fluorescence Absorption of light and subsequent reemission at a longer wavelength.

focal length Distance from a lens (mirror) to its principal focus.

focus (focal point) A point at which incident rays parallel to the axis of a mirror will cross after reflection.

fovea Area at the center of the retina that consists almost entirely of cones.

fractals Shapes or patterns made of parts similar to the whole in some way (i.e., which demonstrate self-similarity under a change in scale such as magnification).

frequency Number of waves per second.

f-stop number Focal length divided by lens diameter.

glaze A thin layer of glass covering the surface of pottery.

halftone process Printing with black dots of various sizes to represent shades of gray.

half-wave plate Birefringent material of the right thickness to retard one ray 180° with respect to the other so that the plane of polarization is rotated.

hertz Unit of frequency; equals one wave per second.

hologram A recording of interference fringes from which a three-dimensional image can be reconstructed.

holographic interferogram A holographic recording using two or more images to show motion or some other time-dependent phenomenon.

hue Color name (e.g., red, yellow, green) that distinguishes one color from another.

hyperopic Farsighted. The eye forms images of near objects beyond the retina.

illuminance Measure of the light intensity striking a surface in lumens/m^2 (lux).

image Replica of an object formed by a mirror (or lens).

impossible figure Figures that lack internal consistency and do not represent actual physical objects.

index of refraction Ratio of the speed of light in air to the speed in the medium.

infrared waves (radiation) Invisible electromagnetic radiation with wavelength slightly longer than red light; radiant heat waves.

interference Superposition of two or more waves; the superposition of two identical waves to create maxima and minima. Constructive interference occurs when the waves are in phase and therefore combine to form a larger wave; destructive interference occurs when the waves are out of phase and partially (or fully) cancel each other.

irradiance Measure of the radiation intensity on a surface.

joule Unit of energy in SI system.

kaleidoscope A device that uses two or more mirrors to form symmetrical, colorful images.

kelvin One degree on the absolute temperature scale.

kilobyte (KB) 1024 bytes.

lake Coloring agent consisting of alumina particles covered with dye.

laser Coherent monochromatic light source that utilizes the stimulated emission of radiation.

law of reflection The angle of incidence equals the angle of reflection. Ordinarily, both angles are measured from the normal (perpendicular) to the surface.

lens An optical device that can form images by refracting light rays.

light-emitting diode (LED) A very efficient semiconductor light source used especially in outdoor displays, radios, TVs, home appliances, and automobile tail lights. Semiconductor junction diode that emits light of a particular color when excited by an electric current.

light ray Line that represents the path of light in a given direction.

linear superposition The resultant displacement of two waves at a point is the sum of the displacements that the two waves would separately produce at that point.

lumen Unit for measuring luminous flux or output of light sources.

luminance Term used in the Ostwald color classification system; similar to brightness.

luminescence Absorption of energy and emission of light; includes fluorescence and phosphorescence.

luminous flux Radiant flux scaled according to the sensitivity of the eye at each wavelength.

magneto-optical (MO) disc Stores data that can be read out using the Kerr magneto-optical effect.

magneto-optical Kerr effect Rotation of the plane of polarization when reflected by a magnetic surface. Direction of rotation depends on direction of magnetization.

Malus' law Intensity of polarized light transmitted through an analyzer is the incident intensity times $\cos^2 \theta$, where θ is the angle between the axes of the polarizer and analyzer.

megabyte (MB) 1,048,576 bytes.

Michelson interferometer An instrument that splits a light beam with a half-silvered mirror and creates an interference pattern between the two beams when they recombine after traveling two different paths.

microscope An optical instrument that enlarges tiny objects to make them visible.

MiniDisc (MD) Miniature compact disc for recording digital audio.

mirage An optical effect that produces an image in an unusual place due to refraction. Typically, the image appears as if it had been reflected from a water surface.

monochromatic filter Filter that allows only one wavelength (color) to pass through.

monocular cues Visual information that allows a person with one eye to perceive depth. Artists frequently use monocular cues to convey depth in drawing or painting.

Munsell color system A color system using 10 basic hues, each of which has 10 gradations. Chroma scales are of different lengths, depending on the particular hue and value.

myopic Nearsighted. The eye forms images of distant objects in front of the retina.

neutral density filter Gray filter that reduces the intensity of light without changing its spectral distribution (color).

Newton's color circle Three primary colors arranged around a circle with the complementary secondary colors directly opposite.

Newton's rings An interference pattern of concentric circles formed by multiple reflections between a flat glass surface and a convex surface.

Nicol prism A calcite prism used to produce or analyze polarized light. Two halves of a calcite crystal are cemented together with Canada balsam.

node Point of minimum amplitude due to destructive interference of two waves.

object beam Portion of the laser beam that illuminates the object.

opponent-process theory Receptors transmit information about color pairs (blue-yellow, green-red, or black-white) by increasing or decreasing neural activity.

optical activity Rotation of the plane of polarization of transmitted light (clockwise in some materials, counterclockwise in others).

optical fiber A tiny glass pipe from which total internal reflection prevents the escape of light; glass fiber capable of transmitting data optically.

orthoscopic image A holographic image that has normal front to back perspective.

Ostwald color system. A color system that uses the variables of dominant wavelength, purity, and luminance. Colors are arranged so that hues of maximum purity form an equatorial circle with complementary colors opposite.

paint pigments Color-absorbing powders suspended in a medium such as oil or acrylic.

parity Behavior of physical laws under the inversion operation.

particle model of light Light consists of photons or particles having energy hf.

partitive mixing Additive color mixing by placing separate sources very close to each other.

penumbra Partial shadow created by blocking out only a portion of the light source.

periodic Repeats in a given interval of time or space (called the period).

phase hologram A transparent hologram in which the fringes modulate the phase of the reference beam during image reconstruction.

phosphorescence Absorption of light and delayed emission at longer wavelength.

photodiode Semiconductor junction that conducts electricity when illuminated by light. Used to detect reflected signals from an optical storage disc.

photoelasticity Some materials become birefringent under stress.

photometer Illuminance meter used by photographers, illumination engineers, and others.

photometry Measurement of energy content in the visible portion of the electromagnetic spectrum.

photon Particle of light (or other electromagnetic radiation) having an energy hc/λ, where $h = 6.63 \times 10^{-34}$ J s is Planck's constant, $c = 3 \times 10^{8}$ m/s is the speed of light, and λ is the wavelength.

photonics Combines optics and electronics. Also called opto-electronics.

photopic Conditions of high light level under which cone vision predominates.

photorefractive Materials in which the index of refraction can be changed by light. Such materials can be used to store data optically.

photosynthesis Chemical process by which plants produce sugar from water and carbon dioxide by using sunlight.

physical illusion A visual illusion that results from physical phenomena outside the body.

physiological illusion A visual illusion that is caused by the functioning of our visual sensory apparatus.

pinhole camera Box with a pinhole capable of making a dim inverted image on a photographic film or screen.

plane of incidence Plane that includes the incident ray and the normal (perpendicular) to the surface.

plane polarized waves Transverse waves (such as light) with vibrations oriented in one plane.

pointillism A technique used by painters to create colors by partitive (additive) mixing of small dots of paint.

polarizer Used to polarize light, or the first of two polarizing filters used to control light intensity.

Polaroid Synthetic polarizing material developed by Edwin Land that consists of long chains of molecules that absorb light polarized in a certain plane.

population inversion A condition in which more atoms are in the higher energy state than in the lower one (a non-equilibrium condition).

primary colors (additive, of light) Three colors that can produce white light.

primary colors (subtractive, of filters or pigments) Three colors that can produce black.

pseudocolor hologram A hologram in which the emulsion thickness is varied to produce colors different from the light used to record it.

pseudoscopic image An image that is reversed front to back.

purity A term used in the Munsell color system; similar to saturation.

Purkinje shift At high light levels a red object may appear brighter than a blue object, but at low light levels the same blue object may appear brighter than the red one.

quarter-wave plate Birefringent material of the right thickness to retard the phase of one ray by 90° with respect to the other so that plane polarized light is changed to elliptical and vice versa.

radiant flux Amount of radiation that is emitted or received by an object each second.

radiometry Measurement of radiant energy of electromagnetic radiation.

rainbow Display of colors due to refraction in raindrops or other droplets of water.

rainbow hologram A hologram whose image changes color as the viewpoint is moved up and down.

Rayleigh scattering Atmospheric scattering of sunlight by small particles, which depends on the size of the scattering molecules and the wavelength of the light.

real image An image created by a concentration of rays that can be projected onto a screen.

real-time holographic interferometry Creating an interference pattern between an object and its hologram in order to see how much the object has moved or changed.

reduced instruction set computer (RISC) Computer design that reduces the number of instructions necessary to perform operations.

reference beam Portion of the laser beam that goes directly to the film or camera.

reflection Change of direction (with reversal of the normal component) at a surface operation that corresponds to viewing an object in a mirror.

reflection hologram A hologram that can be viewed from the front as if it were a painting.

refraction Bending that occurs when rays pass between two media with different speeds of light.

resolution, limit of The ability to separate the images of two objects that are very close to each other. The images can no longer be resolved when their diffraction patterns overlap.

retina The light-sensitive screen in the eye on which images are formed.

retinex theory Theory originated by Edwin Land; receptors in three retinex systems are sensitive to long-, medium-, and short-wavelength light.

rhodopsin Photosensitive material in rods and cones.

rod Photoreceptor that is sensitive to low light levels but does not differentiate colors.

rods and cones Light-sensing elements on the retina.

saturation Purity of a color; spectral colors have the greatest saturation; white light is unsaturated (similar to "chroma" or "color intensity").

scotopic Conditions of low light level under which rod vision predominates.

single-lens reflex (SLR) camera A camera in which focusing and composition can be done while sighting through the lens.

Snell's law A mathematical relationship between the angle of incidence, the angle of refraction (transmission), and the index (indices) of refraction.

software The sets of instructions, codes, operating systems, and languages that enable a computer to perform its functions.

spectral filter Filter that passes a distribution of wavelengths of light.

spectral power distribution (SPD) Power of light as a function of wavelength.

spectral reflectance curve A graph indicating the portion of light reflected at each wavelength.

spectroscope Instrument that measures the power (in watts) of light at each wavelength.

specular reflection Reflection from a polished surface in which parallel rays remain parallel.

standing wave An interference pattern formed by two waves of the same frequency moving in opposite directions; the pattern has alternative minima (nodes) and maxima (antinodes).

stimulated emission of radiation A photon triggers an atom to emit a photon of the same wavelength (as in a laser).

stop bath Weak acid solution used to halt development prior to fixing.

subtractive primaries Three colors of filters or pigments that can be combined to produce other colors (including black) by absorption; examples are yellow, magenta, and cyan or red, yellow, and blue.

telephoto lens Lens with long focal length used to create a larger than normal image.

telescope Optical device for viewing and enlarging distant objects.

time-average interferogram Combining many holograms in the same image; in the case of a vibrating object, the nodes appear as bright lines and fringes of equal amplitude occur in the antinodal regions.

total internal reflection Total reflection of light when it is incident at a large angle on an interface between a slow material (such as glass) and a faster material (such as air).

transfer hologram Hologram that uses the real image from another hologram as its object.

transmission hologram A hologram that is viewed by illuminating it from behind with monochromatic light.

trichromatic theory A color theory based on three different kinds of receptors each with its own frequency response.

TV hologram A hologram that is created by electronically comparing the reference beam and the object beam.

umbra Dense inner portion of a shadow where partial shadows overlap.

value A term meaning brightness.

virtual image An image created by the apparent intersection of reflected or refracted light rays. A virtual image cannot be projected onto a screen.

visual disparity Two different views of the same scene resulting from binocular vision.

visual illusion A situation in which visual perception leads to incorrect interpretation of reality.

watt Unit of power in SI system.

wavelength Distance between successive waves; the wavelength of light generally determines its color.

wave model of light Light consists of electromagnetic waves.

wave plate or retarder A thin plate of a birefringent material with the optic axis parallel to the surface so that it transmits waves having their E-fields parallel and perpendicular to the optic axis at different speeds.

wide-angle lens Lens with short focal length used to expand the field of view.

xerography Printing process that uses an electrically charged photoconductive drum on which the latent image is developed by using a powder called toner.

zoom lens Lens with variable focal length.

Appendix G
Materials in Paintings

Through the ages, master painters have worked with a variety of materials. Some readers of this book would have already studied the techniques of painting and will be quite familiar with them. Others, however, who are using this text to gain an understanding of light and color, or to enhance their appreciation of the visual arts, may appreciate a brief discussion of materials in paintings.

Traditional paints consist of pigments plus a suitable binder. Encaustic paintings combine pigment with wax, fresco paintings combine pigment in aqueous solution with plaster, tempera paintings combine pigment with egg yolk, pastel paintings combine dry pigment with a weak solution of gum Arabic, watercolor paintings combine pigment with an aqueous solution of gum Arabic, and oil paintings combine pigments with oil. The pigment may be ground finer or coarser in one type of paint or another.

Painters over the centuries have been very attentive to the demands of particular materials. The composition of their paintings has often been adapted to best accommodate the materials used. Sometimes paintings incorporate more than one binder because the artist wishes to use different pigments, some of which are compatible with one binder but not with others. Painters often select materials to give a desired texture to their paintings. Most serious painters have carefully studied the works of the great masters and understand the materials they used. However, artists also experiment with new materials and develop new techniques to incorporate them.

In the twentieth century, science has given painters a number of new materials with which to work. Among them are polymer colors, acrylic colors, synthetic organic pigments, and luminescent pigments. Synthetic media have a number of advantages over traditional materials: they can be less expensive, they are fast drying, they are long lasting, they can be built up to greater thickness, they adhere to a wide variety of surfaces, and coloring agents other than pigments can be used with them. Although adopting new materials always calls for the painter to learn new skills, the new synthetic materials have probably made the techniques of painting easier for future artists.

© Springer Nature Switzerland AG 2019
T. D. Rossing and C. J. Chiaverina, *Light Science*,
https://doi.org/10.1007/978-3-030-27103-9

G.1 Traditional Media

Encaustic paintings are made of pigments suspended in melted beeswax. The technique is ancient. The Egyptians made frequent use of encaustic techniques in painting portraits of the deceased to be entombed with the mummified remains. Inscriptions on Doric temple façades testify to its early use, and Roman columns were also painted using encaustic techniques, sometimes to produce backgrounds for sculptured figures or ornamental decorations. To paint with hot beeswax, tablets of pigment are melted along with the wax and applied to the painting surface with heated brushes or spatulas. After the initial applications, the colors are often blended with heated spatulas and "burned in" by holding a hot iron nearby (today's artists use heat guns or heat lamps for this purpose); in fact, the term *encaustic* refers to the process of burning in.

Fresco paintings are made by painting on damp plaster with pigments suspended in water (hence the term *fresco* or "fresh" in Italian). The water evaporates as the lime in the plaster absorbs carbonic acid gas from the air. The particles of pigment are pulled into the surface of the plaster and locked in place by particles of calcium hydroxide that convert to calcium carbonate as the plaster dries. A glassy skin of crystalline carbonate of lime forms on the surface, resisting moisture and giving the fresco a characteristic sheen.

Fresco is also an ancient technique, going back to Roman times and to the Minoan period in Crete, although it made its greatest impact during the Italian Renaissance. Fresco is particularly appropriate for large-scale works meant to be assimilated into an architectural space. The murals of Pompeii, Giotto's great murals, Leonardo's *Last Supper*, and Michelangelo's Sistine Chapel murals all testify to the greatness of the fresco medium. Diego Rivera is among artists making good use of this technique in the twentieth century.

Tempera refers to paint containing a binder of egg yolk. Its vehicle is water, which evaporates during drying. The special character of egg tempera results from the fact that it is an emulsion, an emulsion being a mixture that combines fatty, oily, resinous, or waxy ingredients with a watery liquid. Tempera produces a durable but somewhat brittle paint film. It is usually applied to a rigid wooden panel that has been coated with *gesso*, a mixture of animal glue, water, chalk, and sometimes a white pigment. Using a rigid panel prevents the brittle paint film from cracking or flaking.

Pastel paintings are made by drawing with pigments bound together by a gum solution or other weak binder. The Impressionists Renoir, Degas, Toulouse-Lautrec, and Manet are among the most famous masters of the pastel medium. In spite of the lack of a binder, pastel is a remarkably permanent medium. Degas and others used pastel in association with oil and tempera media, while some contemporary artists are experimenting with pastel in combination with a synthetic tempera. Pastel colors reflect only surface light; glazing is impractical.

Watercolor paintings are made by painting on a white surface with finely ground pigments suspended in an aqueous solution of gum arabic. Although Chinese, Korean, and Japanese painters have used watercolor techniques for ages, American

watercolorists, such as Winslow Homer, were the first to use a full range of color. Watercolors lack durability and thus are nearly always protected by glass.

Gouache is similar to watercolor painting except that opaque rather than transparent colors are used. Gouache generally does not require the extremely fine grinding of pigment particles that watercolors do.

Oil paint, long considered to be the most versatile painting medium, contains a binder of oil or oil mixed with varnish and turpentine. Typically, linseed oil is used, although oils from other plants such as poppies or walnuts have been used. A variety of materials have been used for oil paintings, but canvas and wood panels are generally preferred. Oil paint is relatively slow in drying (usually taking at least a day to dry to the touch and sometimes years to dry completely), which can be an advantage as well as a disadvantage to the painter. Color mixing and texture can be produced by mixing one color into another before the paint dries. Additives may be used to either accelerate or retard drying or to change surface reflectivity (giving a gloss or matte appearance).

Oil paint, which became popular in the seventeenth century, offers several advantages over other media. It is durable and water-resistant. Oil colors change very little on drying, which cannot be said of most other media. Because of the flexibility of the oil paint film, large paintings can be rolled up for transporting. On the other hand, the oil medium tends to darken or yellow with age.

G.2 Pigments

A pigment is a finely divided, colored substance that imparts its color effect to another material either when mixed with it or when applied over its surface in a thin layer. When a pigment is mixed in a liquid vehicle to form a paint, it does not dissolve but remains dispersed or suspended in the liquid. (Colored substances that dissolve in liquids and impart their color to materials by staining are classified as dyes; see Sect. 8.4.)

Pigments may be classified according to color, use, permanence, or origin. One classification according to origin is as follows (Mayer 1981):

A. Inorganic (mineral)

 1. Native earths: ochre, raw umber, etc.
 2. Calcined native earths: burnt umber, burnt sienna, etc.
 3. Artificially prepared mineral colors: cadmium yellow, zinc oxide, etc.

B. Organic

 1. Vegetable: gamboge, indigo, madder, etc.
 2. Animal: cochineal, Indian yellow, etc.
 3. Synthetic organic pigments.

The native earths used as pigments occur all over the world, but there is always some special locality where each is found in particularly pure or desirable form. The chemical nature of pigments varies greatly. Some are simple, almost pure compounds; others contain minor components that are natural impurities or added during manufacture. Pigments may be named for their resemblance to natural objects, for their inventors, their places of origin, or for their chemical composition. Mayer (1981) lists pigments by name, by color, and by the media in which they are best used. His catalog is extensive!

Many synthetic organic pigments have been developed in recent years. Many of them are brilliant and most of them are quite transparent, but they tend to have varying degrees of resistance to fading, especially in bright sunlight. For this reason, many artists have been fairly cautious in adding synthetic organic pigments to their pallettes.

Luminescent pigments are of two types: *phosphorescent* materials that store energy when exposed to light so that they can glow in the dark and *fluorescent* materials that absorb light (or ultraviolet radiation) and reradiate it at a longer wavelength (see Sect. 7.6). Both types of luminescent pigments are sometimes referred to as *phosphors*. Fluorescent paints and inks are used to produce blacklight posters that glow under ultraviolet radiation (blacklight).

Daylight fluorescent paints, produced from certain synthetic organic pigments, have such intense luminosity that they exhibit a glowing or fluorescent effect in daylight. Sold under such trade names as Dayglo and Radiant, they have become very popular in decorative arts. Like many synthetic organic pigments, they are not considered permanent enough for archival painting. For full intensity, they should be applied to a highly reflective ground.

G.3 Synthetic Painting Media

Although the terms *plastic* and *synthetic resin* are sometimes used interchangeably, not all plastics are synthetic resins. Some natural substances, such as esters and ethers of cellulose, are classed as plastics, although they are not synthetic materials. On the other hand, synthetic resins used in paints are not generally referred to as plastics. Most synthetics of use to painters are organic polymers; they are composed of large molecules formed from smaller organic molecules or monomers. Polyvinyl acetate, polyvinyl chloride resin, the epoxies, and the acrylic resins are examples of useful synthetics. The paints derived from the acrylic resins are probably the most widely used synthetic painting media.

Acrylic resins were first made by Otto Röhm in Germany in 1901; they have been produced commercially in the United States by Röhm & Hass and by E. I. duPont de Nemours since the 1930s. In solid form, they are marketed under the trade names of Plexiglas and Lucite, respectively. These materials, dissolved in toluene or xylene, can be mixed with linseed oil or turpentine. (This presents a

hazard, however, since an acylic resin painting can be severely damaged by attempts to clean it with turpentine.)

Vinyl resins are polymers of vinyl acetate, vinyl chloride, and vinylidine chloride. Polyvinyl acetate has been used for the repair and restoration of museum objects, but vinyl resins have few applications in paintings since they are not soluble in convenient, safe solvents. The same is true of polyster resins.

Alkyd resins are synthesized by reactions between alcohols and acids. Oil-modified alkyd resins have enjoyed a high reputation in the industrial paint field. House paints made with alkyds outlast and outperform most other paints. They are faster drying than oil paints, which offers both advantages and disadvantages to painters.

Pyroxylin is a synthetic medium or lacquer sold commercially under the trade name of Duco. Jackson Pollack used pyroxylin in some of his large, tapestry-like canvases. Pyroxylin, which works especially well with dry pigments, can be purchased in several different viscosities. The durability of pyroxylin lacquers is questionable, although it can be improved by adding alkyd acrylic resins.

The term *polymer color* is often used to describe paint made by dispersing pigment in an acrylic emulsion. These colors are thinned with water, but when they dry, the resin particles coalesce to form a tough, flexible film that is impervious to water. Polymer colors can be made matte, semimatte, or glossy by mixing them with the appropriate media, and they are flexible enough to be used on canvas. Because the thinning solvent is water, they are nontoxic. Most important, they are fast drying.

Reference

Mayer, R. (1981). *The Artist's Handbook of Materials and Techniques*, 4th ed. New York: Viking Press.

Appendix H
Analysis of Art Using Physics and Chemistry

To learn about ancient materials such as pigments and media, art historians have two alternatives: the literature of the time and analysis of the art objects themselves. However, ancient writings are sometimes confusing, and errors have been made in translating them. Therefore, the preferred method for research is analysis of the objects themselves.

Methods of analysis can be physical, chemical, or both. If flecks of paint or scrapings are available, microchemical analysis and normal spectroscopic methods can be employed. Other spectroscopic techniques can be employed without disturbing the painting. In addition to the size of the available sample, another consideration that affects the choice of analytical procedure is the structure of the paint. Some paintings have many layers of paint, while others are mainly a single layer.

The ideal way to analyze a painting, especially one with several layers of paint, would be to study a cross-section. Analyses of cross-sections are often carried out using biological stains, which react specifically with certain classes of organic compounds. Some can be observed with visible light using a microscope, while others produce fluorescence in ultraviolet light. Stains provide general information on certain classes of material (such as proteins and lipids) but rarely give a specific identification (Newman 1996).

Infrared microspectrometry is the other major approach to characterization of media in cross-sections of paintings. The resolution of infrared microscope systems is about 10 μm, and it is best carried out on very thin sections that can be obtained by microtoming, a technique used in biology laboratories to prepare thin sections of biological specimens.

Paint scrapings or fragments can be analyzed by techniques involving *pyrolysis*, the controlled heating of samples in an inert environment, leading to the fragmentation of the organic binder. Pyrolysis is usually linked to a mass spectrometer or to a gas chromatograph to analyze the fragments. Pyrolysis procedures generally give information on the entire range of organic materials present in a sample (Newman 1996).

© Springer Nature Switzerland AG 2019
T. D. Rossing and C. J. Chiaverina, *Light Science*,
https://doi.org/10.1007/978-3-030-27103-9

Oil paintings have been more extensively analyzed than other media, which is not surprising since this has been the principal medium of Western art for several centuries. One question of interest is the type of oils that were used during various periods in history. The ratio of palmitic to stearic acid varies in different oils such as linseed oil and walnut oil. A study of Italian paintings at the National Gallery in London, for example, showed that early painters probably used more walnut oil, which is known to resist yellowing.

Some natural binders contain small amounts of unique materials that can be used to identify them. Cholesterol, found in egg yolk but absent from most other binders, is detectable by fluorescence. Plant gums, the major type of carbohydrate-based binder, are polymers that can be analyzed by pyrolysis, while sugar acids can be identified by thin-layer chromatography (Newman 1996).

Various analytical methods are widely used by art historians and conservators to determine the exact composition of metal art objects, such as ancient bronzes. In *neutron activation analysis*, small samples of the material are placed in a nuclear reactor and irradiated with neutrons. Relative concentrations of the principal elements as well as trace impurities can be determined by standard nuclear spectroscopic means, such as using a semiconductor detector and pulse-height analyzer to determine the energy of radioactive emissions from the irradiated sample. *Atomic absorption spectrophotometry* is another standard analysis technique for determining elemental composition of small samples by measuring the absorption of light and other radiation.

Paintings and other art objects are frequently X-rayed to determine their structure and especially any repairs or alterations made in the past. Of course, we have all read about valuable old paintings that have were painted over at a later date. *X-ray spectroscopy* is an especially attractive analytical technique, since it is totally nondestructive in that it does not require sampling the material.

Reference

Newman, R. (1996). Binders in paintings. *MRS Bulletin* 21(12), 24–31.

Appendix I
Conservation and Restoration of Art

The American Institute for Conservation of Historic and Artistic Works (AIC) defines *conservation* as "the profession devoted to the preservation of cultural property for the future." Conservation activities include examination, documentation, treatment, and preventive care. Treatment includes both stabilization (to minimize further deterioration) and restoration.

Although many professionals use the term *restoration* to refer only to the replacement of missing portions by faithfully imitating the original, the general art public is more likely to use the term to include other aspects of conservation, such as cleaning, as well.

It is obvious that conservation and restoration begin with thorough analysis of the painting or other art object. The original materials must be thoroughly understood, and this requires all available means of analysis and considerable training and skill on the part of the conservator. A conservator must be both a scientist and an artist.

I.1 Metal Corrosion and Embrittlement

Museums often must deal with corrosion and embrittlement of metal objects. Lead, for example, corrodes by the formation of lead carbonate. Under exceptional circumstances, this material forms a thin continuous layer that protects the lead and does not need to be removed; more often the white deposit forms as a bulky discontinuous nonprotective layer. The corrosion can be removed by electrochemical or electrolytic reduction, treatment with acids, or the use of ion-exchange resins.

One method for removing corrosion from a lead object is to make it the cathode in a 10% solution of sulfuric acid having an anode of lead, stainless steel, or platinized titanium. When reduction is complete and the object has been cleaned with a brush, the current is reversed for a short time so that a thin protective film of lead peroxide forms on the surface.

© Springer Nature Switzerland AG 2019
T. D. Rossing and C. J. Chiaverina, *Light Science*,
https://doi.org/10.1007/978-3-030-27103-9

Bronze, an alloy of copper and tin, is very durable, and many bronze objects are over 5,000 years old. Bronze casting was developed to a very fine art in ancient China. The finer specimens of bronze exhibit a patina with an inner film of copper oxide and an outer film of carbonate, which account for its characteristic blue-green color. This patina protects the bronze from further corrosion.

Silver objects that have been buried in the ground become very brittle. Embrittlement may be due to three different causes: intercrystalline corrosion, age or precipitation hardening, or growth of large grains (crystals). It is necessary to restore ductility to the silver before attempting to reshape objects that may have been crushed during burial. Before deciding on the method for restoring ductility, a metallographic examination of the metal should determine the precise cause of the brittle condition.

I.2 Paintings

Most ancient paintings show some degree of deterioration. One of the most powerful enemies of oil paintings is water, including water vapor or moisture in the air. Canvas is often sized with glue before an oil ground is applied. If moisture seeps into this thin layer of glue from the back, the picture may detach itself from the canvas. Water seeping through cracks and fissures on the face of a painting may produce the same effect. Thus, it is inadvisable to clean old paintings with water or mixtures containing water. When a conservator finds it necessary to use water, it must be applied sparingly and the painting thoroughly dried.

Many paintings are protected by varnish, and sometimes old varnish turns brown or yellow or becomes encrusted with dirt. In this case, the conservator may remove the varnish by dissolving it and washing it away, an operation that is called *stripping*. The standard method of removing varnish from a painting is to apply the proper solvent by means of soft wads of absorbent cotton. Rarely is the painting denuded of every trace of its protective coating, a condition conservators refer to as *skinned*. Instead, a minute film of the original varnish, made uniform and dilute by the solvent, is left. Obviously, the solvent must be selected with great care after carefully studying the structure and composition of the painting.

Areas of paint composed of lead pigments that have been darkened by the sulphur fumes in a polluted atmosphere can usually be restored to their original color by the application of hydrogen peroxide. This treatment has been known since the early nineteenth century. Smoke and soot can sometimes be removed with swabs dampened with water. Some cracked, deadlooking, or otherwise deteriorated varnish films can be regenerated by exposing them to alcohol vapor (often referred to as the *Pettenkoffer method*), which causes the surface film to coalesce (Mayer 1981).

In some cases, it is safer to remove old varnish with a knife or scalpel than to use solvents. This is especially so when it is necessary to remove heavy oil or tempera repaints from a delicate surface. Obviously, considerable experience and skill are

necessary to remove varnish by scraping, but it is often less risky than using a solvent. Provided a painting can withstand a cautious application of water, mold may be removed by rubbing its surface with absorbent cotton moistened with a 10% solution of magnesium fluosilicate and rinsing with distilled water. Mold, which is a kind of fungus, can be prevented and stopped by sunlight.

Small punctures and larger tears may be repaired by applying patches behind them, provided the painting is otherwise in good condition. The adhesive used is generally either wax-resin or aqueous glue. When injuries or decay have occurred to such an extent that patching will not rectify the damage, the painting may be lined with new canvas, a delicate and painstaking process (see Mayer 1981).

I.3 Should the "Mona Lisa" Be Restored?

Although the protective varnish has yellowed over the centuries, Leonardo da Vinci's *Mona Lisa* remains one of the world's most cherished paintings and the Louvre's top attraction. Some art experts say the painting should be cleaned, but officials at the Louvre say "hands off."

The magazine *Journal des Artes* applied computer imaging technology to demonstrate how the Mona Lisa may have appeared when Leonardo painted her in 1503: rosy cheeks instead of yellow pallor, pale blue skies instead of the famed sunset glow. Restoring the famous painting would be very difficult. The resin, lacquer, and varnish layered on the painting at different times during the last 495 years would require different solvents for removal, which could cause irreparable damage to the masterpiece. The last touch-up of the painting occurred in the mid-1950s, when experts removed several age spots.

Reference

Mayer, R. (1981). *The Artist's Handbook of Materials and Techniques*. New York: Viking Press, Chapter 14.

Appendix J
Laboratory Experiments

• Experiment 2.1
Waves on a Coiled Spring (Slinky®)

Materials: Coiled spring (Slinky®), masking tape, string.

Activity 1. One-Dimensional Transverse Waves

Procedure:

1. Attach small pieces of masking tape at equal intervals along the coiled spring. With the aid of your partner, stretch the spring to a length of approximately 8 m on the floor or a smooth horizontal surface. To prevent possible tangling, be careful not to let go of the spring.
2. Produce a pulse by quickly moving your hand in a back and forth motion parallel to the floor. Sketch the shape of the spring with the pulse on it. Does the spring remain permanently altered by the pulse's transitory presence or does it return to its original position?
3. Describe the motion of the pieces of masking tape when the pulse reaches them. Do the pieces of tape move parallel or perpendicular to the direction of motion of the pulse? Is this pulse transverse or longitudinal?
4. Create a pulse and describe any changes in the shape and amplitude (height) of the pulse as it travels down and back up the spring. What do you think causes these changes?
5. Does the speed of the pulse appear to increase, decrease, or remain the same as the pulse moves along the spring? Suggest a procedure that would enable you to answer this question.
6. Produce two pulses in rapid succession. The second pulse should have a considerably larger amplitude than the first. Does the distance between the pulses change as they travel along the spring? What does this indicate about the relationship between amplitude and wave speed?
7. Send another pulse down the spring and observe what happens when it reaches your partner's hand. Note that the pulse reflects from the fixed end. How does the shape and amplitude of the reflected pulse compare to the incoming pulse?

© Springer Nature Switzerland AG 2019
T. D. Rossing and C. J. Chiaverina, *Light Science*,
https://doi.org/10.1007/978-3-030-27103-9

Does the reflected pulse come back on the same side or opposite side of the spring?

8. Gather up several coils of the spring. This will increase the tension in the spring without altering its length. Send a pulse down the spring. How does increasing the tension seem to affect the speed of the pulse? Do springs under different tensions behave like different media? Is any other property of the spring being altered when coils are gathered up? If there is, how should this change affect the speed of the wave?

9. You have seen how a pulse reflects from a fixed end. To investigate reflection from a free end, tie approximately 3 m of string to one end of the spring. After establishing tension in the spring, generate a transverse pulse by shaking the end of the spring. Do you observe a reflected pulse? If so, does it return on the same or opposite side of the spring?

10. Instead of sending a single pulse down the spring, produce a continuous train of waves by moving your hand back and forth with a constant frequency. How does the frequency of waves passing any point along the spring compare to the frequency of your hand movement?

11. Send two pulses, one from each end, down the spring. The pulses should be on the same side of the spring—that is, both crests or both troughs. What happens when the pulses meet? Do they bounce off or pass through each other? One way to answer this question is to produce two pulses of markedly different amplitudes. This will enable you to keep track of the pulses before and after they meet. Study the spring's amplitude very carefully at the instant the pulses meet. Describe the amplitude of the spring at that instant. Is it greater than, less than, or the same as that of the individual pulses?

12. Now, with the assistance of your partner, simultaneously send a crest and trough of equal amplitude from each end of the spring. Describe the shape of the spring when the two pulses meet.

Activity 2. One-Dimensional Longitudinal Wave

Procedure:

1. With your partner holding one end of the coiled spring, stretch it to a length of approximately 8 m.

2. Gather together 10 to 15 coils at one end of the spring. Watch the pieces of tape carefully as you release the coils. Does a disturbance travel down the spring? How do the pieces of tape move relative to the motion of the pulse? That is, do they move perpendicular or parallel to the spring? Is the pulse transverse or longitudinal?

3. Disturb the spring by quickly moving your hand forward. This produces a region of *compression* where the coils are bunched together. Does a pulse of compression travel down the length of the spring? Does this pulse of compression reflect when it reaches the fixed end at your partner's hand?

4. Quickly pull the spring backward. You should observe a region of *rarefaction*—where the coils are spread out—move down the spring. Does the rarefaction reflect at the fixed end?

5. Produce a series of longitudinal waves by moving your hand forward and backward with a constant frequency. Describe the motion of any piece of tape on the spring.

Questions:

1. Distinguish between transverse and longitudinal waves. Give two examples of each.

2. What factor(s) determines the speed of a wave on a spring?

3. What happens when a crest, traveling on a spring, encounters a fixed end? A free end?

4. When two waves meet on a spring, do they "bounce off" or just pass through each other? Cite experimental evidence for your answer.

5. How does the frequency of the waves that pass a particular point on the spring compare to the frequency of the source of the waves?

6. a. Suppose two identical crests meet on a spring. Describe the amplitude of the resultant disturbance at the instant the crests overlap.

 b. Suppose a crest and a trough meet on a spring. Assuming that the two pulses are mirror images of each other, describe the resultant disturbance at the instant the pulses oppose each other on the spring.

• Experiment 2.2
Transverse and Longitudinal Waves in One Dimension

Materials: Elastic cord, electromechanical wave driver, function generator, stroboscope, audio amplifier, long spring, weight hanger, masses.

Activity 1. Pulses on a Cord

Procedure:

Attach one end of the elastic cord to a fixed object (such as a heavy brick or ring stand) and pass the other end over a pulley. Attach a 200-g mass to the end hanging over the pulley; the tension on the cord will equal the force of gravity on this mass (approximately 2 N). Estimate the wave speed by counting the number of times the pulse goes down and back in one second. (A second is roughly the time it takes to say "one thousand one" at conversational speed.) Estimating the speed this way is neither easy nor accurate, so record your "ballpark" figure and proceed to Activity 2 where the wave speed will be determined more accurately.

Activity 2. Standing Waves

Procedure:

Attach the cord to a wave driver and excite the wave driver with sine waves from the function generator. Carefully tune the generator until you see a standing wave pattern on the cord. In how many segments does it vibrate? Each segment is a half-wavelength (why?), so you can determine the wavelength by direct measurement or by dividing the total length of the cord by the number of wavelengths you observe. Use the function generator display to obtain the frequencies at which the cord vibrates transversely in two, three, four, and five segments (half-wavelengths). Determine the wave speed by multiplying each frequency times the corresponding wavelength. Does the speed of transverse waves in the cord depend on frequency?

Change the mass to 100 g and repeat the activity. How much does the wave speed change?

Activity 3. Stroboscopic Viewing of Waves

Adjust the stroboscope to "stop" the waves and note the stroboscope frequency. Change the frequency slightly so that the waves appear in "slow motion."

Activity 4. Longitudinal Waves

Procedure:

Reorient the wave driver so that it transmits longitudinal waves down the cord. Try to determine the frequencies at which the cord vibrates longitudinally in one and two segments. It may help your observation to make a mark on the cord or to attach a tiny piece of tape. How do these frequencies compare to those determined in Activity 2?

Activity 5. Longitudinal Waves on a Long Spring

Procedure:

Replace the elastic cord with the long spring; it will now be much easier to observe standing longitudinal waves. Determine the frequencies at which the cord vibrates longitudinally in one, two, and three segments. Determine the effect of tension on wave speed. Compare the effect of changing the mass load from 200 to 100 g, for example, to what you observed in Activity 3.

• Experiment 2.3
Standing Waves on a Wire

Material: Wire, kilogram masses (8), pulley, large U-shaped magnet, oscilloscope.

Discussion: In this experiment, you will employ an apparatus that is similar to the simple monochord used by Pythagoras (ca. 200 B.C.) to study vibrating strings. To the apparatus of Pythagoras, we add Faraday's invention (1831) which makes it

possible to observe the motion of the string on an oscilloscope (a twentieth-century device not unlike a TV monitor). Faraday's discovery, that a conductor moving in a magnetic field generates electricity, is the basis for every guitar pickup and magnetic phonograph cartridge as well as for large electrical generators in power plants.

Procedure:

a. By means of the pulley, load the wire with about 4 kg. Position the large electromagnet so that it straddles the center of the wire and connect the two ends of the wire to the vertical input of an oscilloscope. Pluck the wire and note the pattern on the oscilloscope. Adjust the SWEEP TIME/CM control and the sweep STABILITY/TRIGGER controls so that you see a convenient number of oscillations on the oscilloscope. Determine the frequency by counting oscillations during a known sweep time on the oscilloscope. [The SWEEP TIME/CM setting indicates how long it takes the electron beam to travel 1 cm; how long does it take to travel across the entire 10 cm? The frequency is the number of oscillations counted divided by the sweep time in seconds.]

Measure the wavelength (twice the distance between nodes) and multiply it times the, frequency to determine the wave speed. Change the mass on the wire in one-kilogram increments and determine the wave speed. The tension on the wire is the mass load times the acceleration due to gravity (actually 9.8 newtons/kilogram, but using 10 newtons/kilogram introduces only a small error). Make a graph of speed versus tension on the wire.

• Experiment 2.4
Waves in Two Dimensions (Ripple Tank)

Discussion: Water is an ideal medium for studying two-dimensional waves. A ripple tank is a container that, when filled with water, permits the study of water waves. A concentrated light source positioned above the tank forms images of the waves on a screen beneath the tank (see Fig. 2.11a). Wave crests and troughs project as bright and dark lines on the screen. In this experiment, a ripple tank will be used to investigate the propagation, reflection, and refraction.

Materials: Ripple tank, light source, rubber hose, dowel rod, several blocks of paraffin, flat plastic plates (rectangular, double convex, and double concave), motorized wave generator.

Activity 1. Propagation

Procedure:

1. Place a large sheet of white paper beneath the ripple tank to serve as a screen. Add water to the tank to a depth of approximately 1 cm. Adjust the legs on the

tank to make the depth of the water as uniform as possible. Turn on the light source above the ripple tank.

2. Gently touch the surface of the water at the center of the tank with your finger. What is the shape of the disturbance produced? Make a sketch showing the wave and its source. On the sketch, draw four equally spaced arrows to indicate the direction of wave motion.

3. What does the shape of the wave tell you about the speed of all points on the disturbance?

4. Produce a straight wave by rolling a dowel rod forward in the tank. Note the image of the pulse on the screen. Make a sketch of this wave with equally spaced arrows to show its direction of motion. In what direction does the wave move, relative to its length?

5. Generate continuous waves by rocking the dowel back and forth steadily. What happens to the wavelength (distance between crests) if you reduce the frequency? Does the speed change as the frequency is changed? What do you predict will be the effect on the wavelength and on the speed of the waves if the frequency is increased?

Activity 2. Reflection

Procedure:

1. Form a straight barrier on one side of the tank using a block of wood or wax blocks. Generate straight waves by rocking the dowel rod back and forth so that their wavefronts are parallel to the barrier. How does the direction of motion of the incoming wavefronts compare with that of the reflected wavefronts? Make a diagram illustrating your observations. Does the speed of the waves change after they have been reflected? How does the reflection process affect the wavelength?

2. Arrange the barrier so that the waves strike it at an angle. How does the angle between incident wavefronts and the barrier compare with the angle between reflected wavefronts and the barrier? To help you judge the angles, align rulers or other straight objects with the wavefront images on the screen below. Make a diagram showing incident and reflected wavefronts and their directions of motion.

3. Produce circular waves by touching the water in front of the barrier with your finger. Draw a sketch of the incident waves emanating from your finger and the reflected waves leaving the barrier. Do the reflected waves appear to be originating from a point source behind the barrier? Using two hands, touch the water simultaneously at points equidistant from, and on opposite sides of, the front of the barrier. Do the waves produced behind the barrier seem to merge with the reflected waves in front of the barrier?

4. The distance from the barrier to the point at which the circular waves originate (the point at which your finger touches the water) could be called the "object distance," while the distance from the barrier to the point from which the

reflected waves appear to come could be called the "image distance." Measure the "object" and "image" distances. How do they compare?

5. Place some rubber tubing in the tank. Bend the tubing into the shape of a parabola. With the dowel rod, generate straight waves toward the open side of the parabola. Do the reflected waves converge to a point? That is, is there a focal point for the concave barrier? Use a sketch to illustrate your observations. Use your finger to disturb the water at the point of convergence. Describe the reflected waves.

6. Touch the water in front of a concave barrier with your finger. Note the point of convergence of the reflected waves. Now move your finger toward the barrier. What happens to the point of convergence? Does it move closer or farther away from the barrier? What changes in the point of convergence occur when you move the source of the circular waves farther away from the barrier?

7. Bend the tubing to reduce its curvature. Use the dowel to generate straight waves directed toward the open side of the parabola. What happens to the point of convergence of reflected waves as the shape of the barrier approaches a straight line?

Activity 3. Refraction

Procedure:

1. Prop up the tank so that the water on one side is roughly 1 mm deep. Send straight waves from the deep end to the shallow end. In what way do the speed and wavelength change as the waves move to the shallow end? Make a sketch illustrating any changes in wavelength. Do different depths of water act as different media for the waves?

2. Level the tank and submerge the rectangular plastic plate beneath the surface of the water. If necessary, add water to ensure that the plastic is completely submerged. Produce straight waves parallel to the long edge of the rectangle and observe the waves as they pass over the rectangle. Describe any changes in speed and wavelength that you observe as the waves pass from deep to shallow and then back to deep water again.

3. Remove the rectangular plate from the ripple tank and replace it with the convex-shaped piece of plastic. Be sure that the plastic is covered with a thin layer of water. Produce straight waves so that they are parallel to a line running down the length of the plate. Observe the passage of straight waves as they move through the region of shallow water defined by the convex plastic plate. Do you observe any focusing effects? Explain your observations.

4. Repeat Step 3, this time with the concave plate.

Questions:

1. What is the direction of motion of a wave crest relative to the crest? (Include a sketch to illustrate your written response.)

2. How does an increase in frequency of the wave source affect the wavelength?

3. How is wave speed affected by a change in frequency?
4. If the water depth decreases, what happens to the wave speed and wavelength?
5. When a straight wave strikes a straight barrier so that its wavefront is parallel to the barrier, in which direction is the wave reflected?
6. When a straight wave strikes a straight barrier at an angle, how do the angles between the barrier and the incident waves and reflected waves compare?
7. How are straight waves reflected from a parabolic reflector?

• Experiment 3.1
Shadows and Light Rays

Materials: LED lightbulb and socket, bare bulb with line filament (showcase bulb), two point sources (automobile headlamp bulbs, single LEDs, or pen lights), balls of various sizes (marble, ping pong ball, tennis ball or baseball, volleyball), cardboard, rectangular object (small box).

Activity 1. How Does Light Leave a Light Bulb?

Three different diagrams below suggest ways in which light rays might leave a lightbulb. Which one of them is most familiar? Which is the most correct? How could you determine which one is most correct?

Activity 2. How Does a Shadow Depend upon the Size and Shape of the Light Source?

Procedure:

Hold the tennis ball (or baseball) between a white screen or wall and (in turn) the point source, the line source, and the frosted lightbulb. Carefully describe the shadow you observe in each case. Try to explain what you observe by drawing ray diagrams for each case (some cases may require both a side view and a top view).

Activity 3. How Does a Shadow Depend upon the Size and Shape of the Object?

Procedure:

Repeat Activity 2 using letters cut from cardboard (see Fig. 3.2b). Carefully describe the shadow in each case.

Activity 4. Structure of a Shadow

Procedure:

Using the lightbulb (or a larger source, if available) as the "sun" and the ping pong ball as the "moon," create an "eclipse" as shown in Fig. 3.3. Move the "moon" closer and farther from the sun, and note the size of the umbra and penumbra. Measure the distance from the sun to moon and from moon to screen (earth) at which the umbra disappears. If the real moon were twice as far from the earth as it is, would we ever see a total eclipse of the sun? Why?

Activity 5. Shadow Prediction

Procedure:

Arrange a point source, rectangular object, and screen as is shown in the figure below. Do not turn on the light.

screen ————————————————————————

rectangular object ▬▬▬▬▬

point source ○

On a separate sheet of paper make a sketch of the above arrangement and show where you think a shadow will be formed. Now turn on the light. Was your prediction confirmed?

What do you think will happen if the point source is replaced with the LED light bulb? Now test your prediction.

Activity 6. Shadows Produced by More than One Source of Light

Procedure:

screen _____

rectangular object ▮▮▮▮▮▮▮

point source 1 ○ point source 2 ○

 Arrange the two point sources, rectangular object, and screen as is shown in the above figure. Do not turn on the lights.

 What do you predict will be seen on the screen when both lights are turned on? On a separate sheet of paper make a sketch of the above arrangement and show where you think shadows will be formed. Label the umbra (if one exists) and the penumbral regions. Now turn on the lights. Was your prediction confirmed?

• Experiment 3.2
Law of Reflection and Plane Mirrors

Materials: Ray box, small plane mirror, protractor, photocopies of the figures shown in the activities.

Procedure:

Activity 1. Images Produced by Plane Mirrors

Place a plane mirror along each mirror line below. The arrow drawn in each case represents an object. For each case (1–6), observe and carefully draw the image produced by the mirror. Answer the questions following each case.

1.

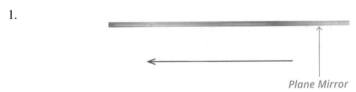

Plane Mirror

 a. Is the image head in the same direction as the object head?

 b. Slide your mirror left and right along the mirror line. Does the image position change when the mirror is moved along the mirror line?

2.

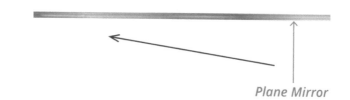

Plane Mirror

Does the image arrow point toward the mirror? Why or why not?

3.

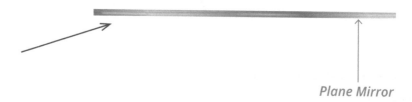

Plane Mirror

Is an image formed in this case? (Don't be too hasty. If your answer is "yes," is the image visible from all viewing angles?) Why or why not?

4.

Plane Mirror

 a. Does the image point away from the mirror?
 b. Is the image perpendicular to the mirror?

5. Reviewing the images found in 1–4, can you state a rule that will enable you to draw the image in a plane mirror without actually using a mirror?

6. Use this rule to construct the image of object ABC in the figure below *without using your mirror*. After constructing the image, check your image by using a mirror. How did you do?

Activity 2. Specular Reflection

Procedure:

1. Use the ray box and the four slit card to produce four parallel rays of light. It may be necessary to adjust the position of the light source in the box to obtain parallel rays.
2. Send the four rays toward the surface of a plane mirror. Based on what you observe, carefully draw in the reflected rays in the figure below.

Activity 3. The Law of Reflection

Procedure:

1. Replace the four slit card with the one slit card. Place the plane mirror along the line drawn below. Send a single ray of light toward the plane mirror along incident light ray #1 in the figure.

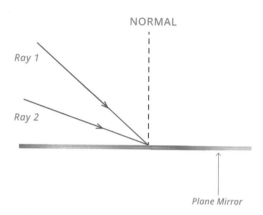

2. *Very carefully* draw the reflected ray in the figure above. Measure the angle between the incident ray and the normal. This angle is called the *angle of incidence*. The angle of incidence = _____
Measure the angle between the reflected ray and the normal. This angle is called the *angle of reflection*. The angle of reflection = _____
How does the angle of incidence compare to the angle of reflection?
3. Repeat step 2 for incident ray #2. Angle of incidence = _____; angle of reflection = _____
How do the angles of incidence and reflection compare for incident ray #2?
Can you state a principle regarding the reflection of a ray of light from a plane mirror?

Activity 4. Locating Plane Mirror Images

Procedure:

1. Using the ray box, shine a ray of light down each incident ray in the figure below. Carefully draw the reflected ray in each case.

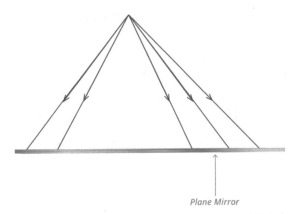

Plane Mirror

2. On your diagram, carefully extend all the reflected rays behind the mirror until they meet.
3. What does the point of intersection of the extended rays represent? Label the point accordingly.
4. Join the object and image with a straight dashed line. Measure the angle this dashed line makes with the mirror.
5. Measure the distances along the dashed line between the object and the mirror and between the image and the mirror. How do the image and object distances compare?

Questions:

1. Describe the location of an image produced by a plane mirror. Is this image real or virtual?
2. Describe the size of an image in a plane mirror relative to the object. What does this indicate about the magnification produced by a plane mirror?
3. Suppose that you are told the position of an object relative to a plane mirror. Describe a procedure you could use to locate the position of the image.
4. What is observed when printing is viewed in a plane mirror? Why does this occur?
5. Suppose an entire wall of a room is covered with plane mirror tiles. How does this affect the apparent size of the room?

• Experiment 3.3
Construct a Kaleidoscope

Sir David Brewster invented the kaleidoscope in 1817. It became popular instantly; in the first year alone, 200,000 kaleidoscopes were reportedly sold. The continuing popularity of kaleidoscopes is evidenced by their availability in toy stores, gift shops, and mail order catalogs.

Materials: Two small mirrors (about 1″ × 6″), sheet of thick cardboard, masking tape, objects to examine.

Procedure: You will enjoy your kaleidoscope more if you take a moment to understand how it works. Before you begin constructing your kaleidoscope, locate the image(s) of the object (a black dot in this case) produced by the mirrors in the figures shown below. To find all the images, remember that an image produced by one mirror serves as an object for the other mirror. After you draw the image or images, check your answer by using the mirrors provided. θ represents the angle between the two mirrors.

Constructing a Kaleidoscope:

1. Trace the outline of one of the 1″ × 6″ mirrors on the sheet of cardboard.
2. Use scissors to cut out the slide-shaped section of cardboard. This will serve as a spacer between the two mirrors.
3. Clean the two mirrors.
4. Place the spacer and two mirrors, face-down, on a flat surface with the long edges parallel to each other. A small gap should be left between the mirrors and spacer so that they can later be folded into a triangle. Connect the three components to each other by placing lengths of masking tape over the gaps, as shown below.

5. Turn the mirrors over so that the reflecting surfaces are facing upward. Form a triangle by bringing the edges of the mirrors together. Tape the mirrors together with masking tape, as shown on the next page.

You now have an open ended kaleidoscope, known as a *teleidoscope*. Look at a variety of objects through the teleidoscope. You may wish to investigate objects such as photographs, the palm of a hand, clothing, printed material, a television picture, and faces.

When you are finished exploring with the teleidoscope, you may wish to complete your kaleidoscope by attaching an object of your choice to the end of the device. Objects such as a stoppered test tube containing water and colored beads and a colored ball, both shown below, are among the many possibilities.

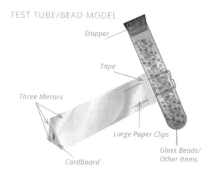

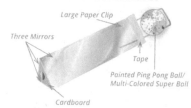

Two types of kaleidoscopes

Questions:

1. In the first part of this experiment, what happened to the number of images as the angle between the two mirrors was decreased? Why do you think this occurred?
2. What equation relates the angle between the mirrors to the number of images produced by the kaleidoscope?
3. How many images of an object are produced by the teleidoscope?
4. How would image production be affected if the cardboard spacer were replaced with a third mirror?

• Experiment 3.4
Image Formation by Concave Mirrors

Materials: Light source (candle or LED), optical bench, converging (concave) mirror, mirror holder, screen (card).

Procedure:

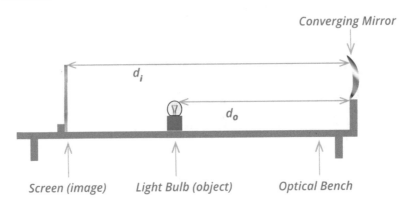

1. Rays of light from distant objects are, for all practical purposes, parallel. Therefore, images of distant objects will be located in the focal plane of the mirror, and you can use this fact to find the focal length of your mirror. Mount the mirror near the center of the optical bench and point it at some distant object (a building or tree 30 m or more away will work well).

 Place the screen in front of the mirror, being careful not to block the light from the object. Move the screen back and forth until the object is clearly focused on the screen. Measure the distance between the mirror and the screen; this is the focal length of the mirror. Focal length = _____

2. For convenience, place the mirror at 0 on the optical bench. Place the object (candle or LED tea light) at exactly three focal lengths from the mirror and record this as the object distance (d_o). Move the screen back and forth until the clearest image is obtained (some tilting of the mirror may be necessary so that the screen does not block the light from the bulb). Record the image distance (d_i) and the image height (h_i) in the table provided. Both the object distance (d_o) and the image distance (d_i) are measured with respect to the mirror. (RSU, USD, and M stand for right-side up, upside down, and magnification, respectively.)

3. Repeat step 2 five more times with $d_o = 2.5f$, $2f$, $1.5f$, f, and less than f. If you are unable to form a clear image on the screen for a particular object distance, place a V in the column labeled "Real or Virtual."

Observation	Object distance (d_o)	Image distance (d_i)	Image height (h_i)	RSU or USD	Real or virtual	$1/d_o$	$1/d_i$	$1/d_o + 1/d_i$	$1/f$	M (h_i/h_o)
1										
2										
3										
4										
5										

4. Remove the screen, place the object at each object position for which you marked "V" in step 3, and look into the mirror. Do you observe an image? If so, is the image real or virtual? Reduced or enlarged? RSU or USD? Enter this information in the table.

5. Compute $1/d_o$, $1/d_i$, and $(1/d_o + 1/d_i)$ for the first four observations. Enter these values in the table.

6. Determine the value of $1/f$ and enter this number in the table.

7. Calculate the magnification using the relationship $M = h_i/h_o$ for the first four observations and enter the answers in the table.

Questions:

1. As the object is moved toward the mirror, what changes occur in the size, location, and orientation of the image? Is the image real for all object distances? If not, where does the transition from real image to virtual image occur?

2. What mathematical relationship exists between d_o, d_i, and f? How well is this followed for each of your measurements?

3. Using the mirror equation arrived at in question 2, calculate the image positions for $d_o = f$ and $d_o < f$. Enter these distances in the table. Are these image distances consistent with your experimental observations? Explain.

4. If an object is placed at a large distance from a concave mirror (>30 m), where is the image formed? Is the image distance found with the mirror equation consistent with your observation?

5. If an object is placed at the focal point of the mirror, where will the image be located? Compare your experimental observation with the image distance obtained by applying the mirror equation to this case.

6. Where would you place an object, relative to the mirror, in order to form a real image? A virtual image?

7. If an object is located two focal lengths from a concave mirror, where will the image be formed? Describe the image's characteristics.

8. Calculate d_i/d_o for the first four object distances and compare these to the values of $M = h_i/h_o$ that you calculated earlier.

• Experiment 4.1
Refraction and Total Internal Reflection

Materials: Ray box, semicircular block of Lucite or glass, semicircular plastic dish, polar graph paper.

Activity 1. Refraction

Procedure:

1. Accurately align the semicircular Lucite or glass block with the horizontal axis on polar graph paper or on the grid provided. The center of the block should lie

on the vertical axis, which becomes the normal from which angles of incidence
and refraction are measured, as shown. Using the ray box with the single slit,
send a ray of light along the normal toward the flat side of the block (zero
incidence). Record the angle of refraction in the table.

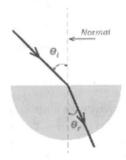

2. Increase the angle of incidence in $10°$ steps, measure each angle of refraction,
 and record the measurements in the table. Make sure the ray always strikes the
 semicircular block at the center.
3. Use a calculator to find the ratio of angles θ_i/θ_r. Also calculate the ratios of the
 sine of the angle of incidence to the sine of the angle of refraction.

Lucite or Glass

Angle of incidence (θ_i)	Angle of refraction (θ_r)	θ_i/θ_r	$\sin \theta_i/\sin \theta_r$
0			
10			
20			
30			
40			
50			
60			
70			
80			

Water

Angle of incidence (θ_i)	Angle of refraction (θ_r)	θ_i/θ_r	$\sin \theta_i/\sin \theta_r$
0			
10			
20			
30			
40			

(continued)

(continued)

Angle of incidence (θ_i)	Angle of refraction (θ_r)	θ_i/θ_r	$\sin \theta_i/\sin \theta_r$
50			
60			
70			
80			

Questions:

1. Describe the path of a light ray incident along the normal (zero angle of incidence) as it passes from air into Lucite (or glass). Does it bend?
2. When the angle of incidence is greater than zero, does the light ray bend toward or away from the normal upon entering the Lucite or glass?
3. Do either the ratio θ_i/θ_r or $\sin \theta_i/\sin \theta_r$ appear to remain constant as the angle of incidence changes? Does this suggest a mathematical relationship between them? Try to write this relationship as an equation.
4. Why are semicircular objects used in this experiment? (Hint: Does the light ray bend at the curved surface? Why?)

Activity 2. Total Internal Reflection

Procedure:

1. Again place the Lucite or glass block on the grid and direct a light ray toward the curved side. The ray should enter the block at the curved surface, pass through the block, and strike the center of the flat edge. Thus, the light path is exactly the reverse of that used in Activity 1.
2. Starting with zero incidence, observe and record the angle of the refracted ray *in air*. Beyond the critical angle, the incident ray will no longer be refracted; it will be totally reflected back into the block. When this occurs, record the angles of *reflection* (again measured from the normal) and mark them with an asterisk.
3. Carefully measure the angle of incidence that results in a refraction angle of 90°. This angle of incidence is called the *critical angle* θ_c.
4. Repeat steps 1–3 using the semicircular dish filled with water.

Lucite or Glass

θ_i	θ_r
0	
10	
20	
30	
40	

(continued)

(continued)

θ_i	θ_r
50	
60	
70	
80	

$\theta_c = \underline{\hspace{2cm}}$

Water

θ_i	θ_r
0	
10	
20	
30	
40	
50	
60	
70	
80	

$\theta_c = \underline{\hspace{2cm}}$

Questions:

1. Describe the path of light for zero angle of incidence.
2. For angles of incidence greater than zero, is the refracted ray bent toward or away from the normal?
3. For transmission from Lucite or glass into air, calculate the value of $\sin \theta_i/\sin \theta_r$ for the angles of incidence less than the critical angle. Calculate the average of these values. How does this compare to the average value of $\sin \theta_i/\sin \theta_r$ for transmission from air into Lucite or glass?
4. For angles at which total internal reflection occurs, do the incident and reflected angles follow the law of reflection (angle of incidence = angle of reflection)?
5. Why does total internal reflection only occur when light passes from a slower medium to a faster medium?
6. How can Snell's law be used to calculate the critical angle for any pair of transparent media?

• Experiment 4.2
Converging Lens

Materials: Optical bench, object (candle or LED tea light), converging (convex) lens, lens holder, screen (card).

In this laboratory, you will investigate the characteristics and locations of the images formed by an object located at various distances from a converging lens.

You will also look for a relationship between the image distance, object distance, and focal length of the lens.

Procedure:

1. Mount the lens and screen on an optical bench or meter stick and place them in a dark part of the room pointed at an object some distance away (>30 m), such as an outdoor landscape, lightbulb, or lighted sign. Move the screen back and forth to obtain the best image, and determine the distance from the lens to the screen. This distance is the focal length of the lens. Focal length = _____

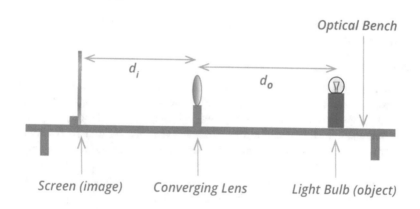

2. Place the lens near the center of the optical bench. Position the object at a distance exactly 2.5 focal lengths from the lens. Move the screen back and forth on the opposite side of the lens until a sharp image appears. Record the image distance, the image height h_i, and the characteristics of the image in the table below. Both the object distance (d_o) and image distance (d_i) are measured with respect to the center of the lens. Note: RSU, USD, and M stand for right-side up, upside down, and magnification, respectively.
3. Measure the object height h_o = _____.

Observation	Object distance (d_o)	Image distance (d_i)	Image height (h_i)	RSU or USD	Real or virtual	$1/d_o$	$1/d_i$	$1/d_o + 1/d_i$	$1/f$	M (h_i/h_o)
1										
2										
3										
4										
5										

4. Repeat step 2 four times with the object distances equal to $2f$, $1.5f$, f, and less than one focal length from the mirror. If you are unable to obtain a clear image on the screen for a particular object distance, write V in the column labeled "Real or Virtual."

5. Place the object at the positions that did not give a clear image on the screen. For each of these positions, look through the lens in the direction of the object. Do you see an image? If so, is the image real or virtual: Reduced or enlarged? RSU or USD? Enter this information in the table.

6. Compute $1/d_o$, $1/d_i$, and $(1/d_o + 1/d_i)$ for the first three observations only.

7. Determine the value of $1/f$ once and enter this number in all rows under the heading $1/f$.

8. Calculate the magnification using the relationship $M = h_i/h_o$ for the first three observations only and enter these into the table.

Questions:

1. As an object is moved toward a converging lens, what changes occur in the size, position, and orientation of the image? Is the image real for all object distances? If not, where does the transition from real image to virtual image occur?

2. What mathematical relationship exists between d_o, d_i, and f? Assuming you know d_o and f, what will this relationship, known as the *thin lens equation*, enable you to do?

3. Using the thin lens equation, calculate the image positions for the object distances equal to one and less than one focal length. Enter these distances in the table. Are these image distances consistent with your experimental observations? Explain.

4. According to the thin lens equation, where is the image located when an object is placed at a large distance (>30 m) from a converging lens?

5. If an object is placed at the focal point of a converging lens, where will the image be located?

6. If an object is located two focal lengths from a converging lens, where will the image be formed? Describe the characteristics of this image.

7. Calculate d_i/d_o for the first three object distances. How do these ratios compare to the corresponding values of h_i/h_o in the table?

• Experiment 4.3
Simple Magnifier and Telescope

Materials: Two converging lenses (one of long focal length, one of short focal length), diverging lens, optical bench, ruler, crystals of salt or sugar.

Procedure:

1. Use each lens to view a printed page. Note that the diverging lens always makes the print appear smaller. The converging lenses, on the other hand, will make the

print larger and right-side up when held close to the page (at a distance less than the focal length f), but will invert the print and make it either larger or smaller at a distance greater than f. Determine approximate focal lengths of each converging lens by noting the distance at which the image disappears (blurs) as it goes from real (inverted) to virtual (erect).

2. Use the short focal length converging lens to view (magnify) crystals of salt or sugar. View a scale (ruler), and by superimposing the magnified image on the direct image (by looking at each one with one eye), determine the magnification of the lens used as a simple magnifier. The magnification is *approximately* given by the formula $M = 25/f$ where f is the focal length in cm. (This formula assumes that you will view the image at the "comfortable" distance of 25 cm.) How close does your measured value for magnification come to this formula?

3. Mount the two converging lenses on an optical bench so that you can look through the short focal length lens and see the other lens. Start with the spacing between the lenses just a little greater than the longer focal length. Move the "eyepiece" (the short focal length lens) until you see an image of a distant object. Is it erect or inverted?

4. View a meter stick though your telescope. By superimposing the enlarged image on the real meter stick, try to estimate the magnifying power of your telescope. It should be approximately given by the formula: $MP = f_o/f_e$, where f_o and f_e are the focal lengths of the two lenses (the "objective" lens and the "eyepiece," respectively).

5. By combining two converging lenses in the previous steps, you created a simple Keplerian or astronomical telescope. It is fine for looking at the moon, but for viewing terrestrial objects the inverted image can be annoying. A Galilean telescope uses a diverging lens as an eyepiece and produces an erect image. Substitute the diverging lens for the converging lens and again view a distant object through the two lenses. Is it erect or inverted?

• Experiment 5.1
Diffraction and Interference of Water Waves

Materials: Ripple tank, light source, motorized wave generator, straight wave source, two point sources, paraffin blocks.

Set up ripple tank, screen, and light source as shown in Fig. 2.11a. Add water to the tray to a depth of approximately 1 cm and adjust the legs on the tank to make the depth of the water as uniform as possible.

Activity 1. Diffraction

Procedure:

1. Place a paraffin block in the water and dip a pencil into the water a few centimeters behind it. Note how the waves diffract around the barrier. Place the

motorized straight wave source behind the barrier and note what happens to the diffracted waves as you change their wavelength by varying the motor speed.
2. Add additional blocks to create a barrier across the entire ripple tank with an opening of a centimeter or so at the center. Send straight waves toward the opening and carefully describe what happens as you change the size of the opening and the wavelength of the waves.
3. Substitute the point source for the straight source. Does this change the pattern of waves passing through the opening? If you were standing in front of the barrier, could you tell whether the waves behind it were straight waves or circular waves?

Activity 2. Interference

1. Remove the paraffin blocks and attach two point sources to the wave generator. Observe the pattern created as the point sources disturb the water with a constant frequency. This pattern is called an *interference pattern*. What happens to the pattern when you increase the frequency of the generator? Decrease the frequency?
2. While keeping the generator frequency constant, increase then decrease the distance between the point sources. How does changing the distance between sources affect the pattern?
3. Some wave generators allow the relative phase of the two point sources to be varied. If yours has that feature, vary the phase and note the change in the wave interference pattern. When the two point sources are in phase, you should see maximum amplitude straight ahead along the axis. When the two point sources are in opposite phase, you should see minimum amplitude in this direction with maximum amplitude to either side of it.

Questions:

1. What factors determine the amount of diffraction?
2. What produces an interference pattern? Can an interference pattern be produced with a single source of waves? Explain.
3. If an interference pattern is to remain unaffected what changes must be made to the generator frequency when the distance between sources is decreased?

• Experiment 5.2
Diffraction Grating

In the experiment you will use a diffraction grating to determine the wavelength of red and blue light.

Materials: Diffraction grating, showcase bulb (with line filament), red and blue filters, meter stick, ring stand, test tube clamp.

Procedure:

1. Cover the showcase bulb with the red filter. Use the ring stand and test tube clamp to mount a meter stick directly over the bulb (with the bulb at the center of the meter stick as shown below). Place the diffraction grating at a distance from the lamp so that the first order fringes appear near the ends of the meter stick when the lamp is viewed through the grating. The grating should be parallel to the meter stick.

2. Create two U-shaped riders for the meter stick by straightening out two paper clips. The riders will be used to indicate the locations of first order fringes.
3. Measure the distance between the diffraction grating and the center of the lightbulb, and record this as L in the data table.
4. Instruct your partner to move one rider to the right until it is aligned with the first order fringe on the right. Record this position as x_1. Similarly, the other rider should be moved until it is at the location of the first red fringe on the left. Record this position as x_2. Find the average distance Δx between the central bright fringe and the first bright fringe on either side of center by taking one half of $x_2 - x_1$. Record this distance in the table.
5. Switch roles with your partner and repeat the measurement.
6. Obtain the grating spacing d from your instructor and use it in the relationship $\lambda = d\Delta x/L$ to calculate the wavelength of red light.
7. Repeat steps 4–6 with the blue filter covering the bulb.

Data L = ———— **d** = ————

Red Light

Trial	x_1	x_2	Δx	λ
1				
2				
3				
4				
Average				

Blue Light

Trial	x_1	x_2	Δx	λ
1				
2				
3				
4				
Average				

Questions:

1. What effect would increasing L have on the spacing between bright lines?
2. What effect would increasing d have on the spacing between bright lines?
3. What is the ratio of wavelengths of red light to blue light?
4. What happens to the observed spectra if the grating is rotated slightly away from the perpendicular?
5. Why is the central maximum white in both the red and blue patterns?

• Experiment 5.3
Diffraction from Tracks of a Compact Disc

Materials: Compact disc (audio or CD-ROM) , point source of white light (penlight) or white LED, red laser pointer, ruler.

Procedure:

1. Shine the laser through a hole in a sheet of paper so that it reaches the compact disc (CD) at normal incidence and reflects back onto the paper spaced about 20 cm from the CD. You should observe first- and second-order spots on both sides of the center hole. Measure the distance D between the inner two (first-order) spots and also between the second-order spots.

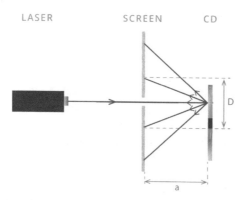

2. Calculate the track separation d from the formula: $d = n\lambda\sqrt{1 + 4a^2/D^2}$, where a is the distance from the paper to the CD, λ is the wavelength of the laser light, and n is the order of the spot ($n = 1$ for first-order, $n = 2$ for second-order). [This formula was derived by Christian Nöldeke in *Physics Teacher 28,* 484–485 (1990), an excellent article on which this experiment is based.]

3. Place the white light source at eye level approximately 2 m behind the observer. The CD is held in front of the observer so that the reflection of the bulb disappears in the center hole (see diagram below). When the CD is held at a distance of about 10 cm from the eye, a circular spectrum can be observed. Increase the distance until the red part of the spectrum appears on the edge of the CD. Record this distance a.

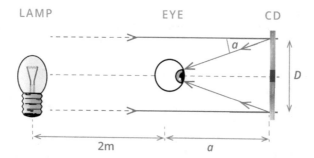

4. Solve the formula in step 2 for λ in terms of d, a, and D. Measure the diameter of the CD and use the formula to calculate λ for red light (set $n = 1$, since only the first order image was observed).

5. Repeat steps 3 and 4 for the violet part of the spectrum and determine λ for violet light.

• Experiment 5.4 Michelson Interferometer

Materials: Michelson interferometer, sodium light source, mercury light source.

Procedure:

1. Familiarize yourself with the micrometer and practice reading it. For some particular setting, you should ascertain that you, your partner, and the instructor all obtain the same reading.
2. When the sodium light source has warmed up, illuminate the diffuser plate and look for fringes. If they are not visible, ask your instructor to help you obtain them.
3. Set the micrometer at some convenient starting value where the fringes are bright and record this setting as R_1. Slowly rotate the micrometer wheel and carefully count the fringes that expand outward from the center. Keep your head stationary while you count the fringes. If you move your head, the fringes will appear to move and you may lose count.
4. After successfully counting 100 fringes ($n = 100$), read the micrometer and record this as R_2 and also as R_1 for the second trial.
5. Switch places and let your partner count 100 fringes and record R_2 for the second trial.
6. Repeat this procedure until 400 fringes have been counted.
7. Most micrometers use a lever to move the mirror M. Thus the mirror moves a distance $(R_2 - R_1)/k$ when the micrometer moves $R_2 - R_1$. Using the fact that $\lambda = 589$ nm for sodium light, determine $k = n\lambda/2(R_2 - R_1)$ for each trial. Does it come out the same? This is a check on whether you counted exactly 100 fringes each time. Find the average k.
8. Repeat steps 3–6 using the mercury light source with a filter to isolate one color (green is generally the easiest). Record R_1 and R_2 for each trial, as you did before.
9. Calculate wavelength $\lambda = 2d/n$ for each trial, where $d = (R_1 - R_2)/k$. (Use the "best" value of k determined in step 7.)
10. (If time permits.) Change the filter and determine the wavelength of another mercury line.
11. Your instructor may wish to demonstrate white light fringes. They are spectacular but somewhat difficult to obtain because the two light paths in the interferometer must be precisely the same in order for a white fringe to occur.

Data:

Sodium (Yellow Light)

Trial	n	R_1	R_2	k
1				
2				
3				
4				
Average				

Data:

Mercury (Green Light)

Trial	n	R_1	R_2	λ
1				
2				
3				
4				
Average				

• Experiment 6.1
Exploring Polarized Light

Materials: Two Polaroid sheets (or filters), wax paper, protractor, calcite crystal, plastic fork and other transparent plastic objects, watch or calculator with LCD display, transparent tape (packing tape works well), beaker, corn syrup.

Light waves emanating from most common sources, such as candles, lightbulbs, and the sun, are unpolarized. That is, they are electromagnetic waves with components of the electric field in all directions. By contrast, *polarized light* consists of waves with the electric field predominantly in one direction. In this experiment you will explore polarization and four methods of producing polarized light.

Activity 1. Direction of Polarization

Procedure:

Overlap two sheets of Polaroid material. Look at a source of light through the filters while rotating one of the filters. Describe what you see. When the light is completely extinguished by the overlapping filters, the filters are said to be "crossed." Rotate the filters through 90°. What do you observe now? Rotate the filters through an additional 90°. Explain what is happening as you rotate the filters.

Activity 2. Polarization by Reflection

Procedure:

Locate a shiny, nonmetallic surface such as a polished floor or tabletop. View light reflected from the surface through a Polaroid filter. Rotate the filter until you no longer see the reflected light. In this position, the filter's axis of polarization is vertical. Place a small piece of masking tape along the edge of the filter and indicate the axis of polarization with an arrow. Rotate the filter to pass the maximum amount of light. Describe the orientation of the axis of polarization now.

View the glare from a surface through a Polaroid filter held close to one eye. When the axis of polarization of the filter is vertical, you will notice that the reflected light is dim for a variety of viewing angles but completely dark for only one. The angle of reflection that produces completely polarized light is called *Brewster's angle* and depends on the reflecting surface.

Measure Brewster's angle for one or two different reflecting surfaces. To do this, have your partner extend a string from the filter to the spot on the surface where the light is totally extinguished. Use a protractor to determine the angle formed by a normal to the surface and the taut string. Brewster's angle for water is approximately 53°; for glass, 56°. You may wish to find Brewster's angle for floor wax by using a waxed floor as your reflecting surface.

View reflected light from a sheet of metal such as a piece of aluminum foil. Describe what happens as you rotate the filter. Compare the reflected light from a metallic surface to that reflected from a nonmetallic surface. Use your filter to view light reflected from the surface of an automobile. Is this light polarized? How do you explain your findings?

Activity 3. Polarization by Scattering

Procedure:

If the weather permits, go outside and investigate skylight with a Polaroid filter. **DO NOT LOOK DIRECTLY AT THE SUN!** Slowly rotate the filter as you view a portion of the sky. Is it possible to reduce the brightness of the sky for certain orientations of the filter? Now examine other areas of the sky. Does the light in certain portions of the sky seem to be more polarized than others? Estimate the angle formed by imaginary lines drawn between your head and the sun and your head and the portion of the sky with the highest degree of polarization.

Look at the portion of the sky with the greatest polarization. If clouds are present in this region, observe what happens as you rotate your filter while viewing the clouds. Do the clouds seem to stand out for certain orientations of the filter? This occurs because the light scattered by the atmosphere is polarized, but the light scattered many times by water droplets in the cloud is not (see Activity 4).

If you can't go outside, observe the simulated sky produced by dissolving a small amount of powdered milk in water.

Activity 4. Depolarizing Light through Multiple Scattering

Procedure:

Polarized light can be depolarized with multiple scattering. Polarized light, produced by atmospheric scattering, becomes depolarized when it is scattered many times by the particles that make up clouds. This phenomenon also occurs when polarized light passes through a sheet of wax paper.

Place two Polaroid filters together and rotate them until they are crossed. Slide a piece of wax paper between the filters. Compare the light transmitted through the pair of filters before and after the insertion of the wax paper. Does your wax paper sample have a depolarizing effect?

Activity 5. Birefringence

Procedure:

Some crystalline substances, such as quartz and calcite, have two indices of refraction. Such crystals are birefringent (doubly refracting). Place a calcite crystal on some printed material. How many images do you see? Now view the printed material after you have placed a Polaroid filter on top of the crystal. What do you see now? Can you extinguish one image at a time by rotating the filter? Why do you think this occurs?

When stressed, plastic and glass can become birefringent. Viewed between Polaroid filters, this birefringence produces colored contours. Place a plastic fork or other plastic object between your filters to make the stress lines visible. If you are using a fork, squeeze the tines together. What happens to the colored stress lines?

You can sometimes observe these *interference colors* in transparent plastic objects without using Polaroid filters. Simply view the clear plastic object (plastic tape cassette boxes and tape dispensers work very well) in skylight. Tilt the object while looking at the reflection of the sky in the plastic. For a particular viewing angle, colors will appear. Can you explain how these colors are produced without Polaroid filters? (Hint: Polarized light must first enter the plastic, pass through the plastic, and then is "analyzed" by a second polarizing mechanism.)

Activity 6. LCD Display

Procedure:

Examine the LCD display on a watch, calculator, or laptop computer through a single Polaroid filter. Rotate the filter and note the effect. What does this tell you about light from liquid crystal displays?

Activity 7. Optically Active Substances

Procedure:

Place a beaker with corn syrup on an overhead projector. The syrup in the beaker is *optically active*. Optically active substances rotate the plane of polarization of a beam of light. Place a Polaroid filter above and below the beaker. Rotate the top filter and observe the color of the light. Can you produce all the colors of the spectrum?

Activity 8. Polarized Tape Art

Procedure:

The birefringent properties of some transparent tapes, for example cellophane, may be used to produce colorful tape art reminiscent of stained glass windows and cubist paintings. On a microscope slide or other clear substrate, place a short piece of tape. View the tape between crossed Polaroid filters. Record what you observe. Apply a second layer of tape on the first and view it between crossed Polaroids. Continue this procedure until the colors begin to repeat themselves, each time noting the color produced. This procedure will allow you to develop a color key linking tape thickness with color.

Since you now know the relationship between color and tape thickness, you are now ready to produce your "work of art." Begin by cutting the tape into the desired shapes. As you prepare the shapes, apply them to a clean sheet of clear plastic or a plastic Petri dish. By layering pieces of tape, you can produce beautiful colored patterns that manifest themselves when viewed between Polaroid sheets as is shown in the example below.

Questions:

1. Why will light pass through a pair of Polaroid filters when their axes of polarization are aligned parallel to each other, but not when they are "crossed," that is, at right angles to each other?
2. When two Polaroid filters are crossed, virtually all the light incident on them is absorbed. What do you think would happen if between the two filters you were to insert a third Polaroid filter whose polarization axis is oriented at 45° with respect that of the other two filters?
3. Is it possible to polarize sound waves? Explain.
4. a. When light reflects off a nonmetallic surface such as a tabletop, snow, or glass, in which direction is the reflected light polarized? Explain.
 b. Based on your answer to part (a), would you expect the polarization axis of the filters in Polaroid sunglasses to be vertical or horizontal?
5. Explain how you could determine if a pair of sunglasses employed polarizing filters or just conventional tinted glass.
6. Why do photographers place a polarizing filter over their camera lens to accentuate clouds?

7. In Activity 8, you prepared your color key by layering transparent tape on a clear support. Why do you suppose the colors repeat themselves after a certain number of layers of tape have been applied?

• Experiment 7.1
Spectrum Analysis with a Diffraction Grating

Materials: Spectrometer, diffraction grating, gas discharge sources (mercury, sodium, other).

Procedure:

1. Familiarize yourself with the spectrometer. Learn how to measure the angular position of the telescope accurately using the vernier scale. (It will probably read in degrees and minutes; one minute is 1/60 of a degree.)
2. With the instructor's help, adjust the slit on the collimator and focus the telescope so that sharp images of the slit and the crosshairs appear together in the eyepiece. Then, illuminate the slit with a mercury light source, place the grating on the table, and adjust it so that you can view the spectral lines of mercury in the telescope. You will see spectral lines on both sides of the grating; adjust the grating angle so that the angles on both sides (measured from the central maximum) are the same. This will occur when the grating is perpendicular to the light beam.
3. Measure the angle of deviation θ for the bright green spectral line ($\lambda = 546.1$ nm). Determine the grating spacing d from the formula: $d = 1/\lambda \sin \theta$ and compare it to the nominal spacing indicated on the grating. (Due to grating shrinkage and other factors, your measured value ought to be the more accurate one!)
4. Measure the angles of deviation for several more spectral lines of mercury and other gases, and use the grating formula to determine their wavelengths.

• Experiment 8.1 Exploring Color

Materials: Prisms (2); ray box with accessories; Variacs or similar variable power supplies available at home improvement centers (3); red, blue, and green floodlights (incandescent, CFL, or LED); red, green, and blue filters; crayons or colored markers, television, computer monitor or smartphone; black cardboard; red, green, blue, and yellow stickers.

Activity 1. Spectrum of Colors

Procedure:

1. Pass a ray of white light through a prism and view the spectrum on a white sheet of paper. Use colored markers to record what you observe.
2. Use a narrow slit to isolate a single color. Is it possible to further separate this light by passing it through a second prism? What happens when you pass light from a different part of the spectrum through the prism? What does this indicate about the spectral colors?

Activity 2. Mixing Colors by Addition

1. Place red, green, and blue filters in the three beams from the ray box and adjust them so that they overlap to produce white light on your paper. See what happens when you place a finger in front of one beam to cast a shadow. What color is the shadow? Move your finger to the other beams and note the shadow colors.

 Describe in your own words the colors produced as you block one beam at a time.

 red light + blue light = _____
 red light + green light = _____
 green light + blue light = _____

2. To experience some of the wide variety of hues possible by mixing the three primary colors, you will need to adjust their brightness. If you use your ray box, you can use gray filters to reduce the brightness or you can stack additional filters of the same color. If you use colored spotlights, you can control each one with a Variac. A demonstration light box with three adjustable sources is particularly convenient, if available.

 Try to create the colors listed below. In each case give a "primary recipe" that others can use to create the same color. For example, strong red light + medium green light = reddish-yellow light.

Color	"Primary recipe"
Pink	
Purple	
Orange	
Lime green	
Color of your choice	

3. Examine a television screen, smartphone screen, or computer monitor with a magnifying glass or through a water droplet on the screen and carefully sketch the pattern of colored dots that you see. Can you see the individual dots without the aid of a magnifying glass? If so, how far from the screen must you be before you can no longer resolve adjacent dots? Describe the dot pattern when the screen is white, black, blue, and several other colors. The use of color dots to form color on electronic displays is an example of *partitive* color mixing.

Activity 3. Additive Color Mixing Using Persistence of Vision

The eye–brain system is capable of retaining an image for a fraction of a second after the stimulus is removed. This is called *persistence of vision* and results in an image that exhibits the colors found in the stimulus. This phenomenon may be used to combine colors additively.

Procedure:

1. Attach a green sticker to the center of a 3 cm × 3 cm piece of black cardboard. Repeat with a red sticker on the opposite side.
2. Bend two of the card's opposite corners in opposite directions to produce "turbine blades."
3. Hold the card's two unbent corners between your index fingers. Blow on the blades to make the card spin, and observe the color stickers. What colors do you see on the spinning turbine?
4. Repeat the above steps with blue and yellow stickers. What color is produced now?

• Experiment 8.2
Mixing Pigments: Subtractive Color Mixing

Materials: Color filters (red, green, blue, magenta, cyan, yellow); diffraction grating; unfrosted showcase lamp; color comics page from the Sunday newspaper, color photocopies, color computer printouts; various colored light sources; pieces of colored paper; Dr. Ph. Martin's Bombay teal, magenta, and yellow India inks.

Activity 1. Selective Absorption

1. View an unfrosted showcase lamp through a diffraction grating (or through grating glasses); adjust the grating so that you see color spectra to the right and to the left of the center image of the lamp. Carefully sketch the spectrum in color and label the colors.
2. View the lamp with a red filter in front of the grating. Sketch and label the colors you see.

3. Repeat using a green, blue, magenta, yellow, and cyan filter in turn. Sketch and label all six spectra and draw an arrow to point out the region in each spectrum that is most strongly absorbed.

Activity 2. Mixing Colors by Subtraction

1. View a white light through pairs of color filters and carefully describe the light that passes through the filter combination. Do you expect a red + green filter to produce the same light as red + green light? Why? Examine all the combinations below.

green + cyan = _____ green + yellow = _____ green + magenta = _____
red + cyan = _____ red + yellow = _____ red + magenta = _____
blue + cyan = _____ blue + yellow = _____ blue + magenta = _____
red + green = _____ red + blue = _____ green + blue = _____

2. Your observations may now be used to deduce the transmission characteristics of cyan, yellow, and magenta filters. In terms of red, blue, and green, list the colors that are transmitted by each of the following filters:

cyan: _____
yellow: _____
magenta: _____
cyan + yellow + magenta: _____

 Cyan, yellow, and magenta are called the *subtractive primary colors*. A cyan filter may be thought of as a "minus red" filter because it absorbs red light. What color does a yellow filter absorb? A magenta filter?

3. Pigments, like colored filters, selectively absorb certain colors. By combining the subtractive primaries (cyan, yellow, and magenta) in the proper combinations, it is possible to produce any desired color. For this reason, they are used in color printing and painting.

 Examine the box flaps for "test dots" indicating the colors used to print the box. You may also find these in colored comic pages in the newspaper or on an inkjet color printing cartridge.

4. Use a magnifier to examine color pictures in books and magazines and a color photocopy. Note that the primary subtractive colors are generally printed directly over each other so that the eye does not have to employ partitive color mixing.

Activity 3. What Color Is It?

Procedure:

Lay out an array of square samples of colored paper, illuminate them with white light, and record the colors in the top line of the chart below. Then illuminate it with other colors of light and record the colors as seen. (Try to forget how they appeared under white light!) Try it with the sodium and mercury light sources. Expand the chart as needed.

Filter used on light source							
Color of paper	None	Red	Blue	Green	Cyan	Magenta	Yellow
White							
Red							
Blue							
Green							
Cyan							
Magenta							
Yellow							
Purple							
Black							

Activity 4. Mixing Inks

Procedure:

1. Slowly mix two drops of yellow ink and two drops of magenta ink together using a clean Q-Tip.
2. Use the Q-Tip to draw a line or other figure on a piece of white paper. What color appears on the paper?
3. Repeat the above procedure this time combining yellow and cyan inks and then cyan and magenta inks. Use a clean Q-Tip each time. Describe the color produced in each instance.
4. Now mix two drops of all three inks together. What does this mixture produce?
5. What conclusions can you draw regarding the various combinations of the subtractive primaries cyan, magenta, and yellow?

• Experiment 9.1
Color Perception

Materials: Neon bulb, extension cord, colored construction paper, color filters (red, green, blue).

Activity 1. Persistence of Vision and Positive Afterimages

Procedure:

The eye–brain system is capable of retaining an image for a fraction of a second after the stimulus is removed. This is called *persistence of vision* and results in a *positive after image*, an image that exhibits the colors found in the stimulus.

1. Positive afterimages may be demonstrated with a small neon nightlight attached to the end of an extension cord. In a dark room, twirl the neon light around in a circle. What do you observe? Why do you see multiple images of the light? How does the color of the images compare to the color of the neon light?
2. Persistence of vision may be employed to construct an entire picture from fleeting image segments. Focus a projected image of your choice on a sheet of paper. After obtaining a sharp image, remove the paper. Rapidly swing a dowel rod up and down in the area previously occupied by the paper. What do you see? Why does the entire image seem to appear in midair?

Activity 2. Retinal Fatigue—Negative Afterimage

Procedure:

After prolonged stimulation, the eye's receptors may become less sensitive. This phenomenon is referred to as *retinal fatigue*. To experience retinal fatigue, stare at a colored object in bright light for approximately 30 s. Now look at piece of white paper. A *negative afterimage* of the object you were staring at will appear in a complementary color.

In the following demonstration, retinal fatigue may be employed to restore the United States flag to its usual colors.

1. Stare at the red dot at the center of the flag for about 30 s.
2. Transfer your gaze to a white surface. The flag's afterimage should appear in more familiar colors.

Activity 3. Subjective Colors—Benham's Disk

Procedure:

The figure below is one example of a nineteenth-century toy known as Benham's Disk. Make an enlarged copy of the disk and place it on a turntable. Watch the disk as it rotates. Do you see colors? If so, list them. Change the speed of the turntable. What effect does the rate of rotation of the turntable have on the colors you see? If possible, reverse the direction of rotation of the turntable. How does this reversal affect the observed colors?

Why this and other similar rotating patterns induce the sensation of color is still not fully understood. One theory holds that the red, green, and blue color receptors in the retina respond to intermittent stimulation, but each at a different rate. As the pattern rotates, the off and on stimulation produced by the black lines results in different levels of activity in the three color receptors, creating a color response in our brain. The intermittent flashing of a white strobe light striking the closed eyelid produces similar results.

Activity 4. Simultaneous Color Contrast

Procedure:

Color perception depends on context. That is, the color of an object may change when viewed against different backgrounds. Painters, weavers, and home decorators have long been aware of the effect.

To study how various colors appear against different colored backgrounds, you will need two pieces of colored construction paper and a number of squares of colored paper. Paint sample cards available from paint and hardware stores work well. Cut one sheet of construction paper in half and glue it to the other sheet of paper (see figure below).

Cut two small squares from each color sample you have. Place each pair of colored squares across from each other on each side of the bicolored construction paper. The figure shows four pairs of squares; you may have more.

1. Which colored squares seem to be different when viewed against different backgrounds? For which pair of colored squares is the effect most dramatic?
2. Now experiment with different colored squares to see which background colors seem to make foreground colors appear lighter and which make them appear darker. Working with other students will provide you with a wide variety of sample and background colors. Describe your findings.
3. Sometimes two colors that are actually different will appear the same when viewed against different backgrounds. Can you find such a sample/background combination? If so, describe it. Again, it will probably be beneficial to work with other students on this project.

In general, surrounding one color with another will change the appearance of the surrounded color. A green dot, for example, surrounded by yellow appears more bluish. One theory suggests that, due to constant eye movement, receptors receive yellow light from the region surrounding the dot and become desensitized to yellow. The green dot is perceived as the additive mixture of green and the complement of the adjacent area, which in this case is blue. Consequently, the green region will appear to be cyan (blue green).

Artists have been aware of simultaneous color contrast for centuries. However, it wasn't until 1839 that tapestry manufacturer Eugene Chevreul discovered the basic principles underlying the phenomenon. He found that by placing complementary colors next to each other he could make colors in his tapestries appear brighter and more saturated. Impressionist painters later took advantage of this knowledge. In the twentieth century, optical artists such as Josef Albers and Ellsworth Kelly employed simultaneous color contrast in many of their paintings.

Activity 5. Simultaneous Color Contrast II

Procedure:

Make a small hole in the center of a piece of colored construction paper. Hold the construction paper at arm's length. With one eye closed, view colored objects through the hole. How do the colors observed using the mask compare to the

normal color of the objects? Do the colors seen through the hole take on a color complementary to the mask's color?

Activity 6. Binocular Additive Color Mixing

Procedure:

With a green filter over one eye and a red filter over the other eye, look at a brightly illuminated piece of white poster board. What do you observe? Now repeat the experiment, this time with a blue filter and a red filter. What do you see now? Finally, try a blue and green filter.

The brain may interpret the separate, but simultaneous, red and green signals as yellow. This is understandable since yellow may be produced from overlapping red and green light. Sometimes the brain is unable to blend the two colors together. When this occurs, you will see first one color, then the other.

Activity 7. Colored Shadows and Lateral Inhibition

Procedure:

Place an opaque object such as a coffee cup or small vase in front of a white screen. Illuminate the object with two light sources, one white and one covered with a red filter, so that two distinct shadows of the object are formed. The shadow formed by blockage of light from the white source will appear red. What color does the other shadow appear to be? Why does this occur?

Most of the screen appears a light red, the combination of red and white light. Because of this preponderance of red, lateral inhibition reduces your sensitivity to red. Therefore, the shadow area illuminated with only white light appears cyan, the complement of red.

Activity 8. Artistic Afterimages

Procedure:

Create a composition representing a landscape, object, or person with the intent that it is to be enjoyed as an afterimage. As you know, what you see when viewing the composition directly is not what you will experience as an afterimage. You may use colored markers, crayons, or pieces of construction paper to create your composition.

• Experiment 10.1
Exploring a Single Use Camera with Built-In Flash

Materials: Used single-use camera, lightbulb (preferably unfrosted), LED tea light, or candle, file card, meter stick, metric tape, or ruler.

Although they are quite inexpensive, single-use cameras contain a number of rather sophisticated components. In this laboratory you will investigate the workings of a single-use camera and, in the process, become familiar with elements common to all cameras.

Procedure:

1. Before opening up your camera, draw a sketch of its exterior. Label all important components and, as best as you can, describe the function of these components.
2. Carefully disassemble the camera. Begin by prying off the camera's plastic faceplate. Be careful not to lose any components when you do this! Once you have removed the faceplate from your camera, examine the camera for lenses. In addition to the principal lens located in the front of the camera, how many lenses can you find? (Note: It's possible that your camera has only one lens.) Write down what you think is the function of each lens.
3. Now describe each lens. What shape do they have (you may use sketches)? Are they converging or diverging lenses? You may wish to examine these lenses by looking through and feeling them. What types of images are they capable of forming? For example, are the images right-side up (RSU) or upside down (USD); enlarged or reduced in size?
4. Locate and remove the principal camera lens. This lens is located at the front of the camera and is responsible for forming images on film. (If this lens is missing, it is possible that it fell out of its holder when you opened the camera.) Can you form an image of a lightbulb or candle flame on a sheet of white paper with the lens? If it's a sunny day, you may wish to try forming an image of an outdoor scene or object on the paper. Describe the image(s) you form. That is, are the images RSU or USD? Are the images enlarged or reduced? Real or virtual?
5. Determine the focal length of your lens, preferably in millimeters. To do this, form an image of a distant object on your screen. When the image is as sharp as you can get it, measure the distance between the lens and the screen. This distance is the focal length.

 Focal length = _____mm.

 Measure the depth of the camera (distance from lens opening to film plane). Depth of camera = _____.
 How does this compare to the focal length of the lens?
6. Try to form an image of a close object on your screen. You may wish to form the image of a lightbulb or candle that is less than 50 cm from the lens. At what distance must you place the screen to obtain a clear image of this close object? Based on the image position you found in #5, why can't disposable cameras be used for close-up shots?
7. Measure the diameter of the camera stop (the hole in the front of the camera) in mm. Diameter of hole = d = _____mm.

 Determine the f-number of your camera. The f-number may be found by dividing the focal length of the lens by the diameter of the hole: f-number = focal length/hole diameter (both measured in mm).

 f-number = _____.

On standard 35 mm cameras, f-numbers often range from 1.8 to 22. The f-number relates to the amount of light reaching the film and to the depth of field (near-far range of subjects acceptably in focus). An inexpensive camera, such as the one you are examining today, will generally have a fairly large f-number. This means that it does not admit much light but does form sharp images of objects over a large range of distances.

8. Examine the mechanical components of your camera. What mechanism is used to advance the film (now removed) in your camera? Is there a frame (picture number) indicator? If so, how is it advanced to provide the correct frame number?

9. Looking at your system's electrical system, locate the battery, the flash lamp, the capacitor (usually a cylinder about $1^1/_2$ in. long), and a complicated-looking collection of electronic components. The battery is the source of energy used by the flash lamp. However, the battery voltage is too low to trigger the lamp. The electronic circuitry you see increases the voltage to the required value. The capacitor then stores electrical energy at a high voltage until the flash button is pushed. You may charge the capacitor by depressing the charging strip on the front of your camera. **This must be done carefully with a pencil eraser or other insulator to avoid shock**. While not dangerous, a shock will certainly startle you and you may find it very unpleasant. You may hear a high-pitched sound while the capacitor is charging. The capacitor is charged when the sound stops. Do not touch any of the contacts on the front of the camera with your hands at this time. You can trigger the flash by discharging the capacitor. To do this, use the tip of a screwdriver, key, or a paper clip to simultaneously touch pairs of exposed copper contact points on the front of the camera. Experiment with pairs of these contacts until you get the bulb to fire.

Questions:

1. What are the essential parts of a camera?
2. What is the function of the shutter and diaphragm?
 a. Did your single-use camera have an adjustable shutter speed? An adjustable aperture?
 b. How do you suppose a single-use camera compensates for a variety of lighting conditions?

• Experiment 10.2
Field of View and Depth of Field of a Camera Lens

Material: Single lens reflex (SLR) camera with time exposure setting, ground glass screen, meter stick.

Procedure:

1. Open the back of the camera and place a ground-glass screen where the film normally goes. With the largest lens opening (smallest f number), open the

shutter (by using the T setting, if available, otherwise the B setting; in the latter case a cable release with a lock feature is convenient). Move the meter stick until it just fills the camera's field of view, and note its distance. Measure the actual length of the meter stick image as seen on the ground-glass screen. What is the ratio of image size to object size? Compare this to the ratio of the lens to film distance divided by the lens to object distance.

2. If a lens with a different focal length is available (or if the camera has a zoom lens), repeat the measurement with a different focal length. A 2X or Barlow lens may also be used to change the focal length by a factor of about 2.

3. Change the camera focus slowly, noting the distance readings at which the image begins to blur. This is a measure of the depth of field. Reduce the lens aperture (increase the f-stop number) in steps and measure the depth of field at each f number.

Questions:

1. How does a photographer maximize the depth of field?

2. Why do cameras with a large lens aperture (small f-stop number) need to be focused, whereas point-and-shoot cameras with small lenses can be fixed focus?

• Experiment 11.1
Making a Reflection Hologram

Materials: Diode laser, holographic film, developers, small sandbox and developer trays. The use of the Holokit™ holography kit, designed by Professor T. H. Jeong and available from Integraf LLC, which contains all necessary materials, is highly recommended. All materials may also be purchased separately from Integraf.

An arrangement for making a reflection hologram is shown in the figure below. A diode laser is mounted on a ring stand approximately 40 cm above the table top: The ring stand, and other objects used in the holographic process, should be placed in the sandbox to reduce vibration.

Procedure:

1. Place an object in the sand. For best results, highly reflective objects should be used. Coins, dice, costume jewelry, and white porcelain figurines work well as objects. Adjust the laser to that the object is completely illuminated.
2. Place a simple shutter, such as a piece of cardboard, between the laser and the object.
3. In a darkened room, illuminated only with a safelight, remove a holographic film plate from its container and place it directly in front of or on top of the object, emulsion side down. (The emulsion side is slightly sticky and can be identified by touching the corner of the plate with a moistened fingertip.).
4. Before the shutter is removed, all motion and talking in the room should cease. Wait ten seconds prior to removing the shutter to ensure that residual vibrations have damped out.
5. Expose the film by removing the shutter for 20 s.
6. Move the film to the developing tray, emulsion side up, and agitate for 10 s. After this time, the plate should turn black.
7. Move film to first water rinse and agitate for 20 s.
8. Move film to the bleach tray and agitate for as long as it takes to turn the plate clear. This will require approximately 70 s.
9. Move film back to the water rinse and agitate for 20 s.
10. Rinse the film in Form-A-Flo rinse for about 10 s.
11. Remove from rinse. Once dry, the hologram will be ready for viewing.
12. View the hologram in sunlight or bright white light from a small light source.

• Experiment 11.2
Making a Transmission Hologram

Materials: Diode laser, holographic film, developers, developer trays, mouse pad, or small sandbox. The use of the Holokit™ holography kit, designed by Professor T. H. Jeong and available from Integraf LLC, is highly recommended. Materials may also be purchased separately from Integraf.

A direct-beam transmission hologram can be made with a simple setup such as the one shown in the figure below. Note that the film is now placed behind, rather than in front of the object.

Procedure:

1. Select an object as your holographic subject. For best results, highly reflective objects should be used. Coins, dice, costume jewelry, and white porcelain figurines work well as objects.
2. Arrange the object and ring stand-mounted diode laser as shown in the above figure. In order to limit vibrations, the object, and later the film, should be placed on a mouse pad or in a sandbox.
3. Adjust the light from the laser so it completely illuminates the object.
4. Hold a simple shutter, such as a piece of cardboard, between the laser and the object. The shutter should not come in contact with the table or any objects on it.
5. In a darkened room, illuminated only with a safelight, place the holographic film directly behind the object. The film plate can be supported by two metal clips attached to each side of the plate. Be sure that the emulsion side of the film faces the object. A good technique to determine the emulsion side is to moisten your finger and touch the film; the emulsion side will be sticky.
6. Before the shutter is removed, all motion and talking in the room should cease. Wait 10 s prior to removing the shutter to ensure that residual vibrations have damped out.
7. Expose the film by removing the shutter for 20 s.
8. Move the film to the development tank, emulsion side up, and agitate for 10 s. After this time, the plate should turn black.
9. Move film to first water rinse and agitate for 20 s.
10. Move film to the bleach tank and agitate for as long as it takes to turn the plate clear. This will require approximately 70 s.
11. Move film back to the water rinse and agitate for 20 s.
12. Rinse the film in Form-A-Flo rinse for about 10 s.
13. Remove from rinse. Once dry, the hologram will be ready for viewing.
14. View the hologram with the laser beam making the same angle as it made during exposure.

Author Index

Subject Index

© Springer Nature Switzerland AG 2019
T. D. Rossing and C. J. Chiaverina, *Light Science*,
https://doi.org/10.1007/978-3-030-27103-9